PRAISE FOR *STONED*

New York Times bestseller

Amazon Best Book of the Month Pick

Christian Science Monitor Best Book of the Month

"[*Stoned*] romps through the stories of eight jewels."
—*New York Times*

"Raden, both a historian and an actual jeweler, is unusually qualified to embark on this beaded necklace of anecdotes and ruminations, which, more than many single-topic histories, earns its outsize 'changed the planet' claims."
— *New York* magazine

"*Stoned* has its own special vitreous luster, just as any emerald worth its salt—an illumination into what makes us irrationally human."
—*Star Tribune* (Minneapolis)

"Riveting, erudite."
—*MORE*

"Raden brings impeccable credentials to the task at hand. She also writes with a blithe and breezy deftness, peppering her narrative with snarky but substantive footnotes that recall the insouciance of Mary Roach. A gem of a study into all that enchants and bewitches."
—*Booklist*

"Aja Raden must be a kick at dinner parties. . . . She's also an appealingly informal, effortless storyteller, fascinated by the stories she tells."
—*Seattle Times*

"A lively, incisive cultural and social history."

—*Kirkus Reviews*

"History enthusiasts will be entertained by Raden's knowledge of famous names as well as her narrative approach to the topic. Occasional injections of humor will keep readers interested."

—*Library Journal*

"Raden's commentary on the often ugly side of human desire through the ages is consistently captivating, and her witty delivery makes the material shine."

—*Publishers Weekly*

"With wit and storytelling flair, Aja Raden explores world history through the prism of our universal and often violent obsession with jewelry."

—*Shelf Awareness*

"Money, power, sexual politics, and jewelry! Isn't this what makes the world go 'round? What more could I ask for in a book?

—Madonna

"A populist history told with humor and great relish. . . . Profanely funny."

—David Duchovny, author of *Holy Cow*

STONED

Jewelry, Obsession, and
How Desire Shapes the World

AJA RADEN

ecco
An Imprint of HarperCollinsPublishers

Grateful acknowledgment is made to the following for the use of the photographs that appear in the insert: Electric Studio/Library and Archives Canada/C-085137 (page 1, top); Stephen Lang, 2009 (page 1, bottom); Rich Durant—Portland, Oregon, 2009 (page 2, top); Shawish Genève, 2015 (page 2, middle and bottom); Abby Stanglin (page 3, top right); Wikimedia Commons/Public Domain/User: M.M. (page 3, top left); Victoria and Albert Museum, London (page 3, bottom); RMN-Grand Palais/Art Resource, NY (page 4, top left); Wikimedia Commons/Public Domain/User: Itub (page 4, top right); Bibliothèque nationale de France (page 4, bottom); Cartier/Private Collection/Photograph © Christie's Images/Bridgeman Images (page 5, top left); Prado, Madrid, Spain/Bridgeman Images (page 5, top right); Society of Apothecaries, London, UK/Bridgeman Images (page 5, bottom); Velikzhanin Viktor/ITAR-TASS/Corbis (page 6, top); Royal Collection Trust/© Her Majesty Queen Elizabeth II, 2015 (page 6, middle); Private Collection/Photograph © Christie's Images/Bridgeman Images (page 6, bottom); Mikimoto Pearl Island Co., Ltd. (page 7, top and middle); K. Mikimoto & Co., Ltd. (page 7, bottom); Patek Philippe Museum (page 8, top); courtesy of the Gallet Watch Company, 2015 (page 8, middle); QualityTyme.net, 2015 (page 8, bottom).

HarperCollins books may be purchased for educational, business, or sales promotional use. For information please e-mail the Special Markets Department at SPsales@harpercollins.com.

A hardcover edition of this book was published in 2015 by Ecco, an imprint of HarperCollins Publishers.

FIRST ECCO PAPERBACK EDITION PUBLISHED 2016.

Designed by Suet Yee Chong

Library of Congress Cataloging-in-Publication Data has been applied for.

ISBN 978-0-06-233470-1

16 17 18 19 20 OV/RRD 10 9 8 7 6 5 4 3 2 1

Beauty is worse than wine;
it intoxicates both the holder and the beholder.
—Aldous Huxley

Contents

—

PART III

HAVE

*Industry, Innovation, and
the Light at the End of the Tunnel*

Preface

The sight of something lovely doesn't just bring us pleasure, it *physically motivates us*. Writing in the *New York Times*, Lance Hosey points to brain scan studies that "reveal that the sight of an attractive product can trigger the part of the motor cerebellum that governs hand movement. Instinctively, we reach out for attractive things; beauty literally moves us."[*]

It is the desire for that beauty—not cataclysms or migrations, wars or empires, kings or prophets—that drives us and shapes us. What moves the world is the same thing that moves each of us.

The history of the world is the history of desire.

There's no more basic statement than "I want."

I, unfortunately, want almost everything. It's been a lifelong affliction . . .

Money may make the world go round, but only because money is a means to an end: that singular, almost lunatic, human desire to truly *possess*, and keep forever, a thing of beauty.

All of human history can be boiled down to these three verbs: *want, take*, and *have*. And what better illustration of this principle than the history of jewelry? After all, empires have been built

[*] Lance Hosey, "Why We Love Beautiful Things," *New York Times*, February 15, 2013.

on the economics of desire, and jewelry has traditionally been a major form of currency.

I've always most especially loved jewelry. My mother didn't have a jewelry box. She had a jewelry *closet*. Some of the pieces were real, some of them were fake. It didn't really matter—it all held me in equal thrall; it was all *real treasure*. When I was good, she would let me sit on her giant bed and sort it into sparkling piles, and rearrange all the drawers and boxes. That was somehow more satisfying even than trying it on. Touching every glittering piece, cataloging them in my mind: how many, what kind. I wanted them *so badly* for my own, that it was like an unrequited love, the kind that leaves an empty pit in your stomach.

Even as an adult—one who, as a jewelry designer, has spent the last decade surrounded by jewels—my mom's jewelry has never quite lost that magic sparkle. I *still* want her jewelry. It doesn't matter that our taste couldn't be more disparate, nor that I've amassed quite a jewel closet of my own. The moment she shows me a new and shiny thing she's acquired, I'm right back on that giant bed, surrounded by her gaudy eighties cocktail jewelry, holding some glittery piece in my tiny hands as though it were the Holy Grail.

Why is that? Why do I need every trinket she buys? Why do I inflate the value of her possessions so absurdly?

It's because they're not just objects. Not by a long shot. Jewelry is symbol and signifier, a tangible stand-in for intangible things. It can mean not just wealth and power but also safety and home. It can evoke glamour or success or just your mom's bed.

The individual stories collected and retold here are stories about beautiful things and the men and women who desired them. They are stories of need and possession, longing and greed. But *Stoned* is more than a book about pretty things. It's an attempt to understand history through the lens of desire, and a look at the surprising consequences of the economics of scarcity and demand. *Stoned* is about the rippling effect that a rare and cov-

eted piece of jewelry can have over the course of an individual lifetime and over the course of history. Pieces of jewelry have spawned cultural movements, launched political dynasties, and even started wars, or at least, been major contributing causes of political and military conflict.

The first section, "Want," examines the nature of value and desire. "Want" is about what things are worth, what we imagine they're worth, and whether there's any difference. When you want something, you imagine that it's valuable, and the opposite is also true. When the Dutch bought the island of Manhattan for beads, it was the beginning of an epic going-out-of-business sale for the Algonquin. But were the Native Americans completely defrauded, or did they make a better bargain than we think? What's a stone worth? What makes a stone a jewel, and what makes a jewel priceless? And what does that diamond on your finger have to do with the GI Bill? Each of the accounts in these first three chapters examines how we determine, create, and sometimes *imagine* value, and how our collective story has been shaped by those valuations.

The second section, "Take," is about the corrosive human tendency to covet. It explores what happens when people want something they *can't* have. This section links several major historical events to desires denied—consequences that, in some cases, reverberate across centuries: Did Marie Antoinette lose her head over a diamond necklace? Did the French Revolution start because of a coveted piece of jewelry? How did two sisters' argument over a valuable pearl in England almost five hundred years ago help draw the map of the modern Middle East? One empire falls, another empire rises, all because of the inherent human weakness for pretty things. "Take" is about what we want, why we want, and how far we'll go to get it.

The last section, "Have," isn't about war or destruction. On the contrary, it's about *creation*. In "Have," we look at some of the more constructive consequences of our ongoing, obsessive love

affair with beautiful things. In this section, we'll meet a noodle maker whose desire to see every woman on the planet wear a string of pearls saved Japanese culture from complete oblivion and helped transform the tiny island into a global economic superpower. We'll also meet a European lady who redefined manliness and helped reinvent modern warfare in the process—all with a single fashion statement.

The end of one story is only ever the beginning of another. "Have" is about what happens when we get what we want, and the incredible things that happen along the way.

The history of the world is the history of desire. This is an examination of that history.

It's the story of desire, and its ability to change the world.

PART I

WANT
DESIRE, DELUSION, AND THE SCARCITY EFFECT

What's a stone worth? Well, it depends on the stone, obviously. The real question is: What are our criteria for measuring?

How do we gauge a stone's value? By its beauty? It's certainly a factor, but only sometimes. Besides, it leads us right back to the question of criteria: How do we accurately judge a stone's beauty? *Beauty is important, but terribly subjective.*

Size matters, but only once absolute value has been established. A large ruby is worth more than a small ruby. But then, a small ruby is worth more than an enormous marble floor, so size certainly isn't definitive. The same holds true for quality: A flawless quartz is still just, well . . . quartz.

So what's a stone worth? What makes a stone a jewel? What makes a jewel priceless?

The answer can, perhaps unsurprisingly, be found in a more general examination of the fluctuating value of physical resources like corn, barley, rice, and crude oil. What makes the value of these resources skyrocket? Scarcity. And what makes

their value plummet? Oversaturation—when the supply of the resource outpaces the demand.

The same is true for a stone. Ultimately, it's not beauty that determines its value—nor is it size or quality, though each of these factors is important.* It is a question of rarity. It's the extremes one must go to to obtain a stone. It's that heady feeling that you have something no one else—or very few other people—have.

The problem with quartz is that it's just so common. Value comes from perceived scarcity, and the reverse is also true. As soon as a thing becomes too accessible, it loses its luster. After all, if you could buy one, a moon rock (as opposed to their dime-a-dozen cousins, meteorites) would cost a great deal more than a diamond. Evidently, a large part of what makes a stone a jewel, let alone what makes us want it, is just how hard it is to get.

This section is about the very real imaginary value of jewels. Think that the phrase real imagined value is a paradox? Think again. How valuable something is depends in large part, if not entirely, on how valuable (i.e., rare) we perceive it to be—as history has shown us again and again. Each of the accounts in these first three chapters examines how we determine, create, and sometimes imagine value, and how our collective story has been shaped by those valuations.

* Even the very concept of beauty is fluid and unreliable. A beautiful woman in the eighteen hundreds would be running on a treadmill today, because fat chicks are as common as French fries in the twenty-first century, whereas a hundred years ago (before the Industrial Revolution) a woman with more curves than bones was scarce. What's "in" one century is out the next, and the only constant is that urge to obtain whatever is rare.

KEEP THE CHANGE

The Beads That Bought Manhattan

(1626)

When asked by an anthropologist what the Indians called America before the white man came, an Indian said simply, "Ours."

—VINE DELORIA JR.

One man's trash is another man's treasure.　　　　—PROVERB

In the Age of Exploration—which could just as easily have been known as the Age of Exploitation—Europe was expanding its knowledge of the world. And it was doing so through unapologetic conquest. What began as a simple race to India's and Asia's gem and spice markets rapidly evolved into a competition to own the world.

The Portuguese employed brute force to lay claim to new land, and the Spanish Conquistadors declared that they were divinely chosen to rule the world. The British felt no need to justify their conquests at all. But the Dutch, perhaps the strangest exploiters of all, liked to *shop* for countries. And in 1626, a Dutchman named Peter Minuit bought the island of Manhattan from the Lenape Indians, an eastern branch of the Delaware Nation, for the bargain price of twenty-four dollars' worth of glass beads and trinkets.

The story of the purchase of Manhattan is one of the most contentious and oft-disputed stories in American history. That modest sale has gone down as the biggest swindle ever perpetrated. The fabled exchange has been dissected and reexamined with the weak hope of proving it a myth. Some people just dismiss the event out of hand, claiming it's apocryphal—that the infamous exchange never took place at all. The deal seems so unfair, some parties have even suggested that the island be returned to the "original" owners.

But what may be the most surprising fact about the whole transaction is that in 1626, and for a long time afterward, both parties were *very* happy with it.

Hello Paleface

In May of 1626 Peter Minuit was working for the Vereenigde Oost-Indische Compagnie, which translates roughly as the Dutch East India Company. From now on, we'll just call it the VOC for short. Minuit was authorized by his superiors at the VOC to buy a large and secure tract of land for the safety and consolidation of Dutch colonists.

He wasn't the first Dutchman to explore the New World. Minuit wasn't even the first governor of the New Netherlands empowered by the VOC to buy a country. He replaced a man named Willem Verhulst, who was an embezzler and who was unpopular with the Dutch colonists in his charge. Far worse, by VOC standards, he was an incompetent businessman. He couldn't strike a deal with the Delaware Indians, as he'd been commissioned to do.

All VOC agents (and by extension, Dutch colonists) were under explicit orders to be "civil and respectful" in their dealings with any and all "Indians," primarily because the New World

was very much a business venture to the Dutch and there's no profit in alienating the people you have to work with.*

When Verhulst, who was alienating pretty much everyone, was summarily sent back to Amsterdam in disgrace on September 23, 1626, Peter Minuit immediately replaced him as governor. Minuit wasted no time buying what became New Amsterdam Island in May of 1626. Then Minuit and five men made essentially the same deal with the Carnarsee tribe for what we now know as Staten Island. And that deed of sale still exists in Amsterdam. So much for apocryphal.

When Minuit approached a group of inhabitants† on New Amsterdam, what we now call Manhattan Island, he did so with every intention of purchasing the land for a fair price, or at least one that was agreed upon as fair by any and all of the inhabitants he found living there.

And yet on May 4, 1626, the island of Manhattan was sold to the VOC by "the local inhabitants thereof" for sixty guilders' (famously calculated at about twenty-four dollars') worth of beads, buttons, and trinkets.

* Verhulst had explicit instructions from the VOC, which was financing the building of the colony, and they went a little something like this:
"In case any Indian should be living on the aforesaid land or make any claim upon it or any other places that are of use to us, they must not be driven away by force or threat, but by good words be persuaded to leave, or be given something therefore to their satisfaction, or else be allowed to live among us, a contract being made thereof and signed by them in their manner, since such contracts upon other occasions may be very useful to the Company."
[A. J. F. van Laer, trans., *1924 Documents Relating to New Netherlands 1624–1626 in the Huntington Hartford Library*, San Marino, CA: 51–52.]
The VOC was pretty much saying: Don't make us look bad. Don't lie, don't steal, don't piss anybody off, don't trash the place, and don't kill anybody unless they really deserve it. In other words: Behave yourselves, kids.
† Probably the Lenape, but the Carnarsee were sort of famous for allegedly selling any land they happened to be walking across to anyone who wanted to buy it, then continuing on their way. According to historians, Raymond Fogelson among them, Manhattan, as well as other surrounding areas, had to be bought by the VOC repeatedly from various different sellers. *Now who's getting hustled?*

Crazy, right? Somebody clearly got worked.

Or did they? According to Native American authority Professor Raymond Fogelson of the University of Chicago, the deal definitely went down and most certainly involved beads. *But* the Lenape Indians with whom Minuit negotiated were most likely under the impression that they were just selling the right to *live* on the island, or use its resources, as they themselves did—*not* the right to own the land itself forever, much less the right to prevent other people from using it. When he and I spoke on this subject, he agreed that at the time the sale was made, the Lenape certainly *knew* they were making a sale, and more important, *were perfectly satisfied with the price*.

This leaves us with the a lingering and disconcerting question: Why would the Lenape Indians, being of sound mind and equal intelligence, have sold *anything*, even the use of an island, for some glass beads and buttons?

There are many possible answers, but the most obvious is also the simplest: Value is relative. If Minuit had presented the Lenape Indians with a sack full of diamonds, no one would question the merit of the transaction. Because glass beads are even less valuable to us than they were to the Dutch, we assume the Indians got taken. But overabundance always breeds contempt—and if it weren't for their value on an international scale, locals in Myanmar today might dismiss their own abundant rubies the same way we do glass beads.

Gemstones are, in fact, just colorful gravel. They're just rocks that we've given special names. True *jewels* are things that are beautiful and scarce. We want them because few others can possess them. We want them even more if they are from some very faraway, exotic place. Their value is, and always has been, 90 percent imaginary.

The Economics of Desire

Imaginary value is a tricky thing; it has a very real way of becoming *very real*. Anyone familiar with the tulipomania of the 1630s knows that a little hype goes a long way, and can easily turn a pretty bauble into an economic bubble.

Tulipomania is the name given to a strange phenomenon that took the Netherlands by storm in the 1630s and destroyed the entire Dutch economy within a single week. And the blowback it caused was in no way imaginary.

Although tulips are deeply associated with Holland (for reasons about to become apparent), the flowers aren't indigenous to Europe. Tulips come from the sexy and exotic Near East—Turkey to be exact. They weren't even introduced to Europe until 1559. For about a decade, a grassroots interest in the flowers spread very slowly. But their popularity gradually increased, especially among the wealthy and competitive, and the market for tulip bulbs expanded, the way markets for novel and beautiful things tend to do.

Tulips made their way across all of Western Europe by 1600, arriving in England for the first time that year. For the next thirty years, the popularity of tulips grew rapidly. But in the three months between February and May 1637, the phenomenon hit a tipping point, and tulips created the first recorded economic bubble in history.[*]

By 1630, all wealthy people had tulip collections. It was *the thing* to own. In 1630 a wealthy Dutch person without at least

[*] It was certainly the first well-documented one: In 1841, Charles Mackay wrote a one-thousand-page account of the events that transpired, titled *Memoirs of Extraordinary Popular Delusions and the Madness of Crowds*, documenting how the bubble appeared, expanded, and exploded. It was so influential that it's still in print and required reading for most future economists.

a modest tulip garden would likely be socially shunned. As the value of tulips increased, the necessity of owning tulips to maintain your social standing also increased. Prices skyrocketed, and bulbs were traded for staggering sums. In the final several years leading up to 1637, the mania for tulips had spread to the middle classes, even though within a few years a single bulb *cost more than a modest house.** Owning at least one tulip plant—like the diamonds of today—was evidence that you belonged to the right class, even if you really couldn't afford one. By late 1636, at the height of the frenzy, the middle and lower classes were selling their homes and farmland to buy a single bulb. Like contemporary house flippers, they believed the bulb's value was real, and that it could only continue to go up.

The most expensive tulip bulb ever sold was a *Semper Augustus,* a pretty red and white flower, sold for the equivalent of *twelve acres of prime building land.* Ultimately, by the fevered peak of February 1636, tulip bulbs were exchanged at such dementedly inflated rates that a few people got rich, but most were leveraged up to their eyeballs in the tulip frenzy and had no idea that they were about to lose everything.

That same month, something shocking happened: People failed to show up at a small, invitation-only tulip auction in Haarlem. The very exclusive event was probably a bust because there was a simultaneous outbreak of the bubonic plague in the very same neighborhood as the auction.

Nevertheless, people panicked—about the tulips, not the Black Death. When that one auction failed to produce the expected crowds, everyone else began to doubt the desirability (and thus the monetary value) of the bulbs. That failed auction was the tiny catalyst that began the equivalent of a tulip stock-market crash.

* Robert O'Brien and Marc Williams, *Global Political Economy: Evolution and Dynamics* (New York: Palgrave Macmillan, 2014), e-book.

People stopped buying and began to default on tulip contracts. Investors of every class were left homeless, holding nothing but suddenly worthless onionlike bulbs. People begged the Dutch government and the courts for help, but the situation was such a Ponzi mess, so complicated, that even The Hague was at a loss. Ultimately, the government declared tulip sales gambling debts and refused to be involved.

Within two months, half of Holland was destitute, and indifferent to the exorbitantly priced bulbs spread across Europe. A few professional bulb traders tried to revive the demand, but it was useless. There was no resuscitating the tulip market; it was as dead as a flower in winter.

This is the scarcity effect and imaginary value at its most sinister.

Value works like an economic syllogism: Everyone has to have it because everyone has to have it. The more other people want it, the more you'll pay to have it. And the more you'll pay to have it, the more convinced other people become that it must be valuable, and therefore the more they, in turn, will pay for the same thing. This is the absurd and imaginary way in which the value of rare, coveted things *just explodes*.

An interesting quirk of the scarcity effect is that it doesn't require actual scarcity.

The fact that one failed auction was the dart that popped the tulip bubble isn't as surprising as it sounds. The value of those coveted bulbs, like the value of diamonds and gems, was not only based on beauty or exoticism. Nor was their record-breaking value determined entirely by dearth—it was determined by other people's competitive desire to possess the same item. When it comes to a limited good, the mere *perception* of scarcity is adequate to send your brain into a tailspin.

You Should Have Your Head Examined

In an experiment on the neurological effect of supply and demand,[*] a group of subjects were given two different kinds of cookies (to keep it simple, we'll call them red and blue) and asked to rate their appeal. The fewer there were of one color, the more appealing that color cookie became to the test subjects. OK—no surprise there, this is an obvious result of scarcity and the way scarcity affects our perception of value.

The second half of the experiment was more interesting. The researchers started with the same number of red and blue cookies, but over the course of the experiment, the researchers took away some of the red cookies and added more blue cookies—all without the test subjects' knowledge.

If one type of cookie remained scarce throughout the entire experiment, that cookie was perceived as valuable. If the same type of cookie remained abundant throughout the entire experiment, it was perceived as not so valuable. But here's the fascinating part: Researchers found that the cookies that became *super* valuable were the ones that started out abundant, and then gradually began to disappear.

The test subjects' *belief* that their fellow participants wanted, and were selecting, the red cookies was enough to make every test subject believe red must be the most valuable cookie, for no reason at all except that they were witness to the dwindling supply.

Apparently the only thing more devastating to your brain than thinking you can't have something is the knowledge that *someone else can*. It may sound petty, but neurology almost always is.

[*] Stephen Worchel, Jerry Lee, and Akanbi Adewole, "Effects of Supply and Demand on Ratings of Object Value," *Journal of Personality and Social Psychology* 32, no. 5 (1975): 906–14.

Another researcher went even further and concluded that the effect of perceived scarcity on our brain "hinders our ability to think . . . When we watch something we want become less available . . . a physical agitation sets in . . . blood pressure goes up, the focus narrows . . . the cognitive and rational sides retreat . . . [and] cognitive processes are suppressed. Thoughtful analysis of the situation becomes less available and brain clouding arousal ensues . . ."* It's not just desire that makes us stupid but jealousy— the belief that the object of our desire may be desired by those around us. It *physically* preps our fight-or-flight response. Desire, and particularly the desire for a limited good, real or imagined, physically affects us. It makes us act without thinking. And then our reaction inspires a similar reaction in the people around us. It's a behavioral feedback loop in which the madness of one person feeds that of the next, and vice versa.

Paradoxically, another group of researchers found that even as you become physically agitated and confused, your perception of scarcity could actually cause you to pay closer attention to the object in question: "The presence of a restriction operates to activate a cognitive resource that is used in rendering a judgment regarding the favorableness of the offering."† If I offer you a whole pile of something, you may or may not register the details; but if I offer you only the last one or two of something, your brain will pay much, much closer attention, simply because you perceive that the item is in short supply.

The long and the short of it is this: Desire makes you stupid. Physically. Chemically. It inhibits your ability to make rational decisions even as it creates a heightened state of concentration and intensity. It's like jamming one foot on the gas and one on the

* R. B. Cialdini et al., "Empathy-based Helping: Is It Selflessly or Selfishly Motivated?" *Journal of Personality and Social Psychology* 52 (1987): 749–58.
† J. J. Inman, A. C. Peter, and P. Raghubir, "Framing the Deal: The Role of Restrictions in Accentuating Deal Value," *Journal of Consumer Research* 24 (1997): 68–79.

brake. At the same time that your brain is in overdrive, chugging like a little engine, trying to make the best rational choice possible, it has been greatly diminished in its capacity to do so.

When something is scarce, you just have to have it. It's a biological compulsion.

Real Estate Prices in Manhattan

So how does the neurobiology of scarcity relate to New York, the prized object of the contested exchange between Minuit and the Lenape Indians?

Manhattan wasn't always the most coveted address in the world. In fact, the island currently known as Manhattan wasn't the first choice of the Dutch for New Amsterdam. Even the Lenape didn't live there. *Manhattan* comes from Manahachta-nienk, meaning roughly "place where we all got drunk,"[*] so-called because of an early encounter with the Dutch.[†] In general, they only visited occasionally to fish or pick up oysters. No one actually wanted the future island of Manhattan.

If you strip away what's been built on the island since that period—the banking and financial and commercial industries, the arts, and everything else we emotionally associate with New York—that little 23 square miles of land isn't great real estate. OK, it has a bay, but such an extensive one with such weak, soft shoals that for the last three hundred years Manhattan has had to be shored up by trash. Quite literally. No less than 15 percent of its landmass, including large parts of the financial district, is made of centuries of deliberate landfill.

[*] It's still a pretty apt name as far as I'm concerned.

[†] Frank J. McVeigh and Loreen Therese Wolfe, *Brief History of Social Problems: A Critical Thinking Approach* (New York: University Press of America, 2004).

The island is also full of granite deposits left by the glaciers receding at the end of the last Ice Age. The huge boulders you see in Central Park are just the tip of the proverbial iceberg. Those granite deposits are ubiquitous, they go all the way down, and they make the land completely unfarmable.* Manhattan is freezing in the winter and blistering in the summer. It's subject to hurricanes and flooding. It's tiny and surrounded by frigid, choppy water. There weren't even many natural resources except a tiny bit of wood and, of course, the oysters.

And yet for a while, New York was the capital of our country. When it surpassed London as the largest city in the world in 1925, it became the unofficial capital of the world. Ironically, it's now among the most desired real estate on the planet.

So what makes it so valuable now?

Manhattan real estate prices obey the basic principles of the scarcity effect. In other cities, you can keep building outward. Manhattan's an island. In Manhattan, you can only build up. There is very little of the island left to develop. Prices have been determined almost solely by the scarcity of the square footage.

Limited good is a powerful thing.

Sometimes less is more, and in the case of Manhattan, the key to its value *is its size*. New York is like a jewel in and of itself. It would seem the scarcity effect is effective whether your commodity is carats of diamond or acres of bedrock.

Space only really became prized in Manhattan when it began running out. Before all the construction and capitalism—before Wall Street and the financial district—Manhattan wasn't worth much, as far as land goes, especially in an expansive continent rich in space and natural resources.

Given this picture, a sack of rare, exotic "jewels" in exchange

* Though ultimately the granite bedrock that made Manhattan useless for most endeavors would make it almost uniquely suited to hold up what would become its trademark: a brand-new type of building known as the "skyscraper."

for a swampy, intemperate island doesn't sound like such a bad trade after all.

The Spice Race

What the hell were the Dutch doing in the New World, let alone in the Hudson River Valley? Why did they even want the rocky, swampy little island? After all, as New World land claims go, Manhattan wasn't exactly the Bahamas.

If you follow the money, the answer is *drugs*.

Few trade goods have ever moved people as powerfully—by which I mean as fast, as far, and with such desperation—as have spices. Why?

Part of their allure, like that of gems, is exclusivity. Throughout most of history, spices were difficult and dangerous to obtain. Like many jewels, they came from far away and required incredible effort and expense (sometimes blood) to procure. It also doesn't hurt that, *un*like most jewelry, spices have served many practical purposes, from treating diseases, to preserving foods, to just good old-fashioned getting wasted. True story: When consumed correctly, many "ordinary" spices give a pretty decent high.

Nonetheless, for explorers, merchants, and financiers like the Dutch, the primary lure of spices, just like jewels, has always been the *demand*. What one man will buy, ten men will fight to sell—and in the Middle Ages there was a violent and competitive market to possess, trade, and sell spices. Remember, you have to have that red cookie if it's hard to get, or worse, if you think other people might get it before you.

For centuries, Western powers attempting to get to the spice markets of East Asia took a standard route. Starting in Europe, passing through the all-important trade city of Constantinople,

the established trade route eventually wound east, along the famous Silk Road, into China. While it was mostly overland, there were caravans, rivers, and minor sea voyages to endure. It was a long, arduous trip, even when passage was possible.

But in 1453, when the Ottoman sultan Mehmed II successfully took the capital of Constantinople after a two-month siege, he blocked all European access to the traditional trade routes. The major powers needed to find a new way to get to Asia, fast. From that moment, as though somebody had shot a starting pistol, the Age of Exploration was *on*.

Just like the race for space exploration of the 1960s, the whole globe was caught up in the excitement of a suddenly expanding world just within its grasp. Every country with the means to participate was competing, and every other country was watching from the sidelines with unprecedented enthusiasm.

Some highlights from the known travel log: In 1492, Columbus sailed west for India, promising pearls and spices, which was moronic because even if all of North and South America hadn't been in the way, he still would have hit China first. His most triumphant rival, Vasco da Gama, sailed south around Africa's Cape of Good Hope in 1497. De Gama was much more successful than Columbus, if you measure success in terms of achieving your publicly stated goal. He reached India on behalf of Portugal and returned only two years later, in a ship wobbling under the weight of precious goods and personal pride. Around 1520, Magellan actually circumnavigated the entire globe. (Well, at least his boat did. He died in battle near the end, in search of a westward route to the desperately valuable Spice Islands of Indonesia.)

As you can see, the early effort to get to the East was largely dominated by Spain and Portugal. They had more money, they had better ships, and they had the most daring explorers. That, in combination with the kind of special favor that came along with being part of the Catholic Church, made them early favorites to

win the spice race and, with it, the mantle of socioeconomic world supremacy.*

The Dutch had a good excuse for their late arrival in the New World. Spain owned the Netherlands in the fifteenth and six-teenth century, and the Dutch had to fight a war (from 1568 to 1648) to throw off Spanish rule before they could establish their own independent country. Only after that could they participate in the Spice Race and make their own bid for global domination. Meanwhile, the British were a weak, cash-poor nation. When Queen Elizabeth I took the throne in 1558, England wasn't in a position to explore anything except bankruptcy.

But with Elizabeth's clever and subversive use of unofficial, crown-sanctioned piracy, she managed to start a decade-long pissing match with Spain. In addition to insulting them and sinking their ships, she condoned and facilitated the theft of an unimaginable amount of New World plunder. Not only did these attacks enrich her country, but Spain was forced to launch an all-out attack on England to make it stop, culminating in the total destruction of the Spanish Armada. In the end, Spain was com-pletely sunk by the British and the Dutch, and Northern Europe got to take a seat at the big kids' table.

So by the 1600s the British and the Dutch had gotten involved in the free-for-all of world conquest. In fact, it's fair to say they'd found their groove. But their strong suit wasn't exploration; it was *colonization*. Both nations had a remarkable talent for making, not just seizing, wealth wherever they landed. If the British and the

* The way things were going, the entire modern world should be speaking Por-tuguese. And yet a mere two hundred years into the race, people would be tossing around the phrase "the sun never sets on the British Empire" in nearly every place the Spanish and Portuguese had landed first. So what gives? How did Spain and Portugal lose their footing, and how did so much of the globe end up under British rule? One word: jewelry. The fortunes and misfortunes of England and Spain have more to do with pearls and emeralds than glass beads, as you can read in Chapters 3, "The Color of Money," and 5, "Hello, Sailor."

Dutch tended to clash, it was due to overlapping business interests. They liked the same places as possible enterprises and aimed for the same targets. As commercial empires with commercial interests, they were looking for places not to plunder but to *groom*— places with precious *and* renewable resources, land they could farm and colonize, mine and expand, and, of course, places strategically located to seek out further trade route exploration or stage defenses. Thus the Dutch East India Company (VOC) and the British East India Company (EIC) had a long and interesting history of fighting over the same islands—and Manhattan was no exception.

Henry Hudson was an English explorer working for the VOC. He was on Dutch orders to search for that famous, but ever-elusive, Northwest Passage that would allow European merchants to sail right through the New World, when he stumbled upon what we now call New York. But Hudson didn't care. He only had eyes for the East.

Nevertheless, he did the sensible thing and claimed the area and surrounding territories in the name of the Dutch East India Company. But understand: That does not mean that the VOC believed it owned the land above any native or sovereign claims. It only meant that they had staked out the territory against the claims of any other European nations. It was a very different thing from the way that Spain, for example, would show up somewhere and claim that place, not *for* Spain, but as a piece *of* Spain. The Dutch were literally calling "first dibs" on new countries for development opportunities.

Less warlike, more businesslike. Equally delusional.

Hudson may have metaphorically peed on New York from the deck of his ship as he sailed past it in 1612, but it wasn't until more than a decade later, when the VOC was looking for a place to consolidate its settlers, that it arranged to actually purchase the island through Peter Minuit. Offering payment for the land was more than a sign of good faith. It was also a way of formalizing the deal.

Papal Bull . . .

Why did the Dutch pay anything at all for Manhattan? What kind of bonehead pays for land in the New World?

The Age of Exploration was the ultimate free-for-all, and I'm stressing the word *free*. As I mentioned earlier, the entire Old World was pouring into the Americas and seizing land as though by right. Some countries actually claimed *divine* right. The Dutch may have been more bean counters than conquistadors, but that didn't make them toothless. And the Dutch certainly had a long history of treating the native populations in other areas, like any and all diamond-producing parts of Africa, with incredible brutality. So why were they so gentlemanly in the New World? Why did they write contracts with the so-called Wilden,* negotiate prices, and sign on the dotted line?

Because it wasn't about the natives. It was about the Catholic Church: a club they absolutely did not belong to. More specifically, it was about the Treaty of Tordesillas.

Starting in 1481, Pope Alexander VI (head of the notorious Borgia family), employing his divine authority as the voice of God's church, issued multiple papal bulls, many of which contradicted each other, and some of which made no sense at all. Technically, a papal bull is any written document issued to the public by the pope of Rome, bearing a formal seal. In practice, a papal bull functions as a decree. Alexander VI loved issuing papal bulls. He tossed them around like bad checks. In the long history of the Catholic Church, he's not remembered with much pride.

Ultimately, Alexander VI's bull Inter Caetera, later ratified formally as the Treaty of Tordesillas, divided the whole globe into abstract territories and parsed them out between Spain and

* Wilden was the term the Dutch used for any and all local inhabitants they found.

Portugal—in exchange, of course, for sizable favors from Spain and Portugal. No other country, on pain of excommunication from the Catholic Church, was allowed to send ships or set up outposts or establish trade routes in the New World . . . the New World now comprising the *entirety* of the undiscovered world, east and west. (There was some haggling, and the line got shifted back and forth a little, which is why Brazilians are the only South Americans who speak Portuguese instead of Spanish.)

This plan worked out great—for Alexander VI, for Spain, and for Portugal. It really sucked for everyone else.

But as the Dutch were definitively non-Catholics, they didn't take papal authority too seriously. In fact, the unofficial motto of the VOC was *Christus is goed maar handel is beter;* that is, "Christ is good, but trade is better." The threat of excommunication wasn't much of a threat, since you can't be thrown out of a club you don't belong to. For the most part, the Dutch simply ignored the Treaty of Tordesillas. But they needed a way to validate their land claims to those who took the Church's authority more seriously.

The VOC weren't pirates or adventurers. They were businessmen, with a unique gift for contracts. Ultimately, negotiating with the Wilden, writing contracts with them, and paying for their land was a clever legal maneuver intended to neutralize any possible attempt by outside Catholic countries to claim that the colonies the Dutch developed had not been rightfully obtained.

Wanna Buy an Island?

So how did they determine a fair price for Manhattan? And why use beads? Why not gems, or tulips, or anything else for that matter?

The fact that the Dutch paid for New Amsterdam in beads isn't surprising or even unique. Venetians had used trade beads

as currency in Africa and Indonesia for a very long time before anyone ever ventured to the New World. In fact, many of the bead makers in Holland *were* Venetians. Glass beads were not only lovely, but glass was a rare commodity outside of Europe.

In fact, in the sixteenth and seventeenth centuries, beads were valuable and accepted pretty much as universal currency. They were actually created for that purpose and used kind of like Renaissance-era traveler's checks. It was just as difficult to trade using unrecognizable foreign currency back then as it is now. And, sure, gold and jewels are welcome everywhere, but the jewels were mostly coming *from* those distant lands in the first place, making them ubiquitous and far less valuable to their original sellers than to their European counterparts. And though everybody values gold, it's heavy, difficult to transport in quantity, and easily stolen.

Glass beads, on the other hand, were easy to transport, easy to standardize for value, and most important, they were rare— and therefore valued—everywhere *but* in Western Europe. There's a distinct advantage to trading something more valuable to your customer than it is to you. Glass beads were particularly valuable, one might even say invaluable, rare, and exotic, in the New World, where glassmaking technology didn't exist and no one had ever seen anything like them.

People hate the idea that Manhattan was bought from Native Americans for beads, because modern people think beads are basically worthless. But there's really nothing scandalous about a sale involving beads. The presumption that the natives who accepted the beads as money were foolish comes from the person hearing this story and not from the story itself. It's informed not only by cultural guilt but by our own modern sense of what objects are worth. If we accept that beads are valueless, if we believe that the native population sold its land for worthless trinkets, then it logically follows that we must malign the intelligence and integrity of the Native Americans who lived there.

The cheapness of beads is a postindustrial perception. We've established that an item's value plummets as that thing becomes common and ubiquitous. The fate of buttons and beads, once moderate luxury items, was one and the same: As the production of the items was aided by factories and machines, the *volume* of buttons and beads that a seller could produce exploded. Before the Industrial Revolution, a bead or button maker might produce a hundred beads in a month; afterward, he might produce *ten thousand*. That success, paradoxically, became the industry's undoing; ultimately, the bead and button market became saturated. That lack of scarcity made the items seem less valuable, and so in time they *were* less valuable.

As the demand for beautiful beads and buttons fell, prices dropped, and manufacturers started using cheaper materials in order to keep prices down. That, combined with constant industrial innovations in machinery, made them easier and easier to produce in the millions. The irony is that as soon as the process had been streamlined and perfected for mass production, the masses no longer wanted them . . . for just that reason.

The problem with the story of "the beads that bought Manhattan" isn't that no one has calculated the interest on twenty-four dollars—way too many clever people have tried that. It's that no one thought to calculate the interest on *beads*. That, right there, is the essence of the scarcity effect: Beads nowadays are ubiquitous, cheap, and disposable. Anyone can have them, so they must be worth nothing.

The question is: What *were* they worth?

All That Glitters

One of my first jobs in the jewelry industry was in the appraisal department of a Chicago auction house, the House of Kahn. On

my first day, I was using a lexicon to verify the maker's marks (which are kind of like artist's signatures for jewelers) imprinted on dozens of rings. But I was confused by a series of two to three numbers I invariably found also stamped into the metal.

I saw Mr. Kahn, the big boss, on his way to lunch, and introduced myself. I showed him one of the numbers that had been troubling me and asked him what it meant. He explained that I was looking at a metal mark: a number, stamped into the jewelry, denoting the purity of the metal—that is, what percentage is pure gold or silver.

I asked him why we couldn't simply file off the numbers and change them. Wouldn't that make the jewelry more valuable? Don't judge me too harshly. I was young, and it was my first day. (Also, I have pronounced criminal tendencies.)

He called me a very clever girl and gave me a pat on the head. Then he sternly forbade me from doing so and explained that being too clever would be a quick way into federal prison.

Tampering with those numbers is no different than adding a zero to a hundred-dollar bill. A ring may belong to you, but those little marks belong to the Federal Reserve. If you look inside your ring or your bracelet, you'll see marks that say things like 925—that means sterling silver, because it's 92.5 percent pure silver; or you'll see 725, meaning the piece is 18-karat gold, 72.5 percent pure gold and 27.5 percent alloy. It's illegal to remove those marks from jewelry, even if it's your *own jewelry*. It's illegal for a pawnshop to remove or alter those marks. It's illegal for a jeweler *not* to put them in, or to put the wrong stamp in deliberately.*

And it's not illegal in that "Don't remove this tag under penalty of law" on your mattress sort of way. It's illegal in the sort of way that counterfeiting is illegal.

Jewelry is money. Literally.

* National Gold and Silver Stamping Act of 1906.

Jewelry can be melted down into bricks and loose stones. It's intended to back currency, if not to function as currency. It's beautiful money, to be sure. It's potently desirable. But at the end of the day, gold and jewels are just money.

The same was true of a particular kind of very special New World bead known as "wampum."

Oyster Island

Long before New York was the city that never sleeps, it was the sleepiest little puddle on the eastern seaboard. It was unrecognizable—even its coastline has changed significantly in four hundred years—but for one important feature: Broadway, the legendary Great White Way.

We didn't actually build Broadway. It's always been there. The reason Broadway runs down the length of New York the way it does, in that funny, wobbly, almost organic diagonal, is that it is, in fact, organic. The fabled avenue that would hundreds of years later become the epicenter of the tourist district in New York, and the bane of every native New Yorker, began as a well-trodden footpath that ran along either side of a wide, shallow brook. For eons, the natives walked this path collecting oysters.

The white brook (it was always white, by the way, full of oysters as it was) was so full of shells that you could just reach in and pluck them out. In fact, the native population referred to the island of Manhattan as Little Oyster Island; its neighbor, Big Oyster Island, is modern-day Staten Island.

The Native Americans didn't just eat oysters either. The Lenape Indians also used the beautiful shells to make those very special beads known as "wampum."

The word *wampum* comes from the Narragansett word for

"white shell beads," but the wampum was actually made in two colors. The white beads were made from the shell of the North Atlantic whelk. The violet beads were made from the growth rings of the Western North Atlantic hard-shell clam, also known locally as a quahog. The beads themselves were tube shaped, with a smooth, polished surface.

The indigenous people of the North American eastern woodlands near New York, or Little Oyster Island, were the traditional producers of wampum, as it was then called. The beads were then traded and used by their neighbors as far west as the Sioux of the Great Plains. They were, in a sense, the coin of the realm.

In 1626, beads were a truly *universal* currency.

Wampum was made in a variety of shapes but most often the long polished tube. The white beads were arranged in long strings and used in standardized lengths as units of currency. The two types of beads were woven into ornate flat belts and necklaces. These woven wampum pieces were used to signify the closing of an important deal. Maybe even a land deal . . .

So what was *wampum* exactly? It was money. It was jewels. It was sacred symbols, pacts, promises, and records—just like our Old World jewels.

In essence, those white shell beads were the diamonds of their day. Both are naturally occurring substances. Both are prized for their beauty and their relative rarity, which is enhanced by specialized techniques known and mastered by only a few. Those techniques are visited upon these rare natural substances to increase their beauty but more important to *exponentially increase their rarity*. They could be used as hard currency, or they could be worked into ornate and elaborate decorative objects, desired by many as beautiful decorations and coveted by all as enhancements to their social status.

First Bank of America

To favor one kind of precious gemstone material for commerce, but also use it decoratively and symbolically, is not a behavior unique to Native Americans, nor is it unique to Europeans. It seems, in fact, to be a nearly universal human behavior.

Almost all cultures use jewels for purposes both religious (symbolic) and practical (transactional). While the transactional currency tends to be used for barter, and the religious currency used for adulation, worship, and ceremonial occasions—*adornment* is where the two meet.

For the Iroquois or the Delaware, it was the white whelks' shells that said money. For contemporary Europeans, it's white diamonds. The more spiritually symbolic stones for the Delaware would have been shells of the purple quahogs; in Europe, blue sapphires have adorned every pope's ring since the time of Edward the Confessor.

In the Middle East, those heavenly blue stones that are so important to Christianity are simply pretty ornamentation. Emeralds have always taken on the far more important religious significance in the Middle East, regardless of the religion du jour. Emeralds have always been favored in that region because all of those Near Eastern religions share a common reverence for the green symbolism of resurrection, and of eternal and recurring life after death. The white stone favored as monetary currency in the Middle East has traditionally been the pearl. Although pearls have less religious significance in the Middle East, they came from the seas in that area in great abundance. In fact, Bahrain was the center of the pearl trade for more than a millennium.*

* That is, until a clever noodle maker in Japan invented cultured pearls at the turn of the twentieth century and the pearl capital of the world moved forever to East Asia. Read about that in Chapter 7, "The Boss's String."

The Chumash of California used Olivella shells carved into disc-shaped beads called "anchum" as a standard unit of currency, very much like wampum. They also used green and violet abalone shell with more religious significance. Both shells were used in jewelry.

Incidentally, the Chumash had a very elaborate banking system as well as a system of regional representation. They had an understanding of the difference between permanent land ownership, temporary or granted land ownership, the more sophisticated land nonownership with land-use rights (rental), and most sophisticated of all, land nonownership with resource-use rights. Now I'll grant you that the Chumash weren't digging for natural gas or drilling for oil, but one person might own a tract of land, whereas another person could own the right to collect acorns, or to fish, or to hunt on it. In essence, according to Professor Raymond Fogelson, they acknowledged that there was land someone might use but not own, as well as land someone might have a claim to and yet not use.

The Iroquois weren't very different. They used wampum in very much the same way the Chumash used anchum. The Atlantic white whelk shells had a more monetary use, like the Olivella shell of the Pacific. The violet quahog shells were reserved for spiritual uses, like the purple abalone shells that the Pacific Chumash believed would replace their eyes after death.

We don't know whether or not the Lenape had a centralized banking system, as the English kept less detailed and interested records than the Spanish did on the comings and goings and cultural technicalities of their new neighbors. But the Native Americans did seem to have a lot in common, both with each other and with us. In fact, when it comes to money and jewelry, we all do. When it comes to money, human behavior doesn't vary much, not even in the specifics. Relative value, scarcity, and novelty all function more or less the same way across cultures.

It's safe to say that currency and ornamentation go hand in hand, both in our hearts and in our wallets.

Strange Currency

So what does it all mean? The Native Americans of the eastern seaboard were not unfamiliar with "money" as such, nor with financial transactions. More to the point, they were already using shell beads as a form of pancontinental currency themselves when the Dutch and English arrived. No one had to trick them into it. Their beads, their wampum, were beautiful in their own right, but more important, they were also carefully regulated and standardized, in the same way we treat loose gemstones: evaluating their size and color and weight, determining their value as part of an elaborate currency exchange. They also could be worn, or traded, or socked away, like diamonds or gems, valued as much for their symbolic significance as for their monetary worth.

The actual beads Minuit exchanged are long gone, but the beads the Dutch would have brought with them to the New World were Venetian glass beads. Trade beads, or "slave beads," as they were called, were Venetian glass beads, manufactured in the Neatherlands expressly for the purpose of advantageous trading with peoples in Africa, the East, and the Americas. The earliest varieties were brilliant colors, often with swirls, dots, or stripes of contrasting colors,* and later millefiori (thousand flower) beads were rainbow-hued and had intricate floral designs embedded in the glass. Even in a postindustrial world, they're still quite striking.

* A particularly common and popular variety of Venetian-glass trade bead used at the time—and a good contender for the actual variety traded.

As the Lenape, and the Delaware Indians in general, already *had* a preexisting system of currency, based in large part on the exchange of standardized wampum beads, it's not unreasonable to surmise that they would have found the Dutch beads acceptable as foreign currency. In a place that had never developed glass, the perfectly symmetrical, transparent glass spheres and barrels in a shocking array of vivid colors must have seemed like stunning jewels indeed—and, as is the rule for jewels and currency in general, all the more precious for having never been seen before.[*]

And accept them they did. On May 4, 1626, Little Oyster Island was sold to the VOC. At the time, and for quite a while after, the sellers were, by all accounts, very happy with the price. Consider: They had perhaps the only Venetian glass beads in the New World. And what really matters, the only ones that *they* had ever seen.

The story of the beads that bought Manhattan is the story of the very real imaginary value of gems. If desire is tantamount to brain damage, and if excitement about a pretty foreign flower was enough to topple the economy of a country in two months, then a stunning new gem—a new but not unrecognizable form of currency—was surely enough to buy an island that no one wanted.

Epilogue: The Other Island

The story of how the Dutch *lost* Manhattan is just as significant as the story of how they bought it, though far less well known. The end is always in the beginning, and to understand how Manhattan was lost, we have to go back to the Spice Wars.

[*] This was before contact with Europeans. Columbus brought glass, as did the Europeans who followed him.

By the seventeenth century, the Portuguese were losing their control over the Banda Islands, or the Spice Islands, as they were known when they were the hub of the Renaissance drug trade. They were a tiny archipelago of volcanic islands in the South Pacific and the only place on earth where nutmeg flourished. And when Portuguese influence weakened in the Banda Islands, the Dutch were only too happy to step in. By 1599, the VOC had driven the Portuguese out of the Spice Islands entirely and seized control of the supply.

The Dutch were so intent upon maintaining their near monopoly that they didn't just torture the Bandanese people to enforce their control, they tortured the *nuts*. Nutmeg could only grow in the volcanic soil of the Banda Islands, but just to make sure no one could grow them anywhere else, before they sold a nutmeg, the Dutch would dip the nuts[*] in poisonous lime to sterilize them.[†] That way, if someone did manage to plant one somewhere suitable, it still wouldn't be able to sprout.[‡]

Don't let nutmeg fool you—it's not the innocent spice we associate with Christmas and disgusting salmonella-laden drinks around the fire. It's in books of medicine and poison, as well as cookbooks, and in the right doses, it's a powerful hallucinogen. According to culinary historian Kathleen Wall, it "really does have the chemical constituents to make you feel good."[§]

It was a drug—and more important, it was an exotic drug that was hard to get your hands on.

The Dutch had one problem: There was one very tiny island

[*] OK, technically they're seeds.

[†] Not delicious lime juice. *Lime* is also a term for calcium oxide, or calcium hydroxide. Very poisonous, and often used to sterilize mass graves. Yummy.

[‡] If you find it disturbing that people were eating nutmeg soaked in lime, remember that they were wearing makeup full of lead, and drinking health tonic full of arsenic . . . so they likely had bigger problems.

[§] Kathleen Wall, "No Innocent Spice," *NPR Morning Edition*, November 26, 2012.

in the archipelago, no more than a rock, that was not controlled by the VOC. It was called the island of Run, it belonged to the British, and it was covered in nutmeg, even by Bandanese standards. The trees were clinging to the hillsides and falling into the ocean.

The Dutch couldn't take Run from the British, and they couldn't barter it away. The British had a navy as formidable as their own, and their tactics were just as fierce. In 1619, their pissing match took a very serious turn when a particularly vicious VOC commander named Jan Pieterszoon Coen was left in command of the Dutch nutmeg plantations. He decided that if he couldn't get rid of the competition, he would just get rid of their supply. He had been expressly forbidden from making a violent attack on the British personnel at Run because of a temporary agreement between the VOC and the EIC back in Europe. So in lieu of open warfare, Pieterszoon Coen and his men snuck onto the island and burned it to the ground, nutmeg and all.

It wasn't until 1666, during the Second Anglo-Dutch War, that the British relinquished control of the charred remains of Run to the VOC once and for all—but not before the British fleet had seized control of the colony of New Amsterdam in 1664.

They didn't take New Amsterdam just to hurt the Dutch, though it was undoubtedly a pleasure. Mostly, the British needed a staging ground in America from which to hurt the Spanish, their mortal enemies. Ultimately, in exchange for official control of the smoking remains of Run, the Dutch relinquished their claims to the equally useless New Amsterdam.

Initially the British weren't thrilled about the trade. Manhattan was considered far less valuable than Run, and they tried to exchange Manhattan a second time for a more valuable sugar-producing island in South America. Sugar was valuable. Boulders and oysters were not. For obvious reasons, the Dutch didn't go for it.

So the British were stuck with the island, later renaming it New York.

But the British got the last laugh in the end. Not just because you've never snorted nutmeg, and not just because Manhattan is the most expensive real estate in the world. The British got the better end of the deal because a few years after the exchange, nutmeg was flourishing all over the island of Granada in the Caribbean, and the nutmeg monopoly was no more. Apparently someone managed to smuggle an unsterilized nutmeg seed off of Run before the groves were destroyed, and found the temperamental plants a new home on the other side of the world.

So what does the sad story of nutmeg have to do with the beads that bought Manhattan? The nutmeg exchange represents the second time the world's future capital was traded away for something of dubious value, but the connection between the two stories goes deeper than that; it has to do with the way in which humans *determine* value itself. It has to do with perennial laws of supply and demand, but more powerfully, with the way our perceptions of rarity distort our conception of value.

The Lenape traded Manhattan for beads. Big deal. They didn't own the island, they just fished there, and besides, beads were the currency of their day. The Dutch, who bought Manhattan, even though it wasn't their first choice, *did* settle there. They put down roots. They built an entire colony there. And then they up and traded Manhattan to the English in 1664, for *nutmeg*.

Value, apparently, really is a matter of taste.

PRECEDENTS ARE FOREVER

The First Diamond Engagement Ring

(1477)

Diamonds are intrinsically worthless, except for the deep psycho-
logical need they fill.

—NICKY OPPENHEIMER, CHAIRMAN OF DE BEERS

Advertising is legalized lying. —H. G. WELLS

In 1976, the economist and writer Fred Hirsch coined the term
positional good to explain the way in which an item might become
desirable to a person simply because another person doesn't or
can't have it. In the sphere of economics, positional good describes
a product whose value is determined, in part or in whole, not by
how much of it there is, but by *how badly other people want it*—kind
of like those tulip bulbs that drove the Dutch so crazy in 1636.

So what do obscure economic theories about envy, need, and
limited social growth have to do with diamonds?

Everything.

Diamonds *aren't* forever. Diamond engagement rings have
only been a "necessary luxury" for about eighty years. We take
the tradition of a diamond engagement ring for granted, as if it
were as old as marriage itself. It is not. In fact, it's only about as
old as the microwave oven.

This chapter is the story *of a story*. In fact, it's the story of two stories. One is the story of the very first diamond engagement ring, given to the princess Mary of Burgundy by Archduke Maximillian when he proposed in 1477 CE.

The second story occurs half a millennium later, when De Beers, having gained control of 99 percent of the diamonds on earth, convinced the entire, previously indifferent world that everybody wanted a diamond ring, and always had. This is the story of how De Beers pulled off one of the greatest con jobs in history, and built a multibillion-dollar empire as a result.

Engineering an Empire

One hundred and fifty years ago, diamonds actually *were* rare. Until the South African diamond rush, the entire world production of gem-quality diamonds amounted to just a few pounds a year. Diamonds occasionally turned up in Indian and Brazilian riverbeds, but only sporadically and in small quantities. These diamonds were often larger stones, and sometimes vividly colored.

The best of the best were Golconda diamonds, from the Golconda region of India.* The quality of Golconda diamonds was so peerless that one of the original standards for judging diamonds had to be abandoned altogether when the supply of Golconda diamonds ran dry. That lost standard was referred to as "water," as it described an almost liquid quality to the diamond's shine. The crystal was so perfect that light seemed to pass through it completely unimpeded. Modern South African diamonds just don't have "water." The contemporary standards for judging diamond quality—the four Cs of color, clarity, cut, and carat—were

* Golconda was also the original diamond trading center of the world and, until about 150 years ago, almost all diamonds passed through there.

actually invented in the 1960s, as part of a marketing campaign primarily intended to make middle-class people feel good about buying smaller stones.

Golconda diamonds, like the infamous Hope diamond, are of an unparalleled quality. Unfortunately, Golconda diamonds have always been incredibly scarce—and by the early eighteen hundreds they seemed to have dried up altogether. But in 1870, diamonds very suddenly ceased to be special or rare, when a curious young boy named Erasmus Jacobs pulled a massive, misshapen crystal out of the Orange River in South Africa. It was the beginning of the diamond rush that would forever change the world . . . and the wedding planning industry. Almost immediately the region was teeming with people and covered in mines. Soon, diamonds were being pried from the ground by the metric *tons*.

De Beers was founded by a man named Cecil Rhodes, born in 1853, a failed cotton farmer and the son of a vicar. Long before Rhodes started the world's most successful cartel, he was a young man with *major* imperial aspirations. He was successfully named the prime minister of Cape Colony in 1890, but he had ambitions for much grander things, like the annexation of multiple African countries under the imperial flag, and a proposed transcontinental railroad that would connect South Africa to Cairo.

He managed to do a reasonable amount of imperialistic damage during his time as prime minister. He even founded the country of Rhodesia, which was named after him, until finally the fallout of an attempted coup forced him to resign as prime minister of Cape Colony.

That might've been the end of Cecil Rhodes and his dreams of empire, but as history would show, annexed countries and puppet governments were really just his warm-up act.

Something far more impressive was coming: Frustrated by the lack of cooperation his imperialistic endeavors were eliciting from the British government, Rhodes went into business for himself. As part of the historic "scramble for Africa"—that is, the

period in which Western powers were rapidly and haphazardly carving up Africa for themselves, in pursuit of riches and natural resources—Cecil Rhodes founded the British South Africa Company, or the BSAC*, in 1889. He originally intended to exploit gold deposits in south-central Africa. Imagine his surprise and delight when that little boy, Erasmus Jacobs, pulled a baseball-sized diamond out of the river in Rhodes's own stomping grounds.

Rhodes got his start in the diamond business by renting out the necessary equipment to miners to pump out floodwater that had nearly destroyed their claims. With his profits from the rental business, he purchased claims of his own, buying up more and more of them and thus beginning what would become the most incredible monopoly the world has ever seen. As the diamond rush rolled on, the cream rose to the top, so to speak, and by 1888 there were only a few big names left in the South African diamond mining business. The biggest mining concern was Rhodes's De Beers Consolidated Mines, renamed for the Afrikaner farmers from whom he'd bought the land for pennies.

But from the very beginning, De Beers aimed to control not just the diamond supply but our very *perception* of the diamond supply.

Relative Reality

The truth is: Diamonds are neither rare nor intrinsically valuable. What value diamonds do possess has largely been created in the mind of the consumer.

The theory of positional good states that a thing achieves value as a result of *desirability*, not the other way around. A good said to possess "positionality" is not valuable because it's neces-

* I know—I love the name too.

sary or even functional, but simply because it's arbitrarily wanted. It is therefore a good whose worth is judged in *relative*, rather than *absolute*, terms. Gems almost always fall into this category.

We've already seen, in Chapter 1, that scarcity enhances the value of an item; you can't help but want something, down to the neuronal level, when you see the supply running low. This is the scarcity effect. But positional good describes something deeper: a unique situation in which value itself is determined by the desire to have something that others (but only a *few* others) possess. That diamond isn't just worth *more* because there are few of them—the fact that there are few of them is the *only reason it's worth anything at all.*

A diamond ring is the epitome of a positional good. It's an item that serves no purpose except as a status symbol, to be compared (hopefully favorably) with the same item belonging to others. Its value is determined by its size and its cost, relative not to itself or any objective standard but to other diamonds in the owner's peer group.

It works like this: You want it because everybody else wants it, and everybody else wants it because someone else has it. Nobody wants it if everyone can have it. Ultimately, it's like a game of economic musical chairs. Because a positional good's value is based entirely on its limited nature, there has to be less of a thing than there are people who want it, or that thing becomes worthless.

If diamonds are the ultimate positional good, what would happen if they ceased to be scarce?

On the Rocks

In 1882, the diamond market collapsed.

A decade earlier, in 1872, one million carats were being pulled from the South African earth *every year*. That was five times as

many as came from the rest of the world combined, and God knows how many more than had ever been taken from India.

As a result, "Cape diamonds"* got a bad name—not only because they weren't as beautiful as the ancient Golconda diamonds, whose source was now long since exhausted, but simply because there were so many of them. They were becoming common. As the diamonds just kept coming out of the ground by the tons, the mine owners realized it wouldn't be long before their stones flooded the market to such a degree that their precious product was little more than a semiprecious stone. After all, as we've seen, it's primarily *scarcity* that makes a rock a gem.

During those tumultuous days, a famous Parisian banker, Georges Aubert, summed up both the essence of positional good and the stuff of Cecil Rhodes's nightmares when he speculated, in print, about the possibility of future diamond discoveries. He was quoted as saying, "One buys diamonds because they are luxuries that not everyone can have. If diamonds fall to a quarter of the current value, then rich people won't buy diamonds anymore but will use their taste to buy other precious stones or luxury items."

In 1888, Rhodes hit on a brilliantly simple, if wickedly dishonest, solution to the problem: If diamonds were no longer rare, he could only maintain his newly won empire by convincing people of the reverse. Rhodes persuaded another major mine owner to consolidate their interests, creating one company (some people *might* say cartel) that would regulate the flow of diamonds into the market. If they couldn't control the quantity of diamonds coming out of the earth, they could at least control the amount coming out of their stockpile.

By 1890 the newly formed De Beers Consolidated Mines owned all the diamond mines in South Africa and meted out dia-

* Cape Diamonds were South African diamonds. So-called after the Cape of Good Hope.

monds as they pleased. Once De Beers controlled most of the supply, it was easy to dictate the terms of the demand. The people who wanted them simply believed that there weren't very many diamonds to be had.

But as more and more mines were discovered, De Beers got increasingly nervous. In 1891, they artificially slashed the production of diamonds by one-third in just one year, simply to make sure people believed the lie: that there weren't enough stones to go around.

If You Can't Beat 'Em—Buy 'Em

That worked like a charm . . . for a while.

But the diamond market nearly toppled a second time during the diamond panic of 1908. In the years before World War I, the price of diamonds was falling. People were digging in and getting ready for war. Diamonds weren't a necessary commodity, like food or power or steel; nobody stocks up on jewelry during hard times. To make matters worse, another massive diamond find—an underground mother lode—was uncovered that same decade, one so large that supposedly Rhodes's surveyor fainted when he saw it.

It was discovered in 1902, the same year Rhodes died, and its owner, Ernest Oppenheimer, wasn't a team player. Eventually, Oppenheimer's so-called Cullinan Mine would produce more diamonds than all of De Beers's mines put together.

The De Beers group was in a panic. They knew that Aubert's prediction would soon materialize if they didn't do something drastic. In 1914, bullied by Oppenheimer, Rhodes's corporate heir apparent, the companies were called together and forced to agree to a price-fixing arrangement. They would merge companies a second time, pool their diamonds, and dole out the gems

as meagerly as possible to maintain the illusion of limited sup-
ply. It worked once, they assumed, so it should work again.

By the end of World War I, the Cullinan Mine was merged
with the De Beers mines and Oppenheimer took over as chair-
man. De Beers was now a totally singular entity, controlling 90
percent of the diamond interests on the planet.

For the first time, the world supply of diamonds was in the
control of one man with one vision. What was that vision? To
create a product that would never, ever dip in value. In 1910,
Oppenheimer stated, "Common sense tells us that the only way
to increase the value of diamonds is to make them scarce . . . that
is, to reduce production."

But the diamond rush just kept rolling, and there was no stop-
ping the deluge. Diamonds poured from their mines like gravel.
And worse, diamonds were being found in new places almost as
fast as De Beers could buy them up. Within only a few years of
creating a global monopoly, diamonds were becoming so abun-
dant that their empire was once again teetering on the edge of
ruin.

Oppenheimer realized that if diamonds were to maintain their
value, it wouldn't be enough for De Beers merely to continue to
"promote the illusion" that they were rare. He would also have to
promote another illusion: that they were *necessary*.

Everything You Never Wanted
to Know About Diamonds

What is a diamond, technically speaking?

In scientific terms, a diamond is an allotrope of the element
carbon. That means that it's one of many forms the substance
might take. Other allotropes of carbon include coal, soot, and
graphite, more commonly called pencil lead.

Carbon is a component of almost *everything*. It's certainly a component of you: 99 percent of the human body is made up of only three elements, and one of them is carbon.* It's also a major component of the atmosphere, the oceans, and every organic (i.e., carbon-based) life form on the planet. To say carbon is common would be an understatement. It's the fourth most abundant element in the universe.

All the diamonds on earth were formed about 100 miles below the earth's surface, more than one billion years ago, under intense heat and pressure. There is no doubt that an almost inconceivable amount of diamonds are still down there. The diamonds that we mine or find near the surface were carried up to the earth's crust by what's known as *kimberlite pipes,* the "roots" of certain small, superpowerful volcanoes that reach three times deeper into the earth's mantle than larger volcanoes like Mount Saint Helens. Millions of years ago, when those volcanoes erupted, diamonds were carried upward in the magma and deposited among the other rocks.

Carbon actually comes from the Latin word *carbo,* meaning "coal." Diamonds are in fact just a really, really compressed variety of coal.

Fancy, huh?

At standard temperature and pressure, carbon will take the form of graphite. In graphite, each atom is linked to three other carbon atoms, all of them linked together in a two-dimensional sheet of fused hexagonal rings. Confused? Imagine a chain-link fence lying on the ground; each place where the chain crosses is an atomic bond. If you layer one chain-link fence on top of another, on top of another, in loose sheets, that's graphite.

* In fact, so much of your mass is carbon that a company called Life Gem, founded in 2001, will take the cremated ashes of your loved ones, and heat and compress them into an actual (albeit lab-grown) diamond. I'm actually considering it. That way I can continue to start fights and cost too much money *forever.*

So what makes some generic carbon a diamond and not a
sheet of graphite? *Organization*. Under very, very high pressures
and temperatures, carbon atoms will form a more well-organized
version of the same thing, in which each of those stacked lay-
ers of chain-link fence is linked to the next *vertically* as well, at
every cross point. Like stacked cubes stuck together at each joint,
a diamond's lattice is symmetrical in every direction. This pattern
gives the mineral all of its properties, most famously its ability to
scatter light waves like a prism. When light enters a diamond, the
incredible density of electrons forming that cubic crystal lattice
scatters the light waves, breaking them apart (into colors) and
causing them to bounce around. This isn't just pretty; it's perfect,
at least from a geometric, molecular standpoint.

That does not, however, make them rare. In 1998, there were
approximately twice as many diamonds in circulation as there had
been fifteen years before that. And there have been massive new
finds since then. The Gemological Institute of America (GIA)
estimates that an accumulated total of 4.5 billion carats of dia-
monds have been mined just since the beginning of the South
African diamond rush in 1870.* That's enough diamonds to pro-
vide *every single one of the approximately seven billion people* on the
planet with a standard one-half-carat diamond ring—with a bil-
lion carats left over.

Nor do diamonds last forever, despite what their many adver-
tisers would have us believe. The word *diamond* is derived from
the word *adamantine,* meaning "indestructable." And while it's
true that nothing can cut a diamond except another diamond,
that doesn't mean that nothing can destroy them. In fact, for an
item that bases its reputation on its strength and timelessness, dia-
monds aren't really that durable. Hard, yes: the hardest sub-
stance in the mineral family, thanks to their perfect cubic lattice,

* A. J. A. Janse, "Global Rough Diamond Production Since 1870," *Gems and
Gemology* 43, no. 2 (2007).

and more than fifty times harder than the next hardest, sapphires. But hard isn't the same as strong.

You can do all kinds of terrible things to them. You can scratch them up in your jewelry box, as long as you have other diamonds; you can actually incinerate them at 1,400 degrees—no joke, they just vanish, not a trace is left behind. Or, if you're like my father, as a curious six-year-old, having heard that diamonds are the hardest substance on the earth, you can take your mother's one and only diamond ring and smash it to dust with a hammer. (It was a trauma from which I'm told she never fully recovered.)

Diamonds are not only brittle, but they're also quite thermo-dynamically unstable. Right now, as you read this, every diamond you've ever seen is slowly converting to graphite. The process is just so incredibly slow at room temperature that human beings will never live to see it.

So . . . who wants coal in their stocking this year?

The answer, apparently, is *everyone*. Just so long as they don't know the real substance of the stones they're getting. Generally, people don't know much, if anything, about the chemical makeup of diamonds, and there's a good reason for that. No one, in the last eighty years, has actually sold a diamond: They've sold an *idea*.

And god only knows what ideas are made out of. . . .

Wrapped Around Their Finger

By the 1930s De Beers had exerted historic control over the diamond supply. By instituting artificial scarcity, they to some extent controlled—or at least manipulated—the demand as well.

But what they couldn't control was the economics of war. Between the Great Depression and a looming *Second* World War,

not only had people stopped buying diamonds, they were—God help us—starting to try to *sell* their own diamonds.

This was a disaster waiting to happen. A lesser-known fact about the diamond industry: It's really difficult to resell your own diamond. In fact, if you take your diamond engagement ring back to the store where you bought it, the store will not buy it back from you, because that establishment would then be placed in the decidedly uncomfortable position of telling you that your stone is actually worth a very, very small fraction of the sale price. Some timeless investment, huh? Reselling diamonds would, for this reason, destroy demand.

Additionally, nearly every diamond ever mined is currently in the hands of human beings. Those stones are owned and accounted for, sitting around, sparkling away, in jewelry boxes, on fingers, and in museums. The sum total of those diamonds is mind-blowing. If large numbers of people began reselling their diamonds, the market would be flooded. As the Dutch learned during the tulip craze of 1636–37, lack of demand combined with excess availability would cause the value of the diamonds to plummet, if not evaporate. Diamonds would, in fact, be revealed as the ubiquitous semiprecious gemstones that they are, and the diamond industry would never recover. In fact, at this point, diamonds have such a keystone economic value that if that value vanished, the entire world *economy* would be rocked.

So what to do? De Beers had artificially manipulated pricing and supply to control demand. They had control over people's minds and wallets.

It needed control over their hearts too.

Diamonds, remember, are a girl's best friend. A diamond ring is the only piece of jewelry that might even be considered necessary, at least to the average adult. It is the only piece of jewelry to which a person is expected to have a personal, romantic, and lifelong attachment. A diamond ring is the only piece of jewelry that anyone *expects* to buy or receive. No one thinks seriously about

that tiara they're going to own someday when they grow up,* but an engagement ring, that's an intense part of the iconography of successful, adult life.

And that idea was invented *for* you, not *by* you.

It was, in fact, a carefully and deliberately crafted marketing strategy cultivated over decades through the precise (and unprecedented) use of psychological testing, consumer studies, early life indoctrination, product placement, and a publicity campaign that has gone on for eighty years. It has been the model for all other modern advertising, particularly tobacco, and has completely reshaped the global economy.

They didn't just do it by manipulating supply and demand. That's kid stuff. They did it by manipulating *you*.

De Beers managed to take a product that wasn't worth very much to begin with and make it the absolute standard of precious materials. In fact, according to Bain & Company's 2011 consulting report, "Despite lingering concerns about the global economy, the diamond industry was surprisingly resilient in 2011. Although it appeared the recession would slow sales of diamond jewelry, overall demand has continued to grow."† Moreover, from a retail perspective, De Beers managed to create a product that has never, ever lost its value since they took control of the industry eighty years ago. That's an incredible statement, given that all goods, even real *necessary* goods, are subject to tremendous market fluctuation.

Who is De Beers now? No one. A lot of people. De Beers comprises multiple companies operating under various names—the CSO, the Syndicate, the Diamond Trading Company, Forevermark.‡ They are quite literally the most successful cartel

* OK—maybe I did.
† Bain & Company and Antwerp World Diamond Centre, "The Global Diamond Industry: Portrait of Growth," 2012.
‡ In 2012 the Oppenheimer family sold the entirety of its 40 percent stake in De Beers to Anglo American mining company, which had previously owned 45

in human history. Above all, they are the unseen hand that has fabricated the idea that diamonds are the most rare and precious of gems, and more important, *psychologically conditioned you to need one.*

How'd they do it? Well, they started with a precedent.

Will You Merger Me?

In 1477 CE, eighteen-year-old Archduke (and later Holy Roman Emperor) Maximillian proposed to his great love, Mary of Burgundy, with the first-ever faceted diamond engagement ring. Thus the two lovers began the swoon-worthy tradition of the diamond engagement ring, a tradition that has persisted, in an unbroken procession of promises, sparkles, and kisses, for the last 539 years. *Sigh . . .*

Well, that's De Beers's version, anyway.

The archduke *did*, in fact, propose (through emissaries and ambassadors) to Mary of Burgundy in 1477—even though he'd never met her, and probably couldn't have picked her out of a lineup. He *did* present a faceted diamond engagement ring, but to her father, Charles the Bold. That part of the story is true. It wasn't the kind of Tiffany's diamond solitaire you might be picturing. The diamonds were tiny, and set into the shape of an *M*. Supposedly it was an *M* for Mary—although it could just as easily, and even more aptly, have been an *M* for monarchy or an *M* for money. It really *should* have been *M* for merger. The marriage was actually an elaborate, multinational land deal, as royal marriages so often are. And that particular ring was a well-thought-

percent of the company, for $5.1 billion in cash—though it bears mentioning that Anglo American was also founded by Ernest Oppenheimer, an original investor in De Beers. So, you know, the cartel's hardly breaking up.

out and heavily loaded symbolic gesture of the most public kind.

Modern diamond faceting had just been invented in Bruges, and Mary's father, Charles the Bold, was infatuated with the technology. Actually, everyone was. But Charles had the money to make his infatuation count; he sent his biggest and best diamonds to be recut in the "new style," in Bruges*—which, incidentally, was a region he happened to own.

A Bruges-faceted diamond was not tradition. It was *technology*. And Maximillian wasn't being romantic—he was thinking ahead (and maybe sucking up to his future father-in-law a little bit). Maximillian was a crafty guy, which was no doubt a contributing factor in his future ascent to Holy Roman Emperor. When he married Mary, he negotiated to obtain the "Low Lands" as part of her dowry. The Low Lands were most of Belgium and the Netherlands, which included the increasingly valuable Bruges, the new center of technology and luxury goods.

Finger Shackles

Before we return to the merger—er, marriage—of Maximillian and Mary, let's skim a little history on engagement rings. Their not-so-romantic origin might surprise you.

Ancient Greeks and Romans really gave us the first betrothal rings. Of course, the association between a circle or ring and a promise is ancient and cross-cultural. When eighth- to eleventh-century Vikings swore allegiance—to a king, to a vow, to each other—they did so on a metal arm ring. In the Far East, mar-

* Charles the Bold was such a huge fan of van Bercken, the man who invented the technology that facilitated the new diamond-cutting style, that he became his primary patron. One of his "best diamonds" that he sent to be recut was the Sancy: a massive, beautifully cut, pale yellow diamond still famous to this day.

riages in many cultures were traditionally sealed with bangles: loose-fitting, hard, round bracelets. Bangles are, in fact, so deeply significant in Hinduism that a married woman should never be seen without one.

But the Roman finger rings of antiquity were something new. While the symbolism of a circle is obvious, a tiny finger shackle was entirely Roman. And just like us, they wore their wedding rings on the fourth finger of the left hand. In fact, that's the origin of our modern tradition. They believed there was a special vein, the *vena amoris*, or "vein of love," that led from that particular finger directly to the heart. Brilliant, guys. One expects better science from the people who invented concrete and indoor plumbing.

Someone should have told them that, much in the same way "all roads lead to Rome," in fact every vein leads to your heart. That's precisely how the circulatory system works. Every vein and artery is full of blood. Each drop of that blood circulates in a giant, complex, living ring all its own.

But the similarities between early Roman rings and ours pretty much end with their fourth finger destination. These simple metal bands most certainly never had diamonds in them. Instead, they were frequently made of iron to symbolize strength. According to some historians, they may even have denoted ownership. (Fifty shades of romantic, huh?) Romans also exchanged pledge rings with friends and allies as a sort of tangible pledge of fidelity. Surprisingly, those bro-rings tended to be more sparkly and ornate than the simple metal bands often exchanged between lovers.

The origin of Western wedding rings can probably be traced to a combination of these two traditions, with modern engagement rings, it seems, actually owing slightly more to the type of ornate, jeweled pledge rings given platonically, most often between two men.

The variety of materials used for pledge rings suggests that

how they were made and what they were made from changed dramatically over time and from one region to another. Nonetheless, early on, the rings were fashioned from mostly humble materials. As a result, they served less as economic symbols than as social ones. An iron band didn't say, "Look how rich we are." It said, "This one's taken, move along." Even as wedding rings became more ostentatious over the millennia, their function as a universal CLOSED sign remained primary.

But after the fall of the Roman Empire, the tradition of pledge rings was lost for many centuries.

Until the Catholic Church intervened.

Holy Matrimony

De Beers wasn't the first cartel to 'invent' the engagement ring for its own purposes. Pope Innocent III was one of the most powerful and influential popes of the Middle Ages. In the early thirteenth century, he was one of the most powerful men in the world.

Innocent III was concerned that people were playing fast and loose with the rules while away in the Holy Land, or in other distant countries on their way to or from the holy war. People tend to shack up on vacation; it's just human nature. (It's hot, you wear less clothes, it just happens. . . .) This irked him. Deeply. Pope Innocent III decided the Catholic Church needed stronger administrative control over the institution of marriage, and not just in the spiritual sense.

So in 1215, he effectively instituted reforms that made the Catholic Church into the DMV of weddings and marriages. You had to apply for permission, you had to go on public record, and there was a mandatory waiting period before your application was granted. This waiting period came to be known as "engage-

ment." And it was the beginning of real engagement rings—or "betrothal rings," as they were known.

The rings were specifically and exclusively a public statement intended to say, "Taken, but not yet married"—in case anyone had any prior claims, objections, or a better offer. Innocent III decreed that "marriages [were] to be . . . announced publicly in the churches by the priests during a suitable and fixed time, so that if legitimate impediments exist, they may be made known." The rings were a required, public declaration of the intent to marry. Both men and women wore them.

This wasn't done exclusively for the sake of maintaining the social order. The Catholic Church, like De Beers many centuries later, was interested in monetizing the institution of marriage. Before then, "Will you marry me" nearly always meant "Will you marry me right now?" There was no such thing as a mandatory engagement. Betrothals existed, of course, but were usually arranged for the intendeds by a third party—often so that one or both of the betrothed could reach puberty.

Other kinds of betrothals were often a matter of convenience: time to negotiate terms or get to know each other if the marriage was arranged, time to get the relatives into town, time to make a pretty dress, time to pick out a location. Before Innocent III, none of these activities necessarily took place in a church. Innocent III instituted another law as well, that Christian marriages *must* take place in a church.

And you think De Beers has a stranglehold?

Engagement rings became popular in part because they were a way to differentiate—and publicize—economic classes. At first, only the upper classes were allowed to have jeweled engagement rings. The more upper class people were, the more ornate and enormous their jewels.

Even so, diamonds were not a popular choice.

For one thing, they weren't regarded as very pretty. They weren't colorful, they weren't luminous, and they didn't seem to

have any special properties. They weren't iridescent like an opal or a moonstone, they didn't glow like a ruby or an emerald, they didn't even have a star, like certain sapphires or chrysoberyls.

They were just sort of sparkly. And not even very sparkly. At least, they weren't very sparkly before Bruges.

The Cutting Edge

If we really want to be accurate, the world's first real diamond ring was actually created last year. It was made by a Swiss jewelry company based in Geneva called Shawish Genève. Valued at $70 million, it is 150 carats and took a year to cut. I say *cut*, rather than *construct*, because the entire ring is made out of a single diamond. No metal, no other stones. Just one giant, multifaceted diamond, with a hole drilled through it into which a finger might be placed.

Cutting the Shawish diamond involved unique laser equipment specifically designed for the task. In that way, the Shawish diamond ring is not too different from the first diamond engagement ring. Like Mary of Burgundy's ring, it was intended to put new technology on display.

So what was happening in Bruges in the late fourteen hundreds that was so sparktacular? A Jewish diamond cutter, Lodewyk van Bercken, revolutionized the craft of diamond cutting with the invention of the *scaif.* The scaif was a rapidly spinning polishing wheel. You've probably heard the legend that a diamond is so hard that nothing but another diamond can cut it. Well, unlike almost every other story about diamonds, that one's actually true.

The genius of the scaif is that it's a standard grinding wheel, but it's been infused with oil and diamond dust. The diamond dust grinds away the surface of the diamond that's being cut. This

allows for the precise removal of tiny, symmetrical sections of diamond. It's the basis of modern diamond cutting.

It all boils down to this: Diamonds, in their natural state, are not much to look at. Before the last century, we lacked the technology to mine them, so the vast majority came from alluvial deposits. That means they were washed up along the banks of rivers, and often collected like gravel on the ground. Because of the rough nature of their journey to the surface, they tended to be more than a little beat up, and often had a dull, coarse texture.

In fact, in 1908, when King Edward VII was presented with the Cullinan—the largest uncut diamond in the world, weighing in at *3,106 carats*—he was unimpressed. The rough stone, which would eventually provide *many* of the best British crown jewels, so underwhelmed him that he said, "Had I seen it in the road, I would have kicked it."[*]

Because of the way the carbon atoms in a diamond are locked together in a grid, the crystal is very difficult to scratch, but if tapped at just the right angle it'll break along a clean plane. (In gem cutting, this is called "perfect cleavage.") The closest thing there was to modern diamond cutting before the Bruges invention was a technique that involved chipping away pieces of the stone by hitting it with something like a chisel. This resulted in a few sharp planes being knocked off, and it would leave several shiny facets on the diamond. It was better than nothing. And it did add a little sparkle. But the scaif revolutionized the industry and made the city the center of the diamond trade. It also made Bruges one of the most valuable pieces of real estate in the Netherlands.

Acquiring Bruges through his union with Mary of Burgundy was a huge coup for Archduke Maximillian. And the "first diamond engagement ring" was the first step on his journey to become Holy Roman Emperor Maximillian.

[*] Victoria Finlay, *Jewels: A Secret History* (New York: Random House, 2007), 343.

But while the merger—I mean marriage—was a success, it wasn't very romantic, and the tradition of the diamond engagement ring failed to catch on.

Of Myths and Men

The "first diamond engagement ring" didn't just help determine the fate of the future Holy Roman Emperor. That same ring was used, 475 years later, to lay the foundations of another empire—this time of a more mercantile kind.

Let's skip ahead half a millennium. Poor De Beers. At the end of World War II, after almost a century of gangster-like economic regulation, the world's only real source for diamonds was losing its market. The war was almost over, but the world had changed.

The aristocracy was basically gone, and gone with them were court jewels. There was no longer a need for evening tiaras for British ladies' dinner parties, or jewel-encrusted gowns for the unfortunate dead Romanovs. And to make matters worse, jewelers hadn't just lost their aristocratic market; a very different one had replaced it. Between the New Deal and the GI Bill, the emerging middle class had become a source of major economic power and cultural influence.

When De Beers did a consumer survey in 1946, the results were alarming. The new middle class had money to spend, but only so much—and they were very disinclined to buy diamonds with it, rings or otherwise. Few were familiar with betrothal rings, and nobody associated diamonds with romance *or* marriage. While diamonds were still considered class symbols of the ultrawealthy and aristocratic of Europe, after World War II that association was no longer universally appealing.

Business was about to tank for the would-be cartel. De Beers's

dilemma became how to unload a bunch of subpar, small, color-less diamonds on the indifferent American public. What it needed was a gimmick.

The diamond engagement ring as we all know it was an inven-tion of De Beers and an advertising agency, N. W. Ayer. It was first and foremost a product. But it was a new kind of product. It was a way to emotionally *compel* people to buy diamonds by reinventing the idea of diamonds as necessities rather than as temptations or frivolities. It was also a way to unload those diamonds on the big-gest new market in the world, the American middle class, even if it was also the market least interested in having them. Finally, it was a way to dress up and present the smallest and least desirable of their stones as though they were something special and important.

So how did De Beers do it? First they invented, or at least sensually massaged, an origin story: They settled on the exchange of the first diamond engagement ring between Maxi-millian and Mary. They mined history for a precedent and made it the center of an epic spin campaign. The story of "the first diamond engagement ring" set just the right romantic tone, mixed with grand historic context.

Then they did something really creative: They hired N. W. Ayer *to sell the idea* of diamond engagement rings to an unwitting public, particularly the under-eighteen crowd.

De Beers already had the scarcity angle covered by manipu-lating the supply to such a degree that diamonds were already considered rare and thus very valuable. All that was left was to manipulate the customer.

Due to antitrust laws, De Beers was prohibited at that point from directly doing business in the United States—but that didn't mean they couldn't promote a concept. And N. W. Ayer didn't actually sell diamonds. They only sold the *idea* of diamonds, in particular the idea of a diamond engagement ring: what it meant, and why everyone needed one. After all, it didn't matter where

the consumers bought their rings, just *that* they bought them—since pretty much all diamonds were De Beers's diamonds.

In 1947, N. W. Ayer created the iconic campaign "A diamond is forever." They engaged in cutting-edge techniques, like product research and social psychology. They employed, if not invented, product placement way ahead of its time: They gifted movie stars with diamond rings, then paid multiple media outlets to show them wearing the rocks.

De Beers didn't invent the diamond engagement ring. They did one better. They invented *the myth* of the diamond engagement ring.

"We are dealing with a problem in mass psychology. We seek to . . . strengthen the tradition of the diamond engagement ring—to make it a *psychological necessity* capable of competing successfully at the retail level with utility goods and services . . ."[*] That quote comes direct from an internal memo of N. W. Ayer to De Beers back in the 1940s.[†] In it, Ayer defines multiple target audiences—unsurprisingly, very young girls are a focus.[‡] Ayer and De Beers together sought to indoctrinate crops of adolescent girls with the hard "fact" that having a diamond ring was the only way to *really* be engaged. The memo went on to state: "It is essential that these pressures be met by the constant publicity to show that only the diamond is everywhere accepted and recognized as the symbol of betrothal."

They targeted boys too. The idea was that a man had not really proposed unless he had a diamond. Not to mention that the size of your, um, *worth* is directly proportionate to the size and cost of said diamond. Another internal memo, from the fif-

[*] Edward Jay Epstein, "Have You Ever Tried to Sell a Diamond?" *Atlantic*, February 1, 1982, 23–34.

[†] The italics are mine.

[‡] Tobacco's "get 'em young" advertising model emulated the diamond industry's, not the other way around.

ties, stressed the need to "promote the diamond as one material object which can reflect, in a very personal way, a man's . . . success in life."

Through a clever combination of pioneering market research, advertising, and product placement, De Beers has bedazzled us so thoroughly that we all believe that this myth is not only true but *always has been*. In fact, it's a mythology so compelling it justified the unprecedented sales of a product De Beers previously couldn't unload, on a population who didn't really want it.

Mad Women

But that myth is really what you paid for anyway, isn't it? For the assurance that you bought the right thing, that the bit of gravel you spent a fortune on is important, and timeless, and has *real value*. In 1938, when De Beers approached N. W. Ayer, they asked the ad firm a question that would become the defining economic question of the next century: whether or not "the use of propaganda in various forms" could be an advantageous strategy for selling its product.

Dorothy Dignam and Frances Gerety were the backbone of the team that essentially invented N. W. Ayer's strategy for De Beers. They are largely responsible for the fact that millions and millions of women now own diamond engagement rings. Roughly 80 to 90 percent of all contemporary brides sport a diamond ring. Last year alone U.S. consumers spent $7 billion on those little sparklers. Dignam and Gerety are equally responsible for the intense sentimental attachment those millions of women have to the diamond engagement rings they wear.

Contrary to what you might assume, back in the thirties and forties it was standard practice at large advertising agencies like

N. W. Ayer to hire women; they were essentially contracted to sell products *to* other women.

First, Dignam and Gerety convinced women that "a proposal is not a real proposal without a diamond." Then slogans like "What's two months' salary for something that'll last forever?"* even dictated the terms of what the engagement rings should cost—on a sliding scale, of course. Because the target was *everyone*.

Then, in 1947, Gerety came up with the now infamous tagline "A diamond is forever." Over her twenty-five-year career, in fact, Gerety wrote nearly all the copy for the propaganda-style ads N. W. Ayer created for De Beers. Two weeks before her death in 1999, Gerety's slogan "A diamond is forever" was named the slogan of the century by *Advertising Age*.†

Gerety's counterpart, Dorothy Dignam, was responsible for PR and, more specifically, for product placement. One could argue, in fact, that she practically invented it. She reached out to movie studios to compel them to include the word *diamond* in their titles and to film scenes pertaining to the gemstones. Most important, she made sure actresses were covered in the rocks, even offscreen: She began the practice of lending out massive diamonds to celebrities for the Academy Awards, film premieres, and the Kentucky Derby, where they would be seen and photographed. Over time, diamonds became associated with celebrities, the new, uniquely American royalty.

But Dignam didn't just go after Hollywood. She made sure debutantes and high-society women were all lent diamonds too. And when the "right people" were incentivized to marry with a

* J. Courtney Sullivan, "How Diamonds Became Forever," *New York Times*, May 3, 2013, ST23.

† According to Gerety's final interview, between the Depression, World War II, and the just barely rebounding economy, Americans would rather spend money on anything than diamonds. In the interview she said that diamonds and engagement rings were considered "just absolutely money down the drain."

diamond engagement ring, there was Dorothy Dignam to make sure the ring got its public due. After engineering the purchase, she then reached out to media outlets to make sure those rings were shown and mentioned in every magazine and newspaper and society journal possible.

Not unlike starting a fire and then reporting on it, Dignam literally gave diamonds to certain people for free, so she could show us all the fabulous people who were wearing them.

So while Gerety was plucking our heartstrings with the most creative and innovative ad copy of the century, her counterpart, Dignam, was making sure that we saw diamonds everywhere— and on everyone—we wanted to be. No wonder the two women responsible for the creation and propagation of the greatest romantic myth of the twenty-first century never got married; they were married to their jobs. Ultimately, they shaped the way we see diamonds and the way we feel about diamond engagement rings. Moreover, they helped invent and refine modern advertising and media. And they did all of it on behalf of a company that just wanted to unload some stones too small and too common to be sold anywhere else.

As it turns out, "propaganda in various forms" was more than useful. It was a global economic game changer.

Can't Buy Me Love

Oh wait—*yes, you can.*

At least according to De Beers you can. They've spent more than half a century convincing the world that a diamond is synonymous with love. Not everyone wants a diamond, but *everybody* wants love. And the best thing about love, as a seller's commodity, is that it's free—so the profit margin is spectacular!

There's a reason that linking diamonds with the idea of love was so completely successful. Love and money share the same real estate in your brain. Researchers in a relatively new field called neuroeconomics are studying just that. They're looking, not just behaviorally or chemically but actually *structurally*, at the way your brain values things. And a team at Duke University finally found the sweet spot. It's called the ventromedial prefrontal cortex (vmPFC); it's a few centimeters in, right between your eyes.

So what happens in this special V-spot?

You value things. You also love things. They've actually discovered that "the processes that determine emotion and value both take place in the ventromedial prefrontal cortex."* That means the process by which you feel an emotional attachment, and the process by which you determine a thing's worth, are all bundled up in the same little cluster of neurons.

Clearly, wires sometimes get crossed.

Everyone's always known that making someone feel good is an effective way to make them part with cash, whether the person doing the charming is a friendly salesman, a pretty waitress, or an ad featuring a smiling baby. But that's just anecdotal. Until now, we had no proof of why or how this mechanism worked. Now, with the identification of the vmPFC's action, we do. According to Dr. Scott Huettel of the Center for Interdisciplinary Decision Science at Duke University, it had been well established that judging value and emotion happen independently in the cortex, but until this breakthrough, no one had found the *physical* link between the two.

Well, De Beers must have had an inkling. . . .

* A. Winecoff and others, "Ventromedial Prefrontal Cortex Encodes Emotional Value," *Journal of Neuroscience* 33, no. 27 (2013): 11032–39.

Playing Hard to Get

Would a tulip by any other name make the Dutch act as crazy?
Is a diamond any less beautiful than a cubic zirconia? They look
the same, and they refract light more or less the same way. If any-
thing, a cubic zirconia tends to be whiter, brighter, and clearer.

Is a diamond really any better than a cubic zirconia?

The natural response is "yes." But I can tell you, as a jeweler,
that most jewelers can't tell them apart . . . not outside of their
settings anyway. At first glance, it's always the cheap setting that
gives away the CZ. If you were to set a CZ in an expensive set-
ting, and set it well, I couldn't tell it from a diamond, not with 100
percent certainty, not without an electronic testing pen that would
shoot a little bit of light into it and back, electronically reading the
refractive index.

So what's the deal with diamonds? Would we love them as
much if they weren't so unattainable? When something's hard
to get, doesn't it make you want that thing, that person, that red
cookie, just a little bit more?

That's the scarcity effect in action. Even when the scarcity
is manufactured—because De Beers is hoarding diamonds, or a
neurologist arbitrarily takes away cookies—it has the same effect
on your brain and body.

The myth of the diamond engagement ring harnessess a
unique combination of the scarcity effect and positional good.

Want is one thing. Need is another. Would we *need* diamonds
so badly if we didn't know they were the "right thing" or the
"best thing" to have? What if we didn't associate them with the
people we admire and the people we want to be, with the people
we worship and the people we hate because they have the things
and the lives we wish we had?

Diamonds aren't the strongest thing on the earth. Percep-
tion is.

Part of the genius of the De Beers strategy lies in the fact that we are socially compelled to obtain that which we are taught to value. By artificially creating a culture of scarcity around a good *they conditioned us to value,* De Beers invented a product that has never lost its value since they seized control of the industry, almost one hundred years ago.*

* So what does De Beers have to say for themselves? I wish I knew. . . .

I've interviewed a lot of different jewelry companies while writing this book. The interviews themselves varied—some people were nervous, others guarded. Some were cagey, some were difficult, and some could not have been more transparent or helpful.

No one really expects to get an interview with De Beers. They're infamously difficult and not known for transparency. So when I simply sent off an e-mail to the head of media relations explaining that I was writing about De Beers and that I would love to talk to them about the history of De Beers and the story of the first diamond engagement ring, I didn't expect a reply.

But I got one—a very friendly reply, in fact. A woman called me from the media relations department and wanted to know what the chapter was about. I gave her an honest but short overview. She was enthusiastic, interested, and asked a great many questions. I asked if I could possibly get an interview with Stephen Lussier, De Beers's executive director of external and corporate affairs. He is also chairman of De Beers Botswana and De Beers Namibia. She said certainly, and suggested some other people I might meet with as well.

And she kept asking for more details on the "incredibly fascinating subject!"

I waited three weeks and she never replied. Eventually, I started calling her on the phone. Every time we spoke she was unvaryingly enthusiastic. They were just so busy . . . and could I send the actual chapter to refresh their memory? I explained to her, patiently, that I don't like to disclose works in progress, and that the chapter was so far unfinished.

Finally, because she gave me a tentative date for the interview, and I had other business there as well, I got on a plane and went to London. And though she made two separate, actual appointments with me, when I would not e-mail her *exactly* what I was planning to write about De Beers (partially because I didn't yet know), she had to cancel them at the last minute.

I e-mailed her a final time. My trip was drawing to a close; I had been in London for *five weeks*. I needed to know whether the interview was still possible. She said that the only way a conversation would "realistically" happen was if I sent her the chapter in its entirety to be read and reviewed by the company. *There would be no interview,* but De Beers would run it past their PR people and give me their official comments. I had to decline. What I wanted was an interview, not a preapproved press release.

A Piece of the Rock

Maximillian's charming, if politically motivated, gesture to his future wife, Mary, five hundred years ago was cleverly repackaged and sold as romance to the entire world, in a calculated maneuver designed to assure De Beers economic supremacy across the decades and the globe. Furthermore, the myth of the engagement ring made diamond rings not only a recognizable icon and global symbol of romance and success but a "necessary luxury."

De Beers successfully took a substance they had already made into a precious gemstone, cut it into very teeny, tiny pieces for the burgeoning middle class, and sold those chips as though they were valuable jewels.

And everybody got a piece of the rock.

Based on the Bain consulting report, business has never been better, despite the fact that De Beers has lost its absolute monopoly on raw diamonds in light of new finds in Canada and Australia far bigger than the one that made Cecil Rhodes's surveyor faint a century ago.

The simple fact is: The supply was never an issue to begin with. It was always about artificial scarcity and manufactured demand. And no one has *ever* managed to manufacture demand like De Beers.

The diamond engagement ring as a *concept* is an incredibly

So what does De Beers have to say for themselves?

Apparently nothing—unless they get to completely control the terms of the conversation.

I was disappointed, but not surprised. After all, from the first diamond engagement ring to the last, De Beers has always been in the business of controlling other people's perceptions: perceptions of diamonds, perceptions of love, perceptions of need.

So it shouldn't be surprising that they are also very much in the business of controlling people's perception of De Beers.

recent thing, and it's remarkable how seamlessly it has been integrated into the iconography of modern life. We're conditioned to fantasize and dream about our future engagement rings, to think about them as our own, as part of our identity. That's a noteworthy statement on the power of media manipulation and the success of De Beers's marketing strategy.

And unlike similar tokens of other eras, the diamond engagement ring is a global phenomenon, a symbol recognized by nearly every country. De Beers didn't even try to crack Asia, a place where, historically, there were no wedding or engagement rings, until 1967. By 1978, half of all Japanese brides were wearing a diamond ring. Now, Japan is the second largest market after the United States.

The fact that we're conditioned not only to *want* a diamond engagement ring but to integrate the idea of one into our concept of who we are, what we want, and what our lives will or won't be; that's an incredible thing. No other company has ever accomplished such a feat, though cigarettes gave diamonds a brief run for their money. No other product has ever been so seamlessly integrated into the American dream, let alone the human vision. And to think: It hasn't always been thus. It's only been that way for about eighty years.

What did De Beers do, really, when they invented the diamond engagement ring? Did they swindle us?

It looks a lot like an emperor's new clothes scenario: maybe they tricked us into buying cheap gravel, exalting it and holding it up high, pledging our love to it, as though it were some sort of a magic idol or holy icon.

Or did they actually *create* value? Is value something that can be manufactured?

Of course. Remember positional good? A thing in and of itself has no absolute value. Its worth is relative. The real root of it, the ventromedial prefrontal cortex, is the squishy area in your heart and in your mind that defines, confuses, and *creates value*—

and our emotional attachment to that valuable—or as we call it in extremis: love.

If you can make someone want something, then that thing has value to the person who desires it. If you can make the *whole world* want something, then that thing just has value, period.

De Beers didn't just create a myth and a market. They *created desire*. And even if it is just wires getting crossed in your brain, that desire created real value.

Maybe that's all love is . . .

THE COLOR OF MONEY

*The Emerald Parrot, and the Making
and Unmaking of the Spanish Empire*

There's a lady who's sure all that glitters is gold / and she's buying
a stairway to heaven. —LED ZEPPLIN

The dose makes the poison. —PARACELSUS

Long before De Beers showed us a diamond ring and asked to
be our one and only, there was another pretty stone that made
everyone's heart skip a beat. For most of Western (and Eastern)
history, *emeralds* were the currencies of the realm.

For millennia, emeralds have been celebrated by cultures as
disparate as ancient Egypt and Napoleonic France for their luster,
scarcity, and association with the divine. But no empire has had
a relationship more profound—and more profoundly complex—
with the brilliant, verdant jewel than the Spanish Empire of the
sixteenth century.

In fact, the mythical story of El Dorado, the glowing City of
Gold, wasn't exactly a myth. It was actually a well-crafted piece
of PR on the part of the cash-poor Spanish Crown, and it had a
very real, very sparkly green counterpart: the true story of the
Emerald Parrot. Not only did it and its emerald-rich city exist,

it forever altered the value of emeralds, the balance of power in Europe, and the population of a continent. But even more profoundly, the rapid fluctuations that influx of wealth created in Spain's sixteenth-century economy—through the problems it caused and the solutions it inspired—would, four centuries later, lay the groundwork for our own.

The Perception of Power

Crushes come and go—but first loves last forever. The human infatuation with emeralds runs so deep, and our desire for them traces so far back, that it can be cited throughout our entire shared history. It's one of the only gemstones found in rank-signifying Neolithic headdresses. Yeah, you heard me: caveman crowns.* In fact, the very word itself, *emerald*, is thousands of years old.

The oldest known emerald mines, at least in the Western hemisphere, were in Egypt. While they date back to at least 330 BCE, several centuries before her time, they're still known as the Cleopatra Mines because Egypt's best-known queen made such extraordinary use of them. More than two thousand years ago, Cleopatra used those emeralds to keep Rome in line—not just financially but also *psychologically*. Then again, very few rulers have understood the fluid relationship between the power of perception and the perception of power as well as she did. Even when she was initially deposed, she wore massive emeralds, the signature gem of her kingdom, everywhere, to remind the people that she was a queen, on or off of the throne. She wielded the jewels both symbolically, as a nationalistic icon for all to see, and as an aggressive display of

* They exist, in North Africa, and they have rough, dark emeralds in them— along with bones and resin.

wealth—leading everyone around her to wonder, if she could pay for that, what else could she pay for: An army? A war?

At that point, Cleopatra's famed mines at Zubarah were the best, if not the only, source of emeralds in the known world. She seduced Caesar with a spectacle of luxury that might easily have doubled for a master class in intimidation. She met with him covered in gold threads, lying on a massive pile of her country's coveted green stones.

Caesar returned to Rome not just smitten with the Egyptian queen and her jewels but also with a new understanding of the more subtle ways in which wealth might be used, not just as a display of abundance but also as a show of force. As a result, he almost immediately instituted a whole new set of sumptuary laws in his capital, laws that forbade or restricted the use of certain luxury items to only a select few.[*]

After Caesar's heir, Augustus, killed Cleopatra and seized Egypt, he took over the emerald supply. He used those same stones to fund the Pax Romana, or the "Roman Peace": an unprecedented two-hundred-year period of internal peace, external expansion, and social development. It was that not-so-brief classical period of emerald-funded Roman glory that inspired Napoleon's later obsession with the stones. He covered himself, his empress, and his court in emeralds, deliberately exploiting their association with the wealth and power of the Roman Empire at its zenith.

Byzantine emperor Justinian forbade the use of emeralds in jewelry for anyone but himself and the empress Theodora—not out of vanity, but for the good of the economy. He didn't want his primary foreign currency and most coveted trade good stagnating in people's jewelry boxes.[†]

[*] For example, he mandated that purple-dyed togas would be reserved for his use alone.

[†] Victoria Finlay, *Jewels: A Secret History* (New York: Random House, 2007).

Suffice it to say that emeralds were the diamonds of their day—"their day" being *every day* from early antiquity until a few hundred years ago. There's even evidence to suggest that emeralds—and the thousands of years' worth of human history during which they were considered the most precious gemstone in the world—are at least partially responsible for the human association between the color green and the concept of wealth.

The Power of Perception

How did emeralds, of all gems, become so inextricably linked with the idea of money?

It could be the color.

The "Red Dress Effect," is one of the most famous psychological experiments on the effect of color perception. Confronted with a series of photographs of women, the surveyed group of men almost universally rated women wearing red as being far more sexual, or more open to sexual advances, than corresponding images of the *same* women wearing any other color.[*]

This simple experiment reveals the way in which humans are conditioned to associate simple color signals with complex social messages. Those signals go a very long way back in our evolution. In all likelihood, the color red says "sex" to men because of its physical association with fertility, ovulation, and flushing— not, in fact, because women wear red when they want sex. But it's easy to see how these things get confused in the modern mind, when twenty-first-century humans are acting on instincts honed over twenty-five million years.

[*] Adam D. Pazda, Andrew J. Elliot, and Tobias Greitemeyer, "Sexy Red: Perceived Sexual Receptivity Mediates the Red-Attraction Relation in Men Viewing Woman," *Journal of Experimental Social Psychology* 48, no. 3 (2011): 787.

Similar studies actually show that when people look at the color green for several seconds, their blood vessels dilate, their pulse rate slows, and their blood pressure drops. Green isn't just intrinsically soothing and lovely to behold, it's also *good* for you. According to numerous studies, living inside green walls lowers blood pressure; there's even evidence that exposure to the right wavelengths of light increases certain stimulating, "feel-good" neurotransmitters in your brain. Have you ever wondered why hospitals, mental institutions, and prisons are so often painted shades of green? *Green actually calms you down.**

This surprising fact is no doubt due to hundreds of millions of years of biological evolution that have caused us to link green with natural abundance. We see green and associate it with springtime, with an end to winter and an end to hunger. We associate the color green with *food* and food with plenty. Nothing says wealth in a preindustrial world like food. In a modern, postindustrial context, we associate plenty with money.†

But there's more. A quick lesson on physiology: Our eye perceives color using specialized cells called "cone cells." Different cone cells are sensitive to red, green, or blue light. But across the board, *all* your cone cells are most sensitive to wavelengths of light hitting them at 510 nanometers. In plain English: You see green light more clearly and vividly than other colors. Your eyes are actually designed to identify green. In short, we've *evolved* to look for it.

Let's look at another everyday instance in which the color green plays a critical role. Every first grader can tell you that green means "go" and red means "stop." Why is that? Traffic-light signals were based on railroad signals, which in turn were

* Maybe that's why the emperor Nero was said to have read and watched public games through glasses made of thin slices of Egyptian emerald. It obviously wasn't enough, though. That guy was nuts.

† Haven't you ever wondered why BUY IT NOW buttons are always green? They're gaming you: Relax, go ahead and *spend that money.*

based on still earlier methods of flag signaling. Red has always been used to say "stop" for the same reason it's used to say "danger": because of its fundamentally attention-grabbing nature—it's pretty hard to miss. If you want to get a man's attention, wear red. If you *need* to get somebody's attention, to convey something urgent (like "stop"), red is similarly useful.

In the color wheel, green is red's opposite, meaning that it stands apart from red and can be easily distinguished from it; this partly explains why the two are used in tandem. But more important, green is used partly because it's the color most visible to the human eye, simultaneously soothing and stimulating. It says, "Come this way—things are good over here." Actually, from an evolutionary standpoint, green—not red—is really the "come hither" color. It doesn't just mean *"safe* to go," it means *"good* to go."

Whether it's the green pastures of Manifest Destiny or the green light at the end of Daisy Buchanan's dock, green has become synonymous in the human mind with freedom, expansion, and possibility.

Money, That's What I Want

Culturally speaking, green is an almost universally significant color. It's a holy color in the Middle East: the color of Islam, and the color of the prophet's cloak. Long before that, green was the color of the skin of Osiris, the dying and rising god of Ancient Egypt. Before the spread of Christianity, green was a sacred color to the Celts, who worshipped the Green Man. His leafy face is still visible, carved in medieval Christian cathedrals. In Asia, green was the color of royalty, the greenest jade being referred to as "imperial jade."

Add into the equation a couple of million years of human conditioning, which over time have caused humans to identify green

more easily than other colors and to unconsciously associate it with abundance, freedom, and choice, and it's no wonder that in America, green is the color of money.

But there are a lot of green gems in the world. Why would emeralds in particular hold such special value, emotionally and economically?

The reason is simple *scarcity*, which as we have seen in previous chapters goes a long way to increasing—and even creating—perceptions of value. Through most of history, emeralds, unlike a lot of other gemstones, have been genuinely rare.

Thus the vividly green stones say "enough" and "not enough" at the same time, which is why emeralds and their color have become synonymous with monetary wealth, not the edible bounty of nature. In fact, until the Emerald Parrot led the way to the emerald-rich mines of Colombia, emeralds had enjoyed the kind of unprecedented scarcity that made them a legitimate version of the limited good that we only imagine diamonds to be.

Most precious stones can be found in some quantity and in various colors and qualities all over the world. But unlike almost every other precious gem (diamonds, sapphires, and rubies in particular), emeralds only occur naturally in a few places,* and they only form under truly earth-shattering circumstances.

So how do you get an emerald? Well, you start by taking two very disparate continental plates and *slamming* them together.

Did the Earth Move?

Emeralds don't sparkle, they shine. It's called a "vitreous luster." In plain terms, it means emeralds look wet. Light doesn't refract inside them, shattering into a million tiny rainbow shards the way

* Most notably, Colombia, Brazil, Egypt, and Zimbabwe.

it does in a diamond. Instead, those light waves glance off the emerald's flat green planes, giving them a glossy sheen like wet nail polish.

The reason for an emerald's particular beauty, as always, comes down to chemistry. Emeralds are simple hexagonal beryl crystals, contaminated during their formation with varying amounts of chromium and/or vanadium. Beryl crystals, or beryllium aluminum cyclosilicate [Be3Al2(SiO3)6], are colorless, really shiny (because of the way their atoms line up and hold hands),* and not particularly common. Clean, gem-quality beryl is even rarer.

When a colorless beryl crystal is contaminated with iron during its formation, it turns various shades of blue, and we call it an aquamarine. When it is contaminated with manganese, it turns pink and is known as morganite.† Yellow is heliodor, and white is goshenite. Beryl comes in a variety of colors, depending on the extra element that infiltrated the crystal during its formation.

Emeralds and their specific green color are by far the rarest and most valuable‡ and are the only beryl considered a precious gem. The extra element in an emerald is chromium, which gives the stones their distinctive color and, in great enough quantities, fluoresces in the ultraviolet radiation in sunlight. In other words, some emeralds quite literally glow.§

* The word *beryl* shares the same root as the word *brilliance*.

† In honor of early twentieth-century industrialist J. P. Morgan, whose brief but ardent passion for gem collecting resulted in the American Museum of Natural History's Morgan Memorial Hall of Gems. He donated his private collection when he became bored with stones and moved on to a new hobby.

‡ Well, OK, that's not totally true. Red beryls, sometimes called red emeralds, are far, far rarer and more valuable, but almost nonexistent. They're stunning, though odds are you'll never see one in real life. There are only a few tiny, recently discovered, micromini veins of them around the world. I happen to be in hot pursuit of a red emerald as I write this.

§ There is some debate about the origin of an emerald's glow. One expert puts

THE COLOR OF MONEY

The same combination of elements that makes emeralds what they are—the chromium and the beryllium together—also makes them a mineral that, at least geologically speaking, shouldn't even exist. Beryllium and chromium are both very rare to begin with. And they both exist not only in minuscule amounts but in dramatically different parts of the earth's crust. Chromium is found in minute amounts in the ultramafic rock—real dawn-of-time rock—that makes up much of the oceanic crust (the tectonic plates beneath the seas that cover the earth's gooey magma center, like ganache on top of molten chocolate). Beryl, on the other hand, tends to be embedded in much newer igneous rocks. These newer rocks, called pegmatites, are formed on land by cooled molten magma and frequently form mountainous caves and cliffs.

Basically, beryllium and chromium are the Romeo and Juliet of elements. Under no normal circumstances should these rare substances ever find each other. Under normal circumstances, these elements aren't even chemically *compatible*. For an emerald to form, those dawn-of-time rocks in the oceanic crust had to come crashing into the floor of the continental shelf with incredible, literally earth-moving force. And it's totally happened. But only a few times.

It's called orogenesis: the making of mountains. Here's what happens: Two different continental plates smash together. The continental shelf is crumpled and pushed upward into jagged peaks, while superheated water and dissolved minerals are forced through every crevice. This is how massive mountain ranges like the Himalayas and the Andes were formed.

This is also how emeralds are created.

the unique glow down to the gem's physical structure. In his book *Emeralds: A Passionate Guide*, Ronald Ringsrud insists that "growth irregularities [that] bend and soften the light" within the mineral structure cause it to disperse the light more broadly and emit a luminous glow.

When those "suture zones" that we perceive as staggering mountain ranges were being crushed into existence, some of that superheated water, which contained, among other things, dissolved chromium from the sea floor, percolated up through the consolidated black crud of compressed shale and into the chambers of evolving mountain rock—kind of like a coffee drip moving in reverse. A few of those premountainous chambers contained growing beryl crystals; in rare cases, that dissolved chromium *replaced* the aluminum of the beryllium aluminum cyclosilicate, turning a simple colorless beryl crystal into a priceless glowing green emerald.

So you see, emeralds are a rare and extraordinary phenomenon—not just as a gem but as an *event* in the earth's 4.54 billion of years of geological history.

Words in Collision

Let's turn now from geology back to the realm of politics, economy, and the ever-popular search for cash. Billions of years after the formation of all the world's emeralds due to orogenesis, worlds would once again collide in the Andes. But before the Old World could come crashing into the New World for a second time, it had to consolidate some nasty black crud of its own.

Forget about the cream rising to the top. In every time, in every place, the *rich* rise to the top—of the social order, that is. Rightly or wrongly, they get there at least in part by standing on the shoulders (or industriousness) of everyone below them. That's just economics. You can't be a boss without employees and vice versa, and as lovely as the idea of Utopia is, humans have yet to pull it off.

Think of the economy as a cheerleading pyramid and the rich

as the girl on top. The problem with being on top, however, is that the position has historically given rise to a dangerous logical fallacy. Let's stick with the cheerleader analogy. Rather than glancing down at her teammates and being grateful she's not on the bottom, or looking down and appraising what a hard fall it would be to the ground, the cheerleader begins to look up. Instead of realizing she's farther from the ground, she starts to believe that she's closer to heaven.

This self-aggrandizing delusion—the belief that one is at the top of the pyramid of privilege because one is favored by God—has been a favorite argument of the überwealthy, the aristocracy, and kings and queens for millennia. They even invented a term for it: the Mandate of Heaven. The expression dates all the way back to ancient China, when the Zhou dynasty seized power from the Shang dynasty in 1046 BCE. They claimed that God had told them to do it, so it was totally OK. And then they took their victory over the previous regime as *evidence* of their righteousness. It logically followed that anything they then did, good or bad, was *right*, simply because it was preendorsed by the cosmic powers that be.

The handy little concept may have emerged in China in 1046 BCE, but twenty-five hundred years later the Spanish Empire really took that idea to the bank.

Although, in 1468, the Spanish Empire was not yet an empire. Spain wasn't even a nation. It was just a loose collection of squabbling kingdoms. And a large part of Iberia (the landmass we think of as Spain) was actually the Moorish kingdom of Granada. It wasn't until 1469, when an eighteen-year-old Isabella, the princess of Castile, married a seventeen-year-old Ferdinand, the prince of Aragon, that there was even the first possibility of a unified Spain.

Sounds like happily ever after, right?

Not quite.

No One Ever Expects the Spanish Inquisition*

Five years after she married Ferdinand, Isabella inherited the crown of Castile. The happy couple had quite the falling-out over it. As the man of the house, Ferdinand expected to be king. Isabella (who kind of *was* the man of the house) was older, and it was *her kingdom*. She had the support of the people. He had sexist precedent. So they decided to rule jointly.

Another five years after that, Ferdinand's parents died, and Ferdinand inherited Aragon. For a brief moment he toyed with the idea of keeping Aragon's throne to himself, but by that point ruling jointly (or maybe just acknowledging that Isabella wore the pants) had become a habit for them, and they decided to continue ruling both kingdoms together.

For the first time ever, Spain truly was unified. In 1481, Ferdinand and Isabella were hailed as "Les Reyes Católicos," or the Catholic Monarchs. This was thrilling for Catholics everywhere, and understandably nerve-racking for everyone else, for many reasons—not the least of which was that Isabella was a freaky religious extremist, with a hate on for all nonbelievers.

The Inquisition was essentially the strong arm of the Catholic Church, instituted in the twelfth century to seek out and punish heretics. By the time Ferdinand and Isabella were born, the Inquisition had existed as an extension of the Catholic Church's power base for centuries. But in 1478, the Catholic Monarchs got special permission from Pope Sixtus IV to conduct their own private branch of the Inquisition in Spain (the so-called Spanish Inquisition), which would focus on the unique problem of false conversions.

False conversions were a unique and paradoxical problem

* Well, not in my family anyway. We have a long history (back to Spain at least) of getting thrown out of places by pointing out the obvious at the wrong time.

indeed. At the time, in order to be part of mainstream Spanish society (or, in many cases, even safe from bodily harm), one had to be Catholic, so a lot of people felt compelled to convert. But they weren't necessarily sincere—fear of death and/or torture is not, it turns out, a powerful motivator for the genuine development of religious faith, much less a love of the Church—and that *really* bothered Isabella. She felt that faking Catholic was even worse than being a Jew.

She told everyone to be Catholic *or else*, but didn't want their identification as Catholic to be motivated by fear. There's just no pleasing some people.

Isabella and Ferdinand issued a command to the Jews of Spain:* convert, die, or get the hell out. Moreover, they determined that if Jews chose to leave, they must leave empty-handed. That last part was critical. People who wouldn't convert had to leave the country immediately, after giving up all their money and worldly goods to the Crown.

A large number of Jews, about a hundred thousand, did convert. But it was a real Catch-22. Once they did, largely to avoid torture or death, they were almost immediately subject to an "inquisition," in which they were either tortured to death or tortured until they confessed that they were really just lying about converting, you know, deep down . . . in their heart.

Those who lived were expelled from Spain, empty-handed, in an exodus that greatly enriched the state. Not too long afterward, the Iberian Peninsula's Muslims met with more or less the same royal treatment. It was quite the economic boost for the Crown. But what had, ten or twenty years earlier, been one of the most sophisticated, diverse, and tolerant corners of Europe was very rapidly beginning to put the *ick* in Catholic.

* And ten years later to the Moors of Granada.

There Goes the Neighborhood

When people think of the Spanish Empire, they think of the New World and Columbus, conquistadors and treasure; they might even think of the Inquisition and anti-Semitism. If they've been to grade school, they certainly think of Isabella and her voyage-financing jewels. But the invisible thread that stitches all those elements together in the story of the rapid fluorescence and decay of the Spanish Empire is *money*. Where did it come from? More important, where did it all go?

The story of Spain is the story of a rapid and repetitive boom-and-bust economy in which, for over a century, the booms just kept getting bigger and more frequent—as did the corresponding busts. And it all started with a land grab.

By 1488, Spain is unified, the Spanish Inquisition is in full swing, and the state coffers are full, thanks to a little *leave-your-stuff-and-get-out* religious policy. Things are going very well (for Ferdinand and Isabella, at least). So what does one get *the* Catholic Monarchs for their twentieth anniversary? Well, at the top of their wish list was a little southern exposure. That is, they had their eye on the only piece of the Iberian Peninsula still eluding their grasp: Granada.

Granada: that multicultural bastion of learning, commerce, art, and science—and, you know, disgusting swarthy heresy. As it was a major hub for trade throughout the Mediterranean and a gateway to North Africa, Granada was full of Moors, Turks, Saracens, and Jews. It was an Islamic kingdom on their soil, as it had been for hundreds of years, and it was like a pebble in their shoe.

It was also a very rich kingdom, which no doubt made it even more appealing.

So they did the only reasonable thing and invaded.

By 1492, Ferdinand and Isabella were a decade into the siege of Granada, and the war was getting pricey. They'd had the cash

when they started their Reconquista (God-ordained land grab), but the conflict dragged on. It was not, economically speaking, the best year for the monarchs. Les Reyes Católicos made a lot of really expensive decisions in 1492, most of them, ironically, based on debt.

Fourteen years after the beginning of the Spanish Inquisition, the Grand Inquisitor, Torquemada,* told Ferdinand and Isabella to expel the Jews from Spain *altogether*. One hundred sixty thousand of them left of their own volition, leaving all their worldly goods (specifically their money in the form of gold and jewels) behind, forfeit to the Crown, as expressly demanded by the Inquisitor.

Cha-ching.

This mass exodus and the resulting influx of cash coincided perfectly with Spain's successful seizure of Granada. But destroying other people's empires is expensive. *Really* expensive, especially when the empires are ancient, well-constructed, and full of highly educated people who resent the invasion. Even the ill-gotten goods of two to three hundred thousand murdered or expelled Jews and/or heretics weren't enough to cover the cost of Spain's "holy war" and annexation of Granada.

And God doesn't cut checks—even to *the* Catholic Monarchs.

Can You Pawn a Crown?

That Queen Isabella financed Columbus's first exploratory voyage to East Asia by pawning her jewels belongs to a special cate-

* Torquemada was the vicious head of the Inquisition and Isabella's personal confessor. Ironically, he was also the grandson of *conversos* (or Spanish converts) himself. Can we get you a little self-loathing with that torture and genocide?

gory of apocryphal stories: the ones that are actually sort of true. People have long argued that she couldn't have pawned the crown jewels for Columbus. That *is* true. She couldn't have. Not because it wasn't allowed* but because the crown jewels were already in hock. She had pawned them the year before to bail out Spain's war effort against the Moors in Granada. Holy war is an expensive business.

According to Irene L. Plunket, royal historian, "the crown jewels were pawned to the merchants of Valencia and Barcelona"† during the Granada campaign. At that stage, the Spanish monarchy hadn't started throwing Jews out of the country wholesale and confiscating their valuables just yet. They did that only when their money was spent and they were in need of a final surge of cash.

Spain was up to its intolerant eyeballs in debt. Holy war, just like emeralds, would be the Spanish Empire's making and unmaking—and in just the same way.

It's a historic irony that the Spanish Crown went looking for treasure in large part to fund its holy wars; ultimately, it was the treasure Isabella and Ferdinand found that not only funded their wars but *justified* their righteousness and was, they believed, a physical manifestation of God's approval of their holy campaigns. Remember that thing I said about God not cutting checks? Scratch that. In sixteenth-century Spain, the Crown apparently thought otherwise.

The discovery and accumulation of wealth, of course, led only to more holy wars, which expanded Spain's empire further,

* Though according to Victoria and Albert curator Hubert Bari, it shouldn't have been, as they belonged not to her but to the state. A queen selling or pawning the crown jewels would be like the president selling furniture out of the White House. She may have had special dispensation, as the loan was against a war effort on behalf of the state.

† Irene L. Plunket, *Isabel of Castile and the Making of the Spanish Nation: 1451–1504* (New York: G. P. Putnam's Sons, 1915), 216–20.

so that they could obtain still *more* plundered wealth with which to fund still *more* holy wars—on and on and on, until Spain held such a large, bloated, unwieldy empire that it couldn't possibly be sustained.

That's when Columbus showed up selling a story about a shortcut to Asia, the same story he'd been peddling to the courts of Europe for years. Finally, in the last cash-strapped days of the Reconquista of Granada, his audience was desperate enough to hear him out. So when Columbus promised the broke and desperate Isabella pearls and jewels, not to mention spices (remember, those were hard drugs in 1492; somebody traded an island for nutmeg, which kind of makes you wonder if they were high on nutmeg), the desperate queen decided to take a gamble.

Isabella pawned the last of her *personal* jewelry (not the crown jewels, which were long gone) to pay for about one-quarter of Columbus's expenses. The rest of the money actually came from private backers,* but is typically attributed to the queen because it was offered in response to her initial show of faith in his endeavor.†

* My family name isn't really Raden; it's Melamed. As in Meir Melamed, one of the financiers who funded Columbus's first voyage. He later suggested that he and his friends were owed their investment back when the treasure ships started rolling in. This was right around the time that Isabella and Ferdinand dropped the forced conversions and practically screamed, *"Just get the fuck out!"* effectively expelling all the Jews from Spain. Maybe not the family's best moment.

† Early in my career, and after I stopped suggesting we commit financial fraud with a metal file, I eventually became the head of the appraisals department for jewels, in particularly antiquities, at the House of Kahn. One of the most remarkable things to come across my desk was a piece of jewelry that supposedly had belonged to Queen Isabella of Spain.

 It was a gold bangle-style bracelet made of rubies swirling around a big diamond. What made the bracelet exciting was that it contained no South American emeralds. That suggested, as an appraiser of antiquities, that it was pre-Columbian. And as a piece of Isabella's personal jewelry, not verifiably one of the crown jewels, it was very likely one of the pieces pawned to finance the voyage. I wore it all week.

And not for nothing, but *china* is traditionally what you give someone for a twentieth anniversary . . .

Don't Come Back Empty-Handed

And so Columbus, the great explorer, set out in the *Nina,* the *Pinta,* and the *Santa Maria,* to sail across the ocean and arrive in the spice and jewel ports of the East, as all schoolchildren learn. That's more or less true. But that version of the story leaves out most of the interesting details, like the fact that this voyage—the first of four that he would make in his lifetime—was his most successful, despite the fact that he never even hit the mainland.

He landed on Hispaniola, or what he decided to call Hispaniola in honor of Spain. He found no emeralds—not that he was expecting them. After all, he thought he was in an undiscovered area of the East Indies.* More disappointingly, he found no gold or pearls either, which were two of the three main things he had promised Isabella.† What little gold the natives had was in the form of jewelry and trinkets. They explained to him as clearly as they could that their small amount of gold was not local, and that they had, in fact, bartered for it with people from very far away.

Not what Chris wanted to hear.

Imagine his disappointment—and by disappointment, I mean white-hot terror—when after having taken a huge amount of money to finance this long-shot‡ voyage, promising a straight trade route to East Asia, he instead ran into an enormous land-

* He actually died believing that Hispaniola was *really* near Japan.
† The third being drugs from the Spice Islands.
‡ All puns intended.

mass on which he found nothing of any real value. He had taken money from the *Crown*, during the *Spanish Inquisition*—which pretty much makes mob money look like a loan from Grandma.

So what to do to pacify creditors waiting at home to be paid back, not the least of whom was an interrogation-happy queen whose remaining jewels were in hock? The obvious: kidnap and enslave. All Hispaniola really had to offer was human cargo. And Columbus, who wasn't exactly the hero we remember from grade school stories, had no problem with that.

Columbus came back as triumphant as he would ever be in his lifetime, ships laden with kidnapped locals and the few stolen gold trinkets belonging to them, which he presented to the court. Were the people of the New World humans, entitled to and deserving of salvation and conversion? Were they now Spanish subjects, as Isabella believed? Or, as Columbus claimed, were they simply a natural resource now owned by the Spanish Empire? It was a debate that would rage for the next few centuries. Some Spaniards were delighted with the possibility of slaves; some were intrigued by the possibility of a New World of resources.

Isabella was excited about a New World of a whole other sort: the eternal kind.

Buying a Stairway to Heaven

We all know that conquistadors went to the New World in search of plunder. And we all know that pious, albeit misguided missionaries followed them there to forcibly convert the natives. What you might not realize is that both missionaries and conquistadors were sent on those seemingly contradictory errands by the very same person: Queen Isabella.

Isabella was a savvy woman and one of the most famous jewelry owners in history, due in large part to the fact that she pawned some of her collection for Columbus. And, as we've seen, she was an intense Catholic. Queen Isabella is also one of the few people whose personal wishes—among them the desire to see all the inhabitants of the New World made Christians, by force if necessary—single-handedly reshaped the globe and the economy of her century and the five centuries that followed.

Despite all her famous Catholic firebranding, she seems to have had rather ambivalent feelings about her new subjects. When Columbus returned from his first voyage with very little bling, but lots of human cargo, it provoked a great schism of opinion in Spain—a schism that would subsequently tear Spain apart and end in the abdication of the king, after a five-day public trial between the two courts of opinion.

Columbus believed that Europeans were intrinsically superior and therefore had a "natural right" to dominate and enslave the lesser races, which included the natives of North and South America. He believed that, in much the same way that gold, silver, and emeralds would be brought back from the New World, the people were also forfeit, and belonged to Spain.

Isabella insisted that the indigenous populations were her subjects, not slaves, and must be converted to Catholicism. In fact, her feelings ran a little deeper and a whole lot weirder than that. Not only did she insist that the natives must be treated with kindness, and converted as you would convert a fellow European (sort of ironic, considering her "kind" methods of converting fellow Europeans), she insisted—in all seriousness—that this was a trial laid out for us in the New Testament. It was the *last* trial, she claimed, before the return of Jesus Christ. She believed that if Spain converted all of the New World to Catholicism, Christ would return to Earth.

But then something happened: She checked her bank balance. Turns out she was broke again.* Are you sensing a theme?

Isabella, being either a very pragmatic or a somewhat hypocritical queen (and there's no reason it can't be both), simply stuck to her guns about the return of Christ and the conversion of the natives—in principle. But she let that first part—about treating them kindly and converting them as subjects and equals—slide, and tacitly accepted the enslavement and abuse and wholesale genocide of the natives, on a truly spectacular scale, to allow for the massive plunder of their jewels, precious metals, and other resources.

So how did she justify this? I'd like to say it was a clever piece of reasoning, but it wasn't. It was ham-fisted, self-serving financial logic. As part and parcel of her attempt to buy her stairway to heaven, she believed that it was indeed vitally important to convert the indigenous peoples of South America to Catholicism as her human equals and her subjects. Just, you know, not right now. Because it was even *more* important to enslave them first, drill all the gold, silver, and emeralds out of that continent, and use it to finance Spain's holy wars against everyone else.

And when Spain, as an empire, had achieved total Western supremacy—on the backs of those slaves and by spending their money—*then* she would embrace the Indians and mestizos, those still alive, anyway, as human equals (because, of course, they wouldn't mind), and they would love her as their queen and

* Because usury was outlawed by Rome, most of the bankers in fifteenth-century Spain were non-Catholics, and they'd just been expelled to other countries. Throwing all the bankers out of your country initially seems like the end of your financial problems but usually turns out to be just the beginning of them. Short-term benefit: Your debts and outstanding loans disappear right along with the lenders. Long-term consequence: *There's no one left to borrow from*— and borrowing is a large part of how economies function. Oops.

she would convert them to Catholicism and Jesus Christ would return to congratulate a triumphant Spanish Empire!

In her defense—she was obviously insane.

Fools' Gold

The court back in Spain and various private investors were waiting for Columbus to return from the ports of East Asia with ships full of jewels, silks, drugs, and gold. Instead, he came back claiming to have found a New World in the middle of the ocean. Exciting, novel prospect—totally inconvenient as an alternate route to Asia—but thrilling nonetheless. However, their enthusiasm was somewhat dampened by the fact that the only cargo he brought back was human and vegetable.

Ultimately, there would turn out to be unprecedented riches in the New World of the old-fashioned kind—gold, silver, pearls, and emeralds—in unimaginable amounts and quality. Not to mention a whole *new*, better class of drugs (screw spices—hello coffee, chocolate, tobacco, cocaine, and the real white devil, *sugar*). But Spain didn't know that in the beginning.

So, what do you do when you've invested heavily in an endeavor and then begin to realize that you may have backed the wrong horse? Simple. What did Rhodes and Oppenheimer of De Beers do after they cornered the market on diamonds, then realized they'd found so many that the stones were practically worthless?

Lie. You lie and you try to make that lie real by making everyone else believe it.

It's called PR. Whether the story is about the alleged scarcity of diamonds or the boundless treasures of the New World, it's all about good old-fashioned spin. That's where the stories of El Dorado, the famed City of Gold in the jungles of South Amer-

ica, came from. Or the Fountain of Youth, which was famously claimed by the great explorer Ponce de León to be in Florida. Which I suppose, if it's true, could explain the median age of Florida's residents.

For what it's worth, El Dorado was real—but El Dorado, or "the gilded one," was not a place but a *person:* a king of the Muisca people. According to Willie Drye, "When a new chieftain rose to power, his rule began with a ceremony at Lake Guatavita. Accounts of the ceremony vary, but they consistently say the new ruler was covered with gold dust, and that gold and precious jewels [emeralds] were thrown into the lake."*

But over time and countless retellings, the person became a place, and the place morphed into a myth: an entire gleaming empire, made of solid gold. Fueled by rumors, fortune hunters swarmed the continent in search of a place that had never existed. Instead, they found only jungle inhabitants to the south and mud pueblos to the north. But disappointment never stopped anyone. When a tantalizing story like an enormous metropolis made entirely of gold starts to make the rounds, it's almost impossible to get the metaphorical toothpaste back in the tube.

It also didn't hurt that people were actually *encouraged* to believe in the promise of El Dorado. The powers that be (whether that was the Crown looking for emigrants to the New World, or captains looking for paying passengers, or suppliers looking for sales) deliberately and systematically spread stories of places like the City of Gold in an attempt to lure fortune hunters into South America and Mesoamerica, for the *very purpose* of sniffing out any wealth that might possibly exist.

It's a clever, circular technique still used today that plays on our fundamental weakness in the face of positional good. A modern

* Willie Drye, "El Dorado Legend Snared Sir Walter Raleigh," *National Geographic*, October 16, 2012, http://science.nationalgeographic.com/science/archaeology/el-dorado/.

equivalent is making people wait on line outside an empty club. The goal is a venue full of people. So making people wait in a line suggests that, not only is it already full, it's a desirable place to be, thus inspiring more people to get in line, believing that what's inside must be worth it. Eventually, hopefully, you've got enough people in line to pack the club, and the lie achieves an external reality.

The Spanish weren't trying to fill a club; they were trying to fill a continent. They were specifically trying to fill it with treasure hunters to explore the possibility of the existence of treasure that they had claimed was definitely there.

And it worked—then, as it does now. And sometimes lies even turn out to be true. They did, ultimately, find a city of treasure. Only the treasure wasn't gold.

It was green.

El Inca and the Emerald City

Garcilaso de la Vega, often referred to as "El Inca," was something of an emerald in his own right. As the son of a deposed Inca princess, Palla Chimpu Occlo,[*] and a Spanish conquistador, Captain Garcilaso de la Vega y Vargas, he was the rare and remarkable offspring of the violent collision of two continents.

More remarkably, he was not the unwanted illegitimate child of some misbegotten sexual conquest. While his parents were not legally married, they were allowed to maintain separate but respectable residences, and he grew up traveling freely between them. He spoke both Spanish and Quach and was proud of both his royal bloodline and his Spanish cultural heritage. By all

[*] Garcilaso de la Vega's mother was a member of the Inca royal family. She was a cousin of the last Inca emperor, Atahualpa, and granddaughter of Emperor Tupac Inca Yupanqui.

accounts he had a happy, privileged childhood and loving, close relationships with both his parents.

Garcilaso de la Vega was born in Cuzco, Peru, on April 12, 1539, and died in Cordoba, Spain, in 1616. He was christened Gómez Suárez de Figueroa, but having been raised in Peru (and having received a rather chilly reception from his extended Spanish family when he returned to the continent), he preferred to be called El Inca, in honor of his mother's people.

El Inca was a poet and a soldier. He was an extraordinarily well educated and multilingual writer. He served with distinction in the Spanish military later in life, but he's most well known for his remarkable contributions to Spanish literature as a writer and a translator and, most important, as a chronicler of his own people's history in Peru. He's credited with having written some of the most complete and accurate accounts of Inca history and culture, as well as some of the least biased accounts of Inca society and religion. Most of his records are firsthand accounts of his travels or secondhand accounts of his parents' lives.

In El Inca's *Royal Commentaries of the Incas,* he chronicled the exploits of his father, a captain in the service of the famous conquistador Pedro de Alvarado. El Inca's father and a number of other Spanish soldiers accompanied Alvarado in search of what was, at that point, still the "mythical land of Peru" and specifically, the fabled El Dorado, the Lost City of Gold.

They never found an El Dorado. Instead, they found Oz. Well, they found an emerald city of sorts.

The Emerald Parrot

Royal Commentaries of the Incas states that "in the valley of Manta, which was, as it were, the capital of the whole region, was a great emerald, said to be almost as large as an ostrich's egg." The local

inhabitants, whom El Inca refers to as "idolaters," "worshipped the emerald."* In this town, he goes on to explain, the people treated this massive, perfect emerald not just as an idol but also as a living goddess. One account describes it as looking like an egg,† but folklore described it as a parrot, carved in perfect detail from a single gigantic gemstone. El Inca writes: "It was exhibited in their great festivals, and the Indians came from great distances to worship it and sacrifice to it, bringing it gifts of smaller emeralds."‡

Worshipped thusly as a living bird-goddess, the emerald inhabited its own temple, which housed still *more* treasure. Part of the living emerald's adulation and sacrifice took the form of "bringing gifts of smaller emeralds, for the priests of the cacique of Manta put it about that it was a very agreeable offering to the goddess, the great emerald, to be presented with smaller emeralds, which were her daughters."§

In fact, the people told Alvarado and his men that the priests taught people *that all emeralds* were the great emerald's daughters, and no other gift would please the mother so deeply as the return of her children. Because of this, and because of the massive geographic reach of this religion, "they collected a great quantity of emeralds in this place, where they were found by don Pedro de Alvarado, and his companions, one of whom was my lord Garcilaso de la Vega [El Inca's father], when they went to conquer Peru."**

It didn't take long for the Spanish to put two and two together. They asked to see the inside of the temple, and to no one's great surprise found it overflowing with emeralds—infinitely finer than any that had ever been seen in the Old World.

* Kris Lane, *Colour of Paradise* (New Haven, CT: Yale University Press, 2010), 26.
† I suspect the confusion may be translational, as the firsthand accounts describe it as being *"as large as"* an ostrich egg.
‡ Lane, *Colour of Paradise*, 26.
§ Ibid.
** Ibid.

Stone Worship

From here, the story unfolds pretty much the way you might expect: The Spanish soldiers torture and kill a lot of people and take all the emeralds from the temple. There's only one interesting twist. Because the Spaniards' rapacious reputations had apparently proceeded them, the giant "emerald that was worshipped as a goddess was spirited away by the Indians as soon as the Spanish entered. . . . And it was so carefully hidden that, despite much search and application of many threats, it has never reappeared."*

Interestingly, the Inca had never hesitated to give up their gold or silver (at gunpoint, that is). But even though the Spanish employed their most creative interrogation techniques, honed throughout decades during the Inquisition, it still took nearly ten years before they managed to extract the location of even *one* of the Inca's emerald mines—and no one ever gave up the location of the hidden "goddess."

There was no negotiating with the Inca for their gems either. Even if the Spanish had been inclined to trade—which they were not—there would have been no buying emeralds with cheap foreign treasures like glass beads or alcohol. They had finally found the mother lode of one of history's most coveted gems in the one part of the world, South America, where emeralds *were not* money.

You see, the Inca believed that the gold and silver they handed over were the sweat of the sun and the moon. Lovely to possess, but precious to neither, and generally not worth dying over. Emeralds, on the other hand, glowed in the sun the way they do because they were, indeed, *alive*.† In scientific fact, Colombian

* Lane, *Colour of Paradise*, 26.
† The most well-documented Inca messiah story was recorded by seventeenth-century Franciscan historian Pedro Simón. According to his account, one of

emeralds fluoresce in reaction to ultraviolet light owing to the large quantities of chromium contaminants that also give them their green color. But this luminescence led the Inca to believe that each stone housed a spark of the divine, and was a piece of the living god's flesh.

So they were understandably more attached to them.

The Green-Eyed Monster

Alvarado and his men may have discovered emeralds that day, but that doesn't mean they were eager to share. The *European* discovery of Colombian emeralds happened very differently and took place neither in Colombia nor Spain, but somewhere in that murky transubstantial area between the material and the divine.

A greedy Dominican friar named Reginaldo Pedraza also accompanied the many conquistadors to find Peru. When instead they found many too-good-to-be-real emeralds, Pedraza ingeniously convinced the mostly uneducated soldiers that *real* emeralds could not be broken in half when struck. Imagine the conquistadors' disappointment when it turned out that all the emeralds they had stolen and subsequently shattered were just pretty but worthless green rocks.

the Inca's great leaders, Goranchacha, was the product of immaculate conception. His mother, the virginal daughter of the region's heroic chief, lay with her legs open on top of a hill at sunrise, pursuant to the directions of the city's soothsayers, who predicted Goranchacha's birth.

Nine months after being knocked up by the rays of the sun, she gave birth to a *guacata*, the Chibcha term for a large, glowing emerald. She swaddled it like a baby, took it home, and in a few days it turned into a human infant.

The Spanish referred to Goranchacha as the "Spawn of the Devil" and claimed that when the great Tyrant-Chief died, he "disappeared into a cloud of fetid smoke."

So, apparently everyone did some embellishing. . . .

The friar, who knew better, then gathered up the still-massive chunks of gemstone and sewed them into his robes. He immediately parted ways with the rest of the expedition and smuggled the stones back to Panama, but that's as far as he got. He died there of a fever a few months after the theft. When his body was prepared for burial by his fellow Franciscans, the smuggled emeralds were discovered by his new companions and returned to Spain, where they "excited the interest of the queen."[*]

I'll bet.

The accidental discovery of Friar Pedraza's loot was just the first (and most unexpected) way in which the army of clergy Isabella sent to the New World would pay dividends. The Spanish considered the Inca idolaters and pagans—and in some cases devil worshipers. The differences between their religious ideologies provided the Spanish with a rationalization for theft on a massive scale: the perennially popular *we're good, they're bad, we have God on our side* excuse.

But there was a deeper subtext to the free-for-all pillage. The account of Friar Pedraza's theft is more than just a meet-cute between the monarchs of the Old World and the treasures of the New. It actually reveals important similarities between two seemingly irreconcilable religions. At a distinct point in time, emissaries from two completely different religions (the Catholic friar and the Muisca priests) met, clashed, and yet showed that, in the final analysis, they both worshipped the same green god.

Fernandez de Oviedo states in book VII of *Historia General y Natural de las Indias* (in which he documents, among other things, the discovery and mining of emeralds) that "until our time no one has ever heard of a discovery, by Christians, of such naturally occurring stones, and the value of that land is enormous, so laden as it is with riches."[†]

[*] Lane, *Colour of Paradise*, 26.
[†] Ibid., 43.

The Spanish could tell that the stones were of far better quality than any emeralds back in Europe or Asia and immediately attempted to locate the *source* of the stones in the New World. Over roughly the next decade, the Spanish found smaller veins of emeralds here and there, mines they couldn't work or that had been exhausted over the years. But they knew they were finally near the real source in 1543, when a hen was cut open and its stomach was found to be full of perfect tiny emeralds (lesser-known fact: Birds like chickens eat small rocks to help them digest things. Apparently, really posh chickens eat jewels).

So they went to war with the locals, a particularly fearsome group called the Muzo, who came equipped with poison blow darts and (alleged) cannibalistic appetites. But the Spanish had European plague on their side, and by 1560 they had all but crushed the Muzo and their neighbors, and set up a town, La Trinadad. The Spanish considered the emeralds, like the indigenous people, to be forfeit.

Deus Ex Machina

La Trinidad was surrounded by conquered Muzo villages, populated by once-fearsome warriors who had been relegated to forced slavery and subject to heavy taxation. However, at least according to Fray Pedro de Aguado, the two to three hundred Spanish conquerors in the region felt that *they* were the ones who were really suffering. They had found no emerald mines, their supplies were running uncomfortably low, a lot of their compatriots had actually died attempting to overpower the native inhabitants, and they just weren't as rich as they had thought they were going to be. Not to mention they were all getting the stink eye from those slaves who used to own the place. The Spanish referred to the winter of 1563 as "the great affliction."

Torture, inquisition, enslavement, exploration, and all-out warfare went on for decades before they found the first major mine. But then a miracle happened. (As they always do when the story's being related by a Catholic priest.) In—no surprise—the middle of Easter week in the year 1564, one of the Spanish settlers walking near the edge of town found a perfect emerald lying on the ground. Excitement spread like wildfire when the Spanish realized that they had founded their town on top of the very place they were looking for!

Alonso Ramirez, the commander of the nearest military encampment, arrived. According to Aguado, he "questioned the Indians of Itoco as to where the emerald mines were, but none wanted to reveal them. So it fell to a little boy named Juan, a native of that village, who had spent much time in Ramirez's power and had been made a Christian. This one, in return for the good treatment he had received from his master, promised to take him to where his parents and other Indians of that village used to get emeralds." Apparently "Ramirez was not at all slothful in this business, but rather, without losing any time, called upon people to join him, along with a magistrate to register the mines. His guide led them [and] . . . they were discovered by the hand of the same Indian boy."*

And so—at least according to Pedro de Aguado, who was, in fact, there—that was how the great emerald mine of Muzo was discovered. Or uncovered, depending on how you look at it. Ultimately, they were led to the greatest of Colombia's sacred emerald mines—by the hand of a young boy. Turns out all that was really necessary was a decade of nightmarish occupation and a little Stockholm syndrome.

The story has all the hallmarks of a classic Catholic miracle. It's Easter, and the Spanish are saved from ruin and merciless heathens by an innocent little boy, newly Christianized; joyful in his heart, he's happy to give up the mines that his people have been

* Lane, *Colour of Paradise*, 56–58.

dying, literally dying, to protect for decades. That may or may not be how things actually went down. But that's their story, and they're sticking to it.

Pennies from Heaven

The Spanish believed that God had delivered to them the unprecedented wealth of the New World because they were in the moral right, because they deserved it, and because he wanted them to *use* it. They were certain that, like a blank check, God's favor would cover the tab for any genocidal transgressions. And they wouldn't be set straight until the "Heretic Queen," Elizabeth I, and her pirate navy crippled Spain's economy and confidence by destroying the massive Spanish Armada in 1588.

Unfortunately, the Spanish monarchy believed that might made right, in a very literal sense. While we may judge this story, and its characters, we're not as far removed from the financial and moral logic of the sixteenth century as we might like to believe. Then, just like now, *rich* was often confused with *righteous*. In fact, our current economy and banking system had its origins in that confused crucible. Our entire modern financial system started in Spain, in 1551, in the port of Seville. And it came into being because of the problems created by that geyser of treasure coming out of South America.

Let's rewind and start small, literally: Why, in the Age of Exploration, were trade beads used for currency exchange in places like America? Because, as I mentioned earlier, they were worth very little to Europeans but were worth a great deal in places the Europeans were exploring, invading, and/or colonizing. Thus they could be used to the Europeans' advantage to exchange for things ubiquitous in these distant lands: say, land in North America, or people in West Africa, or sapphires in Sri

Lanka. A transaction of this kind—in which you take advantage of the difference between two or more markets, thereby making little or no initial financial investment but reaping a substantial profit on the exchange—is called "arbitrage." The term might sound familiar to you; it's commonly used in our modern banking system. We have Spain, and the rapid influx of treasure into the Old World, to thank for that.

The mining of emeralds* by the Spanish in the New World was the first time in history that such a deluge of wealth had flowed so quickly from one place to another. There was no preexisting way to count all that wealth. There was no way to *account* it.

Seville was Spain's only port for ships coming from the Americas, and it was clogged with treasure ships coming from the New World. The ship manifests—the official indexes of cargo—were often extremely inaccurate, due to error, theft, graft, or smuggling†—and generally a combination of all of them. The emerald count tended to be especially lean. Due to their high value and relatively small weight and size, they were an ideal black market treasure, easily hidden and transported—as Friar Pedraza could attest.

Beyond manifest dishonesty, there was no real-time communication between South America and Europe, so there was no precise way of anticipating the size or timing of individual shipments. The only certainty was that the ships were just going to keep coming—fleet after fleet, loaded with emeralds and gold and silver. Every year richer than the last. Paradoxically, the sheer volume of riches that *did* arrive created a problem. How to track it? How to value it? How to exchange it?

Then there was a simultaneous problem: Isabella and Fer-

* As well as gold and silver.

† Contemporary treasure hunter Mel Fisher and his team proved that when they found the sunken remains of the Spanish treasure ship *Atocha*. The ship's official manifest was far leaner than the cargo—even compared only with what Fisher's team could scoop from the sea floor.

dinand's grandson, Charles V. Like all really stupid, really rich kids, he didn't care where the money came from. He (and even more so, his son, Philip II) didn't like thinking about money. He just took for granted that it would never stop coming. So, in a spectacular fashion rivaled only a few times in history, he managed to spend the cash faster than the treasury could refill.

What did he spend it on, you ask? Parties and gambling, like in the infamously flamboyant and profligate court of Versailles? No. On jewels and palaces, like the luxury-crazed Romanov tzars? Not that either. On infrastructure and relentless colonial expansion, like the Victorian British? Nope! He spent it, like his grandparents, on more *holy war*.

I guess the heart wants what the heart wants.

Like all trust-fund babies, the unending supply of money made him overconfident. As a result, he waged some of the bloodiest, most expensive, and ultimately fruitless battles history had ever known, at least at that point (his bonehead son, Philip II, outdid him when he faced off with Elizabeth I). Charles V attacked both in the Netherlands and in the Mediterranean, fighting Protestants and Muslims, and finally both simultaneously. These conflicts culminated in a stalemate that cost unprecedented fortunes. He actually had to declare bankruptcy repeatedly on behalf of the Spanish Empire, over and over again, all the while, waiting for new shipments to come in from the New World and revitalize his cash flow.

Betting Futures in the Past

So what does this have to do with modern finance? Everything. The Spanish Empire took the Mandate of Heaven and ran with it—all the way to the bank . . . and the battlefield. As they had so many times before, they channeled a tremendous windfall of ill-

gotten cash into fighting a war against the infidels (like mother, like grandson). Charles the V, like Isabella before him and his son Philip II after him, believed the money would never end. A lot of rich people make that mistake. But in what was a more interesting and more dangerous delusion, he believed that God had granted Spain boundless riches because he *wanted* them to use that money to kill everyone who wasn't a Spanish Catholic. Except the money wasn't boundless, and as per usual, Spain ended up bankrupt over and over again.

But were they, really? Everyone knew they had only to wait a few weeks, and look to the horizon from Seville to find a fleet of treasure ships approaching, wobbling under the weight of precious metals and tons of raw emeralds.

It was not a problem of cash, at least not at first. It was a problem of cash *flow*. What Spain needed was a new way to leverage the money being extracted from South and Central America, a way to get the money before the ships arrived—because they had just become pioneers of the running budget deficit. They needed credit, on an international scale. And it was then, in the port of Seville, that the foundations of *our* modern economy were born.

The answer to Spain's problem came to them—or rather, was invented by them—in the form of the juro. The juro, was the world's first interest-paying government bond, and as journalists Rubén Martínez and Carl Byker put it, the "ancestor of the treasury bill; the engine of the American economy."[*] European bankers took the risk and bought the bonds, but only because they felt secure, reassured that the flimsy pieces of paper had the material backing of that endless supply of New World wealth.

Ever heard of the *suspension of disbelief?* In a sense, economics is really just a form of theater. From imaginary value to future value, economics requires the willful suspension of disbelief; in

[*] Rubén Martínez and Carl Byker, *When Worlds Collide: The Untold Story of the Americas After Columbus*, PBS, September 27, 2010.

other words, the act of choosing to ignore reality in a specific situation. For example, when watching a play, we all agree to believe, during the play, that the actors can't see us and don't know that we're there. If we didn't, the illusion would be broken, and the play couldn't continue. From burst tulip-market bubbles, to burst housing-market bubbles, someone, and then *everyone*, aggressively reintroduces reality, first in the form of doubt, and then in the form of panic (otherwise known as "shaken consumer confidence"). And it can destroy an economy in days; that's how you get bank runs and stock-market crashes.

The juro was simply a piece of paper with a formal seal on it, promising a return plus interest in exchange for an upfront loan of monies. Spain and its foreign investors were treating the ships as stocks; even more significantly, they were *betting on those stocks*. They were betting that the ships wouldn't be raided by pirates; they were betting that they wouldn't be sunk by bad weather; they were betting that the colonies—back when there were no cell phones or telegrams or Instagram accounts—hadn't been burned to the ground or destroyed by volcanoes or overrun by angry indigenous inhabitants before the ships had ever even left. They were betting that the boats were going to show up as usual, full of treasure.

They were betting futures.[*]

That paper bond was the launchpad of our entire modern economy. The juro, and the subsequent bonds it inspired, would completely change banking, lending, and investing forever. According to historian Sharon M. Hannon: "In this way, the sweat, blood, and industry of the peoples of the New World financed the rise of capitalism in Europe."[†]

[*] In a less literal sense, they'd been betting futures all along. By assuming the Mandate of Heaven and hemorrhaging money by waging constant holy war, they were essentially gambling on, and investing in, their own future salvation.

[†] Martínez and Byker, *When Worlds Collide.*

And it all started with a really big emerald and conflicting ideas about God.

Spain moved from a glowing green rock—valuable because it was pretty and scarce—to a piece of paper that essentially represented *future* value. Bonds and betting futures are imaginary value at its purest, and paper would eventually replace rocks and beads and bits of metal as everyone's favorite units of imaginary currency.

Now *that's* a willful suspension of disbelief.

The Dissolution of Mass Delusions

In the middle of the fifteen hundreds, the Spanish opened the great emerald mines of Chivor, Muzo, Somondoco, and a half dozen others. No one had ever seen anything like the South American emeralds, they were unparalleled in quality, color, and quantity—and have been unrivaled ever since. As the Inca wept (and mostly died of smallpox), the Spanish cracked off and carried away bits of their living god, *half a million carats at a time*.

Spanish fortune hunters—and therefore soldiers and servants and wives and merchants and prostitutes and every other kind of settler—poured into New Spain as fast as the emeralds poured out. According to Hannon, because of its unprecedented wealth the Spanish Empire was the world's only superpower throughout the sixteenth century. Spain set the agenda for the rest of Europe, and that agenda typically included numerous, wildly expensive, bloody conflicts. Courtesy of the Parrot's daughters, Spain enjoyed over a century as the biggest, richest, most powerful bully in the world.

But bottomless greed never ends well.

Imaginary value can be a beautiful thing—literally—like those glass beads that so transfixed the Delaware Indians. But

like all fantasy, its appeal lies in its representation of undefined possibility. The problem with undefined possibility is this: Mass delusions have a delicate equilibrium. They can turn on a dime— and, within a century, the delusion that was the very special value of emeralds did just that. Eventually, the market was so saturated that, *for the first time in recorded human history* and just as their quality and availability were at an all-time peak, the value of emeralds crashed.

Within less than a century of their discovery, a large emerald that had at one time accounted for one-twelfth of the value of the Spanish crown jewels was suddenly worth less than its own golden mounting.

In *Jewels: A Secret History,* Victoria Finlay cites the 1652 first-hand account by English lapidary Thomas Nichols of the rapid depreciation of emeralds as they became abundant. Nichols's account concerns a Spaniard who showed a jeweler an emerald "of an excellent luster and forme." According to Finlay, "The jeweler valued it at 100 duckets. Then the Spaniard showed him an even larger, finer one, which he valued at 300 ducats. 'The Spaniard drunke with this discourse, carried him to his lodging, shewing him a casket full. The Italian seeing so great a number of emeralds, sayde unto him, "Sir, these are well woorth a crowne [about one-eighth of a ducket] a peece." ' "*

Now that's rapid currency deflation.

That's the flip side of the scarcity effect. It's called market saturation. And it's where the vernacular term *cheap* comes from. The overabundance of any item, be it emeralds, oil, or corn, will lower market prices. Anything that's excessive in its availability becomes cheap in its valuation. When that *thing* is a form of currency, the result is crippling inflation.

By consistently overspending their legitimate national resources in an insane attempt to crush Protestant uprisings, push

* Finlay, *Jewels,* 225.

back Ottoman incursions, and convert or kill Jews, the Crown suffocated Spain with monstrous debt. The economic crisis was intensified by the inflation caused by the massive influx of New World treasure.*

The Spanish Empire collapsed as quickly as it had expanded. Its rapid decline in the late sixteenth and early seventeenth centuries was mostly the result of chronic deficit spending (among other bad economic policies) by Charles V and Philip II. They assumed the money would never stop coming, and they were right . . . they just didn't count on the money becoming worthless. Eventually, most of the mines were shut down, though not even remotely tapped out. Some were actually lost for over a century, possibly just because no one was looking for them.

For Spain, very little good came of its global domination. Even in its heyday, the country's material riches didn't do much to increase the average Spaniard's standard of living. In fact, the average standard of living remained one of the lowest in Europe, both during and after the peak of the empire. Its moment at the top was brief, and it left them with a lot of enemies. By the end of the sixteenth century, Spain was back at the bottom of the economic heap.

This is the story of elements far more dangerous than the bloodthirsty conquistadors who slashed and burned their way across the jungles of South America; or of painted, feathered savages wielding poisoned darts. Elements far more powerful than autocratic Inquisition-era monarchs and more valuable than even a single perfect emerald the size of a football.

This is a story about religion and money, and the complex relationship between the two.

From celestial versus terrestrial currency, to value versus worth, this is a story of multiple, conflicting faiths and ideologies. It's a story of the shifting relationship between the righteous

* Martínez and Byker, *When Worlds Collide.*

and the rich, and about how religion can inform and shape whole economies—which, in turn, can become the basis for an entirely new religion.

After all, what currency is more imaginary than divine favor?

The Dose Makes the Poison

Philippus Aureolus Theoprastus Bombastus von Hoenhiem was a sixteenth-century occultist, astrologer, and multidisciplinary scientist. He did his best work in the 1530s, at the same time as the events of our story. He was also a man who obviously had better reason than most to change his name. And he did, to Paracelsus.

Paracelsus is most famous, among nonscientists, as the father of alchemy: the "science" of turning lead into gold. More important, he was the primary pioneer of the modern field of toxicology, the science of poisons. (Not to be confused with *taxidermy*, the science of creatively embalming roadkill.)

He was a botanist, a chemist, and a physician. He gave the element zinc its name.* He's even credited with inventing the terms *gas* and *chemistry*. He was clearly a man ahead of his time, being the first to claim that mental illnesses were, in fact, real illnesses of the body, as we now know them to be. In spite of his fondness for astrology and alchemy, he detested intellectual sloppiness. He caused quite a stir when he claimed that Miner's Disease came from toxic fumes inside mines and not from the magic of vengeful mountain spirits, as was generally accepted in the scientific community in 1530.

One of Paracelsus's most famous quotes—presumably referring to toxicology—could just as easily have been a statement

* Jospeh F. Borzelleca, "Paracelsus: Herald of Modern Toxicology," *Toxicological Sciences* 53, no. 1 (2000): 2–4.

about money. He said, essentially, *"The dose makes the poison."** He was referring to the fact that tiny amounts of a substance, like lead or arsenic, may cause no harm at all, whereas excessive amounts of a substance, even oxygen or water, can cause brain damage and, in large enough amounts, will kill you.

It would seem to me that Paracelsus was also an economist. Poisoning, whether in a human body or the body politic, is a delicate art. It requires careful titration to reach that magic tipping point where medicine becomes poison and ministrations become madness.

Another great philosopher, Groucho Marx, admitted that he "didn't care to belong to any club that would have [him] as a member." Apparently, when it comes to jewels, we all feel that way. While a substance is at its most valuable when it's genuinely (or artificially) scarce, it's at its most worthless when it finally becomes obtainable. For humans, scarcity creates value. Value creates wealth. And both scarcity and wealth can be a good thing or a bad thing: a poison or a medicine. Too much money is as dangerous as too little, and can build or destroy economies.

The Spanish reached that crucial tipping point when they oversaturated the market with emeralds to the point of worthlessness and flooded their economy with an avalanche of such monumental wealth that *the wealth itself became worthless*. Like the tulip bubble crash of 1637, the illusion induced by the scarcity effect was broken. The value of emeralds evaporated as people realized they were trading pretty, but ubiquitous, rocks.

They blurred the line between medicine and poison, allowing ambition to become greed, faith to become fundamentalism, and riches to become righteousness. At what point does drive become

* Actually he said, *"Alle Ding sind Gift und nichts ohn' Gift; allein die Dosis macht, das ein Ding kein Gift ist."* Approximately translated: "All things are poisons and nothing is without poison in it; only the dose makes that a thing is no poison."

insatiability and does greed become justification? Even now, we see it happen around us every day.

This isn't just a story about Spain or emeralds. It's not just about blood or conquest. It's about that green light that says "go"—and what happens when you blindly hit the gas. Perhaps there's no point in blaming market speculators or religious fanatics—or anyone else who sees that green light and drives right over a cliff.

PART II

TAKE

OBSESSIONS, POSSESSIONS, AND THE MECHANICS OF WAR

The earliest known jewelry, to date, is a series of thirteen tiny shells, drilled with matching holes and painted with red ochre. Though the string that undoubtedly held them disintegrated millennia ago, the beautiful little shell beads were found, intact, in the Grotte des Pigeons, or Taforalt Cave, in eastern Morocco. They're eighty-two thousand years old. A sister strand of similar age was found in the Blombos Cave at the very tip of South Africa. According to team leader Christopher Henshilwood of the University of Bergen in Norway, the find represents one of the first tangible examples of abstract thought in our distant ancestors. "The beads carry a symbolic message," he says. "Symbolism is the basis for all that comes afterwards including cave art, personal ornaments, and other sophisticated behaviors."[]*

Similar shells found in Israel are currently awaiting con-

* http://news.bbc.co.uk/2/hi/science/nature/3629559.stm.

clusive dating, but appear to be between 100,000 and 135,000 years old. So adornment hasn't just been an instinctive human behavior from day one, and jewelry hasn't just been a universal human desire since we stood up on two feet; it would appear *that* the invention of jewelry may have marked the beginning of modern human thought and behavior.

Adornment is, in itself, a form of worship. Human beings are so enamored of jewels that different cultures have used any gems available to them to create religious objects—as offering, as display, even as idol—since before the beginning of recorded history. It's the single trait that every human religion has shared throughout time, and the common factor that binds us all together.

In Part I, "Want," we've looked at the ways desire shapes our sense of value and how our sense of value very literally shapes our sense of fiscal worth. We've asked the question "What's a jewel worth?" In this section we'll go deeper and ask, "What does a jewel mean?" What might a piece of jewelry represent to an individual, to a group, and even in the greater theater of history?

In literature, in Hollywood, and in popular lore, jewels are imbued with all kinds of moral characteristics. They can be cursed, or possessed, or have evil inclinations all their own. They can, on the flip side, be powerful weapons of healing and good. Whole cults have arisen around the power of jewels and stones to heal, presage, and influence human life. In Part II, we'll look not just at the ways that a jewel might gain monetary or intrinsic value but the ways in which it might become symbolic of moral and emotional worth and how this moral and emotional dimension, paradoxically, then reinforces a stone's value.

The three stories that follow are about many things, but above all they are about this moral dimension of jewelry: its

social and even ethical meaning. They are, as a result, also stories about the darker side of desire: the common human experience of envy and its often destructive consequences. What is envy, after all, but the desire for something that isn't our own, something we've determined we deserve just as much as someone else?

What power does beauty really hold over us? What happens when we can't have what we desire? Or worse, when the thing we covet is within our sight but out of our reach? When does devotion become obsession? What turns desire into malice? What happens when the want becomes a compulsion to take? When do we strive, when do we seize, and when do we simply level the playing field by seeing that no one can have what everyone wants?

"Take" explores not only perception but obsession, and how it shapes our actions. First—in one of history's most explosive examples of desire turned deadly—insinuations, lies, whispers, and one enormous diamond necklace lay the foundation for the fall of a queen—and with her, all of France. Next, a single perfect pearl redraws the map of the world when it turns sisters—and eventually nations—against each other. Finally, in an icy time and place, which has itself become iconic for over concentrated wealth being redistributed from the top down (by extreme force), an international shell game is played with the most spectacular eggs ever created.

While "Want" was about how economies, nations, and empires are made—and what role jewelry has played in shaping and reshaping them—"Take" is about how they're unmade, and how jewelry has played a central role in some of the most spectacular (and bloody) conflicts in human history.

"Take" is about what we want, why we want, and how far we'll go to get it.

THE IMPORTANCE OF BEING FAMOUS

The Necklace That Started the French Revolution

Gossip is when you hear something you like about someone you
don't.
—EARL WILSON

I have ever believed that had there been no queen, there would have
been no revolution.
—THOMAS JEFFERSON

Marie Antoinette remains, to this day, the ultimate symbol of
Versailles at its peak. She's remembered as a vain and greedy
woman whose love of luxury and frivolity was matched only by
her indifference to human suffering. Never mind that most of it
wasn't true, the French people's hatred for their equally spellbind-
ing and despised queen made her the banner around which the
revolution rallied.

What caused the French revolution? Lots of things. As the
weather got worse, the French government grew more inept, and
the people suffered and starved as they watched the increasingly
surreal behavior of the aristocracy, who powdered their wigs
with the very flour they were so desperate to eat. As the rich got
crazier and the poor died in droves, conditions began to brew for
revolt.

But just as explosions require catalysts, revolutions require a

spark to ignite. In the case of the French Revolution, that spark came in the form of L'Affaire du Collier—or the Affair of the Necklace. L'Affaire du Collier was a scandal surrounding the elaborate theft of the world's largest diamond necklace. Marie Antoinette was charged with having embezzled state (and possibly Church) funds, with having subverted the king, and with having both seduced and plotted against a cardinal—all in order to acquire the priceless necklace. In reality, she had done none of these things. Marie Antoinette knew of the necklace but had repeatedly refused to buy it or have it bought for her over the years leading up to the scandal, stating that she "found [the] royal jewel cases rich enough."*

In the end, the real conspirators of the theft were unmasked, and the queen was found blameless. But by that point, the damage, both to her reputation and to the monarchy, was done. Marie Antoinette became symbolic of all Versailles, and the diamonds were symbolic of all her many wicked excesses. The queen (and the necklace) became the icon into which all the suffering and moral outrage of France was channeled. Madam Deficit, as she came to be called, was found guilty in the court of public opinion: a place where rumor has a way of becoming fact, even when the consequences are historic.

Just as gossip can become fact, and jewelry can become iconic, people can be dehumanized and turned into symbols. It's these very sorts of symbols around which our ideas of worth and "deserving" are built. The story of the Affair of the Necklace is a story about heads of state behaving badly—behaving, in fact, like teenagers. It's about rumors and note passing, poseurs and cliques. It's about the nobility's obsession with appearances, and the common people's obsession with them. But more important, it's about the power of symbols and status symbols.

* Antonia Fraser, *Marie Antoinette: The Journey* (London: Phoenix, 2001).

THE IMPORTANCE OF BEING FAMOUS

Pawn to Queen

Marie Antoinette, the ultimate embodiment of prerevolution-ary French decadence and debauchery, was, ironically, not even French. She was born November 2, 1755, in the powerful but aus-tere Habsburg court in Vienna. Being Austrian was a distinction that would earn her suspicion, dislike, and a nasty nickname in the not entirely friendly French court of Versailles.

Austria's empire was, at the time, sprawling, and ruled clev-erly and ruthlessly by its iron-fisted empress, Maria Teresa, Marie Antoinette's mother and one of the most powerful and intrac-table rulers of her era. She had sixteen children, and famously claimed once that she would've ridden into battle as a soldier herself if she weren't perpetually pregnant. She never hesitated to refer to those children—who, like her subjects, feared her at least as much as they loved her—as "pawns" on the chess-board of Europe. Though beloved by his wife and children, her husband, Holy Roman Emperor Francis I, was largely decora-tive. It was the empress, Maria Teresa, who sat on the Habsburg throne and controlled the Austro-Hungarian Empire, and no one doubted it.

Marie Antoinette's mother wasn't all bad. She was an "enlightened absolutist," which meant that, like Catherine the Great of Russia, she established some very liberal reforms, including universal education for her subjects and the abolition of the medieval tradition of serfdom. To be clear, this was not because she was a woman of the people. She was (unlike her unfortunate daughter) simply a savvy ruler. She could tell which way the wind was blowing. But she never faltered in her belief that monarchy was as absolute as it was necessary—a belief Marie Antoinette inherited.

Marie Antoinette was Maria Teresa's prettiest but, in all other

ways, least impressive daughter. She would not prove to have her mother's gift for ruling, let alone governing. And along with her foresight, she lacked her mother's plain but intimidating gravitas. The almost-forgotten fifteenth child was not highly educated either, as she was thought to excel at nothing but music and dance—and even that was debatable. Of pretty Marie Antoinette, it was said: "She does not dance in time, but if so, it is certainly the time which is at fault."*

She was lighthearted and charming, but no one took her seriously. She was particularly discounted by her mother, whose approval she desperately sought throughout her life. With so many older and supposedly brighter siblings, Antoine, as she was called, was generally ignored—until one of her older sisters died suddenly of smallpox, leaving a gap on her mother's chessboard.

Traditionally, France and Austria had been enemies. In the mid-seventeen hundreds, they bonded over their much greater dislike of several other countries during the conflict that would come to be known as the Seven Years' War. But with the war—and the temporary alliance—winding down, Austria needed a more permanent way to cement its newly cordial relationship with France. Like a wedding. Maria Teresa wasn't going to discount or otherwise endanger a beneficial marriage, even if the bride was only a semiliterate child. Regardless of her daughters' own inclinations, or even limitations, princesses were "born to obey."† So the very young, charming, and inexperienced princess was sent to the last place on earth (or at least in Europe) that she might feel at home.

Versailles.

* Casimir Stryienski, *The Eighteenth Century: Crowned*, reprint (London: Forgotten Books, 2013).
† Fraser, *Marie Antoinette*.

The Real Housewives of Versailles

In April of 1770, fourteen-year-old Antoinette was packed up and shipped off to France, to marry an equally hesitant and underage Louis XVI, dorky grandson of the current, lecherous old king, Louis XV, and heir to the throne. Her mother had given her strict instructions to please the king, his grandson, and the French court in general, *at all costs*.

At the border of the two countries there was a small ceremony. The French envoy that greeted Marie Antoinette immediately and summarily stripped her of all her possessions, from her clothing, pets, and companions to her sentimental keepsakes. Everything was replaced with French substitutes—thereby symbolically making her French, not Austrian.[*]

Unfortunately, this theatrical little switcheroo didn't actually work.

It's incredibly ironic that Marie Antoinette has become the symbol of frivolity, excess, and cartoonish femininity. When she left Vienna, she would really best be described as a tomboy. In fact, Maria Teresa, who wrote to her daughter at Versailles frequently and warned her to spiff up her appearance for the French, had a favorite portrait of Antoinette in which she had posed just before leaving on a hunt wearing her best hunting clothes. Modest garments and tomboyish behavior were tolerated in Vienna, where, according to Maria Teresa, "simplicity of attire is more suitable to exalted rank."[†] In Vienna, the appearance of power and respectability were more important than glamour.

Versailles was just the opposite. People wore their worth on their sleeves—literally. You could gauge how important a person

[*] Fraser, *Marie Antoinette*.
[†] David Grubin, *Marie Antoinette and the French Revolution*, PBS, September 13, 2006.

was by the height of his or her hair—and, of course, the size of his or her jewels. It wasn't a new tune. Jewels have always been used to display wealth, and wealth has often been used (just as it was by Cleopatra) as a show of force and authority. Sumptuary laws throughout history—whether to mandate who can wear purple cloth, or what class one must belong to in order to have a jeweled betrothal ring—were designed predominantly to visually demarcate the economic classes.

But as they did with everything else, the folks at Versailles brought the crazy. To a certain extent, they turned those sumptuary traditions inside out: Rather than affluence determining allowed assets, assets and their flamboyant display influenced social position.

The entire court was entrenched in a culture of conspicuous consumption, gossip, and "vicious intrigues." Where actual intrigues didn't exist, they were invented. Remember, the monarchy and the nobility comprised mostly *incredibly* bored people. What else did they have to occupy their time? It's not like they were working—let alone governing.

In a sense, reality television was invented at Versailles—without the television, of course. It was more like reality live theater. Marie Antoinette was expected to be dressed in front of dozens of strangers and acquaintances every morning. A few lucky individuals got to select her clothing for her. She was expected to eat her meals beside Louis and any companions, facing a gallery of spectators, who were allowed to watch and listen. She lamented, in letters home, not having a moment alone, not even to apply her rouge—a task that was also done for her throughout the day by someone else.

The still very Austrian princess thought the strange, exhibitionistic social protocols of Versailles ridiculous, and in fact openly said so. She may have complained to the wrong people, though, because her reaction won her no friends at court and lost her what little support or goodwill she had previously had. Her

one Austrian "friend," Count Mercy, an adviser from Vienna, was in reality spying for her mother and reporting back every detail of her daughter's various missteps.

Her mother demanded in numerous letters that Marie Antoinette dress better, fit in better, be more like the French around her. She reminded her daughter to observe French customs, however stupid, and make nice with the more senior royal women who determined protocol. Most important, Marie Antoinette was to stop openly sneering at the king's slutty, tacky mistress: Madame du Berry.

That, in fact, had been one of her biggest early transgressions. While no one but the smitten Louis XV could stand du Berry, a "former actress," she and the king were joined at the hip (pocket—where he probably kept his wallet). Everyone else at court knew well enough to be polite to the king's mistress and favorite. But Marie Antoinette found du Berry particularly grotesque and was easily manipulated by the king's mean-girl sisters into making a great show of her distaste. When Maria Teresa was informed of her daughter's strategic misstep, she demanded a reconciliation. Marie Antoinette was reminded that her most important task was to "please"—if only to better relay information home and to advance Austrian interests abroad, primarily through pillow talk.

Marie Antoinette was miserable. She was homesick and generally disliked. She was initially referred to as L'Autrichienne, "the Austrian woman," and then later l'Autruchienne—roughly translated, "the ostrich-bitch." It was a snotty pun in French, mocking both her foreign ties and her over-the-top effort to please people, particularly after she began desperately trying to adjust her fashion choices in order to appear French.

And then there was her husband.

Louis XVI was, by every account, a really sweet guy— and not much else. He was described thusly by a contemporary courter: "There is nothing haughty or regal in his bearing. He

gives the appearance of a peasant, waddling along behind his plow."* He had no interest in nor aptitude for ruling a country. His social skills were limited, to say the least, and strangest of all (for his notoriously libidinous family anyway) he seemed to have no interest in girls—least of all the exceptionally pretty and charming girl he'd just married. His main focus, other than the obligatory hunting parties, was his obsession with locks and key making. Seriously.

Louis confided to his grandfather that he was in love with his new wife, but just needed "more time to overcome his timidity."† In the beginning, his grandfather (who was himself a notorious horn-dog) insisted that everyone leave Louis alone about it when the marriage went shockingly unconsummated. But the marriage remained virginal for over *seven years,* well after Louis XV's death and Louis XVI's coronation. Whatever the actual source of the seven years' dry spell might have been remains a mystery. But according to renowned biographer Antonia Fraser, Louis XVI did indeed have "extraordinary sexual problems," and they were the subject of vicious gossip, both in Versailles and in Paris: Was he gay? Was *she?* Was he impotent? Was it her fault? Everyone knows Austrians are frigid. . . . The speculation, the rumors, the gossip—all of it was very similar to the level of intrusive scrutiny that celebrities endure in our century.

When Louis XV died suddenly in 1774, four years after Marie Antoinette's arrival, the still-virginal teen queen was crowned, along with her socially awkward husband. He quite ominously was quoted as saying, "Protect us, Lord, for we are too young to reign."‡

No shit.

* Grubin, *Marie Antoinette and the French Revolution.*
† Jane Merrill and Chris Filstrup, *The Wedding Night: A Popular History* (Praeger Publishers, 2011).
‡ Fraser, *Marie Antoinette.*

Things immediately started going downhill. Only a few months later, the first of the famous bread riots would take place in Paris, as starving peasants assembled to demand help after yet another disastrous harvest. Stuck in a passive-aggressively hostile foreign court, trapped in a humiliating public spectacle and a failed, sexless marriage—all with her mom breathing down her neck via the post—what's a lonely fifteen-year-old girl to do?

Party Like a Rock Star

Marie Antoinette had no real political power. In fact, she had no real role at all but to be appealing. Yet regardless of what she did, she was deeply disliked, declared barren, and presumed frigid— and at the same time consistently accused of possible adultery. She was suspected almost universally of being a spy for the Austrians—which was actually sort of true, although she proved to be an utterly incompetent one. She was no Mata Hari, and with a husband who wouldn't put out, she exerted very little so-called petticoat influence. So the Austrians weren't too thrilled with her either. She was generally deemed a failure—a fact of which her mother never failed to remind her.

So Marie Antoinette did what any unhappy, unsupervised fifteen- or sixteen-year-old girl with an unlimited credit line would do: With what historian Simon Schama has referred to as her "sort of high school, Valley girlfriends," she ignored the haters, and went to a party. And another and another and another. In fact, for five or six years she didn't really come home from the party. As an unloved, humiliated teenager, she rebelled. According to Schama, "she [didn't] want to listen to . . . her aunts, who define[d] royal protocol at Versailles."* Backed up by her new

* Grubin, *Marie Antoinette and the French Revolution*.

BFFs, the Princesse de Lamballe and the Comtesse de Polig-
nac, she pretty much laughed off any reprimands or disapproval
from superiors at court and did exactly as she pleased. Biogra-
pher Antonia Fraser claims that she was "compensating," whereas
Schama chalks her behavior up to immaturity. Either way, she
took solace in a whirlwind of parties and spending, determined
to outdo the court of Versailles at their own appalling game. And
she never questioned who was footing the bill, or how.

Many of the stories about Marie Antoinette—her fiscal irre-
sponsibility, her unbridled enthusiasm for revelry, and her ready
adoption and interpretation of French fashion—are true. But
these attitudes constitute just a small portion of her (admittedly
short) life, from about age sixteen until about age twenty-two.

She grew up to be a devoted mother with a warm and ami-
cable (though not particularly passionate) relationship with her
husband. As an adult, she would spend what time she wasn't with
her family doing heartfelt charity work and continuing to sup-
port the arts. For most of her life, in fact, though politically and
economically *oblivious,* and certainly no Maria Teresa, she was
a good mother, a nice person, and a useless but mostly harmless
queen.

But when she was *bad*, she was horrid. And her teenage rebel-
lion was a costly one; ultimately, it would cost her the crown. And
the head she wore it on. She threw parties that went on for days
and have been remembered for centuries. She elaborated on the
one-foot-tall French pompadour, the hairstyle *du jour,* and made
it three feet, adding ostrich feathers and jewels and, on one occa-
sion, a scale model of a warship. And even while all the courtiers
at Versailles rolled their eyes, they desperately imitated her.

The empress, who had once been so keen to see her daugh-
ter blend in and please the French, started insisting that she not
appear so frivolous and oblivious to the economic concerns of the
French people. In letter after letter she warned her daughter that
"making people like us is a talent that you have mastered so per-

fectly. Do not lose it. . . ."* And she warned Antoinette that while silly behavior—cavorting with friends, ignoring the courtiers at Versailles, spending what money she hadn't gambled away or shopped with to support every artist that wandered her way— might be forgiven in a young girl, she would certainly pay for it eventually. Ominous . . .

Then again, Maria Teresa had all the acumen and political sense her daughter lacked. She wrote that Marie Antoinette was "headed for ruin."† And she was still pretty steamed that her tedious, high-maintenance daughter, who had no discernible talents other than beauty and charm, couldn't lure her teenage husband to bed. How hard could it be? (or not be . . .) After all, it was the *only* thing she had been sent there to accomplish.

Then, over seven years into their marriage, her husband finally got it up, and Marie Antoinette gave birth to a baby girl (whom she named Maria Teresa, after her own mother). Very suddenly, Marie Antoinette stopped acting like a spoiled, indifferent, money-burning, party girl.

She had a new obsession: the simple life.

Let Them Eat Cake

Let's pause for a second and look at the not-so-simple culture of Versailles. Symbols and icons are just abstractions without a context. Marie Antoinette became a symbol—and L'Affaire du Collier became a symbol of that symbol—of her reign and its decadence. To really decipher that symbol we need to understand the broader context for French rage at the time.

As I've previously said, Versailles was not Vienna. Marie

* Grubin, *Marie Antoinette and the French Revolution.*
† Ibid.

Antoinette had had a relatively normal childhood, or as normal as could be expected when your mother was the empress. The Austrian royal family and the court itself were relatively low-key. For a princess, Marie Antoinette was raised in a reasonably subdued and somewhat casual atmosphere. Court politics were largely political, and the private life of the royal family was largely *private*. Formal protocol, disdained by pragmatic Maria Teresa, was observed only on rare occasions. The palace had two wings, much like the White House: one in which official business was conducted and one in which the royal family lived. The Hofburg Palace, where Marie Antoinette was born, is the current residence of the Austrian president.

Versailles, on the other hand, with its mirrored halls,* cut crystals, and gold-leafed *everything*, was the eighteenth-century equivalent of Graceland—only far more decadent and far more ostentatious: the product not just of a single man's whims (and follies) but that of an entire *national* folly.† Above all else, French culture at the time valued the *appearance* of wealth and power. In the end, it would be an even bigger problem that they were equating appearance with the real thing.

The Austrian court may have been less posh than the French court, but what the Habsburgs lacked in glamour, they more than made up for in authority and influence. If Vienna was DC, then Versailles was Hollywood—in all its Tinseltown glory.

Of course, Austria was an eighteenth-century monarchy, and monarchies are by nature tiered and unfair. But unlike France, Austria had a working class *and* a functional government. By

* In the seventeenth century a mirror required perfect glass and precious foil backing. A large mirror was a luxury item for the wealthy, not wallpaper. Unless you lived at Versailles.

† It may be worth mentioning that, while the Austrian president resides in the Hofburg Palace, the most recent public figure to try to use Versailles for anything other than a tourist attraction was Kim Kardashian.

contrast, social and economic inequality was an integral part of French society. And this hierarchical structure wasn't invented by Marie Antoinette or her French in-laws. Not even close. For centuries, France had operated with a system called the Three Estates; the First Estate was the clergy, the Second Estate was the nobility, and the Third Estate was—you guessed it—*every other single person in France.*

According to historian Simon Schama, "the real problem for France is, actually, it's saddled with an incredibly antiquated set of governing institutions."* Representation for the three groups was thoroughly unequal—not that representation mattered. The Three Estates and their uneven representation hadn't been "summoned" to deliberate anything in centuries. Decisions were made by the privileged elite, and no one else was allowed to argue. A huge amount of wealth and authority was concentrated in the hands of the very few. This was an accepted and, in fact, deeply entrenched way of life in France. What scraps were left for the third estate? Well . . . scraps. Unlike in Austria, France didn't have a working class. France had a *starving* class. And yet somehow, the Third Estate managed to eke out an existence for hundreds of years.

But then things changed. That is to say, they got worse. Beginning with "the Sun King," Louis XIV, and ending with the unfortunate Louis XVI and Marie Antoinette, the dysfunctional culture of aristocratic France had spun completely out of control. Everything was sugared and gilded. Jewels dripped from the aristocrats' three-foot-high hair. There's even a famous story[†] that Marie Antoinette, having spent an unreasonable fortune (even by Versailles standards) on a pair of jeweled satin shoes for a party, was outraged when the next day the shoes were in pieces.

* Grubin, *Marie Antoinette and the French Revolution.*
† And perhaps apocryphal, though probably not.

When she called the frightened shoemaker to her and demanded to know why a pair of shoes that cost more than a home would fall apart after she wore them, he looked at her and stammered, "Well, madam, you *walked* in them." Confections were nibbled and thrown away, as was most of every night's lavish banquet. Small peasant children were kept in elevated chambers fitted with tiny holes in the floor. Those starving children were tasked with trampling fine white flour down through the holes so that it would powder the wigs of the beautiful people as they walk from one room to another.

The last king and queen had seen a series of long bad winters and short damp summers. Very little was harvested, and what did come up was moldy and often had to be thrown away. Livestock froze. People starved. The plague ravaged peasant villages. The Third Estate might as well have been the Third World.

And all the while, a new industry was burgeoning: an industry we would come to know as the tabloid media. Brand-new companies operating out of London and Holland circulated crude political cartoons that exposed secrets and exploited (and often manufactured) scandals. A hated Austrian queen; an incompetent if not handicapped king; the huge amount of money pouring out of France and into America to support—pause for the irony—the American Revolutionary War against France's favorite despised nation, England. All of it combined into some truly shocking, titillating, and incendiary reading material.

For most of France's history, the Three Estates and their rigorous hierarchy had been the accepted order. But in the 1780s, after the last three generations of monarchs had taken the French culture of economic inequality, dramatic spectacle, and conspicuous consumption to increasingly deranged and dysfunctional heights—and that warped culture was exposed and exaggerated by the new media—brewing dissatisfaction would, at last, explode into open dissent.

The Simple Life

Marie Antoinette would, throughout her life, continue to be an ardent consumer and supporter of the arts. She would continue to have very little involvement in the government outside of the many different charities that she created and supported. But after the birth of her first child, gone were the days of the former Marie Antoinette, the glamorous, drunken reveler who threw parties that featured fireworks, exotic animals, and champagne fountains.

Louis gave Marie her own small palace: Le Petit Trianon. Trianon, which had been built by his grandfather for one of his mistresses, would ultimately be one of Marie Antoinette's primary residence. She had Trianon (expensively) transformed into an idyllic version of a rural village. She spent most of her time there with her children, her girlfriends, and favored guests. They picked flowers, enjoyed picnics, played with the sheep, and indulged in the ultrachic, Rousseau-inspired "simpler life."

She still threw parties, but much smaller ones, for her nearest and dearest. (Interestingly—or maybe not interestingly—her husband was only occasionally invited.) One could argue that her artificially created simple life was equally as expensive and self-indulgent as her lifestyle at Versailles, but it's worth pointing out that Marie Antoinette at Trianon was a very different queen from the one that most people imagine.

Marie Antoinette's seclusion at Trianon pissed off the courtiers at Versailles even more than her half-a-decade-long, over-the-top efforts to impress them had—mostly because *they weren't invited to the party*. After all, everybody wants to be on the A-list, even if they can't stand the person at the top. One thing that never changed about Marie Antoinette was her disregard for protocol. That was evident just in her refusal to spend more time at court or to invite

"important" courtiers to her village at Trianon—just as she had refused to participate in, and thereby unofficially abolished, many of the traditions at Versailles that she had found so appalling when she first arrived, such as eating in public or dressing by consensus, in front of an audience, or having private conversations with her husband in front of anyone who wished to watch.

Always the fashion pioneer, she also decided she was done with the very finery for which she would be forever known. She decided to start wearing large brimmed hats and comfortable, loose muslin dresses with silk ribbons tied around the waist. Her jewelry became (relatively) minimal. And just as before, the eye rolling and complaints were universal, but that didn't stop anyone from imitating her—just as people always do with the celebrities they love to hate.

Keeping Up with the Bourbons

Why do we do that? Where does the urge to copy—and compete—come from?

Envy is, in a manner of speaking, the evil twin of positional good.* We've already established that positional good is how you may have ended up with a diamond engagement ring on your finger—but what about your car, your clothes, the house you live in, the places you shop? What if your very financial and social existence become subject to positional good?

In his 2011 book, *The Darwin Economy,* economist Robert

* Positional good, you'll recall, is the economic theory that what one possesses has no absolute value; its worth is measured only and directly in comparison with the similar possessions of one's peers. In other words, your one-carat diamond looks pretty good until you see your friend's two-carat stone. At that point the worth of yours plummets. Positional good also has the funny side effect of making us feel we *need* what our peers and betters own.

H. Frank of Cornell University deals with just that question. His conclusion involves a model he calls "expenditure cascades." Because "we don't simply try to keep up with the Joneses, we try to surpass them,"* an expenditure cascade is like an arms race. Every action (or purchase) must be met with a greater and greater counteraction, like ping-pong balls being hit back and forth with increasing force. We're all just jockeying for position in the unending race to keep up. After all, it's survival of the *fittest*, not survival of the decently fit. We are literally hardwired to compete. A woman has a diamond necklace. Her rival needs a bigger diamond necklace. In response, the first woman adds earrings. The second woman needs bigger earrings. Eventually, a third person, who can't afford diamonds at all, feels compelled to buy *some kind* of jewelry just to be in the race. The behavior—or obsession—spreads like wildfire until everyone is running off the same financial cliff. Remember the tulips?

Dan Ariely and Aline Grüneisen remarked on the expenditure cascade model: "This chain of events can culminate in all classes spending more than they [can] afford, leading to higher likelihood of bankruptcy from increased debt."† The U.S. financial crisis of 2008 was multifacatorial, but a combination of consumer expenditure cascades and a similar (if inverted) obsession among the institutions financing them was at the very heart of the system failure. Expenditure cascades were also the driving social and economic model at Versailles, and to some degree in Paris.‡ And they were pushing the country to bankruptcy.

The furious and frantic desire to get closer to the top of the aristocratic pyramid didn't stop when Marie Antoinette dropped out of the never-ending party at court. In a way, her social abdi-

* Dan Ariely and Aline Grüneisen, "The Price of Greed," *Scientific American Mind*, November/December 2013, 38–42.

† Ibid.

‡ Just not so much with the people who couldn't even afford food.

cation from Versailles just made that frenetic desire worse. Before Trianon, the rules of conduct were, if not simple, at least well understood. But then the queen changed the game. Previously, everyone knew what to do to remain fashionable, powerful, and respected (the three adjectives were, at the time, synonymous). Spend. Look rich. Look idle. Show up at parties dripping with jewels. But then the woman at the tip of the social pyramid suddenly hopped off and walked away.

She took off her gowns and her wigs and her jewels. She wore a straw hat and a muslin dress and declared shabby to be chic. Was she just being on trend (Rousseau was all the rage) or did she really long for the more casual circumstances of her childhood? Who knows. Maybe she wasn't finished acting out yet. Maybe she just honestly hated court. Maybe she just really loved sheep.

What matters is that the members of the aristocracy, many of whom had never much liked Marie Antoinette in the first place, were growing increasingly confused, frustrated, and angry about how exactly they were supposed to keep up with the Bourbons—even as the peasants were growing increasingly confused, angry, and frustrated about the absurdity of the competition itself.

Dirty French Laundry

Lady Antonia Fraser, Marie Antoinette's most renowned biographer, made the very salient point: "Why kill a queen consort?" Fraser insists that no one outside of France, even during the Reign of Terror, really expected the French people to kill the queen. Exile her, certainly, be done with her, but kill her? And rally the entire revolution around her death?

Why?

She was in charge of absolutely *nothing*. She made no real

political decisions in her nearly twenty years in France. Her job was to produce heirs. And eventually, when her weird husband finally got it up, she did just that. There's no point in blaming her teenage years of partying and spending for the French economic crisis. *That* storm had been brewing for half a century. But as taxes continued to get higher (due in no small part to her husband's support of the American Revolution[*]), people were losing land, a temporary climate shift had made harvests disastrous— and the queen was roundly, almost universally blamed. Understandably, the people came to hate the government. But how did the *queen* become the scapegoat?

Well, the tabloids didn't help.

There was "a huge smuggling industry of semilegal or totally illegal pamphlet literature coming out of Holland, coming out of London, coming out of Switzerland," according to Simon Schama.[†] New companies were setting up shop with the express purpose of creating these scandal rags and distributing them for profit. They ran a business sniffing out and, more often than not, *inventing* information damaging to notorious or famous people, primarily royalty—most especially the Bourbon monarchy at Versailles.

They accepted rumors and hearsay as legitimate fact and, for the most part, simply took public opinion and reflected it back to the public, as though through a fun house mirror, more distorted and exaggerated than before. Not only did they help propagate the image of the monarchy as ineffectual, self-indulgent, and lasciviously excessive, far more radically, they validated and legitimized criticism of the monarchy in the first place by making it an acceptable topic of public conversation.

[*] Louis XVI supplied guns and almost all the gunpowder to the American revolutionaries. Even as conditions in his own country worsened, he refused to stop. His primary objective was to weaken the English. His secondary objective was to escape his reputation as a weak ruler.

[†] Grubin, *Marie Antoinette and the French Revolution.*

The pamphlet literature, which is a polite term for it, was circulating all over Paris, all over France, and to some extent the rest of Europe. These so-called pamphlets were made up primarily of cartoons—some with captions, some without—that featured crude, obscene, and offensive depictions of the monarchy. They were vicious and mostly libelous, but the royal censor was powerless to do anything about it, even at the king's specific demand: "Try and stop these vicious things by any means you can."* But the problem was endemic and the onslaught of the literature too large and international for an old-school royal censor. The rags were not only endless, thanks to the high-tech printing presses—so was the population's desire for them.

The king was depicted as an obese, slow-minded donkey eating all the food in France. He was ridiculed as impotent and cuckolded and his children teased as bastards. But the queen was the primary target. She'd be the "It Girl" of the tabloids for the last ten to twenty years of her life. The pamphlet literature depicted her in grotesque scenarios with extraordinary detail, committing everything from treason, to blasphemy, to incest and perversion. She was caricatured as a godless, obscene, money-grabbing monster, whispering in the useless king's ear and destroying France from within. The infamous and indifferent suggestion that starving peasants should "eat cake" has actually been misattributed to her; the statement was made by Maria Theresa, wife of Louis XIV. According to Antonia Fraser, "it was a callous and ignorant statement and she, Marie Antoinette, was neither."

And just because, financially speaking, it's always a good idea to throw napalm on a fire, the tabloids began to expose and ridicule the queen's new faux-pastoral life, knowing it would whip the farmers into a frenzy.

It was the beginning of a changing attitude that made the

* Grubin, *Marie Antoinette and the French Revolution*.

previously inviolable (if not godlike) monarchy more human. By dragging princes down to earth—and often into the gutter—the new media made them not just vulnerable but ultimately dispensable. This is the flip side of symbolism: It pertains not just to a thing's worth—but to its *worthlessness*. By rendering the monarchs as ridiculous and flawed characters, the tabloids were actually dissipating their meaning, diluting the context of unassailable and inarguable power upon which the monarchy had previously rested.

According to historian Chantal Thomas, "Marie Antoinette became the scapegoat. Everything going wrong, and there were many things, it was her fault, it was her responsibility. . . . This new powerful thing, public opinion, was really beginning and it was making a new world."* Certainly, humans have long used illustrations as a way to narrate stories and make sense of the world. However, the frenzied reporting and voyeuristic, almost prurient interest in penetrating (and fictionalizing) the lives of the ruling class was unprecedented, and it coincided with developments in the printing press and with the growth of an international community to generate an explosive culture of anger and contempt.

The Tragic Kingdom

Marie Antoinette believed she had found a sanctuary at Trianon: an expensive, totally engineered sanctuary, but a sanctuary nonetheless. The grounds contained an artificial village with rivers and streams and ponds. There were cottages and birds. Meadows were filled with flowers and the rolling grass was tastefully

* Grubin, *Marie Antoinette and the French Revolution*.

dotted with sheep, wearing blue silk ribbons around their per-
fectly pouffed necks. It was Disneyland's version of rural France.
According to historian Evelyne Lever, Marie Antoinette said,
"when I am at Trianon, I am myself. I am no longer queen."*
A charming sentiment—not, however, a true one. Unfortunately
she still *was* queen, and even as she totally dropped off the stage
show that was court at Versailles and took up life in her terrarium
of Trianon, she was more reviled than ever.

When the actual peasants of rural France saw cartoon depic-
tions of Trianon, they were understandably disgusted. And they
weren't the only ones. The aristocracy—people who had, ironi-
cally, only recently despised Marie Antoinette for her three-foot-
high hair and her diamond-encrusted shoes—also took issue.
They mocked her behind her back while desperately coveting
invitations they would never get.

Rumors and resentment began to boil. And those absurd sto-
ries made their way to the common people, who began to hate her
even more than they did the aristocracy. It wasn't that they were
being excluded from the VIP room—they'd never even hoped to
have a pass to the club. It was that she was making a mockery of
their entire grueling way of life.

And then the necklace happened.

Poor Relations

The French jewelry firm Boehmer and Bassenge had been com-
missioned by Louis XV (Louis's grandfather) to create a truly
massive and absolutely unique diamond necklace, which he
intended to give to his mistress, the much-reviled Madame du
Barry. She loved jewelry—the bigger the better—so it took the

* Grubin, *Marie Antoinette and the French Revolution*.

firm a few years to accumulate the *2,800 carats* of diamonds the design required. Louis XV didn't have to pay in advance, because, you know, he was the king. Unfortunately, he died shortly before the necklace was completed—or paid for. When Boehmer and Bassenge suddenly found themselves without a buyer, the jewelers, left on the hook for probably hundreds of millions,[*] attempted to sell it to the then nineteen-year-old, newly minted queen, Marie Antoinette. Though the gargantuan necklace wasn't to her taste even back then, she had developed her reputation early as a lover of fine things. And frankly, who else had that kind of money? Unfortunately for the jewelers, she knew that the necklace had been designed and intended for her old enemy, Madame du Barry. She wanted nothing to do with it, much to the despair of the distraught jewelers.

Ironically, the necklace destined for the whore, a woman the queen despised, had already taken on morally repugnant connotations for Marie Antoinette—just as it would later take on morally repugnant connotations for a public that despised her. In both cases, the jewels would serve as an emotional substitute for the woman (believed) to own them, and all her respective misdeeds. In essence, the necklace had begun its transformation from *stone* to *symbol*.

Enter Jeanne de Saint-Rémy, Comtesse de la Motte. Though she had been raised by her mother, a peasant, in relative poverty, Jeanne liked to claim noble birth via her father—a very, very distantly removed, and in fact illegitimate, descendant of Henry II. It was a pretty extreme stretch. But she leveraged that fact, along with her natural charms, to secure a marriage to a low-level aristocrat, Nicholas de la Motte, allowing her access to Versailles.

Jeanne's most fervent desire was to get close to the queen. She hoped that her charm and her faint connection to Henry II might

[*] We'll get to why an exact figure is impossible in just a moment.

be enough to secure her a spot in the queen's inner circle—and the money and favors that went with it. Whether she ever even met the queen is uncertain; if she did, the queen took no notice of her. So when the necklace started floating around court—with the increasingly desperate Boehmer, who tried for years to sell it to the queen at every chance—Jeanne saw a social opportunity of a different kind.

The Comtesse de la Motte was, essentially, a con artist. And like every great con artist, she needed a patsy. She found one in the person of Louis René Édouard, Cardinal de Rohan. Rohan was a prince, born into one of France's older and wealthier aristocratic families. Before he was made cardinal by the Catholic Church, he'd held a number of very important positions in French government, presumably granted to him due to his high-ranking birth and not his intelligence. He was both vain and stupid; most of all, he was, to put it bluntly, a fame-whore.

He was determined to do *anything* to get near the VIPs and back on that A-list that was Versailles's inner circle. He'd already blown his shot in Vienna, where he was the ambassador to Austria before Louis XVI and Marie Antoinette were married. Unfortunately for him, he'd bet wrong and expressed opposition to the marriage. The marriage happened anyway, both because Maria Teresa wanted it and because Cardinal de Rohan was neither very bright nor very important. Later Rohan was certain (and probably correct) that this faux pas was how he had lost the goodwill of the empress, something no one in Vienna could survive without.

When, upon Louis XV's untimely death, Marie Antoinette became queen of France, Cardinal de Rohan realized he had a less intimidating but more immediate enemy to contend with. According to Mrs. Goddard Orpen's 1890 account of the necklace scandal, he "had been ambassador at Vienna where he had ridiculed Maria Teresa, Marie Antoinette's mother, and afterward

a courtier at Versailles where he had criticized the *dauphiness,* Marie Antoinette herself."[*]

Once again, in more modern parlance: In addition to his early objection to Marie Antoinette's marriage to Louis, he'd also trash-talked the now-queen and talked smack about her mother, publicly, on their own respective turfs. According to Orpen, "by these double deeds he was cordially detested by the Queen who, like young people generally, was extreme in her likes and dislikes and vehement in the expression of her sentiments."[†]

In other words, Marie Antoinette could be a little bit of a mean girl and was known to punish people socially, like du Barry, simply because she didn't like them. She might as well have executed them. In Versailles, social status *was* life.

Upon Marie Antoinette's ascension to the throne, Rohan stopped obsessing solely about Maria Teresa and became convinced that, because of her daughter's obvious hostility toward him, he would never be accepted back at court nor ever advanced further in his political and professional life. He was desperate for social resurrection. Meanwhile, lurking around at court, Jeanne had learned of the diamond necklace, of Marie Antoinette's public refusal to buy it, and of the jewelers' desperation to sell it. But Rohan, who was on the outs with the In Crowd, was not at court and so didn't know anything about it.

La Motte saw in Rohan the perfect patsy. When she first approached (and possibly seduced) him, she just used him for his connections and hustled him for some money, supposedly for her "cousin" Antoinette's charities. But all the while, she had her eye on the prize. She soon convinced him that she was part of the queen's inner circle of girlfriends and could, *perhaps,* arrange the

[*] Mrs. Goddard Orpen, *Stories About Famous Precious Stones* (Boston: D. Lothrop, 1890).

[†] Ibid.

reconciliation he sought. And, of course, there was something in it for her—money here, a favor or two there. At least so the cardinal believed. But her con was a long one. The cardinal became ever more disarmed by the charming la Motte and hopeful about his future reconciliation with the queen, all the while la Motte was working an elaborate plan to steal the giant necklace and leave the cardinal holding the bag.

L'Affaire du Collier

Once la Motte had secured the cardinal's trust, she encouraged him to correspond with the queen. It would be a bold move, but one for which she assured him she could soften the ground. (Conveniently for her, she didn't actually have to soften up anything, since she was throwing away his letters.) She had her boy toy, Rétaux de Villette (another con artist), forge the queen's handwriting, while she herself wrote the replies. They even forged the queen's signature—not, however, correctly. La Motte made the mistake of signing the letters "Marie Antoinette of France." But as in the case of A-list celebs, monarchs didn't ever use surnames—surnames were for regular people.

The error would eventually incriminate la Motte at trial. But the deception worked on the obtuse cardinal. People believe what they want to believe—and he believed he was actually corresponding with the queen and was overjoyed. He didn't even question the authenticity of the letters when they assumed a more intimate turn. In a shocking plot twist, la Motte and Villette convinced Rohan that Marie Antoinette was really, really hot for him and that her overwhelming feelings of attraction were a big part of why she had previously kept him at such a distance. And he believed it—likely because he was, as historian

Simon Schama put it, "too vain, too stupid . . . with a brain the size of a flea."*

The cardinal assured her of mutual feelings, and the notes he unwittingly exchanged with the con artists became more and more affectionate. La Motte and Villette even went so far as to arrange an actual *meeting* between the cardinal and Marie Antoinette. In actuality, they arranged a meeting for the cardinal with a random prostitute named Nicole d'Olivia, who was just an absolute dead ringer for Marie Antoinette.†

Rohan and "the queen" met at night, in the Grove of Venus, a secluded corner of the gardens at Versailles, when the light was (conveniently) practically nonexistent. She gave him a rose. He fell to his knees and kissed the hem of her dress, but, of course, before she could speak, a contrived interruption brought a rapid ending to the tryst. The noise fake-startled fake-Marie Antoinette, and she ran away in feigned fear of discovery. But the clueless cardinal was over the moon.

Was he actually in love with her? Who knows. He certainly acted as though he was. And he laid it on pretty thick in his letters. It's probably unimportant. He fell victim to the seduction of one of the greatest positional goods of all: power. He was desperately in love with the idea of *any* sort of relationship with the queen of France. So happy, in fact, that he'd really stopped paying attention to the details. He'd stopped questioning the reality, or surreality, of the situation altogether and was completely under la Motte's spell.

With her fall guy eating out of the palm of her hand, la Motte convinced the cardinal that the queen desperately wanted a particular piece of jewelry: an enormous diamond necklace currently for sale. Despite the fact that Marie Antoinette had publicly

* Grubin, *Marie Antoinette and the French Revolution*.

† At least she was when dressed up and in really low lighting.

refused the necklace on multiple occasions, the cardinal was easily convinced. La Motte claimed that secretly the queen wanted the necklace *but* didn't want anyone to know she had bought it, having only very recently made the transition from party poster girl to pastoral poseur. It was a stupid story, but it was no more stupid than any of the other lies they'd fed him. Certainly it was far more believable than the rendezvous in the dark garden with the mute prostitute.

In a classic sleight of hand, they further convinced the cardinal to buy the necklace on the queen's behalf, claiming that the queen would subsequently pay the jewelers for it when the time was right. All that was really needed was an IOU from someone with royal credit. The jewelers were nearly bankrupt at this point, so they were thrilled that after years of trying, someone had finally managed to unload the necklace on the intractable queen. Everybody got something to believe.

All parties did as la Motte instructed. The jewelers turned over the necklace to Rohan, he in turn wrote them an IOU and then entrusted the necklace to the queen's personal valet. But, of course, the "valet" was none other than la Motte's signature-forging con-artist boyfriend, Villette. As soon as he absconded with the necklace, la Motte and Villette removed the stones and sold them abroad, reaping a fortune.

And the necklace was never seen again.

The Court of Public Opinion

The deception finally came to light when the jewelers eventually demanded to be paid. First they wrote a very sweet note to Marie Antoinette saying how happy they were that she had finally purchased the necklace. When the note was delivered to her, she hardly glanced at it before tossing it into the fire. But on second

thought, she told her first lady-in-waiting, Madame Campan, to find out what that "mad-man Boehmer wanted."*

Madame Campan went to see the jewelers, as instructed. The firm offered to wait for payment if Marie Antoinette couldn't pay right now, as they believed she was in possession of the necklace. Campan insisted that the queen neither had it nor wanted it, and hurried back to the queen to tell her that there might be more going on than she realized. "She greatly feared some scandal was being effected in the Queen's name,"† and she was right. The jewelers spilled their guts immediately, about Rohan, his IOU, and the queen's best friend, the Comtesse de la Motte, who had arranged the sale. Unfortunately, the necklace was long gone by then. The jewelers caught on to the deception far faster than the hapless cardinal, but it was still way too late.

When the entire plot came to light, the queen was enraged. Not because she'd been robbed of the necklace—a necklace she neither owned nor wanted—but because she'd been deceived and, even worse, *used*. She was particularly galled by the cardinal's presumed flirtation with her. Once again, someone was smearing her good name. Her name wasn't that good to begin with, frankly, but nevertheless she ran crying to her adoring husband and demanded justice. Rather than just arresting and executing everyone involved, he resolved to put them on public trial, so that all of France could see what an innocent, mistreated, and wonderful woman his wife was.

Predictably, and unfortunately for Marie Antoinette, that's not how things shook out.

The king and queen waited until the cardinal was prepared to give an enormous public service on the Feast of the Assumption. When the vast crowds had amassed, the king had guards storm the pulpit and arrested the cardinal in front of the masses. He

* Orpen, *Stories About Famous Precious Stones.*
† Ibid.

was shackled and dragged away, accused of treason and thievery. (Remember when I said that Marie Antoinette was known to socially punish people she didn't like?)

Even the hopelessly obtuse cardinal eventually caught on to the reality of the situation. He immediately rolled over on la Motte and her accomplices. He wept to the king and queen that he suspected he had "been deceived."* He even offered to pay for the missing jewels himself. He also managed to sneak a note to one of his servants to destroy the remaining letters he'd exchanged with the fake Marie Antoinette before the real one could read them and become further incensed.

The cardinal, the comtesse, and her alleged accomplices—including various servants and the prostitute who'd posed as Marie Antointette—were thrown in prison to await trial. The trial was the sort of public circus that comes along once in a generation. A dirty cardinal, a criminal queen, a sex scandal, massive jewels, con artists, and a prostitute: All that was missing was an alien cover-up.

And the public went *wild*.

While the queen was not herself on trial, no one living in France at the time would have known it. Though the queen was blameless (and ignorant) of the events that took place surrounding the theft, the majority of the French people believed that Marie Antoinette had actually *slept* with Cardinal Rohan, embezzled money, and tried to steal the necklace from the jewelers. Others believed she had ordered the necklace to be stolen, as part of a plot to destroy her enemy, the cardinal. The forged notes were believed (by the public, though *not* by the court) to indeed have been written by the queen and to be evidence of her financial and sexual misdeeds, as well as plotting, thievery, and malfeasance against the Crown. In the end, the trial became more about the queen's character and reputation than it was about the missing necklace.

* Hey, better late than never.

A Tale of Two Trials

The tabloids became particularly enamored of the Affair of the Necklace, partially because the French word for jewels, *bijoux*, is reminiscent of the term *les bijoux indiscrets*, the French euphemism for women's private parts.* (Kind of like *the family jewels* in English.) During the trial, one particularly detailed and pornographic cartoon circulated of the queen with her legs spread wide open, being admired by her male guests at Trianon while her best girlfriend held the enormous diamond necklace above them.†

The scandal sheets got nastier as they became more absurd. Rumor, which had become opinion, became fact: She had seduced and destroyed a cardinal. She had manipulated and lied to the king. She had embezzled enough money to feed half of France, all for a hateful piece of jewelry originally intended for a whore. Oh, and that poor, pretty French girl, Jeanne de la Motte, tragic every-girl heroine, caught up in the queen's web of corruption and vice . . .

None of it, of course, was even remotely true. Interestingly, and despite the popular image of her, the adult Marie Antoinette was somewhat fiscally conservative. Sheltered? Yes. Ignorant of the bleak reality of France's economic sinkhole? Absolutely. Enjoying her blissful ignorance, no doubt. Nonetheless, when she was advised that her charities were running a little lean and the people had never been hungrier, she responded that the court jewelers should stop sending her diamonds and put the money to better use.

Jewelry plays a lot of different roles: It can be ornament, it can be currency, and often it can even be totemic. Occasionally jewels have the ability to surpass the merely symbolic and become an actual substitute for their owner (that's why we refer to kings

* Grubin, *Marie Antoinette and the French Revolution*.

† Fraser, *Marie Antoinette*.

and queens as "the Crown"). Marie Antoinette was, in addition to being a fiscal conservative, also relatively *sexually* conservative. Remember, one of the reasons she didn't care for the enormous diamond necklace in the first place was its association with Madame du Barry, the woman whom she considered a prostitute. Du Barry's jewels were as odious to the queen as the woman was herself.

But that's not a great story to tell if you're trying to sell papers. According to historian Chantal Thomas, "It is because Marie Antoinette was seen as a frivolous woman that the necklace affair could exist. The diamond necklace affair was a turning point for Marie Antoinette. She was condemned at that point— she was condemned forever."* Though it would be a few short years more before Marie Antoinette's head rolled, the outcome of the diamond necklace trial did indeed seal her fate. Despite the fact that the entire truth of the affair came to light during the trial, no one cared that the guilty parties had been found out. By then, most of the seething crowds who imagined her dripping in jewels had no idea she'd turned away the monthly offerings from the royal jewelers, suggesting instead that the money be used to beef up the flagging charity accounts. Or that Boehmer and Bassenge did an end run around her, after she originally refused the necklace, and instead tried to sell it to her unwitting husband as a gift for his wife. Nor that when she found out, she refused it again, scolded the king, and suggested the money would be better spent on their growing war debt in America.

Later, even as the revolution raged, the Affair of the Necklace managed to become one of the most reviled "facts" about Marie Antoinette. Days before her execution, her own trial, which was an almost absurd formality far more concerned with spectacle than justice, focused heavily on the scandal. Rumors and popular opinions had indeed become factual evidence.

Amazingly but perhaps unsurprisingly, her prosecutors then

* Grubin, *Marie Antoinette and the French Revolution*.

charged her with *another* jewel theft, one that had occurred *while she was imprisoned*—even though the thieves had already been found. Most of the rest of the charges came straight from the old tabloids, which were themselves used as evidence.

"Manufactured truth" has never had a more literal meaning.

In June 1786, the trial of the century came to a close. Verdicts for everyone involved in the Affair of the Necklace were read. Only a few weeks later, in August, the finance minister informed Louis XVI that the French monarchy was completely insolvent and that the situation could not last. By the end of the year, on December 29, the Assembly of Notables was called together, but then ultimately dissolved when they could find no solution to the crisis.

L'Affaire du Collier, as it was referred to in the papers, was not only the end of the French people's tolerance for the woman they began to call "the queen of debt," it was also the beginning of the end of the monarchy.

The Necklace That Started the French Revolution

The necklace that hastened the downfall of the French monarchy existed only briefly, not only because Boehmer and Bassenge couldn't find a buyer for the masterpiece (or monstrosity, depending on how you look at it) but also because the thieves immediately broke it up and sold the diamonds individually. However, there are detailed drawings and engravings of the piece still in existence, and exact replicas have been made (though not with real diamonds). Mrs. Goddard Orpen quotes a firsthand description of the so-called "necklace" in *Stories About Famous Precious Stones,* written a century later, in 1890:

> A row of seventeen glorious diamonds, as large almost as filberts, encircle, not too tightly, the neck, a first time. Looser,

gracefully fastened thrice to these, a three-wreathed festoon, and pendants enough (simple pear-shaped, multiple star-shaped, or clustering amorphous) encircle it, enwreath it, a second time. Loosest of all, softly flowing round from behind, in priceless catenary, rush down two broad threefold rows; seem to knot themselves (round a very Queen of Diamonds) on the bosom; then rush on, again separated, as if there were length in plenty; the very tassels of them were a fortune for some men. And now, lastly, two other inexpressible threefold rows, also with their tassels, unite themselves (when the Necklace is on, and at rest) into a doubly inexpressible *six*-fold row; stream down (together or asunder) over the hind-neck—we may fancy, like a lambent Zodiacal or Aurora-Borealis fire.[*]

To be clear, the so-called necklace was a multitiered, jewel-encrusted *garment* more than anything else. Weighing in at 2,800 carats, with 647 individual diamonds,[†] the top layer was a loose choker made of seventeen diamonds, each one a massive stone. Hanging from that was a garlandlike series of three large draped rows of diamonds, with five enormous pear-shaped stones hanging from each point. From there it draped front and back, from throat to waist—crisscrossing in wide, solid diamond ribbons across the body, accented with multiple enormous clusters, bows, and monumental drop-shaped stones, all terminating in several large diamond tassels at the waist and elbows.

It wasn't really a necklace in the traditional sense; it was more like a wearable chandelier. The diamonds alone weighed almost a pound and a half. It was the most expensive piece of jewelry of its day. It was, in fact, possibly the most expensive necklace ever constructed.

Or was it?

[*] Orpen, *Stories About Famous Precious Stones.*

[†] Fraser, *Marie Antoinette.*

Incomparable?

At present, "the most valuable diamond necklace in the world"[*]
is a piece made by the Swiss jewelers Mouawad. It doesn't hold a
candle to Boehmer and Bassenge's ill-fated necklace for size or
sparkle, weighing in at a mere 637 carats, but it's far more wear-
able.

The modern piece is called the "L'Incomparable Diamond
Necklace." It owes its completely uncreative name to the fact
that it showcases L'Incomparable Diamond,[†] the world's largest
internally flawless diamond, weighing in at a staggering 407.48
carats.[‡] On the 9th of January 2013, Mouawad's L'Incomparable
Diamond Necklace was officially awarded the position of most
valuable necklace in the world, along with an estimated worth of
$55 million.[§]

L'Incomparable Diamond itself, once housed in the Smithso-
nian, is the third-largest diamond ever cut. The stone is almost
the size of a child's fist. It's a rich golden-yellow color and has its
own unique cut: an angular drop shape, which rather resembles
a coffin. The rare gem is suspended from two long, glittering,
branchlike sprays. In place of leaves or buds, the branches display
ninety variously shaped, flawless white diamonds, totaling 229.52
carats.

It's a beautiful necklace, but most of its actual value is tied
up in the L'Incomparable Diamond[**] (a stone that, one assumes,

[*] *Guinness World Records*, 2015.
[†] Really big diamonds get official names. Sometimes the names are descrip-
tive, sometimes they're a tribute. Often they're absurd and cringe-worthy. But
either way, having a name is how you know you've *really made it* as a diamond.
[‡] Anthony DeMarco, "The 'Incomparable' Sets Guinness Record for Most
Expensive Necklace, Valued at $55 Million," *Forbes*, March 21, 2013.
[§] *Guinness World Records*, 2015.
[**] L'Incomparable Diamond was classified by the Gemological Institute of Amer-
ica as the world's largest internally flawless stone.

would be worth just as much if it were used as a paperweight).
Beauty may be in the eye of the beholder, but cost is something
you can—and must—put a price tag on. So, which necklace is
really the most expensive necklace ever made?

That, it turns out, that is a wickedly difficult question to
answer.

What *Was* a Stone Worth?

On the surface, comparing the worth of these two necklaces
should be a simple matter of calculating currency exchange and
inflation. One necklace was made in 1768 in France and the other
in 2012 in Switzerland. So it seems that in order to compare the
two, we should just have to figure out how much the former was
worth in its time, and how much that equals in today's currency.
Simple math problem, right? Wrong. Business writer John Steele
Gordon has called converting historical values into modern fig-
ures "one of the most intractable problems a historian faces."[*] It's
not as simple as crunching the numbers.

Value is a very fluid concept. As we've seen in the story of
New World emeralds, a gem can be worth everything one day
and nothing the next. To simplify the question, let's pretend
the hypothetical stone has a definite dollar value in 1772. Just *a*
stone (not an obscene set of diamond body armor.)[†] Whatever
the amount of money that stone is worth is inextricably tangled
up in the question of what *everything else* at that moment in time
is worth. What's an egg worth, what's a house worth, what's a

[*] John Steele Gordon, "The Problem of Money and Time," *American Heritage
 Magazine*, May/June 1989.
[†] And even as I repeatedly mock it—it must be obvious how much I want it. . . .

man's labor for a day worth? And for that matter, how long will that man live, to work days, eat eggs, and live in his house? How many days will he have to work to afford a house?

As an example, let's take the price of a horse in 1772 in France compared with the price of a physically similar horse today in dollars. There's the basis for your exchange rate, right? The problem is that actual prices are a reflection of accepted value—*but only in context*. Take those prices out of context and they mean very little. The problem with the horse example is that horses themselves, as a concept let alone a commodity, aren't worth what they were in 1772. Two hundred and forty-three years ago, a horse was a *car*. And most of them luxury cars at that. As L.P. Hartley put it, "The past is a foreign country."*

Associate economics professor Ronald W. Michener of the University of Virginia describes the problem of value assessment across centuries: "Interpreters can't answer this question," he said in an interview. "The differences between today and then are too great to make a comparison. Viewed from the twenty-first century, life in colonial America was like living on a different planet."† Though he was speaking of manufactured goods in colonial Virginia, the same could be said of a piece of jewelry from prerevolutionary France—and the problem becomes eerily similar to the question of the value of those beads that bought Manhattan. It's pointless to try to calculate a few hundred years' interest on sixty guilders. The money didn't just change; the value of *glass* changed, as did the value of Manhattan. All those values are organically intertwined, and they never go up or down in a straight line, let alone independently of one another.

* L. P. Hartley, *The Go-Between* (New York: Knopf, 1953).
† Ed Crews, "How Much Is That in Today's Money," *Colonial Williamsburg Journal*, Summer 2002.

Now we're getting into the economic—as opposed to psycho-logical or sociological—nuts and bolts of what a stone is worth. It's pointless to ask what those glass beads are worth today. In the same way, it tells us very little to know that the diamond neck-lace was finally "sold" to Cardinal Rohan and the Comtesse de la Motte for the bargain price of about 2 million livres*—a sum that might equally have been used to build and outfit a small palace or create and arm a battleship. There's a contextual value. . . .

Here's a better one: The real problem with the necklace was that *no one in Europe had enough money to buy it*. Even Marie Antoinette, after repeatedly refusing to purchase it, suggested to the jewelers that they break it up and sell it in pieces. It was the most expensive necklace ever created—so costly that no one in the world could (or would) afford it. So what was it really worth? Well, according to the philosophy of an old boss at a pawnshop I once worked in, an object's worth is always and entirely equal to what a person will consent to pay for it. With no buyer, it wasn't worth anything at all.

Then again, it's impossible to calculate the value of obsession. And to the French in 1780, that necklace was worth a revolution.

Positional Envy

The accepted definition of *envy* comes from the work of W. Ger-rod Parrott of Georgetown University and Richard Smith of the University of Kentucky: "Envy occurs when a person lacks another's superior quality, achievement, or possession, and either desires it or wishes that the other lacks it."[†] But as it turns out

* Orpen, *Stories About Famous Precious Stones*.
† Simon M. Laham, *The Science of Sin: The Psychology of the Seven Deadlies (and Why They Are So Good for You)* (New York: Three Rivers Press, 2012).

there are two different *kinds* of envy. The first variety, known as "benign envy," is when you admire what someone else has and wish that you had it for yourself. The second kind of envy is called malicious. "Malicious envy" is the psychological phenomenon by which you admire what someone else has, but instead of wishing to have it yourself, you simply *wish for the other person to lose it*. You don't want that covetable item (car, house, job, wife) for yourself, necessarily—you want to steal it, destroy it, make it vanish into thin air.

Not very nice, huh? Benign envy makes instinctive psychological sense. You see it—you want it. However malicious her *actions*, Jeanne de la Motte was suffering from benign envy. She wanted an exalted position in the queen's inner circle, and failing that, she just wanted money, which would *buy* her a higher social rank. It was not her objective to impoverish or punish her victims. Malicious envy, on the other hand, is slightly more complex—and it was certainly a factor at play during the French Revolution. This is illustrated by the fact that the revolutionaries weren't wearing stolen tiaras during the Reign of Terror.* During the bread riots and other violent displays that lead up to the Revolution, the people cried out for bread. They cried out for justice. Hell, some of them just wanted equal representation in government. But at no point did the raging mobs cry out for better jewelry.† It was very much the people's desire to punitively take those treasures away from the king, the queen, and the nobles.

Not to have. To *take*.

So what turns benign envy into malicious envy? When we think we *can* compete, we do, much in the way the courtiers copied everything Marie Antoinette did. As her lady-in-waiting

* They took all the jewels as soon as they had beheaded the king and locked them up for safekeeping.

† Although they probably should have. I mean, if there was ever a time and place for that particular ask . . .

Madame Campan put it, "while the queen was blamed, she was blindly imitated."[*] But when we're not so sure, or we know we can't compete, a nastier way of leveling the playing field is hardwired into us: malicious envy, that impulse to take away an advantage someone else has. It's not as nice as getting it yourself, but we all end up equal, don't we?

Limited good is a powerful thing: It can create the illusion, and even the reality, of value. But when the goods are necessary (like food), and the limit is real (like a decade of famine), a whole new set of economic rules emerges, and the consequences become not just social but political.

Diagramming How the Macaroon Crumbled

So how did the fervor over L'Affaire du Collier foment a violent revolution? What happened in the three years between 1786 and 1789? A lot: The French Crown defaulted on its loans, essentially declaring bankruptcy. Biographer Antonia Fraser surmised that the king "did not respond well under pressure," which might be the understatement of that or any other century, and stated that "in 1787, he really had what we would call a nervous breakdown."[†]

By 1788, no solution to the financial crisis had been found. It became clear that no substantive progress could be made without calling the three Estates General to vote on the sweeping reforms necessary for the ailing country. Bickering ensued throughout the rest of the year between the Estates General and

[*] Mme. Campan (Jeanne-Louise-Henriette), François Barrière, and Mme. Maigne, *The Private Life of Marie Antoinette, Queen of France and Navarre*, vol. 1 (New York: Scribner and Welford, 1884).

[†] Grubin, *Marie Antoinette and the French Revolution*.

THE IMPORTANCE OF BEING FAMOUS

the Assembly of Notables, who demanded that the Estates General follow tradition and agree to one vote per Estate. The Third Estate, which comprised 99 percent of the population, was not on board. Ultimately, in the spring of 1789, the king ordered the meeting closed.

He went on throughout the early summer to propose various reforms, but they were meaningless so long as he refused to let the Estates General vote. Finally, the members of the Third Estate changed their name to the National Assembly: a breakaway revolutionary party with a whole new set of demands.

And then, because it always does, the weather got worse.

God Willing and the Creek Don't Rise

The autumn of 1788 was not good. There was yet another devastating harvest. By April 1789, food shortages and piteous wages had resulted in brutal riots in Paris. The extreme tension, the catastrophic winter, and the subsequent failed harvest had left Louis XVI in a state that can only be described as "fragile." So who was running the country? That's right—the most hated woman in France! Fraser states that "Marie Antoinette realized, for the sake of her son's future, her children's future, for the sake of the monarchy in which she believed—she'd been brought up to believe in it—she had to be the strong one."* Marie Antoinette was a nice woman, and perhaps a historically misrepresented one, but she was far better at throwing parties and playing shepherdess than at leading a deeply divided and economically unstable country. The queen tried to pick up the reins for her husband but had no experience, a mediocre education, and minimal authority.

Her efforts only made things worse. As brochures circulated,

* Grubin, *Marie Antoinette and the French Revolution.*

they ceased to focus solely on her supposed unnatural sexual proclivities and her diet of entirely diamond-encrusted food and were replaced with depictions of, among other things, her face on the body of a monster eating France or whipping her fat donkey husband.

This was a critically divisive moment in the history of France. And yet it was perhaps a moment that a different monarchy, a different leader, might have successfully navigated. The National Assembly was not yet calling for heads-on-sticks. What they wanted was a constitution, and to abolish aristocratic privileges—essentially something more in line with a constitutional monarchy.

Marie Antoinette flatly refused. Her husband was on the fence, in part because he was on the fence about everything, and in part because he was (God help us) more of an intellectual than she was. But ultimately, he was in such fragile psychological condition that *she* had the deciding vote. Like her mother, Marie Antoinette honestly thought that the only thing that stood between order and chaos was the monarchy. Believing that the mobs gathering in Paris threatened the stability of the country, she demanded that troops be mobilized to essentially block off the city and the route to Versailles.

Historian Chantal Thomas called Marie Antoinette "blind to what was changing in France."* When she panicked and demanded troops be moved between the city of Paris and the Palace of Versailles, she wasn't trying to start a conflict—she was trying to avoid one. But her actions had just the opposite effect. The show of strength didn't intimidate the people, or remind them of the monarchy's ultimate authority. Instead, the National Assembly saw the deployment of the troops as an aggressive coup d'état against the people.

* Grubin, *Marie Antoinette and the French Revolution.*

French Toast

On July 14, 1789, the people stormed the streets of Paris and "liberated" the Bastille prison: the massive, miserable, crushing symbol that in Bourbon France, they were *all* prisoners. It was hardly the extent of what they did, or would do, but bringing down the Bastille was a symbolic victory over the government's absolute and unquestionable authority. Ten miles away at Versailles, Louis XVI was awaked at 2 A.M. that night by the grandmaster of the wardrobe and told the Bastille had been taken. The governor, Louis XVI was informed, had been murdered, his head carried on a stick through the streets by the enraged crowds.

When Louis asked, "Is it a revolt?" he was allegedly told, "No, sire. It's a revolution."

Within a week the press was declared free. The (marginally effective) royal censors were no more, and a new wave of vicious papers began to circulate. Most of the stories were, unsurprisingly, about the queen and her depraved ways. Increasingly violent and pornographic, these stories were also increasingly divorced from reality. Chantal Thomas describes them as "a world of dark fantasy, full of hatred."* Approximately two weeks later a mob of seven thousand women marched to Versailles and, in an unprecedented event, managed to gain access to the palace. As they tore through Versailles looking for the queen, killing guards and aristocrats, ignoring the various treasures heaped around them, they had their mind on a single goal: the queen. When the women, some covered in blood, arrived in her room only moments after she'd slipped away, they took their pikes and knives and other weapons in hand and stabbed her bed over and over—just in case she was hiding in the mattress.

* Grubin, *Marie Antoinette and the French Revolution.*

Meanwhile, Jeanne de la Motte had escaped prison, slipping out of her cell dressed as a boy, and fled to London. Later that same year, 1789, in a move that would presage the actions of fallen celebrities everywhere, *she published a book,* her *Mémoires justificatifs.* In her memoir she once again slammed the queen and told an even more elaborate (fabricated) version of the Affair of the Necklace than she had at her trial. She even published some of the fake correspondence.

The people loved it. She was seen as a heroine, and issued a formal pardon by the new government of France.

As all of Europe allied against rebelling France, all of France allied against the queen. Marie Antoinette was "deliberately targeted, in order to bind the French together in a kind of blood bond."[*] As Antonia Fraser points out, there was no reason to kill a queen consort who had no authority. Nor could the court find any actual crimes she had committed.[†]

Chantal Thomas called Marie Antoinette the scapegoat. But by the time of her trial, which mostly consisted of outrageous charges taken directly from old tabloids, she was more of a sacrificial lamb.

Curses!

The necklace sparked all sorts of rumors in its day—where had it gone? and to whom?—and even more colorful legends as it settled in among the curio cabinet of history. As with much of Marie Antoinette's jewelry, people have long propagated the idea that the diamonds were cursed. People have been all too ready,

[*] Grubin, *Marie Antoinette and the French Revolution.*
[†] Ibid.

then and ever since, to believe practically all of her jewels were cursed—and who can blame them? She met a rather nasty end. But so do a lot of people.

Why is it so easy for people to believe there might be an actual mystical blight on *her* jewels? Not her husband's, not her friends', not even her more onerous predecessors'. No one even seems to remember the ice queen who *actually* said, "Let them eat cake," let alone trembles at the thought of encountering one of her stray earrings. So why has it been so easy to believe that those diamonds (and her many others) were somehow magically tainted?

Simple—she wasn't a person—she was a symbol. In fact, she still is (right behind great big diamonds) the ultimate symbol of *too much*. Human beings recognize a natural balance to the world. When things are out of balance, it's troubling. The idea of someone having that much too much doesn't just feel off—it feels wrong, *morally* wrong. Jewels assume a moral dimension even faster than queens. And the idea that an ill-gotten treasure might, itself, be the instrument of its owner's undoing satisfies our very human need for moral retribution—even if it's all just imaginary.

So where did all the supposedly cursed diamonds end up after la Motte and her lover disposed of them? A great number of them were sold to various jewelers in London and Paris. Where they went from there is anyone's guess, because people have a way of losing records very quickly when it turns out they've trafficked in stolen goods. According to Fraser, "It cannot be known for certain what happened to the stones. Some of them may have been acquired by the Duke of Dorsett and remained in his family according to tradition." But the only diamonds that have actually been accounted for are twenty-two of the "most fabulous brilliants," which were "made into a simple chain [choker] by the Duchess of Sutherland; this chain was exhibited in the Versailles

Exhibition of 1955."* The Sutherland diamond necklace is all that
remains of the massive, era-ending necklace.†

But the diamond necklace from Boehmer and Bassenge wasn't
the only fabulous piece of jewelry belonging to Marie Antoinette
that was supposedly cursed: far from it.

After Marie Antoinette's husband was beheaded—with far
more dignity and humanity than his wife and children would be
shown—most of the treasures of Versailles, including the crown
jewels, were moved to the Garde-Meuble in Paris, an allegedly
secure storage location. It turns out, however, that it wasn't secure
enough.

One night in September 1792, while Marie Antoinette was in
prison awaiting her execution, a group of drunken thieves looted
the royal treasury and "gained so much confidence during the
three nights of undetected robbery, that the fourth evening fifty
turned up with food and wine." So French . . . "The next morn-
ing, when the National Guard discovered the robberies, they
found some of the perpetrators still lying in an alcoholic stupor
on the floor."‡

Most of the jewels were recovered, but a priceless diamond,
the French Blue, was never found.

* Fraser, *Marie Antoinette*.

† There's some minor argument about whether or not they're the actual stones,
because the cut is slightly irregular in shape, whereas drawings of the neck-
lace itself showed them as more perfectly rounded. However, they were very
large stones, and contemporary accounts from the various jewelers Villette
fenced the diamonds to stated that he had pried them from their prongs so
roughly that there were nicks and chips on the edges. Any decent jeweler
would've ground them down and recut them very slightly to maintain their
size while removing the imperfections. I believe this accounts for the slight
irregularity in shape.

‡ Victoria Finlay, *Jewels: A Secret History* (New York: Random House, 2007),
319.

The French Blues

The French Blue, one of the most valuable crown jewels in the treasury, was an enormous sapphire-blue diamond said to have a faint, sinister red glow in sunlight. And like most of Marie Antoinette's diamonds, it is also supposedly cursed. During the mid-seventeenth century,* a French adventurer and gem merchant named Jean Baptiste Tavernier allegedly broke into a Hindu temple, Indiana-Jones style, in the jungles of India. He ripped the giant blue diamond from the central, third eye of a giant Indian idol, possibly Shiva the Destroyer,† whose twirling dance both creates and destroys the world. Once pocketed, the stone accompanied Tavernier back to France where it was cut, polished, and sold to the French Sun King, Louis XIV. Louis XIV made it the centerpiece of an elaborate set of jewelry and passed it to his heirs, the last of whom were Louis XVI and Marie Antoinette.

Marie Antoinette was said to have worn the diamond frequently, and most people who believe in the curse of the French Blue believe that it stems originally from Marie Antoinette's horrific death. Then again, things really began to go south for France during the Sun King's reign—so maybe the diamond brought the curse with it from India. I guess that's what you get for robbing and destroying religious idols. One of the curse's first victims, Tavernier, sold many magnificent stones to the Sun King. But after the Edict of Nantes, he was expelled from France as a Huguenot and died penniless. He may or may not (depending on the version of the story) have been torn apart by dogs.

* It's uncertain on which of his voyages to Asia Tavernier obtained the stone. He traveled to the region six times between 1631 and 1668.

† There's debate about *which* Hindu idol, but according to Finlay, Shiva, whose dance represents the death of material desires, is the best candidate.

After the 1792 theft from the treasury in Paris, the French
Blue was never seen again. At least not in its entirety. It was
such a rare and remarkable stone—due not so much to its 69-
carat weight as to its unusual sapphire color and strange red
fluorescence—that when an identical stone of only 45.52 carats
surfaced in the possession of a London diamond dealer named
Daniel Eliason about twenty years later, in 1812, it was clear that
it was the missing French Blue, cut down and reshaped to hide its
less-than-illustrious origins.

That diamond passed through several hands before ending up
in the collection of a wealthy Dutch banker named Henry Philip
Hope. In 1823, what was left of the French Blue appeared for
the first time under the name the Hope Diamond. Hope passed
the stone on to his descendants, who eventually had to sell it to
stave off bankruptcy. The stone made its way back to Paris when
Hope's impoverished descendant sold it to Pierre Cartier in 1910.
Like Boehmer and Bassenge, Cartier could find no buyer for the
great treasure, even among the elite of Europe and the East.

Despairing of his investment, he finally sold the diamond
to a flamboyant American gold heiress named Evalyn Walsh
Mclean. As party girls go, Evalyn did a young Marie Antoinette
proud: At the peak of the Jazz Age, she threw nonstop parties,
flung money around like confetti, and stopped just short of
actually bathing in champagne. At one of her New Year's fetes,
she was spotted at the top of a staircase, checking out her guests
below, before dashing off—wearing nothing but the Hope Dia-
mond. She even let her dog wear it on his collar.[*]

She was warned that the Hope Diamond was cursed, but
laughed off the idea. She claimed, in fact, that she collected
curses, that the diamond would prove to be good luck for her
even if it was bad luck for other people. Unfortunately, she was
mistaken. Only a few years after she bought the diamond, one of

[*] Finlay, *Jewels*, 320.

her two children died of a fever while she was wearing the glow-
ing diamond at the Kentucky Derby. Her only daughter took
her own life, and her husband eventually lapsed into alcoholism,
gambling, and debt, losing most of their fortune and eventually
dying in an asylum. Her grief, either for her family or for her
lost lifestyle, never ended. Still a substance abuser, she died alone
at sixty, from a "combination of cocaine and pneumonia," still
clinging to the dark blue diamond.

Evalyn McLean's tragic life had already made the Hope Dia-
mond one of the most famous diamonds in the world when Harry
Winston bought it from her estate. But like his predecessors,
he could find no buyer for an item so costly. And that's where
the story of the Hope curse gets interesting. Not because some
tragic fate befell Harry Winston. He did just fine. But because
that was when the story of the curse was popularized—by Harry
Winston himself. When nobody wanted the diamond, Winston
made it special—sort of the way De Beers subsequently invented
a mythos around diamond engagement rings to make small, col-
orless diamonds special. Because whether you've declared your
diamond emotionally necessary or mystically verboten, *everybody*
wants to be part of a story.

He told the story of Tavernier, the Hopes, poor Evalyn McLean,
and most especially Marie Antoinette. He sent the stone on tour, as
though the diamond itself were a celebrity. Wealthy and famous
people gathered to stare in wonder, awe, and a little bit of fear at this
unobtainable—and even dangerous—treasure. And it worked:
The stone evolved from merely unsellable to actually priceless.

In the end, all Winston could do was donate it to the Smith-
sonian, where the symbol of all that is glamorous, dangerous,
and forbidden still glows in its case today. He called it "an act
of generosity" to encourage others to donate their best jewels to
the nation.* But in reality, it earned him his own gallery in the

* Finlay, *Jewels*, 321.

famous museum, and as he declared the stone's value to the IRS as beyond measure, it also earned Harry Winston perhaps the most phenomenal tax write-off in history.

Epilogue: The Only Curse

The interesting thing about the story of the curse isn't that it's not true (who knows?); it's that it wasn't very original. Harry Winston certainly didn't invent it.* It's a version of a very common tale that people tell, and have long told, about many colossal, and thus infamous, jewels.

The Black Orlov, originally a 195-carat black diamond,† was supposedly also stolen from the eye of an idol—Brahma, in this case—by some daring thief. According to the standard legend, the diamond is now cursed. In 1932, the diamond's first dealer, J. W. Paris, allegedly jumped off a New York City skyscraper while the diamond was in his possession. Not long afterward, two separate Russian princesses‡ also supposedly threw themselves from windows while the stone was in their possession.

Another, the 194-carat citrusy white Orloff diamond, is a completely different stone with a very similar story.§ Its origins were chronicled in 1783 by Louis Dutens, a Huguenot clergyman. It was supposedly "ripped from a statue of Brahma in the Temple of Sheringham" by a deserter from the French garrison in India. The soldier had pretended to convert to Hinduism and had ingratiated himself into the inner sanctum of the temple, then

* Nor did two of its earlier architects, Tavernier and Cartier.
† Now cut down to 67.50 carats.
‡ Named Leonila Galitsine-Bariatinsky and Nadia Vygin-Orlov, the diamond's namesake.
§ Orpen, *Stories About Famous Precious Stones.*

stole one of the idol's eyes.* The obscene sparkler is named for Prince Orloff, who gave it to Russian queen Catherine II. Her heirs lost the Russian throne and their spectacular jewels in the Bolshevik Revolution.

But my favorite story is that of the Koh-i-Noor, a diamond so large and of such magnificent beauty that it was valued by one of its owners, the emperor Babur, as "worth the value of one day's food for all the people in the world." Damn. Unfortunately, due to its long, blood-soaked, and tragic history, it is also said of the diamond that "He who owns this diamond will own the world, but will also know all its misfortunes."†

Are you sensing a theme yet?

Apparently, all giant diamonds are cursed, and most of them have been stolen from the eyes of Hindu idols. The Hindu part is easy to explain. Historically, the biggest and the best diamonds have come from the Golconda region in India. The ones with "water." But why the story about an idol? Did such a theft really happen at one point? Do all those scary legends derive from a single original fact? Or is it just a fanciful tale of exotic locales and frightening savage religions, just strange enough to titillate Westerners into buying overpriced gems? Impossible to say, though there's certainly no reason both can't be true.

That said, I think it's the *stolen* part that's the most provocative element of the story. Who admits to having stolen a diamond? (Jeanne de la Motte never copped to it, and she was pretty shameless.) But those stories—about the theft, the desire to possess, and the subsequent curse—are universal simply because they reflect how we feel when confronted with a stunning display of concentrated wealth. And that's one of the

* Finlay, *Jewels*, 325.

† It goes on, "Only God, or a woman, can wear it with impunity." So it's probably for the best that it was finally given to Queen Victoria when she was empress of India.

things a jewel is: a glittering fortune you can hold in your hand.

All those stories about cursed diamonds are the same for a reason: They're morality tales. Maybe we just can't imagine one person having exclusive ownership of something so beautiful or worth so much money. We can only assume that there must be some cosmic, even mystical downside. So we invent stories of cursed diamonds to explain away the unfairness of the distribution of resources. In the case of diamonds like the Hope Diamond, it inspires the invention of stories of curses and death and misfortune. In the case of L'Affaire du Collier, it inspired violent revolt and the beginning of the end of an age.

So were Marie Antoinette's diamonds cursed? Well, maybe all really big diamonds are. Bad things inevitably seem to happen to the people who own, covet, or seek them. As for the necklace that started the French Revolution: Villette was exiled. La Motte may have escaped from prison and penned a book, but she ended up jumping, or being thrown, from a window in London not long afterward. Marie Antoinette and Madame du Barry *both* lost their heads. The jewelers went bankrupt, the abused became the abusers, and the Revolution inadvertently gave birth to Napoleon.

Perhaps, in the end, the only *real* curse is greed.

5

———

HELLO, SAILOR

*How Sibling Rivalry and
a Really Big Pearl Shaped the Fate of Nations*

(1786)

The enemy of my enemy is my friend. —PROVERB

It's more fun to be a pirate than to join the Navy. —STEVE JOBS

La Peregrina remains, to this day, one of the most famous pearls in the world. The perfectly pear-shaped natural white pearl is enormous. At approximately 200 grains,* or 10 grams, it could easily fill the palm of a hand. It was, in its time, probably the largest pearl of such quality in the Western world. It remains one of the largest pear-shaped pearls of its caliber ever found. In a time before cultured pearls, it was certainly a wonder worth fighting over.

Its name means "The Pilgrim" or "The Wanderer." The pearl was so named because of its long history of changing hands and countries. La Peregrina was found in the mid-sixteenth century, off the coast of the isle of Santa Margarita in the Gulf of Panama,

* Neil H. Landman et al., *Pearls: A Natural History* (New York: Harry N. Abrams, 2001).

allegedly by a slave. The pearl was turned over to Don Pedro de Temez, the administrator of the Spanish colony in Panama, who granted the man his freedom on the spot in exchange for the treasure.*

The pearl left the New World when it was given as a token of loyalty to the king of Spain. In Spain, it was described by our old friend Garcilasco de la Vega—El Inca—who claimed to have seen the pearl for himself in those great treasure ports of Seville. He described it as "a pearl brought from Panama by the courtier Diego de Témez intended for the king Philip II. This pearl was of the shape, size, and manner of a good muscadine."† The upper part of the pearl was elongated and shaped precisely like the top of a pear. The bottom had a small indentation, or hollow, like a pear. The body was large and well rounded like a pigeon's egg.

Shortly after its arrival in Spain, The Wanderer changed hands and countries yet again, when an alliance-seeking Philip II of Spain sent it to Mary I of England as a betrothal gift. Both his proposal and the gift were enthusiastically accepted by the nearly forty-year-old virgin Queen Mary. Philip had the pearl suspended from an elaborately mounted square-cut diamond so large it was referred to as "La Grande." Queen Mary was so enamored of Philip that she wore his jewel as a brooch or pendant in almost every portrait painted of her after its arrival. The pearl itself was admired by all, and especially adored by the queen's pearl-loving little sister, Elizabeth.

In modern times, however, La Peregrina's fame is mostly attributed to a different Elizabeth: its most recent owner, Elizabeth Taylor. It was purchased for her as a Valentine's Day gift by her husband, Richard Burton, in 1969. But it was the devotion of

* George Frederick Kunz, *The Book of the Pearl* (New York: Century, 1908).

† A muscadine is a small pear. I'm sure you knew that.

the first Elizabeth to the beautiful pearl that changed the map of the world.*

The Patroness of Heretics and Pirates

Sometime around the year 1560, Elizabeth I began to covet La Peregrina. Mary had died several years after her wedding but made a point of deliberately willing the pearl back to Philip rather than allowing her hated half sister to inherit it along with the rest of the crown jewels. Philip, having apparently decided that one sister was as good as the other, proposed to Elizabeth almost immediately. She denied him, so he in turn denied her La Peregrina and instead took the pearl back to Spain and gave it to a different new wife.

Thereafter, the newly crowned Queen Elizabeth I began

* La Peregrina passed through different countries and numerous royal families over the centuries and was represented in paintings on a variety of beautiful (and some really ugly) women—on so many, in fact, that there's some serious dispute about its provenance. Currently another pearl in London is making a lot of noise and is occasionally referred to as the Mary Tudor pearl. It's owned by Bond street dealer Symbolic & Chase and was unveiled at the 2013 Masterpiece London show. It's stunning. It's a little asymmetrical, more like an eggplant than a drop, but truly amazing. And they make a decent argument, with a convincing painting of Mary Tudor wearing a pearl that looks more like theirs than the one traditionally accepted as La Peregrina. So I went to New York to speak with Greg Kwiat, the CEO of Fred Leighton. Fred Leighton is a heavy hitter in the very best of estate jewelry and—most important—has no skin in this game.

According to Greg, the problem with absolute authentication via paintings is that paintings were often inaccurate—and sometimes even deliberately so, as in "Can you make my nose look a little smaller and my diamonds look a little bigger?" While Greg acknowledged that these things are always at best opinions, he believes that the pearl traditionally believed to be La Peregrina (the one owned by Elizabeth Taylor) is indeed the Peregrina given to Mary Tudor.

a policy of looking the other way as English sailors preyed on Spanish ships, plundering them for New World treasure. Eventually, she even got in on the act: Her "privateers" were pirates, provisionally pardoned and even employed by the Crown to raid and sink treasure ships on the Spanish Main, the West African coast, and the eastern coasts of the Americas. They were under specific orders to seize any and all pearls, all in search of one like La Peregrina.

Over the decades, what started as a nasty case of benign envy turned into a mad scramble for and competition over precious resources. Piracy, previously only tacitly sanctioned, turned into an economic and military strategy. The English navy itself was gradually reborn in the more successful image of Elizabeth's privateers, and some of the most dangerous pirates become national heroes.

Eventually, the Spanish tired of the relentless English piracy, and—still smarting over decades of slights and insults and no small amount of religious tension—Philip II raised an armada unlike any the world had ever seen. It was not just a fleet of warships but a floating *war*— tens of thousands of soldiers and sailors, cannons and cavalry, in a fleet of ships set to invade the English nation and depose Queen Elizabeth, the "patroness of heretics and pirates," as she was called.

The "Invincible" Spanish Armada, though, never made it to English shores. Using their new hybrid navy, honed over years of simmering conflict, with adapted ships and unpredictable techniques of attack, the English completely and rapidly decimated the Spanish fleet. The defeat of the Armada marked the end of Spanish sea dominance, a new landscape of European power, and the beginning of Britain's commercial empire.

But it had its roots in a more mundane domestic struggle: sibling rivalry.

Daddy Issues

Henry VIII was an asshole. He had two daughters, Mary and Elizabeth. Mary was his eldest, the daughter of his first wife, the devout Spanish Catholic queen, Catherine of Aragon. Elizabeth was the daughter of his second wife, Protestant temptress Anne Boleyn. When he made the radical decision to ditch Catherine for Anne, he also ditched Mary. And you know what they say—divorce is always hardest on the children.

Just to be a jerk, Henry VIII also forbade the "inconsolable" mother and child from seeing each other—*ever again*. His word, in fact, proved to be law, since Catherine died several years later without ever having laid eyes on her daughter again. Elizabeth and her mother, Anne, enjoyed a few years of Henry's favor, but ultimately weren't treated any better than his first wife and child—and in Anne's case, worse.

Henry burned through four more wives, most of the treasury, and then died. But his matrimonial flip-flopping, lavish spending, and revolutionary break with Rome had left his country broke, his children (as well as his subjects) at one another's throats, and his kingdom at the mercy of a continent in turmoil—and particularly vulnerable to a puissant Spain at the peak of its influence and military power.

Ultimately, the ongoing rivalry between Henry VIII's first two daughters, and the differences in their respective reigns, would epitomize the contradictory ethos of both the old and the new eras and would plant the original seed that would grow into an epic conflict. This conflict was intense enough to permanently divide those ages, letting one drift backward into the dim past while the other went on to define the modern commercial era and explode into the so-called Golden Age.

Pretty impressive, considering it all started with a fight over a pearl.

Playing Favorites

Jewels were more than mere baubles in Tudor England. They were a frank method of communication. Jewelry telegraphed wealth and social status, certainly. But they also communicated your rank, your social affiliations, your family and friends, and your political allegiances. Often jewels were exchanged as a form of diplomacy, to seal a deal or make a pact, or sometimes just to publicly or privately show favor or express intent. They were also a heavy-handed method of personal communication, and sometimes a semibinding contract. In contemporary society, what we have left of these traditions are a few items like the crown and the wedding ring, items that still maintain an intense symbolic value distinct from their practical one.

Henry VIII was never subtle in showing his favor—or his displeasure. While "courting" Anne Boleyn he showered her with jewels worthy of his actual queen, many of which she initially refused. She wanted *Catherine's jewels*—the crown jewels—or nothing at all. Later, after Jane Seymour (wife number three) at last gave birth to Henry's only son, Edward, Henry expressed his love for his son the only way he ever did—in carats. A letter from Edward to his father read, "I also thank you that you have given me great and costly gifts, as chains, rings, jeweled buttons, neck-chains, and breast-pins, and necklaces, garments, and very many other things; in which things and gifts is conspicuous your fatherly affection toward me; for, if you didn't love me, you would not give me these fine gifts of jewelry."[*]

As messed up as Edward's line of reasoning is, at least he was in a better position than his two half sisters. They were for the

[*] Michael Farquhar, *Behind the Palace Doors: Five Centuries of Sex, Adventure, Vice, Treachery, and Folly from Royal Britain* (New York: Random House, 2011).

most part shut out altogether from their father's love and generosity, although he did occasionally enjoy playing one against the other, flip-flopping about which girl was in favor.

Mary, his eldest, was pious, judgmental, self-righteous, and somber. She was her momma's girl through and through, and far more Spanish than English. Being as intractable and temperamental as her father only made matters worse. Obviously, after her parents' bitter parting, none of these qualities endeared her to her father.

Elizabeth, the daughter of dark-eyed seductress Anne Boleyn, was, as a ruler, in many ways very much like her showy, swaggering father. But in her youth she showed the same viciously clever, charming, and even manipulative tendencies she'd inherited from her mother. She was also brilliant, pretty, charismatic, and could flirt in half a dozen languages by the time she was fourteen. Unlike Mary, she was thoroughly English, but with an educated, continental flair and a certain moral flexibility. She too resembled her own mother,* with the same long neck and hypnotic black eyes.

Having two carbon copies of his dead wives staring at him in judgment no doubt made Henry decidedly uncomfortable, which perhaps does a little something to explain his erratic and mostly condemnable treatment of them. Luckily, for the king, parenting wasn't a top priority. Henry had new wives for that.

Stepmothers and Stepmonsters

When Henry threw off Catherine for Anne, the old queen stuck to her moral, legal, and spiritual guns. She *would not* agree to an

* So much so that there is some current debate over one of the most famous portraits of Anne Boleyn. Turns out it might be her daughter, Elizabeth, wearing Mom's necklace. . . .

annulment. Mary felt the same way and wouldn't disavow her mother—so Henry disinherited her and then some. He stripped her of her titles and possessions, including her jewelry, giving it all to the new princess, Elizabeth. Most humiliating of all, he forced Mary to live and work in her infant sister's household as a servant.

Anne had long seen Mary as a threat, especially so when Anne failed to produce a male heir. At one point Anne even lobbied to have Mary killed, saying of the child, "she is my death, or I am hers."* According to biographer Tracy Borman, Anne "therefore immediately resolved to do everything in her power to undermine Mary's position—if not destroy her altogether—by endeavoring to take everything that was hers and give it to Elizabeth. This even included her name: Anne had argued fiercely that her new-born daughter should be christened Mary."† That pretty much set the stage for the battle between the two girls: They fought over everything, all the way back to the very right to exist.

And in classic wicked stepmother fashion, Anne made sure that the former princess was treated very badly while serving in her baby sister's household. While bejeweling the infant and having her carried around on golden cushions, Anne mandated that Mary was to have nothing not befitting her new abased station.‡

Elizabeth and Anne enjoyed a few years of Henry's favor, but in the end they got tossed aside as well. Almost as soon as Anne miscarried his son, Henry began looking for ways to cut her loose. His opportunity came in the form of (probably baseless) rumors that the seductive queen had been unfaithful. The mostly unpopular queen's many enemies lined up to tell tales of nearly

* Tracy Borman, *Elizabeth's Women: Friends, Rivals, and Foes Who Shaped the Virgin Queen* (New York: Random House, 2010).
† Ibid.
‡ Ibid.

a hundred different lovers—including her own brother, George Boleyn. A number of the unfortunate men, her brother included, were executed.

Anne was at least granted the honor of a sham trial, in which she was accused of everything from adultery and incest to witchcraft and treason. She was imprisoned in the Tower of London for most of it, and when her turn on the stand came, she calmly denied all the accusations made against her. But confessions had been extracted from a number of her alleged lovers via torture, and various "witnesses" came forward, out of either spite or ambition.

Henry claimed that Anne had bewitched him, among other things, and that they were never truly married. For that reason, he didn't even bother with formally disinheriting Elizabeth. He just commenced referring to her as a bastard. He even questioned her paternity, given her mother's alleged scores of illicit lovers.

It was all over for Anne. She was found guilty and executed on May 19, 1536. Among other sweeping changes she'd brought, she earned the dubious honor of being the first queen of England to be beheaded.* Within twenty-four hours of Anne's execution, Jane Seymour was formally betrothed to Henry VIII. Eleven days later they were married.

Jane Seymour didn't live long. She was only queen for around a year and a half—just long enough to give Henry the son, Edward, for whom he'd torn his country apart. She died two weeks after Edward's birth. Meanwhile, Henry's daughters receded into the background as Henry burned his way through three more wives over the next nine years.

The king grieved Jane for a couple of years, then agreed to an arranged marriage with Anne of Cleves, a princess from the Protestant Alliance. Europe was in the throes of the Reformation

* Robert Lacey, *Great Tales from English History* (Boston: Back Bay Books/ Little Brown, 2007).

and was engulfed in religious warfare. England had pissed off
both the Protestants and the Catholics at various points (mostly
the Catholics) and needed to formally take a stand. The marriage
of Henry to Anne of Cleves was intended (by his more clear-
headed ministers) to be a political alliance. But when the increas-
ingly irrational Henry actually met Anne (who was, let's say, a
little plain) he lost what was left of his mind. He referred to her as
a "Flanders mare,"* and refused to marry her. He threw a tantrum
worthy of a child and had to be talked down by his advisers. Ulti-
mately, he married the good-natured, if slightly dumpy, German
girl in January of 1540. She was taken with her clever and preco-
cious stepdaughter Elizabeth, and while Mary was initially put off
by the Protestant, the two grew very close and remained so until
Anne's death many years later. She was a little homespun, but
she was a kind stepmother and a sweet and accommodating wife.
Nevertheless, Henry said he didn't like anything about her: The
sight of her allegedly left him impotent. He wanted out.

Anne—being perhaps a little brighter than her predecessors—
cheerfully agreed. The marriage was dissolved six months after
the wedding, and in gratitude for her unprecedentedly amiable
acceptance of his desire to annul, Henry gave her a palace, a
household, and the honorary title of king's sister.

Thus he'd dispatched with the only stepmother who was
really nice to all of his children. A mere sixteen days later he mar-
ried his fifth wife, Catherine Howard. She was Anne Boleyn's
cousin, a promiscuous, empty-headed teenager more than thirty
years the king's junior. Over their two-and-a-half-year marriage,
she made no effort to act like a queen at all and proved a petty
and vindictive stepmother. (She was, remember, almost a decade
younger than Mary, who openly disapproved of her.) In retali-
ation against Mary for her perceived lack of respect, Catherine
dismissed Mary's ladies and attempted to publicly humiliate her.

* Lacey, *Great Tales*.

But Henry was infatuated with Catherine, as old fools often are with young tarts—famously referring to her as his "rose without a thorn." In classic fashion, the old perv showered his moronic new toy with money, gifts, and attention—as well as a very long leash. Long enough to hang herself with, it turned out. Everyone was happy enough to ignore her many liaisons *before* her marriage—but she simply never stopped taking lovers. Given that she was a hot teenager married to an obese, emotionally labile old man with a huge sex drive and a rotting leg,* you can hardly fault her for seeking company elsewhere.

But Henry certainly could.

By November 1541, everyone knew about or suspected her of various indiscretions, and in some cases people were even blackmailing her in exchange for their silence. Finally, Archbishop Cranmer decided that the evidence against her was so overwhelming that he had no choice but to tell the king. Unlike the case of her (innocent) cousin Anne, Henry wasn't willing to believe any of the accusations. For some reason he allowed the claims to be further investigated—perhaps only because he was so sure of her innocence.

Instead, when all the facts came to light, the truth was worse than Henry imagined. Still sexually obsessed with her, he took the news extremely hard (supposedly he openly wept in front of his council).† When the guards descended on the queen to arrest her, she attempted to plead with her husband, but he remained immutable. She was dragged by her hair down a corridor while everyone, including Elizabeth, watched.‡ The queen was executed on Tower Green on February 13, 1542. She was buried near

* Henry had a festering wound from an old jousting accident that had occurred during his more robust and athletic youth. It never properly healed, and in his later years smelled and constantly bled or oozed puss. Sexy. . . .

† Lacey, *Great Tales*.

‡ Susan Ronald, *Pirate Queen: Elizabeth I, Her Pirate Adventurers, and the Dawn of Empire* (Stroud, UK: History Press, 2007).

her disgraced cousin Anne Boleyn in the Chapel of Saint Peter ad Vincula at the Tower of London. Mary was surely happy to see her go, but Elizabeth was so traumatized by the event that she (now famously) claimed that she would *never* marry.[*]

Henry's sixth and final wife, Catherine Parr, was older, already widowed twice, and was a veteran stepmother at thirty-one. She became more of a companion to the old and ailing king than anything else. She was a very well-educated woman and a closet Protestant reformer. Most important, she was diplomatic enough to handle the king and smart enough not to try to manipulate him. She was a huge influence on Elizabeth, and continued to treat both Elizabeth and Edward as her wards after Henry's death.

Beyond the care and education of Elizabeth and her younger brother, Catherine Parr's most important contribution to this story was her final (successful) stab at reconciling Henry with his two daughters and restoring them both to the royal succession. In doing so, she not only bound them as sisters but gave them each a shot at the crown.

Bloody Mary and the Virgin Queen

After over a decade of abuse—frequent disownings followed quickly by retractions, banishments, punitive confiscations and redistributions of their cherished possessions—you might expect that the two half sisters hated their domineering and sadistic father. But as it turned out, they worshipped him. Instead, they simply hated each other.

Well, Mary hated Elizabeth. And Elizabeth's mother, Anne. And Protestants in general. It was her persecution of English

[*] Borman, *Elizabeth's Women.*

Protestants (she liked hers well-done) that later earned her the moniker "Bloody Mary." She blamed first her stepmother and later her sister for both her stark reversals of fortune and for the years of misery that followed. She tried, as soon as she ascended the throne, to be magnanimous and sisterly, but she couldn't keep up the act for long. Very rapidly all her bitterness, rage, and contempt came spewing out, most of it directed at her younger sister.

Elizabeth played her cards a little closer to her chest. But she clearly hated being pushed around. She spent most of Mary's reign under a glorified version of house arrest at the behest of her paranoid older sister. Trying to stay out of the line of fire, she hid at her estate in the country as often as she could. But in time she came to the same realization that her mother had decades earlier—Mary was a problem, and one of them would have to die.

Suffice it to say, the two ladies had a tense relationship.

Mary and Elizabeth couldn't have been more different. Like I mentioned earlier, where Mary was dour and pious, Elizabeth was theatrical and glamorous. She was also young and beautiful, which her sister definitely was not. As rulers and thinkers, they were also diametrically different. Elizabeth was a born politician and a progressive thinker. She was also highly educated and an unapologetic intellectual. She wanted to move the country forward into a bright new era. Mary, in part out of genuine faith and in part out of a proclaimed desire to avenge her mother via the Church, was dead set on going backward. She was intractable in her conviction that the world must return to the old order of her childhood, before England's break with Rome.

Mary was fanatically religious and as intolerant of Protestants and other non-Catholics (not to mention false conversions) as her family lineage would suggest. She was also genuinely, deeply religious and by many accounts spiritual, humble, and generous, like her mother. Unfortunately, like her father, she seemed to have gone insane somewhere around midlife.

In her thirties, the formerly long-suffering saint became increasingly paranoid, erratic, violent, and delusional. She believed her sister was plotting against her. In fact, she believed *everyone* was plotting against her. She burned a great many so-called heretics at the stake, thus earning her the unflattering nickname for which she would forever be known to history.

In her defense (not that acts of mass murder are particularly defensible), she suffered enormously during her life, not just at the hands of Elizabeth's mother Anne Boleyn but also from the currents of history and a revolving door of stepmothers with interests of their own. The same could be said of Elizabeth, though she had her own older sister to punish her, and an entire court of nobility to call her a bastard and her mother the "great whore," right up until (and probably after) she became queen. So it seems that nobody got off easy in Tudor England. Yet both girls survived and ascended to the throne in due course. But where the gauntlet of their youth made Mary paranoid and rigid, it made Elizabeth clever and adaptable.

By the time of Henry's death in 1547, the country was broke and at war with itself, literally and figuratively. Henry's Acts of Suppression, which stripped the monasteries of their authority, lands, and wealth (and redistributed it to himself and the nobility), had severed ties between England and Rome, seated supreme religious authority in England with the monarch, and inflamed an already deep divide between Protestants and Catholics. The only thing Henry didn't leave in a total mess was his succession. Remember, he had that one sickly son, Edward. Because both his first wife, Catherine, and his second wife, Anne, were dead by the time he married Jane Seymour (though in Anne's case, only by a matter of days), there could be no question as to Edward's legitimacy. He was male, he was legitimate, and he was the heir apparent. Except that he was a child, so there would follow a little less than a decade of regents, power plays, coups, and plots before Edward graciously succumbed to what was probably tuberculosis.

Catholics and Protestants alike were unnerved by the fact that the next in the line of succession was Edward's older sister Mary Tudor. This was terrifying to the Protestants, who suspected what was in store for them, and upsetting to the Catholics, who did not care to see a woman on the throne, even a faithful one. Nonetheless, "a woman she might be, but she was also a Tudor, and as such the only true heir in the eyes of most Englishmen."* In other words, at that moment, in the summer 1553, she seemed to be the least awful option, and Mary was swept into power on her first and last surge of popularity,† proclaiming, "Vox populi, vox dei": The voice of the people is the voice of God.

Her popularity was short-lived but it was pretty while it lasted. She even felt magnanimous enough to invite her younger sister, Elizabeth, to ride alongside her on her procession through the country to the palace. Biographer Tracy Borman described the scene thusly: "Mary embraced her half sister warmly and proceeded to kiss each of her ladies in turn. She subsequently presented them with gifts of jewels and gave Elizabeth an exquisite necklace of white coral beads trimmed with gold, together with a ruby-and-diamond brooch. In the celebrations that followed, the new queen accorded her half sister first place after herself and appeared anxious to keep her by her side at all times. It seemed that Mary's accession had healed the old wounds between the two sisters and that thenceforth they would enjoy mutual affection and harmony. In fact, this was to be a fleeting high point in their relationship."‡

As Mary and Elizabeth rode through the streets of London, however, "the seeds of discord were already being sown."§ Mary was awkward and unpleasant and hardly a woman of the people.

* Borman, *Elizabeth's Women*.
† After one last failed attempt to install someone else: Jane Grey, the so-called nine-day queen.
‡ Borman, *Elizabeth's Women*.
§ Ibid.

She made neither a powerful regal impression nor an enchanting queenly one. "Lacking her father's ability to charm and enthrall the crowds, Mary progressed through them, responding awkwardly to their cheers and appearing distant and aloof. When a group of poor children sang a verse in her honor, it was noted with disapproval that she 'said nothing to them in reply.'"*

And it didn't help that Elizabeth was the same sort of natural showman that their father had been and the same flirtatious beauty as her mother. "By contrast," Borman wrote, "Elizabeth, who had inherited Henry VIII's gift for public relations in abundance, attracted the most attention as she gracefully inclined her head and waved her hand, making every member of the crowds that thronged the streets feel that she had saluted him or her personally."[†]

Elizabeth, whose popularity was bolstered by her looks and charm, kind of Pippa Middleton-ed her older sister: She stole Mary's spotlight in her own procession to victory. She was described as having that "same indefinable allure that drew men to her" as Anne Boleyn had possessed. According to Borman, "She was also taller than her sister, who was described as being 'of low rather than of middling stature.'" In other words, Mary was short, even for the sixteenth century. Worse, "Although she was only in her midthirties, Mary appeared much older. The turmoil and sadness of her youth had aged her prematurely, and the somber, tight-lipped expression she wore did nothing to lift her lined face."[‡] Not only was her brief moment of popularity comically short, the comparisons (both between the sisters and between Elizabeth and Anne) were numerous and loud. It was the beginning of the downhill slide for a pair of sisters who were never on the easiest of terms.

* Borman, *Elizabeth's Women*.
† Ibid.
‡ Ibid.

Two Girls: One Pearl

Things soured quickly at court, between the sisters and for Mary in general. Mary was deeply paranoid, a tendency not helped by the fact that Elizabeth's enemies at court—particularly the Spanish ambassador, who wished to discredit the Protestant princess before she could inherit the throne—relentlessly imagined plots and slights to report to Mary. Nor did it help that one of the first things Queen Mary did was pass a bill in Parliament to declare Henry VIII's first marriage to her mother legal, relegitimizing Mary but leaving Elizabeth out in the cold. It was also a problem that in Mary's new, very Catholic court (and country), Elizabeth refused to attend mass or to convert to Catholicism. Elizabeth only occasionally pretended she might attend, a ruse Mary enthusiastically fell for every time. The act just made the queen look and feel stupid, and made her resent her smug little sister even more.

Eventually things got so bad between them that Elizabeth sensed she might need to make herself scarce. She requested Mary's permission to leave court and take up residence at her home in the country. Unfortunately, almost as soon as she was gone, a man named Sir Thomas Wyatt the Younger (the son of the poet Thomas Wyatt, one of Anne's more credible alleged lovers) led a massive Protestant rebellion against Mary.

Elizabeth had nothing to do with the uprising—and Thomas Wyatt even cleared her of any involvement from the scaffold before being executed—but nonetheless, Mary refused to believe her sister was innocent. Between the venomous rumors about Elizabeth that Mary's closest counselors had been whispering in her ear from day one (probably just because Elizabeth was next in line to the throne) and the pressure she was under, given how unpopular she was already, Mary was a nervous wreck. The mere rumors of Elizabeth's involvement in the plot were enough to send her into a

paranoid tailspin. The queen decided to imprison her sister—just like Elizabeth's mother, Anne Boleyn, had been—in the Tower of London: the place where everyone knew people went to die.

And Elizabeth knew it too. In a rare instance of public panic, Elizabeth refused to get out of the boat that took her to the Tower, then refused to enter, sitting in the dark in the pouring rain on the step outside the gate. Eventually, she regained her composure and consented to be imprisoned. She remained in the Tower only from March through May 1554, although throughout her three months she was terrorized and relentlessly interrogated. In the end, despite Mary's vehement desire to execute her sister, no evidence turned up of Elizabeth's guilt. From a legal perspective, Elizabeth's execution would have been nothing more than murder. Finally, Mary released Elizabeth, who was allowed to stay at her estate—under armed guard.

Meanwhile, Mary, because of her devoutness, agreed with the conservative opinion that a woman should not rule alone. At thirty-seven, she also didn't have a lot of time left on the marriage market, and so she very quickly began looking for a king. She settled on, unsurprisingly, a Spanish marriage to Philip II. She claimed to be in love with him immediately upon seeing his picture. She was so in love, in fact, that she "would brook no opposition from her council."* Either she didn't notice or didn't care that she was enraging the nobility and the common people alike. A Spanish queen was one thing; a Spanish king was another. Spain was the world power at the time, thanks to all that New World cash, and the xenophobic English felt that the country would be completely subjugated under Spanish rule. Had Mary and Philip's union lasted longer, they would probably have been proven right.

Preparations for the marriage went forward, and it soon came to light that Mary would pose no opposition to Philip's wishes. It was Philip who insisted that Mary release Elizabeth from house

* Borman, *Elizabeth's Women*.

arrest, bring her to court, and reconcile with her. Mary hated the idea but bitterly agreed to follow Philip's command. After all, Mary was smitten. Philip was handsome and charming, and eleven years younger than she. She acted like a giggly young girl, talking about very little else, and frankly, at thirty-seven, made a little bit of a fool of herself. Her counselors finally gave up and reconciled themselves to the union, and dedicated themselves instead to creating the most intense prenup of all time. There were provisions, such as England would not be conscripted into Spanish wars, and Philip would have neither independent authority nor any right to the crown jewels. As it later turned out, Mary refused to ever enforce most of the terms.*

But it was at that point that Philip sent the pearl, La Peregrina, to Mary as a wedding gift, and the jewel became "the wonder of the English court."† No one had ever seen anything like it. It was still early days in what would come to be known as the Age of the Pearl, and it was considered the most perfect and most valuable pearl in the world.

As soon as Elizabeth laid eyes on it, she was consumed with desire.

Beauty and Other Parasitic Conditions

Pearls have been valuable for about as long as humans have used tools. Widely regarded as the oldest recognized gemstone, they've even been found fossilized in Stone Age graves. It probably helps that pearls come in a finished form—no cutting or polishing is

* Mary gave him the "Crown Matrimonial," meaning joint rule. He then helped himself to the English treasury to fund holy war in two different countries, and at the end he even insisted the English fight a war in France alongside Spain.

† Victoria Finlay, *Jewels: A Secret History* (New York: Random House, 2007).

necessary to bring out their luminous beauty. In many ancient cultures throughout the world, pearls have been associated with everything from the moon and its mythology, to love, to purity and flawless perfection. In parts of the ancient Near East, the belief that pearls were a product of tears shed by goddesses under the moonlight persisted for millennia.

The use of pearls among the extremely wealthy as a means of denoting class also dates back to antiquity. In ancient Rome, Julius Caesar enacted sumptuary laws to restrict certain social classes from wearing them. In medieval France, Italy, and Germany, this custom was revived and restricted the ownership of pearls to the aristocracy. In England, Edward III took it even further: He dictated not just who *couldn't* wear certain gems but mandated a complex system of adornment for every social class.

Conspicuous consumption notwithstanding, pearls have long been associated with the divine and reserved for religious purposes. Anywhere there was a goddess of marked femininity, there were pearls. In Rome, pearls were most often "dedicated to Venus, the goddess of love and beauty, who according to mythology, emerged from a shell in the sea."[*] In the Greek story, pearls were formed by droplets of water that fell from Aphrodite's body as she emerged from the sea. Pearls were believed to retain some of the qualities of their progenitor: both her visible radiance and her incorruptible purity. In addition, pearls have been symbolically linked to Isis, the mother goddess in Egypt, and to the pearl maiden Xi Shi in China, whose legendary beauty was rivaled only by the heavens.

The connection of jewels to religion, in other words, is universal. Every religious culture expresses it differently, but the message is the same: *Shininess is next to godliness.*

Regardless of the supply and demand tug-of-war, pearls have always been really hard to acquire—mostly owing to the fact that

[*] Landman et al., *Pearls.*

they're uniquely located underwater—and *inside* another animal. Unlike most gems, pearls aren't stones. They're the biological by-product of another animal. Most people have heard the story about a grain of sand that irritates an oyster and causes a pearl to grow around it. That story is sort of accurate, except that there's no grain of sand and the pearl doesn't grow, exactly. It's built in staggered layers like a brick wall, making pearls the only precious gemstone that isn't a crystal, but rather a mineralized, deposit of secretions within living tissue. Just like a kidney stone! Sexy, huh?

Actually, they're the biological by-product of *two* animals. Instead of sand, the oyster* gets an infection (I know, not very romantic) or a parasite—usually something tiny like a parasitic worm (sorry) or a rotting bit of detritus that penetrates the shell. When the animal can't expel it, it does the next best thing to protect itself: It *coats* the offending bug. Layer after layer of its own organic material builds up around the intruder until the parasite or infection (or whatever) is rendered harmless. There are even the rare few cases of extremely tiny fish or other sea creatures crawling into an oyster and getting essentially shellacked alive, thus retaining their shape.

Mother nature—she is freaky.

Pearls are made mostly of calcium carbonate ($CaCO_3$), in two forms, or polymorphs: aragonite and calcite. Calcite is the more stable of the two polymorphs. Aragonite and calcite are made up of the same component parts, but the molecules are arranged differently, lending the two polymorphs very different physical properties. Just like diamonds and graphite, it all comes down to how the atoms stack up. In fact, aragonite will actually transform into calcite if you heat it.†

* Or any mollusk really; they all make their own versions of pearls, some much
 more valuable than oyster pearls.

† A lot. You have to heat aragonite to 380–470 degrees centigrade to change it
 into calcite.

But calcium carbonate doesn't make up the entire pearl. Ten to fourteen percent of a pearl's mass is made up of numerous organic membranes composed of conchiolin, which is a mix of polysaccharides and proteins. The remaining 2 to 4 percent of a pearl is just water (another good reason not to heat them). Pearls are built in concentric layers, kind of like an onion. The oyster coats the intruder in microthin layers, one upon another, of that organic membrane, conchiolin, and argonitic nacre, also known as mother-of-pearl.

Unlike in the case of an onion, the composite layers of a pearl (in this case of hard nacre and gooey membrane) are irregular. The layers don't politely wait for each other to form, cleanly laying one over another, in concentric rings. Instead, in a process known as "biomineralization," the two very different substances are interspersed like bricks and mortar. The aragonitic nacre forms clear hexagonal crystal bricks, which are held in place and irregularly filled in by the organic conchiolin, which acts like mortar.

The varying thicknesses and arrangement of those crystal bricks and fleshy mortar determine the luster and the iridescence of a pearl. The luster of the pearl—how shiny it is, how well it reflects light—is due in part to its curved, mirrorlike surface, which is made of very hard, scratch-resistant aragonite crystal bricks. The smoother the curve, the more flawless the surface, the better the luster, and the brighter the shine. But pearls do more than just shine. A pearl is composed of millions of layers of stacked crystals and tissue, so the light doesn't merely glance off of the surface. In the millions of microscopic gaps between the hexagonal crystal bricks, the light *penetrates* the surface of the pearl, like sunbeams shining through a crumbling wall. Once inside, the light diffuses, the way it does in water, making some pearls luminous. In other words, some rare pearls actually appear to glow from within.

Because those bricks aren't stacked in straight lines, the pearl also benefits from the optical phenomenon called "diffraction."

Once the photons of light have penetrated the pearl's surface, they scatter like a bunch of pinballs as they bounce off of the irregularly placed crystal bricks. And because the bricks are clear and the mortar is opaque, ranging anywhere from white to black, the appearance of pearls can vary enormously.

To put it simply, pearls are so uniquely captivating because they do almost everything that the human eye finds beautiful. They *sparkle*—in the form of diffraction or iridescence; they *shine*—because of their hard reflective surface; and they *glow*—when the light enters and is diffused through them. They're pretty enough, in fact, to make you forget that you're looking at the remnants of an infection, wrapped around a dead parasite.

Just for Show

Pearls have always been rare and difficult to procure, so between the scarcity effect and the law of supply and demand, pearls are a gem that has always said *money*. But La Peregrina said more than that. Why had Philip not gifted his bride-to-be with a ruby or a diamond? Why not a giant emerald? That would have made the most sense. This was the Spanish Empire, after all. But as it turns out, Spain was rolling in more than just emeralds.

Originally, Columbus was promised 10 percent of the revenue recovered from any lands he discovered. But he failed to fully disclose the assets he found there and eventually fell into disgrace. Among many other things he lost (like his freedom), he was relieved of his stake in the venture. The original terms of his agreement with the Crown also stipulated the standard "royal fifth," or 20 percent, of all the revenue from the New World would go directly to the Crown.

And what revenue there was. The volume of pearls coming from the New World was so great that America was called "the

land of pearls." The sixteenth century itself became known as the "Great Age of the Pearl." According to the curators of Chicago's Field Museum of Natural History, "in all probability more pearls were put into circulation between 1515 and 1545 . . . than over any comparable period of time either before or since."* In an era before cultured pearls, both pearls currently claiming to be La Peregrina would have made a decent gift for a queen.

Pearls are among the most consistently valuable gems in history, due to the uncertainty of their supply, and by the sixteenth century, they had an intense, almost exclusive, association with royalty. Owing to their unique optical properties, combined with their enigmatic, fleshy origin, pearls have always been associated with mystery and sensuality—which, combined with their white color, resulted in an ancient association with femininity, virginity, and Christianity. A gigantic pearl was a good choice for a newly crowned, deeply Catholic queen who was a thirty-seven-year-old virgin bride and more than a little insecure about her position as royalty.

But that's not really the answer to our question. Pearls were now coming en masse from the New World, and for the most part, Spain owned the New World. Like any engagement ring, La Peregrina was meant to be seen by other people at least as much as it was meant to be enjoyed by the bride. A giant pearl from the Spanish fiancé sent a very clear message to Mary—and to everyone else in England. And the message wasn't just one of mutual Catholicism, matrimonial intent, or even a tip of the hat to Mary's (uh, impressive?) virginity at the age of almost forty.

It was a message of wealth, power, and global dominance.

Whether or not Mary got the point, the rest of the country did—and it didn't exactly endear the new queen, or her soon-to-be king, to the impoverished English locals. It also didn't help that after an obnoxiously gaudy, heavily Roman Catholic wed-

* Landman et al., *Pearls*.

ding, twenty cartloads of Spanish gold were dragged through the streets of London.* The anti-Spanish feeling at court and throughout the country was inflamed day by day. Fortunately, it was to be a very short marriage.

Short but disastrous.

The Worst Three-Way Ever

Mary and Philip were married on July 25, 1554. Mary was beside herself with joy. Philip, however, hated everything about England, from the weather to the people. And while he was diplomatic about it, he was particularly disgusted with his new wife. Mary was eleven years his senior, and in his (not entirely incorrect) opinion she was homely, clingy, and generally disappointing. There was also the fact that the English Parliament had refused to crown Philip jointly with Mary. It was a public humiliation for the Spanish emperor's son to be treated like no more than a queen consort.†

That isn't to say that Mary didn't go out of her way to obey his every command, which further incensed the English court. There were even rumors that she intended to defy Parliament and crown him king.‡ The simmering tension between the Crown and the court was reaching a boiling point when, just a few months after the wedding, Mary announced she was pregnant. In her defense, she looked pregnant. Then again, so had her father at her age. And she *seemed* pregnant: She stopped having periods and even appeared to be lactating. But she was not, in fact, pregnant. After

* Peter Ackroyd, *Tudors: The History of England from Henry VIII to Elizabeth I*, vol. 2, *History of England* (New York: St. Martin's Press, 2013).
† Ibid.
‡ Ibid.

way too many months of over-the-top anticipation and prepara-
tion and formal announcements—nothing. To her total public
humiliation, her pregnancy, the first of two she would have before
succumbing to whatever was causing them (prolactinoma, histo-
rians later surmised[*]), was false.

It's safe to say that Mary had gone full-metal crazy at this
point. Not satisfied with returning England to Roman Catholi-
cism, 1554–55 was also the year Mary went on her wild rampage
of Protestant persecution, torturing and killing many of her sub-
jects, including the roughly three hundred burned at the stake.
Even the Spanish contingent thought she was overdoing it. And
when your holy war–waging, religious fanatic husband suggests
maybe you need a time-out (which is essentially what happened),[†]
the wheels have come off the cart.

In April of 1555, Elizabeth was under house arrest again,
until not-really-pregnant Mary went into false labor. Elizabeth
was called from Woodstock to her sister at Whitehall. This might
seem a touching expression of sisterly affection, but in fact Eliza-
beth was simply there in case the queen died in labor.

Here's where the story gets interesting: Philip took it upon
himself to meet the princess in private a couple of days after she
arrived. Elizabeth supposedly "charmed"[‡] him, and he presented
her with a very valuable diamond, just a gift, worth 4,000 ducets.[§]
(By vague comparison, that's around 23 million of today's
dollars—not a bad *getting-to-know-you* gift for a new sister-in-
law.) After that, he allegedly insisted to his wife that she forgive
Elizabeth. At Philip's insistence, Mary reconciled with Eliza-
beth, or at least pretended to. Much later, when his wife lay on

[*] A prolactionoma is a tumor of the pituitary gland that can create very realistic
symptoms of pregnancy—as well as migraines, mood swings, and the gradual
onset of blindness, all of which Mary also complained of.

[†] Lacey, *Great Tales*.

[‡] Ronald, *Pirate Queen*.

[§] Ackroyd, *Tudors*.

her deathbed and it had become clear there would be no child, he even demanded Mary reinstate Elizabeth as her heir.

Years later, Elizabeth would tell people that Philip had fallen in love with her as soon as they met. He remained silent on the matter. If the two of them had some understanding, or even an actual arrangement in the works, it never materialized. But by the time Philip met Elizabeth, he had no doubt realized that Mary was a dud. Maybe Philip *was* in love with Elizabeth. Maybe he was in lust. Maybe he was just thinking ahead and wanted first dibs on the *next* queen of England. It doesn't really matter. Either way, he wanted Elizabeth, not Mary. And people noticed.

By August, it was humiliatingly clear that there was no baby, and by September 4, Philip was gone, having insisted duty called elsewhere.* He wouldn't return for two years. In his absence, Elizabeth was allowed to return to now more lenient house arrest, and Mary was given to fits of hysterics, sobbing, beating her fists, and privately cursing her bastard sister. When Philip did return in June of 1557, it was only for a month and to seek support for a Spanish-Habsburg invasion of France. Mary, of course, gave it her full support (meaning money, among other things) despite the fact that her elaborate prenup expressly forbade it. Not that she got much for her money. All that came of his second visit was a second pseudopregnancy and the loss of Calais, the last English territory in France.

The laughingstock of Europe, hated by a majority of her people, abandoned by her husband, and vexed by her healthy younger sister, Mary began to wither. In September of that year, Philip was informed that his wife was about to die. He responded by sending an envoy to Elizabeth proposing marriage.

* In fact, Philip lucked out and got to use the very timely excuse that he was needed to run the Spanish Empire—his father, Emperor Charles V, was abdicating to seek solace in a monastery for the remainder of his life. Maybe he felt bad about South America. . . .

Bad Blood

So Mary was hot for Philip, Philip wanted Elizabeth, and Elizabeth had eyes only for the family jewels. Oh, love triangles . . .

For Philip, the marriage to Mary was an arrangement of political convenience and evidently a rather inconvenient one at that. According to his friend (and wedding guest) Ruy Gómez de Silva, "it will take a great God to drink this cup."* So when Mary died a few years after their wedding, Philip wasn't exactly broken up about it. He was so unfazed, in fact, that he immediately proposed to her much younger sister. (In terms of taste, that's nearly on par with beheading your wife, then marrying her illiterate, nymphomaniacal teenage cousin. Keeping it classy, Tudors.) Elizabeth, who'd supposedly sworn she would never marry, found the offer objectionable for both personal and political reasons—and made a point of saying so.

The reasons for the lifelong grudge between the two sisters are fairly clear. What is slightly more mysterious was the depth of hatred and tension that existed concurrently between England and Spain at the time. For decades, the two countries had been engaged in a sort of cold war. But why? Why did the English hate the Spanish so intensely, and why did the Spanish return the favor? The answer, as it turns out, takes us back to Henry VIII, who didn't just sow discord between his wives and daughters. He was also responsible for hostility between England and Spain that would culminate decades later in the Anglo-Spanish Wars.

Henry's Act of Supremacy in 1534 was supposedly part of his "great matter": his desperate desire to annul his marriage to Bloody Mary's mother, Queen Catherine (who was, remember, Spanish). But ultimately, this act took the form of acts of retaliation against the Catholic Church. Church lands, wealth, and jew-

* Farquhar, *Behind the Palace Doors.*

els were seized and doled out to the Crown and the nobility. The Act of Supremacy was part of the systematic dismantling of the Catholic Church in England, and while it greatly enriched the English aristocracy, it also laid the groundwork for the tensions that would eventually erupt between Spain and England.

Spain was understandably insulted when Henry threw off Catherine of Aragon, the daughter of Les Reyes Católicos, for some hot young thing (Anne), then declared the half-Spanish heir to the throne a bastard. But they were outraged when Henry broke with the Church, "suppressed" (i.e., mugged) the abbeys and monasteries, and basically proclaimed himself the pope of England.

The rift between the countries was temporarily and only imperfectly healed when—as Henry married and disposed of one woman after another, made and broke alliances in every country, terrorized his children, and executed half of his friends for various imagined treasons—Spain was reassured that Henry's actions had not been the targeted act of an anti-Catholic, but rather an expression of the erratic whims of a madman. Spain was further pacified when Mary ascended the throne after a brief regency on behalf of Henry's young son. Mary accomplished her two great goals before she died: She reconciled England with Rome, returning Catholicism to the land, and avenged her mother via the Church by having her parents' annulment declared invalid. She even married the Spanish heir for good measure, over the extreme objections of her people.

But the English couldn't tolerate Philip, Philip couldn't stand Mary, Mary couldn't get pregnant, and then she died too. When Mary died, Elizabeth took the throne. And she made it clear, very publicly, that she _wouldn't have_ the most eligible bachelor in Christendom.

Burn.

So the two countries were right back where they started, but with a lot more personal antagonism, embarrassment, and hurt feelings between Elizabeth and Philip than there had been

between their respective fathers, Henry VIII and Charles V. Still, no one wanted an open conflict, so for years the two countries existed in a kind of state of cold war. Spain flaunted its wealth and unquestionable sea dominance, declaring any English trade or exploration in the New World illegal. Elizabeth laughingly regaled foreign dignitaries with stories of Philip's desperate attempts to woo her, deliberately insulting his pride. There were also more serious transgressions: For decades Philip waged holy war against Protestantism, notably in the Netherlands, where a great many English Protestants had fled during Bloody Mary's reign of terror. Elizabeth, in turn, continually looked the other way when English subjects waged private attacks on Spanish interests at sea, raiding and sinking treasure ships, with no expectation of reprisal by their queen.

In fact, one of the two primary sources of rancor between England and Spain was what the Spanish called English "sea dogs" in Spanish waters—pirates, essentially, who openly attacked Spanish merchant and treasure ships. Elizabeth at first merely tolerated these pirates, but later, as her desire for pearls like La Peregrina grew in proportion to her determination to humiliate the Spanish, she employed them. These were the pirates that would, over time, form the basis of the greatest naval force in the world.

You Can't Take It with You, but You *Can* Take It Away

Mary was many things—more than a little mean, bitter, and vindictive—and certainly she was malicious in her sisterly envy, but she wasn't completely stupid. When it became clear that she was going to die without an heir and was abandoned by her husband, she resentfully, and with no small amount of despair, left

the throne to Elizabeth, if only to save her already decimated country from another civil war. But while she wouldn't have the pleasure of denying her sister the crown, there was one desire of Elizabeth's that she could thwart. She made a point of mandating in her will that, though by right the crown jewels went to the new queen, Philip should have back all the jewels he gave her— including La Peregrina.

In fact, during their very brief union, Philip gave Mary quite a few remarkable jewels. In 1554, for example, he sent the Marquis de las Navas ahead, bearing "a table diamond in the shape of a rose, beautifully worked: appreciated for a thousand ducats. A necklace with eighteen point-cut diamonds well worked and beautifully placed together with grace one next to the other: This collar valued at 30,000 ducats. Another diamond from which a large pearl hung from the front. These two pieces were the most lovely and handsome ever made in the universe, and because of their delicacy and appearance, they were appreciated for 25,000 ducats."[*]

You can read whatever you want into the fact that he gave all of it to Mary *before* he ever actually set eyes on her and little or nothing afterward. Nonetheless, Philip gave Mary a number of substantial (and genuinely unique) pieces: a legitimate fortune worth of jewelry. And while she willed all of it back to Philip, the only piece he actually bothered to take back to Spain was the pearl Elizabeth absolutely adored.

Big mistake.

Religious Icons and Fashion Icons

As every rapper knows, bling equals power. Unmarried Elizabeth wanted to make a show of her independent power. In addi-

[*] Andrés Muñoz, *Viaje de Felipe Segundo à Inglaterra*, 1877.

tion to money, femininity, purity, and the divine, pearls are also heavily associated with marriage. The tradition goes back thousands of years and is owed in part to the story that the Hindu god Krishna found the very first pearl, representing purity and love, and presented it to his daughter on the day of her wedding. Many other cultures, including our own, have co-opted that symbolism to integrate pearls into wedding traditions.

Because of their nearly universal connotations of purity, in fact, pearls have a particular association with the spread of Christianity. Christianity ultimately adopted the pearl as a symbol of the Virgin Mary, of purity and of the incorruptible soul. According to the New Testament, the gates of heaven are made of one solid pearl. It's no wonder the newly minted "Virgin Queen" would choose them as her emblem. And it's no coincidence either.

Portraits and descriptions of Elizabeth throughout her reign document her unparalleled pearl collection. Men and women in her court were covered in pearls, but the best specimens were, of course, reserved for the queen. She had dresses so heavy one can't imagine how she wore them; it is likely she could hardly stand, she was so weighed down in pearls.

While she may not have had La Peregrina, she certainly acquired a number of slightly lesser look-alikes. Numerous portraits of the queen show her wearing a variety of different brooches and necklaces, all subtle variations on a large square diamond and suspended pearl: Mary's jewel. On the one hand, she was expressing her flair for benign envy—she wanted La Peregrina, but an equally valuable copy (or twelve) would do—for now. . . .

On the other hand, she was also aggressively displaying to her people her success at acquiring riches commensurate with those of their Spanish rivals. She was showing her strength as a "prince," as she liked to call herself; one more than capable of protecting her people and promoting their interests in a dangerous, expanding world. And her people got the message. In one

instance, during the peak of tensions, right in front of the Spanish ambassador "a loyal British nobleman withdrew from the pocket of his velvet breeches a pearl worth 15,000 pounds, pulverized it, dropped it in a glass of wine, and drank a toast to Queen Elizabeth of England and King Philip of Spain." He might as well have given him the finger. It certainly would have cost less. . . .

Ever keen to the power of impressions, Elizabeth only tolerated attractive people in her court. She instituted what she called the "Statutes of Apparel," dictating, in detail, who could and *should* wear what. Like a bride, she wanted her ladies-in-waiting to look good—but not better than she did. One famous story tells of a Lady Howard who arrived at court in a velvet dress adorned in pearl embroidery. When Elizabeth saw the dress, she was so taken with it that she asked to "borrow" it. The owner said yes; she had little choice. Unfortunately, Lady Howard was quite a bit shorter than Elizabeth. When the dress didn't fit the queen, Lady Howard was informed that if Elizabeth couldn't wear it, neither could anyone else.[*]

Elizabeth was, in many ways, a marketing genius—and the product she was marketing was herself. It wasn't just because she owned and displayed such a vast quantity of pearls that she became associated with them. She deliberately employed pearls and all of their associated virtue as the most crucial element in a giant spectacle of symbolism that became central to her ability to govern.

She was, remember, at a disadvantage. She was a female monarch, and as such she was considered weak, inadequate, and fundamentally handicapped by her own gender. But Elizabeth had no desire to marry. She had no desire to be hobbled by a husband or a king, and she refused to see England sidelined by a foreign power. So rather than acknowledging this perceived deficit, the way her older sister had, and immediately hiding behind a husband, Elizabeth did the reverse. She became *more* public, more

[*] Ki Hakney and Diana Edkins, *People and Pearls: The Magic Endures* (New York: HarperCollins, 2000).

visible, more ostentatious. She gave the people something that they had so desperately lacked ever since her father's half-finished reformation: an icon. By fashioning herself as the Virgin Queen, Elizabeth managed to occupy that vacant position in her people's hearts and minds. She claimed often that she needed no husband because she was "already bound to a husband, the kingdom of England."*

She wore white face paint and covered herself in pounds of pearls. While her actual love life is a matter of raging debate, she fiercely maintained the public facade of virginity until the day she died. By the time she was in her forties, the "cult of Elizabeth," referred to as "Gloriana," was in full swing. All paintings of her, like religious icons, had to align with an official template. They centered heavily around the use of pearls, and other secondary religious symbols representing her virginity, her Christian virtue, and her femininity.† Elizabeth thus made herself one part public servant and one part living deity—and effectively neutralized any criticism of her gender, her marital status, or her religion, as the ruler of England.

The queen's carefully cultivated image had to be constantly maintained. The symbol-laden state portraits were just the beginning. She also made public processions every summer during which her people could adore Gloriana, the Virgin Queen, in all her luminescent, white-faced, pearl-dripping majesty. In time, her Accession Day was observed as a national holiday, in spite of the fact that for Catholic Europe, it was also Saint Huge's Day. She also took up her father's tradition of tournaments and jousting matches, with some important modifications. During Henry's reign, those tournaments were legitimate athletic competitions for the boys. Elizabeth turned them into fanciful, glamorous events intended to unite the English people in a sense of grandeur,

* Lacey, *Great Tales.*
† Ibid.

chivalry, and Arthurian splendor. According to John Guy, "Here protestant propaganda fused with courtly love and chivalric and classical traditions to create the legend of Elizabeth as the vestal virgin of the reformed religion, worshipped by her knights on the occasion of a new quasi-religious festival."*

In many ways, Elizabeth I's story is the exact inverse of the unhappy Marie Antoinette's. The French queen was also associated with jewels—but in a very different capacity. Both women were ultimately dehumanized and regarded as iconic during their own lifetimes. But unlike Marie Antoinette's sexual, economic, and moral guilt by association, Elizabeth took control of public perception and wielded it like a tool. She used some of the more positive moral connotations of jewelry to achieve a kind of reflected virtue.

Cleopatra used emeralds to look rich and powerful. Elizabeth used pearls to look virginal and holy. Same game, different angle. But the emeralds belonged to Egypt. The pearls did *not* belong to England. They belonged to Spain.† And Spain was not amused.

Her Majesty's Not-So-Secret Service

When Elizabeth inherited the throne, England's infrastructure was falling apart, the country was about to explode, once again, into religious civil war, and it faced numerous military threats from abroad. Worst of all, Philip had used the English coffers to finance war (the disastrous one during which they had lost Calais), and conveniently failed to repay the debt. So England

* John Guy, *Queen of Scots: The True Life of Mary Stuart* (Boston: Mariner Books, 2005).

† OK, so they actually belonged to the various people of the New World. But they lost them two chapters ago, so let's not split hairs.

was dead broke. What's a girl to do? If that girl is Elizabeth I, the answer is: hire pirates.

Or rather *privateers*. Technically, a privateer is a civilian—in other words, not a sanctioned naval officer—who is nonetheless authorized by the government to attack foreign vessels during wartime. Authorizing privateers was a very effective way for any nation to mobilize extra men and ships during war, without having to keep them on the payroll during times of peace. A pay-for-play navy—in essence—but one that paid itself. Any money or items of value were forfeit to the ship that could obtain them, making privateering a free strong arm for the state and a potentially lucrative payday for the sailors.

The distinction between a privateer and a pirate is really a matter of perspective. For all practical purposes, a pirate and a privateer do the same thing; terrorize, raid, plunder, and sink enemy ships. The only appreciable difference is that privateers generally have formal (sometimes even written) authorization to do what they're doing. Additionally, privateers give the powers that be a generous cut, making privateers pirates who pay taxes.

Elizabeth wasn't the first or last monarch to employ privateers during wartime. But her particular innovation was that she covertly authorized them to act during times of relative peace. Elizabeth's arrangement with her privateers was at first a tacit understanding, and later an explicit (if verbal) contract. She supplemented the English navy with privateers, granting pirates and would-be pirates legal immunity from the rest of the English navy in exchange for their services. She then gave them orders—by which I mean that Elizabeth let it be known that it might please her if they would attack, plunder, and sink every Spanish ship they encountered. She particularly requested that they bring her as many pearls as they could from ships on the Spanish Main.*

While deliberately allowing Anglo-Spanish relations to dete-

* Landman et al., *Pearls*.

riorate, she generated enormous revenue for England. She took a standard one-third cut of all the plunder, substantially improving on the royal fifth demanded by the Spanish Crown on any New World enterprise. (I guess the graft is higher when what you're doing is flagrantly illegal.) It was the actual Vatican that finally dubbed her the "patroness of heretics and pirates."*

These attacks on Spanish ships were also a subversive form of national defense. As one of Elizabeth's favorite captains, Sir Walter Raleigh, pointed out, whatever hurt Spain made England safer. "Gentleman adventurers," as these sea dogs were sometimes called, came in every shape and size, from aristocratic second sons, standing to inherit very little, to criminals with nothing to lose. Some were just average men looking for a little excitement—and, of course, a payday. They were flamboyant and exciting, with thrilling tales of distant countries and dangerous sea battles. And they always came to the queen bearing gifts, usually in the form of jewels.

Some of the most successful (and colorful) gentlemen adventurers, like Sir Francis Drake, whom she knighted on the deck of his own ship, or Sir Walter Raleigh, who named the colony of Virginia in her honor, took the top spots as her favorites at court. They were fearless, lawless, and flashy—and these were the kind of men who would become the cornerstone of Queen Elizabeth's pirate navy.

During Elizabeth's reign, she encouraged these gentlemen adventurers with favor, titles, positions, even with flirtation, and, of course, a lack of any kind of prosecution. And then Elizabeth took shelter behind plausible deniability. When Spain was outraged and petitioned the queen for justice, she would express sympathy but claim to have no control over the acts of these fearsome and immoral pirates—all the while smugly aware that the entire world knew the men acted at her pleasure. Often she disclaimed

* Ronald, *Pirate Queen*.

responsibility for the pirates' actions while obviously wearing the spoils of one of their recent plunders: for instance, "a magnificent emerald and gold crown and a diamond cross" presented to her by Francis Drake,* after his circumnavigation of the globe.

It was at this point that Spain, or more specifically Philip, began musing on what would eventually be termed the "Empresa de Inglaterra," or the Enterprise of England. The undertaking, which would ignite what was still an undeclared war, involved invading England by sea, overtaking the small, unprepared country, ousting the bastard patroness of heretics and pirates from her ill-gotten throne, and reclaiming Philip's title as king of England. The endgame was to put a stop to the heretical government, prevent any future aid from England to the Protestant Netherlands, and most important, to stop the tide of treasure from pouring out of Spain's pockets and into England's.

What's Yours Is Mine, What's Spain's Is Also Mine

Elizabeth's desire took a very different form than her sister's. One of Mary's final acts of malicious envy was to ensure that Elizabeth couldn't have the pearl she wanted. Elizabeth, on the other hand, didn't care all that much if Spain also had wealth. Giving Spain a bloody nose didn't cost her any sleep, but ultimately, she really just wanted to possess what Spain possessed; from colonial access to cold hard cash. In that way, her envy was benign, although its consequences would be far from peaceful.

In a short time, simple raiding became the foundation of England's New World ventures. The flirtatious, swaggering Sir Walter Raleigh, one of Elizabeth's favorites, received permission

* Sally E. Mosher, *People and Their Contexts: A Chronology of the 16th Century World* (n.p., 2001).

to found the first colony in the Americas, Roanoke, in what he called Virginia,* named for the Virgin Queen herself—it was to be, among other things, a staging ground for attacks on Spanish colonies and shipping. She sent infamous pirates Francis Drake and John Hawkins to harry the Spanish and Portuguese along the western coast of Africa and seize all they could while disrupting trade routes and settlements.

The greatest (and most celebrated) act of piracy was committed by the infamous Francis Drake. In 1585, Drake, or El Draco (the dragon) as the Spanish called him, actually led a fleet of twenty-one ships and nearly two thousand men to the Americas. Instead of just harassing and raiding treasure ships, they made landfall and attacked the Spanish colonies. Drake went from city to city from Colombia to Florida, taking hostage quite a lot of New Spain. Having not enough forces to hold it, Drake, in typical pirate fashion, ransomed all of it (less the portable treasure) back to Spain. He was celebrated throughout England, and his ship, the *Golden Hind*, became an emblem of English pride.

Between 1577 and 1580, Drake famously circumnavigated the entire globe.† He didn't just circumnavigate it—he looted and pillaged the whole way. At one point, he even landed in Spanish California and brazenly claimed it for his queen. Upon his return from this unofficially sanctioned mission, crowds gathered to cheer him. On the deck of his ship, the *Golden Hind*, Queen Elizabeth, holding a sword to his neck, playfully asked the crowds if she should execute the scoundrel. When they all shouted "No!" she used the sword to knight him instead.

The Spanish ships tried various evasive maneuvers, even attempting to disguise their cargo, but the English pirates had

* Technically, by modern standards, Roanoke was in North Carolina, not Virginia. But at the time Elizabeth issued Raleigh's charter "Virginia" stretched from Carolina to Florida.
† Drake's was only the second successful circumnavigation, after Magellan's.

figured out early on how to spot a low-riding ship that was heavy with treasure. And the slow, heavy galleons were no match for the smaller, faster, armed-to-the-teeth English pirate ships. All of that New World money was pouring out of Spain's hands and into England's. And gradually, like a pocket with a hole in it, Spain started to really hemorrhage cash. (To give you a sense of the volume of treasure exchanging hands, one particular raid in 1585 turned up pearls in such a great quantity that "Elizabeth . . . kept a whole cabinet filled with them for her own use."*)

What had been subversive, albeit transparent, piracy was getting bigger and louder. Piracy had become not just a part of English foreign policy but of the national identity. These adventurers, these glamorous (and supposedly platonic) admirers of the queen, were national heroes, and as their success and their popularity grew, so did the license they took on the seas. The queen barely bothered to deny her involvement with these gentlemen adventurers anymore—and what had once been a suggestion that they bring her pearls was becoming a complex arrangement of naval defense, trade exploration, and, of course, "harvesting the seas."

England's benign envy was paying off—the country was transforming itself from a backwater pawn into a global presence. And in the sixteenth century, there was only one thing the Spanish Empire was more intolerant of than religious diversity: losing money.

Statecraft and Stagecraft

Early in Elizabeth's reign, King Philip of Spain was said to "admire her, but lament her heresy."† By the 1570s, that admi-

* Ronald, *Pirate Queen.*
† Ibid.

ration was all dried up—and not just among Spanish Catho-
lics. Although a majority of the people worshipped and admired
Elizabeth, there was still a fringe Catholic element in England
taking orders directly from the Vatican. In 1570, this fringe
received the same sort of ambiguous standing order from the
Church regarding the English queen that Elizabeth gave her
pirates regarding pearls: There was a general call to arms for
any devout Catholics to kill the queen. This shocking mandate
was couched in religious rhetoric, but it actually had more to do
with money and with the English piracy that was slowly upset-
ting the balance of power.

By that time, religious division in Europe had reached a fever
pitch. A seminally divisive moment had occurred in 1568 when
Elizabeth's most senior and most trusted minister, Cecil, an elder
statesman, had ordered the seizure of Philip's treasure ships,
blown off course and bobbing under the weight of tons of Span-
ish gold—gold intended to pay the soldiers fighting Spain's war
in the Netherlands. Not only did Cecil's first (and only) turn as
pirate violate Elizabeth's general policy of avoiding other people's
religious skirmishes, it reaffirmed for the entire world, and cer-
tainly for Philip, that no English were to be trusted: They were *all*
pirates. Shortly thereafter, in February of that year, Pope Pious V
issued a papal bull, Regans Excelsis, which not only excommu-
nicated the English queen but declared her, in the eyes of all of
Catholic Europe, to be deposed. Most important, the Regans
Excelsis absolved her subjects of any loyalty to her. By May, if
you were an English Catholic, it was open season on the queen.

This papal mandate coincided with the plot against her led
by her very Catholic cousin Mary, Queen of Scots. Mary was
younger, Mary was sexy, and where Elizabeth carefully managed
her own image like a PR firm, Mary just swung wild. She was a
Catholic, but she was by no means the violent fanatic that Mary
Tudor had been. And not only was she the queen of Scotland, she
was also next in line to the English throne.

By the time Mary had burned through her third marriage, the scandals surrounding her various husbands and their various suspicious deaths and misdeeds had reached such a crescendo that she was forced by her own people to abdicate the Scottish throne to her infant son, James I—and subsequently to hightail it out of there before the Scottish nobility decided to deprive her of anything more than her crown. She hurried to England, hoping for protection from her older, smarter, and far more powerful cousin Elizabeth. Mary hoped that her cousin would support her cause, and help her retake her throne in Scotland.

Did I mention her trademark poor judgment?

Instead of granting her military support, Elizabeth kept her cousin (and presumptive heir) in polite captivity for the next nineteen years. Mary wasn't thrown in the Tower, but she wasn't allowed to leave England either. It was rather reminiscent of the generous version of house arrest under which Elizabeth herself had lived for many years. The primary difference in their respective situations—and their outcomes—was that during her captivity, Elizabeth focused on keeping her head down and attached to her neck. Mary, on the other hand, did not—with predictably awful results.

Having spent years in Fotheringhay Castle, Mary was bored, she was stir-crazy, and she was feeling that old itch to do something stupid when Elizabeth's Machiavellian spymaster, Francis Walsingham, got tired of waiting for Mary to commit the treason he felt sure was imminent. So he helped move her along. Mary believed that her private correspondence, which was smuggled in and out of the castle in a beer barrel, was secret and secure. But Walsingham knew what she was doing, and arranged for all of them to be intercepted, opened, and read, then resealed and delivered to her without anyone's knowledge. (He essentially wiretapped her or, more accurately, barrel-tapped her.) When she received a letter from a supporter offering to help install her as queen of England after assassinating Elizabeth, Mary took the

bait hook, line, and sinker. She wrote back enthusiastically and agreed to the plot, the assassination, and her role thereafter.

As soon as Walsingham read her reply, he had the conspirators rounded up and brutally executed, while Mary was arrested and thrown in the Tower to await her turn. Strangely, Elizabeth vacillated. She firmly believed in the sovereignty of monarchy (as monarchs always seem to do). More important, she was also a pragmatist and a canny politician. Kill a queen, and queens are mortal. Beyond the symbolic implications, which didn't suit her, she equally didn't like the precedent it might set for legal regicide. She also now found herself in an awkward situation, playing the Virgin Queen—living demigoddess. She couldn't have her hands dirty. She couldn't be seen to execute some petty rival, and thereby acknowledge that said rival posed a very real threat to her sovereignty.

So she took a page out of her father's playbook. She issued the order for Mary's execution, and then blamed her cabinet for enforcing it, claiming she only signed the death warrant *in case she needed it* and that they'd preempted her authority. After the execution, Elizabeth spent days making a public spectacle of her grief, her rage, and her remorse that Mary No-Longer Queen of Scots had been executed without Elizabeth's *really* real consent. (And then she took Mary's very famous pearls for her own collection.)*

Mary, meanwhile, had died with all the power and dignity her life had thus far lacked. She showed up for her execution wearing a brilliant scarlet dress and a totally sorry-I'm-not-sorry attitude. With her head on the block, Mary presciently said, "Look to your consciences and remember that the theatre of the world is wider than the realm of England."†

* Mary had some truly legendary pearls of her own: an enormous six-strand necklace gifted to her by her first mother-in-law, French queen Catherine d'Medici, and an unprecedented, waist-length strand of perfect black pearls. Elizabeth certainly didn't execute Mary for her pearls, but she displayed no qualms about snatching them up as soon as Mary was headless.

† Guy, *Queen of Scots*.

Boy, was she right.

While Elizabeth may have done her dead father proud by publically escaping blame for the execution of her cousin, she had given Philip of Spain the pretext he had so long desired. With the "murder" of a Catholic queen now in play, he at last had an acceptable reason to invade England.

Always Hire Pirates

Finally, the Empresa de Inglaterra, the Enterprise of England, was a go.

The plan was simple, relatively speaking. Spain would build the biggest, baddest fleet of warships (or *armada, en español)* ever created and use them to bring tens of thousands of troops to invade England, whereupon they would overthrow the queen, thus ending England's relentless piracy, further isolating the Protestant Netherlands, and bringing England back into the Catholic fold. The massive Spanish warships were loaded with soldiers, horses, cannon, weapons, and, of course, gold. Philip wasn't just planning on waging a war—he was planning on importing one, down to the last bullet. The scale of the plan was epic. He burned through both the treasuries and the forests of Spain making the Armada a reality.

But by that point, between her pirates and her spies, Elizabeth had ears everywhere.* She caught wind of the plan—admittedly the worst-kept secret in Western Europe—before the first ship had ever set sail. When Elizabeth found out that Philip had finally decided to assemble the Armada he'd been fanaticizing about for,

* Elizabeth was one of the most formidable spymasters in the world. She's even shown in one of her most famous portraits wearing a dress covered in stylized ears and eyes—meant to suggest her all-seeing and all-hearing status.

oh, the last couple of decades, she launched a preemptive strike. She sent Sir Francis Drake, in command of a very small fleet, to destroy the Armada ships and supplies in the port at Cadiz, where they were being built. At the last minute, she apparently changed her mind, but Drake, intent on "singeing the king of Spain's beard," hurried up and set sail before the anticipated letter rescinding his orders could arrive. In April 1587, he and his crew headed toward the Iberian Peninsula and launched a lightning strike on the harbor. The first Armada was destroyed before it ever left the shipyards.

Drake's mission was a total success. Even so, it only bought the English about a year. Philip was undeterred, seriously pissed off, and more determined than ever to remove the heretic queen from the throne. So he cut down what was left of Spain's forests, emptied what was left of the treasury, and started building again. The Armada was imagined and executed to the last detail by Philip himself, and by the time he was done, in May of 1588, the second Spanish Armada represented the biggest, most terrifying military show of force the world had ever known.

On the 12th of July, 1588, the Armada sailed under the command of the Spanish admiral the Duke of Medina Sidonia. The fleet was a vast array of 151 ships in various shapes and sizes. The largest were like gargantuan sailing castles—the smallest, merely enormous. The primary fighting ships, all of them on the smaller side, were about a thousand tons each. Sailing east in a massive crescent formation *several miles across*, the sheer magnitude of the Armada was terrifying, even moving as slowly as it did, at only about two miles per hour.

The Armada was designed to bring the war to England. It was never really intended to fight a sea battle, which explains why so many of the ships were filled with horses, land weapons, and money. The Spanish even brought hundreds of priests and servants in anticipation of their victory and occupation. Though a sea battle wasn't necessarily expected, the Spanish had no doubt

their "Invincible Armada"* could hold its own if it had to. Just the size of the crescent offered protection, as naval battles in the sixteenth century were universally fought "face-to-face." Even if a few English ships made it through the cannon fire and into the formation itself, fighting traditionally unfolded *on* one of the ship's decks. Beyond the incredible size of their defensive formation, making it almost impossible to get close to most of the ships, the Spanish had superior numbers, with about twenty-five thousand soldiers and sailors alone. In a traditional conflict, they had every reason to be confident in their ability to crush the English.

But they had no idea what they were about to encounter.

The Enemy of My Enemy Is My Navy

The English fleet was made up of about ten thousand men and 140 much smaller ships, most of them captained by privateers. Even legitimate naval ships had been redesigned or retrofitted over the years to more closely resemble the fast, nimble, heavily gunned pirate ships that were crippling Spain's income. And what the English ships lacked in size, they made up for in firepower. In addition to the usual guns, they also carried unusually long-range cannon that had been developed for sinking ships out on the open sea.

The fleet was commanded by the queen's cousin Lord High Admiral Baron Howard of Effingham, but the vice admiral was none other than Sir Francis Drake. Command posts were filled by a mishmash of officers, both nobility and infamous pirates. The strange fusion went beyond personnel and equipment; it extended to the entire British approach to battle. The English used new

* Invincible Armada? That's just asking for trouble. That's like saying the "unsinkable Titanic."

tactics, which, like their ship design, had been developed and adapted over several decades of open-ocean piracy. The Spanish moved in a tight formation that was difficult to approach or breach, because they expected the English to attempt to board and take their ships. That is, after all, how naval battles had been fought for centuries. But what the Spanish didn't realize was that the English had no interest in "taking" their ships—except for the handful carrying all the money.* They wanted just one thing: to destroy the Armada ships before they reached England.

On July 21, the English fleet encountered the Spanish Armada. The Spanish expected to steamroll their way through any English resistance. But rather than engaging their ships head-on, the English fleet opened fire on the several-mile-long crescent from a safe distance. They used their long-range cannons to pick off one huge ship at a time, even as they chased the fleet through the English Channel. It was slow progress. The crescent shape protected most of the ships, and the Armada refused to break formation. The admiral wrote to Elizabeth that "their force is wonderful great and strong, and yet we pluck their feathers by little and little."† For the first few days, the English fleet had to settle for following the Armada and picking off ships or forcing them into collisions.

The Armada was intending to rendezvous with the Duke of Parma and pick up a second reserve army of an additional twenty thousand soldiers who would be ferried out to the waiting Spanish warships. When, on July 27, they attempted to do so, they found that Parma's forces were unable to make the short crossing without being preyed upon by the smaller English ships. The Armada had to drop anchor near Calais, on the French coast.‡ This was a

* Drake in particular tried to pick off a few of those.

† Lacey, *Great Tales*.

‡ The same Calais that the English had, ironically, lost under Philip's military leadership decades before.

turning point in the battle, the moment at which it became truly clear that the English navy had become a different animal altogether. Just after midnight on the 28th, the English covered eight of their *own ships* in pitch and set them on fire. They launched the burning "fire ships" into the harbor where the Armada had cornered itself. The Spanish ships were not only made of wood and rope and canvas, they were absolutely packed with gunpowder in anticipation of the battle on land. Once the roaring fireships came close, the Spanish ships were basically giant explosive devices.

Needless to say, the Armada finally broke formation.

The ships that didn't explode or burn were forced to cut anchor and flee the harbor in panic. Once the Armada was scattered in the open water, the pursuing English fleet was able to employ one final advantage. Their ships weren't just smaller and faster—they could sail in any direction. The giant Spanish juggernauts, on the other hand, could only really move *forward*. The fast, heavily armed hybrid vessels zipped in and around the massive warships, firing at them from all sides, intending to sink, not board them. When the already fearsome weather shifted direction, the English herded the massive Spanish ships into the Zeeland coast, wrecking them in the shallows. The remaining Spanish ships, outgunned and outmaneuvered, were forced to flee north, into a worsening storm.

Meanwhile, back on land, a terrified army of seventeen thousand men and boys was all the English had mustered together. In the increasingly torrential rain and ferocious winds, they waited to fight the estimated fifty-five thousand soldiers of the Armada and Parma's forces, should they break through the English defenses. No longer a battle of wills, a scramble for resources, or even an instinct to take, the back-and-forth between England and Spain had become an all-in fight for survival. The possibility of any kind of victory against the invading army was so very slim that the queen herself showed up, vowing to "live or die" with her people.

In what was probably the greatest theatrical moment of her reign, the queen donned a white velvet dress and a silver breastplate and, always the icon, rode out among the troops on a white horse to deliver one of English history's greatest battle speeches. She rallied her army, assuring them: "I know I have the body of a weak and feeble woman, but I have the heart of a king, and a king of England too." And going on to promise them that she was "resolved, in the midst and heat of the battle, to live or die amongst you all; to lay down for my God, and for my kingdom, and for my people, my honor and my blood, even in the dust."

She had no idea the battle had already been won.

I Wanted a Pearl, and All I Got Was This Empire

The clash with the Spanish Armada represented the largest and most powerful offensive England had faced since the Norman Conquest centuries earlier. The Armada had failed: It never made it to shore despite having every variable (except for the weather) stacked in its favor. What remained of the Invincible Armada was forced to take the long way home, north around Scotland and past Ireland. Broken and beaten by the epic storms, many of the remaining ships were driven into the coast or lost in the sea. By the time the remains of the fleet limped back to Spain, half the ships were destroyed or sunken, and approximately twenty thousand men had been lost. The English, on the other hand, had lost only the ships they burned, and not a single man in battle.

Philip refused to blame his commanders: "I sent you out to war with men, not with the wind and waves." But it's hard to genuinely blame an act of God, like the weather, and leave it at that. Philip II was an extremely religious man, and as such he used God's will as a justification for the worst of his actions, from

inquisition to genocide. While the Armada's shocking failure was viewed in Spain as a failure on Philip's part to adequately prepare for and understand the kind of defensive he would face, it was viewed by Philip as a sign of Spain's fall from God's favor. The English only rubbed it in, minting a commemorative victory medal that read, "God blew and they were scattered."

The crushing defeat of the Invincible Armada left Philip's confidence in his moral and military supremacy shattered. And not only were both piracy and the mythology of the Virgin Queen now seared into the English psyche and the nation's sense of self, the victory also established England as a major player on the world stage and opened the door for global expansion of English interests.

Throughout the 1590s the queen encouraged writers of pamphlets to glamorize and praise the acts of England's adventurers and instituted policy that elevated piracy to a legitimate form of commerce. She and her councilors effectively broke the Spanish monopoly on colonialisms and sea power. From plunder, they built the basis of the largest most powerful mercantile empire the world had seen since the Romans.[*]

In spite of the very explicit instructions that Queen Elizabeth I gave to her English pirate captains to seize American pearls from Spanish ships, she never quite found what she was looking for. She owned countless pearls in the end, and even got a few nice ones, judging by all of those portraits in which she wears replicas of—maybe homages to—her sister's jewel. But according to jewelry historian Victoria Finlay, "she never found a pearl as beautiful as the one that was given to her elder sister, Mary."[†]

She may not have gotten La Peregrina, but in the end, she got everything else.

Big things have small beginnings: In 1600, after the defeat

[*] In fact, the British royal family still half jokingly refers to itself as "the Firm."
[†] Finlay, *Jewels*.

of the Armada, Elizabeth signed the charter of the Company of Merchants of London Trading to the East Indies—later the East India Company—which would rule over colonies stretching from India to China and for a time support an empire covering two-fifths of the world. The EIC, along with numerous other joint stock companies, would pave the way for a new kind of empire—one supported by the military but based on trade. The colonialism that would redraw the map of the world during the next two centuries wasn't about theology, war, or Manifest Destiny. It was about money. Elizabeth's reign was the so-called Golden Age of England, and it wasn't just the beginning of the British Empire. It was also, in a very real sense, the birth of modern *commercial* empire.

And it all started with a pearl.

THE OLD SHELL GAME

The Golden Eggs That Funded the Soviet Start-up

(1929)

Revolution is a trivial shift in the emphasis of suffering.

—TOM STOPPARD

Rebellions happen; revolutions are made. —RICHARD PIPES

The most surprising thing anyone ever found in a Russian Easter egg was a death threat. In the spring of 1883, just after "Tsar-Liberator" Alexander II's untimely assassination at the hands of fringe Russian Nihilists and just before Easter, his son, Alexander III, was to be crowned in Moscow. Countless jeweled and gilded eggs had been sent to the impending tsar and his notoriously glitter-loving wife, the tsarina, as Easter gifts, a tradition that predated Fabergé by many hundreds of years. It was the gem-obsessed tsarina, that day, who first dug into the treasures and started cracking open the jeweled eggs. Inside of the most beautiful egg were a small silver dagger and two skulls, carved of ivory, which represented the new tsar and tsarina. There was also a lovely card, that accompanied it, which read, "Christ is Risen," the standard Easter greeting. But this one also said, "You may crush us, but we Nihilists shall rise again!"

I suppose we can add sending greeting cards to the list of

things that are intrinsically silly about Nihilist revolutionaries.

Not so silly? At the same time, Moscow's head of police received his own, more humble basket of painted eggs, stuffed with dynamite. The accompanying card read, "We have plenty more for the coronation." Luckily, or unluckily, depending on your perspective, the threat proved an idle one, the coronation went off without a bang, and the reign of the Romanovs continued.

Rotten Eggs

The Peacock Egg is named for the surprise inside it. A horizontally set crystal egg sits on top of an ornate swirling golden base. Though the jeweled egg is embellished with ornate etchings, the crystal is still primarily transparent so as to display an elaborate gold tree inside. In the tree sits a splendid mechanical peacock. The peacock itself is made of multicolored gold, glittering enamel, and various colored gems. It's fully articulated: When wound, the peacock spreads its tail, turns its head, and walks back and forth. It's one of the eggs that best exemplify the image of opulence, luxury, and unfettered excess associated with the vanished Romanov era.

The Romanov court was one of unparalleled luxury. The degree of wealth and the profligacy of display at the Romanov court made the other royal houses of Europe look modest in comparison. Like the Romanovs themselves, the Romanov court may have been European, but it was technically seated in an Eastern country, and the Eastern influence was undeniable. The opulence, extravagance, and design aesthetic were unmistakably "oriental." Only the biggest and most vivid gems would do. The imperial wedding dress was actually made of silver and gold and weighed so much it required several people just to carry it. Alexander III's wife, the one who opened the world's scariest Easter egg, Maria Feodorovna, was said to wear jewels so massive that according to

one witness, "they would not be handsome" on any other woman, as in any other context "they would not be supposed to be real."*
Anything that had gone on at Versailles couldn't hold a candle to what went on at the Winter Palace, or the Summer Palace, or half a dozen other palaces the royal family traveled between during the year.

This wasn't just the result of an enviable fortune, or the luxury-based arms race and expenditure cascades that had always existed between various branches of European royalty. It was an issue of isolation. The Romanovs had so little to do with the common people that there was no one to object to their behavior—and, perhaps more important, no one with whom they could compare themselves. The autocracy that they practiced, combined with the spectacular fortune that their massive country of endless people and natural resources afforded them, resulted in a completely anachronistic and out-of-touch monarchy. Ultimately, it was a rotten system, presided over by rotten tsars, ruling a country that, socially and structurally, was rotting from within.

Upon Closer Inspection

The Moscow Kremlin Egg looks the least like an egg of all of the Imperial eggs. It's over 14 inches high, and the majority of the piece is a large and detailed replica of the Uspenski Cathedral in the Moscow Kremlin. Like the most lavish and expensive dollhouse you can imagine, the Moscow Kremlin Egg is crafted in Quatra-color gold, in perfect detail. Carpets and icons are visible through the crystal windows, and the cathedral is even set with tiny chiming clocks. The only part of it that resembles an egg is nearly hidden. It's large, but takes a moment

* Toby Faber, *Fabergé's Eggs: The Extraordinary Story of the Masterpieces That Outlived an Empire* (New York: Random House, 2008).

to see it. Ensconced within the three perfect turrets is a massive, opales-
cent, white enameled egg—with its own windows and a golden onion
dome roof, topped with an Orthodox cross. At first it appears to be
part of the building itself, and it's only upon closer inspection that it
becomes apparent that the heart of the Kremlin building is, in fact, a
Fabergé egg.

The funny thing about the Romanovs—maybe the only
funny thing—was that they weren't actually Russian. Obviously
the doomed, last tsarina wasn't. Tsarina Alexandra, formerly Alix
von Hesse-Darmstadt (though originally from Germany) was
British and Danish—and one of Queen Victoria's favorite grand-
daughters. Her mother-in-law, jewel-loving Maria Feodorovna,
previously called Dagmar, was the sister of the king of Greece.
Foreign brides were de rigueur—especially when protocol
required marrying another royal. As a result, the Romanovs
had ceased to be even remotely Russian long before they were in
power. It was calculated at one point that the last tsar, Nicholas II,
was only 1/128th Russian. Beyond being politically, socially, and
god knows economically out of touch with their own people, the
Romanovs weren't even of the same *ethnicity*. The only thing they
did have in common with them was their religion.

Quite unlike the modern connotations of the godless and
austere Soviet state, Russians have a long and colorful history of
deeply felt and joyously expressed religious belief. Their love of
opulence and jewels goes all the way back to the beginning of the
country. In 987 CE, Vladimir of Kiev was debating whether to
become Christian or Muslim, and he had sent diplomatic envoys
to Constantinople to find out—among other things—what this
whole Christianity thing was all about. His people were taken to
the magnificent Byzantine cathedral Hagia Sophia, where they
were utterly overwhelmed by the beauty of the twinkling jeweled
mosaics and spiraling domes, and, in particular, the gilded amber
that would later inspire the famous Russian Amber Room. They
wrote to Vladimir, describing what they'd seen: "They said that

as the light filtered through the windows, the priests chanted their prayers, and the mosaics shone in the candlelight, 'we knew not whether we stood on earth or in heaven' and on that testimonial he, and all Russia, converted to Orthodoxy."*

Nearly a thousand years later, the vast majority of Russians continued to belong to an eastern sect of Christianity referred to as Russian Orthodox. Easter was the most important holiday of the year, and was celebrated by everyone from the tsar to the poorest peasants. It's important to note that the tradition of exchanging Easter eggs has deep roots in Russian Christianity. Even before Fabergé, the royalty and nobility tended to exchange jeweled eggs, which is why so many were sent to Alexander III before his coronation. The peasantry tended to exchange painted wooden eggs, often one within another, like Russian nesting dolls. Some were simple, but many contained surprises, like the Fabergé eggs would later.

The first Fabergé egg was a gift from Alexander III to his wife, Maria Feodorovna. It probably helped the unlikable dictator that his wife was so pretty and charming, loved by her husband and the masses alike. Though she was not exactly a woman of the people, in classic celebrity style, she adored them for adoring her and made a great show of it whenever possible. She loved attention and parties, but she loved jewels even more. And she had the distinction of being the original recipient of the first Fabergé Imperial Easter egg. It was a desire on the part of her husband, the rigid, somber tsar, to please his sparkly, vivacious wife that inspired the first commission—which would become a tradition spanning thirty-three years and fifty-two eggs, resulting in what historian John Andrew called "the last series of commissioned objets d'art."†

* Victoria Finlay, *Jewels: A Secret History* (New York: Random House, 2007).

† John Andrew, Fabergé Heritage Council member, in conversation with the author, London, 2013.

Even after Alexander III's death, his son, Nicholas II, continued to send his mother—and then his own wife, Alexandra—a Fabergé Easter egg every year. And despite the long religious and social significance of Easter eggs in general to Russian culture, it was the fifty-two imperial Easter eggs commissioned by Alexander III and Nicholas II that would redefine both the Russian Orthodox Easter egg and jewelry as an art form.

The Maker

Even among a vast collection that itself defies comparison, the Mosaic Egg is undoubtedly Fabergé's greatest achievement. It's quite large, and at a distance it appears to be made of glittering needlepoint. Up close, the egg is revealed to be made of an intricate, delicate platinum latticework, like a honeycomb.

The platinum framework is pieced together in panels, each of them surrounded by diamond- and pearl-set circular frames and bands. Many of the holes in the platinum lattice are set with individual precious gems of every color, hundreds of carats worth, creating a pattern of flowers and swirls that one might expect on petit-point embroidery. Others are left empty to complete the illusion of an embroidery work in progress.

The gems are tension set, a method that was lost to time and wouldn't be rediscovered until many years later, when Van Cleef & Arpels mastered the so-called invisible setting. The meticulous engineering and design of the stunning sculpture is exceeded only by the unprecedented level of interdisciplinary cooperation required to create it.

The name Fabergé, from the Latin *faber*, means "one who makes things." The son of a jeweler, Carl Fabergé went into his father's business after the family relocated from France to Russia, where they opened a shop in St. Petersburg in 1842. When he took over for his father in 1882, he did more than expand the business: He

elevated jewelry making to an art form, and he transformed the classic workshop into a refined modern standard that existed nowhere else in the world. Fabergé quickly became a visionary among jewelry designers. He said that "expensive things interest me little if the value is merely in so many diamonds or pearls."* That was an extraordinary statement at a time before the Wiener Werkstätte, Art Deco, or industrial arts movements—let alone in imperial Russia, where in art everything was gold, and in jewelry the carat was king.

Fabergé was also very prolific. When someone says Fabergé, you might think only of the eggs, but Fabergé's repertoire was wide-ranging. The company made everything from jewelry and objets d'art to items as simple as cigarette cases and picture frames. There was a time in Russia when any gift of real value, whether it was diplomatic, romantic, or simply an attempt to impress, was "a little something from Fabergé."†

Apart from being a creative genius, Fabergé was also a great businessman and—an equally rare and unexpected talent—a good boss. He had hundreds of employees, all of whom were well trained and taken care of and greatly valued for their individual contributions. His model was based around semiautonomous groups, or workshops, of individuals with unique and disparate talents, all working together on the same piece, overseen by a single workmaster. Each workmaster would report up the pyramid, all the way to Fabergé. It was an extraordinarily modern model, and a hotbed of artistic, technical, and business innovation. Numerous existing records show that many of the items (though not the imperial Easter eggs) were evaluated first for cost-effectiveness before they were engineered or manufactured. Fabergé sometimes altered (or entirely dismissed) designs if they skewed the company's profit margins too much.

And all without Excel.

* Faber, *Fabergé's Eggs.*
† Ibid.

According to biographer Toby Faber,[*] Fabergé was a model employer. "He provided the designs, sourced materials, and marketed the finished product. It was a business structure that would prove remarkably flexible as the firm continued to grow."[†] And grow it did. Over Fabergé's lifetime, he not only became the favorite jeweler of the most opulent royal family in the world, and eternally famous for his collection of Easter eggs, he also did extensive business throughout Russia and the rest of Europe, affording him the ability to expand his business, diversify his workforce, and make noteworthy innovations in the technology of jewelry.

He revolutionized numerous techniques, some of which *still* haven't been reproduced. He employed chemists, goldsmiths, gem setters, carvers, and miniature portrait painters from as far away as the other end of the empire. While the best French jewelers could only produce four simple colors of gold (yellow, white, greenish-yellow, and a coppery orange), Fabergé's workshops managed to expand that to include red, gray, purple, lilac, and even *blue* gold.

In enameling, he achieved techniques that still are unrivaled and not very well understood. While his contemporaries had only mastered a few simple colors, Fabergé offered over one hundred and fifty different shades from shocking pinks to vivid violets, some opalescent, some nearly neon, that could be had nowhere else. He took the French technique of guilloché enamel, which involves engraving or inscribing faint patterns on the gold before fine glass powder is melted and fused to the surface, and perfected it to create surfaces of such delicacy, beauty, and unusual textures that to this day they have yet to be re-created.[‡]

According to Faber, "this all emphasizes that Fabergé's real

[*] No relationship to Fabergé. Sorry.
[†] Faber, *Fabergé's Eggs.*
[‡] John Andrew, Fabergé Heritage Council member, in conversation with the author, London, 2013.

genius lay in his ability to harness the creativity and talents of others."* But even taking that into account, the most amazing thing about his diverse, prolific, exacting factories was that they were full, by all accounts, of very happy workers. Well-paid, well-treated workers. People who were valued and cared for, and more than adequately compensated. He wasn't even stingy about giving credit where it was due. The Mosaic Egg and the Winter Egg were originally conceived of and designed by Alma Pihl, the daughter of one of Fabergé's master craftsmen. Rather than keeping her contributions a secret, he openly praised her work, and gave her ever more prestigious assignments.†

As the head of a massive, multinational firm, with offices as far away as London and hundreds of people in his direct employ, he certainly was a capitalist, but Carl Fabergé came closer than any man in his era (let alone in Russia) to running a business in a manner that we might, in 2015, consider *socialist*. Sharing credit and dispersing profits—all while seeing to the health and well-being of your employees—was a completely revolutionary practice. It was Marx himself who claimed that history begins as tragedy and ends as farce, but it's ironic, to say the least, that a figure like Fabergé had to flee the Bolshevik Revolution—and then subsequently, that his eggs and his name were integral decades later in financing a regime that would be so ultimately repressive.

Carl Fabergé wasn't just a great artist and a great craftsman, socially and economically speaking he was a man apart. He combined, in a really effective way, the very best elements of intellectual socialism and practical capitalism.

And everyone got rich.

* Faber, *Fabergé's Eggs*.
† John Andrew, Fabergé Heritage Council member, in conversation with the author, London, 2013.

How to Believe the Lie

The Flower Basket Egg is exactly what it sounds like. It's a simple white enameled egg, atop a blue enamel pedestal base, with its top cut off and a massive sweeping handle, creating the impression of a standing basket. The entire confection is encrusted with crisscrossing swirls of diamonds, evocative of wickerwork. Equal in size to the egg itself are its contents, bursting from the top. A specialty of Fabergé's, a jubilant collection of the most delicate and lifelike spring flowers sits inside the basket as if it were a vase. Dozens of varieties of flowers, all enameled in realistic colors and textures, create an Easter bouquet, so real—you almost believe it.

While many people associate the workshop of Fabergé with Romanov-style decadence, very few know just how pioneering Fabergé's work was. Nowhere was his genius more evident than in the creation of the imperial Easter eggs, a series of fifty-two objets d'art, remembered for their extravagance but remarkable for their craftsmanship. Each egg had a unique theme and artistic style, and each contained a jeweled surprise inside, often even more impressive than the egg itself.

While it was certainly vanity, greed, and desire that drove Nicholas II and his crowd to hoard the works of Fabergé, they inadvertently did the rest of us a favor. Many of the masterpieces of artistry and engineering that Fabergé created for the imperial court were destroyed in or after the Bolshevik Revolution, during which Lenin encouraged the masses to "loot the looters"—that is, steal or destroy all they could, particularly from the wealthy. In the newly formed Communist government's mad grab for cash, jewelry was disassembled or melted down and stones scattered, either to hide their origin, or just to simplify the resale of bulk diamonds, gems, and gold to the West.

The imperial eggs, however, were saved—by none other than Lenin himself. Why? Because the so-called Russian Revolution

was a put-up job, bought and paid for by the overextended German government during the worst and most costly days of World War I. The United States also had its fingers in the revolution from the beginning—maybe not as directly as Germany, but certainly by tacit consent, and eventually by monetary support.

Various heroes of capitalism—some of them real anti-Commie firebrands, including Henry Ford, the onetime Treasury Secretary Andrew Mellon, and publishing magnate Malcolm Forbes, to name a few*—stepped in, in one way or another, and provided the extensive funds required by the burgeoning Soviet state, mostly through massively inflated purchases masterminded by another of Uncle Sam's heirs, Armand Hammer.

Hammer, a famous U.S. capitalist, was a lifelong Communist sympathizer who engineered the sale of millions of stolen Russian jewels and precious objects, funneling the money back to the USSR. And he did it primarily by selling the American public on the *idea* of the Fabergé eggs and all the psychological strings attached. The story of Hammer, Stalin, and the Fabergé eggs is a story about contrasts, between haves and have-nots, Communism and capitalism, friend and foe, the old order and new ideas, and most of all, between what things are and what they appear to be.

The Fall of the Romanov Empire

The 1913 Romanov Tercentenary Egg, meant to commemorate three hundred years of Romanov rule, is an appropriately lavish imperial

* Some of them knowingly, some of them not. Some of them deliberately not. Treasury Secretary Andrew Mellon not only spent 6.6 million in 1930s dollars on stolen Russian treasures in New York—the money transferred to Soviet accounts the same day—he wrote it off as a charitable deduction from his taxes.

statement piece. The egg is poised over a regal red and gold, symbol-covered base and held aloft by the Romanov crest: a great golden two-headed eagle over three inches high. The predatory creature, its wings raised upward in triumph, claws clasping a scepter and a sword, makes both an intimidating impression and a stabilizing stand for the egg. The egg's luminous gold glows through layer upon layer of opalescent white enamel, which is almost completely decorated with the egg's main motif: eighteen perfect delicate portraits of each of the Romanov rulers. Each one is painted on ivory, framed in a circle of rose-cut diamonds (over eleven hundred total), and set in the shell amid inlaid patterns of golden eagles, crowns, and wreaths.

A large diamond is set at the peak of the egg, along with the dates 1613 and 1913. The egg opens at the top, like a jewelry box, and the top flips back to reveal a rotating globe made of steel, multicolored gold, and blue enamel. On one side, the globe shows the dimensions of the Russian Empire in 1613 under the first Romanov tsar; on the other, it shows the empire's much greater expansion under the man who would be its last tsar, Nicholas II, in 1913.

Nicholas II would become tragically famous as the *last* tsar of the Romanov dynasty. But the seeds of his eventual fall had been sown at least several generations earlier, and probably many more than that.

His grandfather, Alexander II, was a bright man and an engaged leader. He came close—or as close as an absolute power-wielding tsar can come—to being a liberal reformer. During his reign, and particularly toward its end, the Russian people were unhappy. It has been suggested, by nicer individuals than me, that the Russian people are pretty much always unhappy—but let's assume, in this case, that the government was to blame. The tsar himself certainly seemed to think so. For over two decades Alexander II was bent on modernizing his country. He instituted a series of reforms to the military, judiciary, and educational systems. He even reformed outdated

censorship laws.* In 1861, the "Tsar-Liberator," as he would come to be known, freed all Russia's serfs from their centuries of bondage and economic enslavement.

Better late than never, I guess.

On the morning he was murdered, he had just—of his own free will—signed a document that would convene an elected national council. That sounds revolutionary, but let's not get excited. It was nearly the turn of the twentieth century and the institution of constitutional monarchy hadn't been politically groundbreaking in hundreds of years. Russia was just tragically behind the times. But Alexander II never ceased attempting to improve his country.

Fat lot of gratitude it got him. His imperial order calling for the election of what amounted to a parliament was on its way to the printing presses, and the tsar was on his way back to the Winter Palace, when a member of a self-professed Nihilist movement called Narodnaya Volya threw a bomb under his carriage as he rode home. How Nihilists can even form groups, let alone stage revolutions, while still remaining *actual* Nihilists is, like most of Russian history, utterly baffling. Nevertheless, Narodnaya Volya believed that the only way to achieve progress was by first destroying everything. So, good guy or not, the Tsar-Liberator would have to be blown up.

The first bomb was thrown under Alexander's coach, and it actually didn't harm him. When he got out of his carriage, thanking God for his safety, to berate and interrogate the captured Nihilist, a second assassin shouted that it was too soon to thank God, and threw another bomb right at his feet. That one did the trick.

Alexander was succeeded by his son Alexander III shortly before Easter in 1881. If Alexander III had ever had any of his

* That's a lot of trust—telling people they can laugh at you.

father's modern or liberal leanings, seeing him die, legless and eviscerated by a bomb, pretty much cured him of it. His first real act as tsar was to rescind his father's order to assemble an elected council. Thereafter, iron-fisted Tsar Alexander III made it clear that he was an absolute autocrat, and no one else's opinion would be sought or tolerated, least of all the opinion of "the people." That approach pretty much worked for him (if not for anyone else) because he was a classic strongman dictator type. Unfortunately, his son, Nicholas II, was not.

Nicholas II wasn't a strongman like his father and he wasn't a reformer like his grandfather. He was just kind of a putz. His own dad thought so, and made no real effort to involve him in the business of state. As a result, he had no clue how to run an empire. Maybe Alexander III thought that, along with his many other unquestioned—if quite questionable—orders, he could simply mandate his own immortality. If so, it probably came as a pretty big shock to the strapping (and at only forty-nine, reasonably young) tyrant, when out of nowhere, in the summer of 1894, he took to his bed and died. Nicholas was twenty-six years old, timid, and completely unprepared to rule. He knew it too. On the momentous occasion, he is alleged to have said: "What is going to happen to me and all of Russia? I am not prepared to be a Tsar. I never wanted to become one. I know nothing of the business of ruling."[*]

Unfortunately for everyone, rather than turning over the reins of power to another, better-suited ruler or accepting the help of a close cabinet, the prodigal son got all dressed up in Daddy's clothes and tried to play dictator. In 1895, he began his reign with a now infamous address, stating, "Let everyone know that I will retain the principles of autocracy as firmly and unbendingly as my unforgettable late father."[†]

[*] Nigel Kelly and Greg Lacey, *Modern World History for OCR Specification 1937: Core* (Oxford: Heinemann, 2001).

[†] Faber, *Fabergé's Eggs*.

It was a bad move, for a lot of reasons. The only thing worse than a dictator, it turns out, is a reluctant one. Tyrants may be nasty, but at least they have some sort of vision. While his still young, widowed mother continued attending balls and spending money, and his beautiful but socially bizarre wife, the new tsarina, alienated people and had babies, Nicholas himself did almost nothing at all. He loved his wife. He enjoyed a lot of private (i.e., vacation) time with his family, and like his mother, he was always ready to play dress-up: He enjoyed his military responsibilities because they were largely and lavishly ceremonial. But as a ruler, he actually did *very little*. And when push came to uprising, he made all the wrong choices, one after another.

Sergei Witte, a Russian minister at the time, said, "I pity the Tsar. I pity Russia. He is a poor and unhappy sovereign. What did he inherit and what will he leave? He is obviously a good and quite intelligent man, but he lacks will power, and it is from that character that his state defects developed, that is, his defects as a ruler, especially an autocratic and absolute ruler." He was right. Nicholas II wasn't a bad man, he just wasn't a good man either, and his reign was defined by a terrible combination of incompetence, intransigence, and inevitability.

Just Another Bloody Sunday

When it was created in 1897, the Coronation Egg was the largest, most intricate, decadent, and ambitious egg Fabergé had yet produced. The entire golden exterior is covered in interwoven patterns of starbursts. Delicately coated in microthin layers of brilliant yellow enamels, it glows like sunlight itself. The luminous surface is trellised in delicate bands of golden laurels, crisscrossing around the egg and intersecting each other at points marked by tiny, diamond-chested imperial eagles. The sunflower-yellow eggshell was designed to match the coro-

nation gown worn by its recipient, Tsarina Alexandra. Inside the velvet-lined egg is an exact replica, less than four inches long, of the eighteenth-century carriage that bore her. It was the finest example of enameling to date. The coach, made of gold, platinum, and enamel, is beautifully jeweled—it boasts a diamond crown and rock crystal windows—and perfectly reflects the details of the tsarina's carriage, down to the C-shaped shocks and folding stairs. The surprise within the surprise was a jeweled pendant.

The Coronation Egg, like Nicholas and Alexandra's coronation itself, subtly marked the beginning of a new phase for both Fabergé and for Russia. It simultaneously signifies the beginning of Fabergé's ascendance as one of the greatest artists and craftsmen in history and the beginning of the end for the Romanovs and imperial Russia.

Nicholas and Alexandra's coronation was the "it" invite of the decade, if not the century. When the most decadent royal family in Europe throws itself a once-in-a-lifetime destination affair, people take notice. All the eyes of the world were on Moscow. The ceremonies, parties, and balls, attended by most of Europe's royalty, went on for two solid weeks. The guest list was a who's who of over seven thousand people from all over the world. And the public turnout was even more spectacular.

On the fourth day of the two-week-long revelry, there was a traditional celebration for the commoners, held on a makeshift fairground at Khodynka Meadow. Half a million people showed up at the meadow to celebrate the coronation, which was hundreds of thousands of people more than were expected. Everyone arrived in an uncharacteristically positive mood. They hoped to enjoy free beer and food and, most important, one of the relatively cheap commemorative cups handed out as keepsakes. The cups may not have come from the master's workshop, but for people excited about a new tsar and as poor as you can possibly imagine, the mass-produced, roughly enameled little metal cups might as well have been stamped Fabergé. If nothing else,

they would leave with an anecdote to tell their grandchildren.

Unfortunately, some of them wouldn't leave at all. Sometime during the night before the fair, rumors started to spread among the people that there were anticipated shortages—and particularly that there might not be enough of these commemorative cups to go around. Anxiety grew, and the crowd, fearing that they might miss out on this treasure, rushed the too-small field. In the predawn chaos that followed, countless people were crushed to death, trampled underfoot, and killed as they fell headlong into deep trenches in the field that no one had bothered to fill in. To make matters worse, the new tsar had hired Cossacks as crowd control. They might as well have been the Hells Angels at the infamous Rolling Stones concert where, as security, they started killing the attendees. Most of the thousands who died were killed in the crush or simply trampled to death. But the Cossacks also panicked when the crowd was no longer under control and opened fire directly into it. What should have been a joyous celebration ended, before it even began, in a massacre.

And the Band Played On

The Revolving Miniatures Egg was created for Tsarina Alexandra, formerly Princess Alix von Hesse-Darmstadt of Germany. Just under ten inches high, the egg has a hollow, clear crystal shell. The two halves are fused together with a thin band of diamonds. It's gracefully balanced vertically upon an ornate gold-colored enamel and polished crystal pedestal.

The surprise inside the egg is a book of ivory pages that appears to be suspended in midair. Each page is framed in elaborate gold and depicts in beautiful colors, a detailed painting of one of the many European palaces that the new tsarina had lived or spent time in. As a massive, peaked emerald, which is set on the top of the egg, is depressed

and turned, the pages flip open like a book's, two at a time, revolving around a golden post, showing a travelogue of all her favorite vacation palaces and castles.

It was not an auspicious start for a nervous twenty-six-year-old monarch, to say the least. Nicholas was only informed of the tragedy around 10:30 A.M., well after the dead had been cleared away. There was nothing he could have done to help them, but the general consensus among the people and the guests was that it would have been nice for him to at least pretend that he cared. Instead, having taken some very bad advice from his courtiers, he attended a ball scheduled for that evening at the French Embassy and, as Faber put it, "danced while the wounded died."* Had he legs long enough to step over thousands of dead bodies, he would've done just that. This was not lost on the survivors of the massacre. The grief-stricken and traumatized people who came to celebrate quickly realized that the tsar wasn't going to let a little carnage interfere with his plans—not when the French had imported thousands of roses from Versailles for the occasion. Even people in the tsar's inner circle were shocked by his actions, and a fair number of the guests were disturbed by his callousness.

For the royal couple, it was the beginning of their reign, but the beginning of the end of their popularity. The catastrophe had shown them to be incompetent, ineffectual, and callous rulers, and the Russian people's affection for the couple, and Europe's sympathy for them, began to slip. Maurice Paléologue, the French ambassador to Russia, would eventually write, "I am obliged to report that, at the present moment, the Russian Empire is run by lunatics."† Over time, their Western European relatives slowly distanced themselves from Nicholas and Alexandra, who then retreated into their small immediate family and their intense

* Faber, *Fabergé's Eggs.*
† David R. Woodward, *World War I Almanac, Almanacs of American Wars, Facts on File Library of American History* (New York: Infobase, 2009).

Orthodox religion. Gradually, they had less and less in common with either their own people or their relatives abroad.

The coronation was only the first of many events that would prove the Romanovs' intense disconnect with Russia and the Russians, but it portended the callousness that would mark Nicholas's ill-fated reign. It doesn't matter that the weak-willed tsar had originally thought to cancel the ball, nor that the tsarina was so upset by the tragedy that she miscarried a child. As in the case of so many things, perception is everything—and the tsar and tsarina looked, at a critical and symbolic moment, as bad as two rulers can look.

The coronation disaster became symbolic of the staggering differences between the lives of those seven thousand glittering courtiers, and the factory workers and serfs who lived in Russia; between jeweled eggs and too few tin cups to go around.

Retail Therapy

The Lily of the Valley Egg is a marked departure from the previous imposing, regal pieces that Fabergé made for the Romanovs. It was designed specifically for Tsarina Alexandra, and it's a Belle Epoque masterpiece. The golden egg is intricately engraved and covered in layers of transparent rose pink enamels, allowing the yellow gold to shine beneath it, giving it an opalescent, jewel-like quality. It sits atop four curling, organic gold legs, inlaid with veins of tiny diamonds. Overlying the entire luminous pink egg are green-gold leaves and stems dripping with pearls, modified with gold and diamond caps to look like lilies of the valley.

Ultimately, the surprise is that the egg doesn't open. Instead, when the right flower bud is turned, a diamond crown sitting atop it rises up, revealing a painted cluster of three miniatures depicting the tsarina's husband and two daughters.

The egg created a sensation at the 1900 Paris World's Fair, but it

*was an even bigger hit with the tsarina. In addition to the organic Art
Nouveau style, the egg's most important distinction was that it repre-
sented Fabergé's first successful attempt to personally understand and
please Alexandra, the notoriously fickle new customer for whom he was
designing commissions.*

Why do people like to buy things? A simple question but an
important one, and one that is critical to this chapter and to our
understanding of what happened to the Fabergé eggs. Buying
things doesn't make us happy; it's a widely known psychological
fact contrary to our gut instinct. Not for more than a few minutes,
anyway. Then the happy fades, often it's even replaced by bad
feelings: anxiety, guilt, remorse.* So what's really going on there?
Why do we think that the acquisition of material goods will fulfill
us, why don't they, and what does? Because let's face it; we all like
to spend money. We love it, in fact. So why is our brain telling us
to do something that won't actually help us out?

Biologists have suggested that the human drive to overac-
quire (in other words, to covet) is no different than the human
tendency to overeat. We're programmed to get as much of what
we need as we can because, consciously or not, we assume that
resources are scarce and hard to come by. When our hundred-
million-year-old brain tells us to eat as much as we can, and we
live around the corner from the supermarket, we end up obese.
When our hundred-million-year-old brain tells us to acquire all
the valuables we can, and we have the unfettered means to do so,
we end up like the Romanovs.

But if objects don't make us happy, what does? A number of
recent studies have suggested that you can, in fact, buy happiness,
at least in two forms. You can buy a little momentary happiness
with the purchase of a material possession, but it wanes quickly.
Or you can buy a slightly longer-lasting form of the drug when

* Money can't buy happiness; so the saying goes. But as my mother has always
pointed out, it makes a *hell* of a down payment.

you pay for an *experience*. In a study published in *Neuron*,[*] a team of researchers looked at what goes on inside your brain when you buy something, or even just think about buying something. The surprise inside is that both actions have the exact same neurological effect.

The brain's pleasure centers flood the brain with pleasurable neurochemicals (most prominently dopamine) when you acquire an object you want. But they do the exact same thing when you merely think about or plan to acquire an object you want. In effect, thinking about buying that new shiny thing will make you just as happy as actually buying it—and neither emotional state will last very long. However, if you spend your money on an experience—a vacation, a concert, a thing you can do, particularly with other people—that momentary happiness can be revived every time you think about the thing you paid to do.

Maybe that's why Fabergé's most cherished imperial Easter eggs were the ones that commemorated happy events, like the construction of the Romanovs' favorite vacation homes, or the birth of the tsarevich. When episodes of state, like the royal coronation, became uncomfortable topics of public failure, and Nicholas and Alexandra failed to have any political or military victories of their own to memorialize, Fabergé looked inward. He got to know personal things about the tsarina: that her favorite flowers were lilies of the valley and that her favorite color was rose pink, for example. Even the surprises inside were a reflection of the psychology of their recipients. After a certain point, he ceased making many surprises for the tsarina's eggs that didn't focus specifically on her husband and children. Unlike her mother-in-law, she had no other real interests or accomplishments.

Mere valuables produce a momentary happiness, here and then gone. But mementos, physical representations of intangible experiences, create a permanently retrievable feeling of happi-

[*] Alain Dagher, "Shopping Centers in the Brain," *Neuron* 53, no. 1 (2007): 7–8.

ness. Objects really do induce good feelings on a chemical level—
particularly when they reference actual events. As you can see,
obtaining the object isn't strictly necessary—even the *thought* of
obtaining something we deem valuable changes our very brain
chemistry. If just the thought of things is enough to change how
we feel, are things, or the thought of things, enough to change
how we *behave*? In other words, does evolutionary biology play a
role in the emergence of benign and malicious envy?

Returning to the discussion of positional good, another inter-
esting study was conducted to measure it.* Participants were
grouped in pairs. Each partener in a pair was given a larger or a
smaller diamond, and scientists asked him or her, independently
of each other, how happy they were with their gem. The partici-
pants ranked the jewels based on a numerical scale. When the pairs
were allowed to see that the person next to them had a bigger or
smaller diamond than they did, as expected, their ratings changed
dramatically. The girl with the bigger diamond was much happier
with her stone than she had been moments before—and the girl
with the smaller diamond was suddenly even less happy. No sur-
prises there. Positional goods, as we have seen, depend for their
worth, in part, on the very idea of competition and comparison.
But what happens when goods are a necessity?

The study was repeated again, but instead of comparing
diamonds, the pairs were asked to evaluate the temperature of
bathwater. The participating pairs were given bottles heated to
two different temperatures: one very hot, one lukewarm. You'd
expect the findings to be the same, but they weren't. In this ver-
sion of the study, the participants didn't need to compare with
their partner to decide how happy they were with the temperature
of their respective bottles. The girl with very hot water gave it a
high rating, which didn't change when she found out her partner's

* Simon M. Laham, *The Science of Sin: The Psychology of the Seven Deadlies (and
Why They Are So Good for You)* (New York: Random House, 2012).

water was cooler. And her partner gave her lukewarm bathwater a lukewarm rating that didn't go down any farther when she found out the other girl had hotter water.

What's important about the diamond and bathwater study is that it tells us that while luxury items and status symbols are positional goods, creature comforts are not. Context is not required to decide whether or not you're too cold or your stomach's too empty. Those decisions can be made in a vacuum. When it comes to necessities, your neighbor's relative fortune or misfortune has no impact on your estimation of your own.

The Russian peasants who would eventually riot had no jeweled eggs to compare unfavorably with the imperial ones. The poorest Russians didn't have much of anything. Because of the Tsar-Liberator's unfinished reforms, they were free, but the vast majority of them were not really living any differently than they had a hundred years before. Those people didn't need to know that the Romanovs had better eggs than they did to know that they themselves were cold and hungry. They wanted nonpositional necessities, not to inflict punishment on those who they felt had unfairly profited from their labor. Even at the peak of riot season in February 1917, they asked only for the tsar's abdication— not his death.

And yet, by October the whole country was burning.

So what happened?

Boomtown Blowup

The Trans-Siberian Railroad Egg was created to celebrate the completion of the Trans-Siberian Railroad, which connected East Asia with Western Europe. The egg sits on a curved triangular base of stepped white onyx. It is supported by three golden griffins, each brandishing a sword and shield and balancing the egg on its wings and back.

The egg itself is large, made of blue and green enameled gold, with a wide silver band around its center. The silver band is engraved to form a map of the entire Trans-Siberian Railway line, from the Pacific to Europe, with precious stones marking the stations and cities. The egg is topped with the two-headed imperial eagle crest and opens to reveal inside a velvet lining and a perfect one-foot-long train fashioned in gold and platinum with rose-cut diamonds and rubies for lights and rock crystal windows. It's a perfect wind-up replica of the train that first traversed Russia, an endeavor that cost millions of rubles and countless lives.

At the turn of the century, Russia was a massive and rapidly industrializing country that encompassed one-sixth of the world's population, and contrary to post-Communist propaganda, the country on the whole was prosperous. Both the upper and middle classes lived in luxury. If you were part of the nobility—or better yet, part of the bourgeoisie—business was *booming*. Never short of manpower or natural resources, Russia was the fastest-growing economy in Europe or Asia and, had it been better managed, might have given the United States a run for its money. Even the haphazard, belated, and largely chaotic attempts at modernization that ultimately contributed to much of the country's brewing discontent were still sufficient to create bustling cities. Factories popped up like mushrooms. Every industry imaginable was blossoming. Fortunes swelled—and not just those of the royalty. Between heavy industrialization, a variety of public works, like the Trans-Siberian Railroad, linking East Asia with Western Europe, and a cultural renaissance best demonstrated by Fabergé's workshop, Russia was in ascendance.

But it was a pretty terrible place to live if you were a peasant. All of the country's industrial splendor was constructed on the backs of barely paid, overabundant labor. Because the Tsar-Liberator had freed the serfs in 1861 but had then subsequently been blown to bits before he could make many more of his planned reforms, the life of an average peasant was not so terribly differ-

ent from that of his serf forebears. Peasants, then, had freedom in name only and were still slaves to the land they didn't own. And as the Russian economy boomed, they were lured into the cities and into factory jobs by the possibility of change for the better. For most of them, it wasn't better. The unhappy have-nots were now smack in the middle of cities filled with all the delicious, wonderful, and glittering things they couldn't have.

And Nicholas and Alexandra certainly weren't in the business of making any reforms. After a while, they'd ceased to be in the business of doing anything. By the time their son, their fifth and last child, was born, they spent most of their time in seclusion and the rest of their time making really bad decisions. Although Nicholas hated being in charge, he wouldn't cede an iota of power. His wife didn't help. She actually advised him in a letter to "be more autocratic than Peter the Great and sterner than Ivan the Terrible." Awesome advice.

As the country continued its relentless economic and industrial expansion, despite the archaic social and economic conditions in which the vast majority of the population was floundering, the stage was set for revolution. While the United States and the rest of Europe were ushering in the twentieth century, Russia hadn't *really* changed, socially or politically, in hundreds of years. It was a country with no real leadership, stymied by an intractable and increasingly out of touch monarchy that wielded absolute authority. The combination made for all the power and control of a semitruck with a driver asleep at the wheel. And it was rolling toward a head-on collision with the rest of the Western world.

Give It Your Best Shot

The Steel Military Egg was the last complete imperial Easter egg. Crafted in blackened steel, it features only minimal decoration in the

*form of four gilt emblems, and a small, dark crown sits on its apex.
The egg rests on an abstract stand composed of four vertical artillery
shells, which stand atop a dark green, angular jade base.*

*It wasn't made of gold and contained no priceless gems. Still, the
Steel Military Egg may be one of the most exceptional pieces of art in
the series. Its exaltation of the beauty to be found in industrial design
anticipated the Art Deco movement and was at least a decade ahead
of its time. It certainly expresses a clearer grasp of the Russian zeitgeist
in 1916 than its own commission did.*

Nicholas made a great many mistakes during his uncompro-
mising, but uninspired, reign, but perhaps the worst of all was his
failure to understand either the mood or character of his country.
And while the tsar was fighting his losing battle against the rising
tide of modernity, the rest of Europe was about to explode into
open combat.

On June 28, 1914, Archduke Franz Ferdinand of Austria was
assassinated by a Bosnian Serb named Gavrilo Princip. The bel-
ligerent, international chain reaction that occurred over the next
sixty days would lead to the First World War. On August 1, Ger-
many and Austria declared war on Russia. Despite the ineptitude
of Nicholas's command, Russia was still a sizable and intimidat-
ing foe—and Germany's reasons for wanting to take them down
a notch weren't purely military. Russia had the fastest-growing
economy in the world and was in the top five world economies
and industries, right behind the United States. It was a rich coun-
try. And its access not only to manpower but to seemingly inex-
haustible natural resources made it terrifying to the rest of the
world. They were the China of their day. They were too big, they
worked too hard, and they had too many natural resources. Rus-
sia was an unstoppable financial juggernaut.[*] And the rest of the
world was terrified.

[*] Sean McMeekin, *History's Greatest Heist: The Looting of Russia by the Bolsheviks*
 (New Haven, CT: Yale University Press, 2009).

One would imagine that with Russia's opening ante of 4.5 *million* troops, they were a lock to be the big bad of "the Great War." They certainly thought so; the tsar and his generals anticipated a quick victory, only provisioning for a month or two of combat. The problem with their logic was that World War I wasn't just the first world war, it was also the first *modern* war, and despite its rapid industrialization, Russia was anything but modern. While industry and commerce were running full tilt, mostly on the backs of the lower class, the boom had just begun, and Russia had none of the necessary infrastructure to fight a twentieth-century war. It didn't have the weapons, the ammunition, the machinery, or even the sort of transportation needed to mobilize a major war effort. Germany not only had modern leadership and advanced weaponry, it had no trouble mobilizing its troops across the whole continent. Russia had just barely finished the Trans-Siberian Railway, and could scarcely get its people to the front lines of its own borders—let alone feed them or bandage them once they were there.

Jewelers were not exempt from the draft. With millions of men—nearly 10 percent of the population—conscripted into the imperial army, Carl Fabergé's workshops could no longer turn out treasures created by whole teams of talented, specialized craftsmen. So with a shortage of enamelers, diamond setters, and watchmakers, Fabergé turned his factories to a compatible task: military and munitions production. The original Saint Petersburg factory produced delicate items, such as glass and metal syringes, shock tubes, and detonators. The large Moscow branch turned out grenades and bullets, as expertly crafted as the brooches and cigarette cases they'd produced the year before.

The war effort was a well-funded but disorganized disaster. Within just the first five months, Russia lost well over a million men. Most were killed or wounded. But conditions within the army were so appalling that many soldiers simply surrendered—believing that life as a German prisoner of war (or even possible

execution) was a far better option than staying in the Russian army. There were shortages and illnesses. The soldiers froze, starved, and often lacked even basic weapons with which to fight. Once they reached the front, they "suffered worst from the combination of institutionalized incompetence and authoritarian rigidity."* The trenches were dug incorrectly. The soldiers were untrained. Many didn't even have shoes. And just like their tsar, who couldn't rule but wouldn't stop, the commanders had no idea how to combat the organized and industrialized German war machine, so they just threw human bodies at it.

A little less than a year after the war began, the entire Russian front finally crumbled under the weight of incompetence and despair. Completely outmatched by the smaller but more effective German forces, Russia's colossal army was forced into retreat. The Eastern Front was pushed back so far that the capital, Saint Petersburg, was no longer considered safe. The loss of territory, not to mention of face, was a huge blow to the tsar. As a result, in 1915 he appointed himself "Supreme Commander of the Army." In doing so, he ousted his cousin, Grand Duke Nikolaevich, who had been in command of Russia's forces. The army under Nikolaevich may not have been an effective one, but he was at least a real soldier, and deeply beloved by his men.

As supreme commander of the Russian forces, Nicholas was no more than a disruptive figurehead. As the Russian army lost battle after battle, ceding more and more ground, the tsar was held personally responsible. By 1916, even his staunchest supporters were delicately expressing their concern. Unless he could loosen his white-knuckle grip on absolute power, allow the Duma† to actually function, accept the advice of a real cabinet, and make

* Faber, *Fabergé's Eggs*.
† The Duma was an assembled council created by the tsar. It was supposed to be a concession to the country's desire for representative government, but it was often hostile to and treated with contempt by the tsar, who had no intention of cooperating with its decisions, despite agreeing to its formation.

some of the liberal social reforms the country demanded, his reign was doomed. He dismissed the warnings with contempt. Wave after wave of increasingly too old or too young Russians were sent to the front to freeze, starve, and physically absorb German bullets. By the end, bodies were all that Russia had left. Its military tactics were at best antiquated, at worst suicidal.

Even so, the sheer magnitude of the Russian forces was enough to tax the German military beyond its capacity to fight on two fronts.

The Winter of Our Discontent

The Winter Egg is a freestanding sculpture as much as it is an egg. The body of the Winter Egg is a large clear rock crystal. Delicate etchings cover its interior—to give the impression that it is made of icy glass covered over in frost crystals. The same frost etchings cover the outside of the egg as well but are inlaid with diamonds set in platinum. It sits in a monumental base of crystal, polished to appear as if it were a glistening, melting shelf of ice. The egg opens like a closet, to reveal a glittering diamond and platinum basket filled with colorful spring flowers, promising inevitable change to come.

By New Year's 1917, the rest of the country wasn't faring much better than the army. All the empire's resources were directed at the losing war effort. Rural flight to the cities and factories, along with mass conscription, had resulted in a lack of manpower in the fields. Combined with a wickedly long, cold winter (even by Russian standards), the result was widespread famine and death. By the end of February, the people—or what was left of them—had finally had enough. On February 23—International Women's Day—thousands of women, from housewives to factory workers, flooded the streets of the capital. They demanded bread and refused to leave. By the next day, two hundred thousand factory

workers from all backgrounds had gone on strike and joined them in the streets.* As their numbers swelled and daily industry ground to a halt, the police attempted to disperse the crowd, but the workers pelted them with ice and rocks.

By the time students, business owners, and other members of the middle class joined them on the third day, the crowd had stopped demanding bread and was now demanding change. They carried signs demanding an end to the war and shouted, "Down with the tsar!"

Troops were finally dispatched to crush the protest-turned-strike-turned-massive riot. On February 26, the soldiers were ordered to open fire on the crowds, and hundreds of unarmed people were killed. By the next day, the troops, both contrite and angry, had *switched sides* and joined the uprising. It was a slightly less murderous version of the events that had preceded the French Revolution. The people got too cold and too hungry, and they exploded. But in Russia in 1917, the explosion wasn't exclusively malicious in nature—there was an element of benign envy as well. Initially, they weren't looking for a pound of flesh, or a bigger diamond. They wanted the same thing they *needed* but didn't have: a more livable standard of living.

Meanwhile, Nicholas was at the army headquarters in Mogilev, play-commanding the army. He was kept apprised of the events leading up to the riots and was warned by the nobility that he would have to make concessions if he wanted to keep his crown. He did nothing. Duma leader Mikhail Rodzianko sent a telegram stating: "Situation serious. There is anarchy in the capital. Government paralyzed. Transport of food and fuel completely disorganized. Public disaffection growing. On the streets, chaotic shooting. Army units fire at each other. It is essential at once to entrust a person enjoying the country's confidence with the formation of a

* S. A. Smith, *The Russian Revolution: A Very Short Introduction* (New York: Oxford University Press, 2002).

Chiefs of six nations with their traditional wampum belts—gathered by Horatio Emmons Hale, an American-Canadian philologist, ethnologist, and author, in September 1871. Hale invited the chiefs to display and explain their wampum, and to be photographed for posterity. A little over a decade later, Hale published the *Iroquois Book of Rites*, which documented the history and rituals of the Iroquois, and focused heavily on the group's wampum belts.

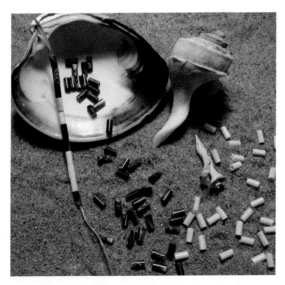

Wampum beads were made in white and purple. The white beads were made from the inner spiral of the channeled whelk shell, whereas the rarer purple beads were carved from the growth rings of the quahog shell.

The vast size and scale of an open-pit diamond mine has to be seen to be believed. Some are the size of small towns.

RIGHT: The Shawish all-diamond ring, very much like the purpose of Mary of Burgundy's diamond ring, was created to put technology on display.
BELOW: Shawish's all-diamond ring, laser cut from one giant diamond.

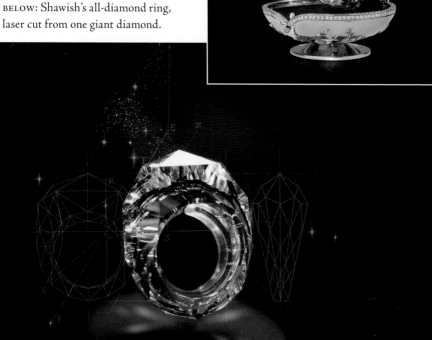

A naturally occurring emerald crystal in matrix has a distinct hexagonal shape as well as that eye-catching green color.

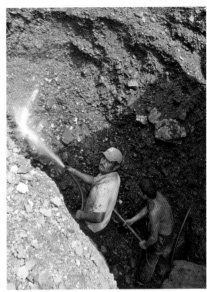

Contemporary Columbian emerald miners, clearing surface debris.

This massive Spanish pendent, made of New World emeralds and gold, dating from between 1680 and 1700, is a classic example of the post-Columbian Spanish-style: huge, heavy, elaborate, and covered with emeralds.

Représentation exacte du grand Collier en Brillants des S.rs Boëhmer et Bassenge
Gravé d'après la grandeur des Diamans.

LEFT: The necklace that started the French Revolution—well, the original jeweler's engraving of it at least. The real necklace didn't last long once Jeanne de la Motte got her hands on it.

BELOW: The devil's in the details, so they say, and the difference between diamonds and graphite is just a few atomic bonds.

Le Serment d'Amour.

The original tabloids. Who knew gossip could be so destabilizing?

La Peregrina, as it looked in the twentieth century, when Richard Burton bought it for Elizabeth Taylor.

"Bloody Mary" Tudor wearing La Peregrina as part of the jewel Philip II gave her for their engagement.

The failure of the Spanish Armada was the moment when the tides turned in the fortunes of the Spanish and the English.

The Imperial Coronation Egg had the dubious distinction of commemorating Tsar Nicholas II and Tsarina Alexandra's disastrous and tragic coronation.

The Imperial Mosaic Egg was designed to resemble petit-point embroidery. The honeycomb-like frame created to hold the gems in place was a remarkable feat of engineering and was decades ahead of its time.

Designed by Alma Pihl, the daughter of one of Fabergé's master craftsmen, the Imperial Winter Egg was such a success that the motif was used in a line of jewelry and in an egg for Emanuel Nobel.

Traditional Japanese pearl divers, called *Ama*, who once wore only *fundoshi* (loincloths), held their breath for up to two minutes and dove to depths of twenty-five meters in freezing cold water. Kokichi Mikimoto employed these *Ama* to retrieve akoya oysters and, once implanted, to return them to the seabed. *Ama* are no longer needed, but they are still celebrated in Japan for their role in the history of pearl cultivation.

The Taisho-ren—once the largest and most perfect pearl necklace in the world.

Mikimoto's most dramatic, and certainly his most expensive, public spectacle was when he burned bucketfuls of pearls in a large trash fire in front of the Kobe Chamber of Commerce. He declared that any flawed pearls were inferior and were "only good for burning."

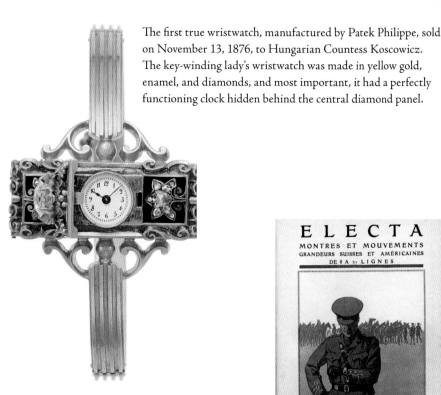

The first true wristwatch, manufactured by Patek Philippe, sold on November 13, 1876, to Hungarian Countess Koscowicz. The key-winding lady's wristwatch was made in yellow gold, enamel, and diamonds, and most important, it had a perfectly functioning clock hidden behind the central diamond panel.

During World War I, the narrative began to shift, and suddenly a wristwatch wasn't quite so girly, as shown in this Electa watch advertisement from 1914.

These early modified "strap watches" show ways in which men in the field attempted to turn their pocket watches into wristwatches.

new government. There should be no delay. All delay is death."

Nicholas responded by saying, "that fat Rodzianko has again sent me some nonsense to which I will not even reply."[*]

By March, riots and strikes of every kind were exploding in nearly *every* major city across the Russian Empire. The tsar's troops, otherwise occupied with World War I, were spread too thin and could no longer contain the violence. Not that they really tried; by March 1, 170,000 troops had joined the mob, which had now begun tearing down police stations, attacking prisons, and, most tellingly, debasing and destroying any symbols or emblems of tsarist tyranny.[†]

The following day *the entire government resigned* and, without the tsar's cooperation, formed a provisional government. By the time Nicholas seemed to grasp the scope and danger of the situation, it was far too late. The next day, March 3, he was forced to abdicate on behalf of himself and his son.

Relative Poverty, Subjective Utopia, and Weaponized Ideals

The Red Cross Egg is beautiful in its simplicity. Made during World War I, it comes the closest to evoking the aesthetic of Soviet Russia. And it looks the most like an egg. It sits in a simple gold wire stand, with luminous glowing white enamel over intricate etched patterns covering the entire egg. A wide band around the center is filled with dark gold Cyrillic writing and punctuated by a large, squared, blood-red cross emblazoned across the front.

The ideals of socialism weren't invented in Russia. They

[*] Alan Howard, *Reform, Repression and Revolution in Russia: A Phased Historical Case Study in Problem Solving and Decision Making* (n.p., 1977).

[†] Smith, *The Russian Revolution.*

weren't even invented in the twentieth century. Socialism as a concept has existed for centuries. But Communism is fundamentally different from socialism in a rather nasty way. Karl Marx, the man known as the father of Communism, put forth the theory's basic principles in his *Communist Manifesto*, published in 1848. He was a champion of the little guy. He was also a philosopher, not a revolutionary. Like Thomas Moore before him, Marx was playing with ideas for how the world could be a better, fairer place. But like most philosophers, he was more concerned with the *why* than the *how*. As a result, his thoughts on eliminating poverty globally were nice in principle—but they were economically unsound, and socially unviable.

The crux of Marx's theory is that *poverty is relative*. He has that right, to a degree—but only if we're dealing in positional luxuries, like diamonds, and not at all if we're comparing non-positional necessities, like heat. But Marx believed if no one was *relatively* poor, that is, poorer than the next person, everyone would be happy. And in order for no one to be relatively poor, that is, to *feel poor*, no one can ever have more money than anybody else. Thus, everyone must have exactly the same. He called it a one-class system. The best way to achieve this one-class system, in his view, was to abolish private property. In the Marxist utopia, people can't even own their own personal belongings. Or intellectual property. Or their own business or work product. The system, though, requires that people continue to run those businesses and produce that work product—be it grain or jeweled eggs—and once that work is completed, the government owns everything and divvies it up evenly.

The hitch is, wealth isn't a zero-sum game. Value can be added. It can be created out of nothing—usually in the form of intellectual property—or value can be increased with work (as in what happens when you turn a pile of wood into a chair). That's a large part of the basis of capitalism. Unfortunately, in his theory of relative poverty, Marx argues that the problem isn't one person

having too little, it's the person next to him having *too much*. In this theory, Marx essentially *institutionalizes* malicious envy, and malicious envy is always, by definition, destructive.

But let's not be too hard on old Karl. He was just throwing around ideas. The problems didn't really start until these oh-so-trendy ideas fell into the hands of Vladimir Lenin. Lenin, impractical intellectual that he was, thought Marx's ideals were splendid—and more important, pragmatic. Lenin, who had already been exiled from his own country for his involvement in Narodnaya Volya, the Nihilist group that assassinated Alexander II, was a man so contentious and shortsighted that no one took him seriously—except Germany. And as far as Germany was concerned, Lenin was as serious as cancer. A cancer they very much wanted the Russian Empire to contract.

You Say You Want a Revolution?

The Karelian Birch Egg came the closest of all of the Fabergé eggs to revealing its Russian soul. Though each egg celebrated the wealth and decadence and even orientalism of the tzarist empire, the Karelian Birch Egg is an overt acknowledgment of the deeply rooted spirituality of Orthodox Russian belief. The egg, like the iconic Russian nesting doll, was made of indigenous Russian Karelian birch wood, which only grows in Karelia, between Saint Petersburg and Finland. The birch, polished to perfection, is subtly highlighted by a soft gleam of engraved golden edges. A single tiny blue sapphire marks the latch. The surprises inside have long since been stolen, but a gold and diamond key was left behind, to wind a missing diamond elephant noted on the invoice. In this case, a second, unintended surprise was left for the rest of us. The bill of sale, dated April 25, is made out not to the "Tzar of all the Russias," who had abdicated over a month before, but simply to "Mr. Romanov."

So how did Russia go from *riots* to *soviets*?

There were actually two revolutions: The first was in February and the second in October. The February Revolution was more of a spontaneous uprising. Though it ended with the abdication of the tsar, it was protesting a single issue—hunger—and didn't seek broad political change. Just like the Paris bread riots over a century before, hunger turned to anger, and anger was channeled into political outrage and eventually ended in mass violence and regime change. But the October Revolution, or *Red October*, during which the Bolshevik party seized power, was a lot nastier than the February Revolution.

Fun fact: The "Russian Revolution" was neither Russian nor technically a revolution, as it was a takeover funded and engineered almost entirely by outside German interests. The motivation had nothing to do with the hungry people or the incompetent tsar. The Germans wanted Russia out of World War I because they could no longer fight on a Western and Eastern front simultaneously. Nicholas had stated publicly that Russia would never relent so long as there was a foreigner on its soil—and at the rate he was letting his people get slaughtered, he seemed to actually mean it. That didn't leave the kaiser a lot of options. On March 31, "the Swiss Communist Fritz Platten obtained permission from the German Foreign Minister through his ambassador in Switzerland, Baron Gisbert von Romberg, for Lenin and other Russian exiles to travel through Germany to Russia in a sealed one-carriage train." Lenin, at that point, had been exiled almost a decade earlier for plotting against the tsar. The Germans were so committed to the safe arrival of their precious cargo that, "at Lenin's request the carriage would be protected from interference by a special grant of extraterritorial status."*

In other words, the German foreign minister—not some

* Richard Pipes, *The Russian Revolution* (New York: Vintage, 1991), 411–12.

low-level flunky or subversive Communist nestled in the German government but *the actual* German foreign minister—smuggled what amounted to an exiled terrorist cell and its ringleader back into a rival country. The German government even footed the bills.* As Winston Churchill so vividly described it, the Germans "turned upon Russia the most grisly of all weapons. They transported Lenin in a sealed truck like a plague bacillus from Switzerland into Russia."[†]

It was win-win for Germany. In the event that Lenin and his cronies were successful in overthrowing the government, they promised to do what the tsar wouldn't, and pull Russia out of the conflict. Even if they failed to take power, "the aim was to disintegrate Russian resistance in the First World War by spreading revolutionary unrest."[‡] A Russia in the throes of revolution, or better yet, civil war, would be a weak Russia. For that reason, "Well after April 1917, the Germans continued to subsidize the subversive Lenin as well as his subsequent Bolshevik regime into 1918."[§]

And they got what they paid for, at least in the short-term. The original German strategy worked out exactly as arranged: Russia was thrown into chaos. The tsar and his family were murdered, and the interim government was overthrown by the Bolsheviks. Most important, the new puppet government did exactly as they were told and withdrew Russia from the war. Though Germany would still lose.

* According to Pipes, "there is much evidence of German financial commitment to the mission of Lenin."
† Susan Ratcliffe, ed., *Oxford Treasury of Sayings and Quotations* (New York: Oxford University Press, 2011), 389.
‡ Albert L. Weeks, *Assured Victory: How "Stalin the Great" Won the War, but Lost the Peace* (New York: Praeger, 2011), 39.
§ Ibid.

White Russians and Molotov Cocktails

Designed to be presented in 1917, the Constellation Egg was the last imperial egg and the only egg that Fabergé never completed. Had work on the Constellation not been interrupted by the revolution, sketches show that the diamond-sprinkled "egg" would have been a cobalt blue globe etched with stars and constellations, seemingly supported by a swirl of frosted crystal clouds. And the surprise? It was a clock, with a silver and gold disc of numbers rotating around the orb, like rings on a planet.

The Constellation Egg disappeared, and its whereabouts were a mystery for decades. It was considered by some to be one of the "lost Fabergé eggs," but by most to have never been created at all. It turns out it was lying in two pieces, unfinished, on a shelf in a Moscow mineral museum all along, having been mistaken for a lamp. Fabergé's great-granddaughter Tatiana says, "they claimed that my grandfather gave it to them . . . in 1928. But he fled in '27, so I am not convinced."

The first thing Lenin did when he assumed power was to withdraw Russia from World War I, making good on his end of the bargain with Germany. The next thing he did was to institute a violent, lawless state that resulted in wholesale murder, pillage, and inevitable economic free fall.

At the beginning of 1918 the Bolsheviks renamed themselves the Russian Communist Party and claimed to be enacting the principles set forth by Karl Marx. What Lenin was espousing, however, was anything but communism. He told the people to "loot the looters," suggesting that anyone who had money or a measure of success had certainly attained it wrongly. Therefore, he surmised, it was acceptable and necessary to strip them of their possessions, French Revolution style, in the most degrading ways possible. It was less of an economic restructuring than an eco-

nomic *de*structuring, and his "revolution" descended into a violent, murderous riot the size of a country.

People like Carl Fabergé, a man who employed hundreds directly (thousands indirectly), had contributed to the war effort, and ran the largest successful jewelry firm in the world, were given no more than, as he put it when Lenin's commissars arrived, a few moments "to put on my hat and coat"* before they were removed from their own premises.

Carl Fabergé—who was, ironically, running a nearly socialist business in the middle of a decadent autocracy—was subsequently declared a war profiteer by Leon Trotsky. He and his family only barely escaped to Switzerland, less one son, captured and imprisoned by the new regime.

His life was safe, but his life's work was not. His business was closed and then nationalized, and buildings full of treasures and great works of art were seized. New laws were written by the revolutionaries, claiming all the imperial possessions and treasures (including the Fabergé eggs) to be the property of the state. Ironically, in the free-for-all that followed the frenetic revolution, many of the priceless eggs went missing and ended up in the hands of private owners.

The eggs may have been some of the Communists' most impressive loot, but they were only a fraction of the wholesale plunder. Lenin had managed to tap into a deep-seated vein of rage and hatred common among all people and channel it into the utter destruction of the previous order. Private property now belonged to everyone. Safety deposit boxes were emptied, jewelry boxes were turned over and strewn among crowds. Even churches were no longer sacrosanct: Gold and jewels were ripped from their walls and altars. It was a frenzy of malicious envy turned violent. Even Russian socialist writer Maxim

* Faber, *Fabergé's Eggs*.

Gorky, an early cheerleader for the revolution, who had openly opposed the tsarist government for years and was a personal friend of Lenin's, couldn't hide his disgust. Even he condemned what he called the "malicious desire to ruin objects of rare beauty." He wrote: "They rob and sell churches and museums, they sell cannons and rifles, they pilfer Army warehouses, they rob the palaces of former grand Dukes; everything that can be plundered is plundered, everything that can be sold is sold."[*]

But straightforward as it might seem, this wasn't purely a case of malicious envy, of wishing to deny the wealthy their possessions and advantages. Nor was it exactly a case of *benign* envy leading to destructive or bad behavior—like, say, deploying a fleet of pirates to steal things that aren't yours from a wealthier neighbor. This revolution managed to combine the benign envy of an unprecedentedly massive underclass that wanted and needed more, with massive and institutionalized malicious envy in the form of a social system that deemed success intrinsically problematic and wealth intrinsically wrong. It was government-sanctioned malicious envy, combined with some very real deprivation.

In new, Red Russia, you could have whatever you could take from the White Russians—the loyalists, the aristocracy, and the bourgeoisie—that is, until someone bigger took it from you. Along the way, everything and everyone was an appropriate target for the anger of millions. Gorky insisted that "In the course of two revolutions and one war I observed hundreds of instances of this dark vindictive urge to smash, cripple, ridicule, and defame the beautiful."[†] It was the poisonous flowering of benign and malicious envy merged, that really gave birth to what we think of as Communist Russia.

[*] McMeekin, *History's Greatest Heist*.
[†] Faber, *Fabergé's Eggs*.

The Nihilist Revolution

By 1917, there would be no more eggs.

The Bolshevik Revolution was in full swing—and one-sixth of the world was forced to succumb to their principles and ideals. The Communists forcibly decimated their own culture and rewrote their own history, and as result, most of the facts we take for granted about them are made up. The idea that, for example, things were better for the vast majority of people under the new Communist government than they were under the tsarist government is absurd. At very best, things were the same. In most cases, they were far, far worse.

Most people have an image of pre-Communist Russia as home to a spectacularly wealthy royal family and a country full of impoverished, illiterate farmers. This is incorrect.

Before the revolution, Russia had more wealth than the rest of Europe combined, and most of it was not in the Romanovs' pockets. While the Romanovs were certainly the wealthiest royal family in Europe, there were many other wealthy families in Russia, aristocratic *and* common, who could outspend the monarchies of their Western cousins. Below them was an entire section of society, the bourgeoisie— industrialists, craftsmen, scientists, bankers, lawyers, and people like Fabergé—who were spectacularly successful and extraordinarily wealthy. The people who suffered economically were, of course, the former serfs, many of whom were not financially any better off than they were before they were freed. Still, they had no real desire to overturn the *system* of government. The February Revolution itself was really just a demand for the abdication of the current loser tsar *in favor of his brother.* Some of them would've liked a representative government, as Alexander II, the Tsar-Liberator, had intended. But mostly they were just tired of Nicholas II.

That was pre-Red October. Because the October Revolution

was a coup, and not a reflection of the will of the people, the new powers that be didn't have the popular support they needed in order to maintain power. As a result, the Communists had to use brute force and economic terrorism to control their own country. And they did just that, without mercy. They started with the vindictive seizure of goods from anyone who wasn't a party member, notably people like Fabergé or other successful entrepreneurs. In order to tighten their unsuccessful grip on an enormous country, they began utilizing forced labor camps and instituting manufactured famines, intended to starve hundreds of thousands of people to death.

Leon Trotsky stated that "We Communists recognize only one sacred right—the right of the working man, his wife, and his child to live." Sounds nice. He went on to say, "We did not hesitate to wrest the land away from the landlords, to transfer the factories, mills, and railroads into the hands of the people." Class warfare is a drag, but it's also a predictable outcome when the divide between rich and poor is too vast. Trotsky went further, justifying the actions of those who "by the force of arms, . . . [tore] the crown from the stupid Tsar's head." Still standard issue regime change. We hit the real problem with his conclusion: "Why then should we hesitate to take the grain away from the kulaks?"* Kulaks were peasants. They didn't have jeweled eggs or thriving industries—they were farmers. They were only slightly more successful than their nearest, starving neighbors. The top-down terror that started with the royal family had trickled all the way down to the peasants. Even *they* were subject to economic destructuring within the first year.

The result of this "loot the looters" economic policy was total economic chaos. Within the year, hyperinflation in Russia made it impossible to exchange a diamond bracelet for a loaf of bread.

* W. Bruce Lincoln, *Red Victory: A History of the Russian Civil War* (New York: Da Capo, 1989).

In the first of many bitter ironies, the treasures that had partially inspired the explosion were now so worthless that they couldn't even be traded for food.

Why Workers' Revolutions Don't Work

Most people assume that the failure of communism is a failure of human nature. No one likes to share. More to the point—who's willing to work as hard as they possibly can for as little as they need to survive? No one—that's who. But surprisingly, that's not really the system's fatal flaw. Communism doesn't work precisely because of positional good—or rather, the lack of a functioning positional value. Positional value is the determination of something's specific worth in relation to everything else. Remember, whether it's a horse or a giant diamond necklace, things only have a set worth in context.

Because the Communist state had done away with the free market, goods and services were no longer associated with a 'market price' that indicated their value. Without this price guide, there was no concrete value to *anything*, and without a set value for goods and services, there was no way to assess the viability of an undertaking or the priority of a need. It was impossible to say how much more urgently machinery was needed on farms than it was by other industries, so machinery was misallocated and crops rotted in the fields. There was no way to propose a building project and determine how much it would cost. Would the final product be worth more than the sum of the parts? Nobody knew. Without private ownership and a free market in which to buy or barter, there was no way to determine the value of *any* of it.

Three years after the October Revolution, an Austrian economist named Ludwig von Mises wrote that communism was a nonsustainable economic system. He predicted that because of its

very nature, communism defied rational economics and was destined to implode. You can't put a price tag on a healthy, functioning state—but it turns out that a functioning state requires that almost everything else have one. In 1919, Maxim Gorky stated that "only the Commissars live a pleasant life these days. They steal as much as they can from the ordinary people in order to pay for their courtesans and their unsocialist luxuries." It turns out, when nothing belongs to anyone, and there's no way to compare or compete, the system *just crumbles* under all that "fairness."

Try Again, Fail Better

Lenin was a lot of things—a sociopath, a megalomaniac, a dictator—but he was not, actually, a nihilist. By 1921, even he could see that the last vestiges of his great social and personal experiment were circling the drain. In addition to its swift departure from rational economics, the "people's utopia" failed to come to fruition because, well, a lot of "the people" wouldn't cooperate.

One of the first things the Communists needed to do, for example, was nationalize the banks and all their gold, currency, and other assets. But the bankers wouldn't play ball. They wouldn't even honor Lenin's requests for withdrawals to pay the Red Guard, at least not until the Bolsheviks started kidnapping their coworkers and family members. At that point, they handed over the keys to the vaults and walked out. Every other banker across Russia followed suit. The problem then became that Lenin and his cronies had no idea how a bank even operated. When he finally seized the banks, he couldn't run them. All he could do was take the gold out of the vaults and the jewels out of the safe deposit boxes and try to pay people with them.

Ultimately, Lenin got the message that utopia was on hold—at the request of the people. In the meantime the country was falling

apart. In a desperate attempt to cover his assets, he surrendered the intelligentsia high ground and instituted the New Economic Policy (NEP), which mostly consisted of some minor philosophical and economic backpedaling. The linchpin of NEP was the abandonment of total nationalization in favor of a food-based tax, which left the peasants with a small surplus of crops, which they were allowed to—*gasp*—sell on the open market. This so-called wartime concession to capitalism, alongside other compromises, like the granting of concessions to foreign investors, eventually led to the denationalization of small-scale industry. The NEP was considered, at least by Lenin, a necessary evil. He claimed to be taking "one step backward to later take two steps forward."

In addition to allowing the people their slice of capitalism, as he disdainfully put it, Lenin had his: He began amassing not just the crown jewels of Russia but all the accumulated wealth of centuries. Looted from the looters, it was consolidated along with state treasures, church treasures, and the possessions of the Romanov family to sell to the West. The Soviets were so confident that the entire world would soon fall to the new Communist world order that they had no qualms about selling off their own history and wealth in exchange for badly needed foreign currency. They insisted that it would all be returned to them soon, when the Soviet Union inevitably ran the world.

Cool plan, guys.

Lenin founded the Gokhran, a bureau that existed specifically to amass and appraise the misappropriated accumulated wealth of Russia and prepare it for sale abroad. Agathon Fabergé, Carl Fabergé's captive son, was the preeminent gemologist of his day. He was released from prison and forced to appraise the items for sale at the Gokhran, earmark them, and ready them for foreign buyers. (Quite a few of these items were probably made by his father.) This mostly involved pulling the diamonds out of precious works of art, ripping the gold binding off ancient church books, and heaping the materials in great piles for resale. The idi-

ocy of destroying ancient treasures and modern works of art—in a sense, stripping them for parts—when doing so actually *diminished* their overall value, was indicative of the Communists' complete lack of rational economic policy. Aside from the ethical and commonsense objections, the biggest problem with the plan to fund the Soviet start-up with the foreign sales of Russian treasures was that Russia soon managed to flood the international market with jewels to the point that, by 1920, their value was dropping like that of emeralds in sixteenth-century Spain.

Lenin died in 1924, three years after his NEP began. His wife blamed his constant "rage." Some have suggested that Stalin deliberately hastened the process. Maybe it was just the stress of his failed economic theory. Either way, his even crazier secretary, Josef Stalin, seized power immediately after Lenin's death. Stalin killed most of his rivals and drove the rest, most notably Trotsky, into exile. He emerged victorious in a free-for-all power grab and asserted himself as the supreme head of the Soviet state. Russia was once again under the autocratic rule of one man.

In 1927, Stalin canceled the NEP in favor of total national control. But that doesn't mean he canceled the fire sale on Russia's heritage. In fact, he expanded it to include items even Lenin wasn't willing to sell, like the Fabergé eggs. Basically anything and everything had to go. The new Soviet state was desperate for foreign currency, as its own was nearly worthless. And Stalin had major, and expensive, plans to make a bid for world power status. He intended to launch a rapid industrialization of the entire country—bringing it up to twentieth-century military and industrial standards in only five years. The only problem? No money. The economy was foundering, infrastructure was crumbling, and people were dying like flies. As it turns out, even utopia has bills to pay.

Stalin could hardly admit that the Marxist dream was an unprecedented economic, social, and political disaster. He just had to find a source of money quickly—and quietly.

For the Western world, the problem was this: The puppet regime, which should have flamed out with the death of its pseudointellectual front man, not only refused to wither on the vine, it was growing nasty roots. All it needed was a subversive source of Western capital. Enter Armand Hammer: famous U.S. capitalist and, strangely enough, personal friend of Vladimir Lenin.

Sympathy for the Devil?

When I was very little—single digits—and people asked me what I wanted to be when I grew up, I would say, with icy confidence: "a KGB agent." This was in the eighties, and it didn't go over well with adults—not teachers, not pediatricians, not friends of my parents or parents of my friends. My dad occasionally laughed, but usually my mother would give me a pinch on the neck, flash a glamorous smile at our guests, and hiss, "*Stop it, Aja.*"

Of course, I didn't have any deep political leanings at that age and certainly no beef with my own country. What I was actually enamored with was the idea of the KGB. I blame my parents. They let me see too many James Bond movies as a small child. I doubt I understood the plot, let alone the subtext. But I knew that I liked fur, I liked over-the-knee boots, and I liked evil Bond girls. I've always had a soft spot for bad guys too. As a very small child, I cried at the end of Disney movies when the evil queen was defeated. Apparently my sympathy for the devil runs pretty deep. And yet everything about Armand Hammer makes my skin crawl.

Hammer combined the worst elements of a liar, a thief, a traitor, a war profiteer (even if it was a Cold War), a con artist, and a carnie. He was undeniably clever and outrageously successful. He managed to parlay one treacherous, backstabbing

success into another—and another and another—like someone smoothly waltzing across a floor, trading partners as he goes.

So who was Armand Hammer? Toby Faber called him "the man who kick-started America's love affair with Fabergé." Brilliant journalist Edward J. Epstein called him "one of the great con men of the twentieth century." They were both right. Really, Hammer's greatest con job was using the Fabergé eggs to sell America on the emotional mythology of the wasted Romanov dynasty and funneling the money to the very people who had leveled it—and who happened, at the time, to be our sworn enemies.

To the public, he was an American captain of industry, most notably the president of Occidental Petroleum for decades. He was Dr. Hammer, though he never really practiced medicine. He was a "citizen diplomat," with personal connections and presidential associations all over the world. He was a famous philanthropist and world-famous art collector. He was a shameless and notorious self-publicist, who was actively lobbying for no less than a Nobel Peace Prize before his death in 1990.

He was also, for most of his life, a Soviet agent.

Hammer and Sickle

Armand Hammer was born in the United States, the son of Ukrainian-born immigrants. His father, Julius Hammer, was not only an enthusiastic (and closely scrutinized) socialist, he was one of the founders of the Communist Party USA. He started a chain of drugstores that turned into the company Allied Drug and Chemical. When he went to prison (after, some people say, taking the rap for his son Armand), his sons continued to run that business.

Armand Hammer originally went to the Soviet Union on the pretext of related business—the type and kind of business

depended on whom he was talking to. He applied for a visa and left the United States with special permission from the government to visit Europe on Allied Drug business. He claimed in his visa application that he would be visiting Western Europe for a short time. He then somehow found himself in the Soviet Union, where he stayed for almost a decade.

Insisting that he was moved by the plight of the Russian people, he began to engage in entrepreneurial business activities there, without ever returning to the United States. Early on in his visit, Hammer toured a mining region in the Urals. He promised, for no apparent reason, to arrange a grain shipment from the United States in exchange for Russian "concessions," which consisted of luxury items like furs and jewels.

This got Lenin's attention, and the two became close. Lenin decided to make Hammer the first foreign middleman, or "concessionaire." He was also, technically, the last.

Hammer was successful right off the bat. One of the concessions he negotiated was the right to exploit an asbestos mine in the Urals. According to Epstein, "shortly after meeting with Lenin, Hammer was told that his family firm would do more than operate an asbestos mine in the Urals. It would also act as a financial conduit for Soviet activieties in the United States at a time when funding such activities was illegal."* The plan involved setting up a banking concern in New York and using Allied Drug to essentially launder money, funneling it from the United States to the Soviet Union.† He also negotiated the so-called right to help import foreign vehicles and machinery. He was actually negotiating semi-illegal, certainly subversive, deals on behalf of the Communist government.

He brokered a deal between Henry Ford, at the time "Amer-

* Edward J. Epstein, *Dossier: The Secret History of Armand Hammer* (New York: Carroll & Graf, 1999).
† Ibid.

ica's richest capitalist,"[*] and the new Communist government to import numerous Fordson tractors, while obscuring their origin.[†] Ford was looking for a testing ground and a test market as early as 1919, when the export of machinery or vehicles to the Soviet state was completely embargoed. When Hammer approached him in 1922, Hammer offered to buy "millions" with Allied American (another version of the same front) as purchasing agent, in case anyone should look. Ford got a test run for his new horseless plows, and Russia got all the farming equipment it needed, with or without anyone's formal blessing. He made similar deals with over thirty other companies on behalf of Stalin's government by 1923.[‡] Of course, these deals were made mostly under the radar, given that the only countries that diplomatically acknowledged the Bolshevik government at that point were the ones also imposing sanctions against it.

When Lenin died in 1924 and Stalin seized power, Hammer's mine was seized by the government and nationalized. But it was far from the end for a man who seemed to have a strangely charmed life in Russia. Somehow, no sooner had his previous business interests been snatched by the Soviet government than he was granted new ones—almost as if they were a pretext for his ongoing presence. The next was a pencil factory. The supposed pencil maker was even provided with an unnecessarily luxurious Moscow headquarters by the Soviet "Special Concessions Committee." One that just happened to be the hastily evacuated, four-story building that had formerly housed the Fabergé workshops and offices, for the very obviously "token rent of twelve dollars a month."[§]

While Hammer and his brother Victor, who had by then

[*] Epstein, *Dossier.*
[†] Ibid.
[‡] Ibid.
[§] Ibid.

joined him, were allegedly running a pencil factory, they were accumulating the warehouses full of prerevolutionary treasure that they would bring home to the United States in 1929. Once they were imported, and passed off as the brothers' own personal possessions, Hammer planned to sell those items, literally and figuratively, to the rest of America. Of course, Hammer wasn't the only man helping to liquidate and export the looted treasures of Russia. He was, however, the only one who really achieved Stalin's goal of funding the Soviet start-up with foreign currency.

Because of the amount of liquidated treasure, the world diamond and gem economies were in free fall.* So what did Hammer do so differently? He did what De Beers did when it had too many diamonds. He sold more than jewels. He sold a story.

The Wages of Sin

In his 1987 autobiography, *Hammer: Witness to History*, Hammer spun a fantastic, if mind-numbingly long, story of the many feats of brilliant diplomacy, genius entrepreneurship, and dumb luck that made him one of the most spectacular art collectors in the world, a personal friend of numerous world leaders, and the president of Occidental Petroleum. Most of it was complete fiction.

Edward J. Epstein sniffed him out for the snake that he was, back in 1981, when the journalist was asked to write a biographical article about Hammer, who was being considered for a Nobel Peace Prize, for the *New York Times*. Epstein couldn't actually

* Many of the jewels once owned by the Romanovs were of so little cultural value to the Communists and so little monetary value to the impoverished post–World War I Europeans that they were being sold by the kilogram like scrap metal. In 1926, one famous London gem dealer, a man named Norman Weisz, actually bought 9 kilograms of the Russian crown jewels for the equivalent of $7 million.

prove any of his suspicions then, but his instincts were spot on.[*]
So instead he just wrote an article that didn't cast Hammer in a
good light and allowed readers to draw their own conclusions.
The *Times* article suggested but never outright accused him of
espionage, and implied that Hammer's business dealings with
the Soviet Union were deliberately advantageous to the USSR's
interests. That was not something that the octogenarian Hammer
tolerated. While Hammer failed to repress the article, because he
didn't see it coming, he was more careful with the press going
forward. He tied a number of other journalists up in expensive
court battles until the time of his death.

So Epstein bided his time. A few years after Hammer's death
in 1990, the Soviet Union fell, and with it so too fell most of the
(iron) curtains that had previously obscured its business dealings.
Hard and detailed evidence of Hammer's misdeeds began run-
ning out of the old Soviet archives like rusty water. At that point,
using State Department sources and declassified documents,
Epstein wrote a book called *Dossier: The Secret History of Armand
Hammer.* It tells a very different story than that of Hammer's offi-
cial account.

Hammer's version of his dealings with Russian art, particu-
larly Fabergé, goes a little something like this: Hammer and his
brother had previously been avid collectors of any and every spe-
cial jeweled object, important historical artifact, or piece of art
they could get their hands on. They bought things like personal
effects of the tsar at flea markets or imperial china from restau-
rants that were just tired of the dishes chipping, and scored pretty
much all the patrimony of tsarist Russia for a song, because he
was just that clever.[†]

[*] And it probably doesn't hurt to have the occasional source within the clandes-
 tine services.

[†] Armand Hammer with Neil Lyndon, *Armand Hammer: Witness to History*
 (New York: Perigee Books, 1988).

At some point in the late twenties, a friend of his named Emery Sakho suggested that he and Hammer start their own art gallery and antique dealership in the United States. Sakho suggested they call it L'Ermitage, in honor of the Hermitage in Russia, the great national warehouse of ancient and priceless treasures, where Fabergé had begun his career decades before. Hammer agreed that it was a swell idea.

And so off Hammer's brother went to begin L'Ermitage in New York.

It was only a coincidence, of course, that the Hammer's pencil factory was then immediately nationalized, leaving Armand Hammer, for the first time in a decade, with no good reason to remain in Russia. So he went too, leaving his wife and child (additional local treasures picked up in Russia) behind in Paris. According to Hammer, Sakho had some sort of vague business problems in 1929, and so unfortunately couldn't join them in the venture he himself proposed. *Ever.*

In reality, there's no record that "Emery Sakho" ever existed in the first place.

Fabrications

While Hammer liked to maintain that he was a wunderkind of the arts and antiques world, the truth of the matter is that he owned almost none of what he was selling. His brother Victor (the not-so-bright half of the pair) readily admitted that all of it belonged to the Soviet government, and they were only selling it on commission.* What his brother failed to mention was that he and Armand were a front for the Soviet government, funneling the vast majority of the proceeds, basically all of it, right back to

* Faber, *Fabergé's Eggs*.

Moscow and using Allied Drug as the Soviets' laundering bank in the United States.[*]

Epstein wasn't the first guy to notice that Armand Hammer was a Soviet agent. J. Edgar Hoover tracked his movements and watched his contacts throughout his lifetime.[†] He kept an entire file cabinet on him and actively monitored him for over twenty years. Hoover was well aware of what Hammer was doing but was unable or unwilling to stop him. He suggested at one point that he let Hammer continue because he was leading the FBI to bigger fish, and given Hoover's very, very long blacklist, that may well have been true.

But Hoover wasn't the only one who was seeing Red. Hammer's Soviet connections were the worst-kept secret in the art world. A number of other individuals before him had refused the commission in Russia. One French dealer had famously said, upon seeing the extent of the looted treasure, that he was "an art dealer. Not a jewel thief."[‡] Hammer obviously didn't feel the same way. He was even referred to by one American critic as "Stalin's U.S. field representative."[§]

While the Hammers and their ties to the Soviet Union were well known, or at least well suspected, in some circles, his primary target—the American middle class—didn't have a clue. The middle class, of course, was the same demographic that De Beers would seduce using a similarly glittery fairy tale. They were the consortium with the greatest collective buying power the world had ever seen and perhaps also the greatest capacity for self-delusion.

In order to exploit that audience, Hammer would have to first make them fall in love with Fabergé. He'd also need inventory—

[*] Epstein, *Dossier.*
[†] Ibid.
[‡] McMeekin, *History's Greatest Heist.*
[§] Faber, *Fabergé's Eggs.*

tens of thousands of pieces of inventory. The solution to the first problem arrived when yet another "friend" suggested to Hammer that in order to sell off his many warehouses full of priceless treasures, Hammer should turn to department stores. A strange place to sell treasure? Perhaps, but a fair amount of it was never intended to sell. The first step in his strategy was in essence a performance and a sales pitch. Where better than department stores to raise awareness of the "lost Romanov treasures" and to generate interest and enthusiasm among the masses?

In his multiyear tour of the enormous American department stores, Hammer employed every psychological trick in the book. He showed things that weren't for sale, like the eggs. He paraded beautiful women in imperial robes through his exhibitions. He even hired a fake deposed Russian prince to come and gaze wistfully at the cases in front of the buyers and lament his plundered history and lost treasures. He was the Svengali of jewelry salesmen. He turned the eggs into icons. And the American public ate it up.

They bought any and everything that said Fabergé on it, anything small or modestly priced. Remember, Fabergé made everything from cigarette cases to picture frames. After a while, Hammer actually ran out of stock, even though shipments from Moscow continued steadily. Hammer was so intent on creating wealth for himself and funneling the much-needed funds to the new USSR that when he ran out of Fabergé eggs and objects, which, of course, he did, he began counterfeiting them in the United States—with Stalin's blessing. Hammer had Fabergé's original steel dies—the metal stamps bearing the maker's mark—tapped into a finished product as proof of authenticity. When he ran out of authentic Fabergé to sell to the U.S. population, he simply had French knockoffs shipped to him and marked them with Fabergé's own stolen stamps, probably acquired during his stay in Fabergé's headquarters.

It's worth emphasizing that in this case it wasn't the scarcity

of the items that determined their value any more than their carat weight. In fact, the bulk of what he sold to the upper middle class was more enamel than real jewels. Hammer had liquidated most of the wealth of Russia and then just flooded the market with more and more "authentic" pieces. It would be like someone flooding the market with diamonds, then successfully passing off glass as *additional* diamonds and selling them for higher and higher prices. The proliferation of Fabergé pieces should have caused the value to plummet. But it didn't. This wasn't a case of scarcity driving value. It wasn't even the false perception of scarcity. This was a case of *symbolism* linked to value.

The scarce commodity in this case was royalty. It was tragedy. It was history. Hammer flooded the market with countless items stamped Fabergé, real and fake, and he banked on the emotional attachment people had to the idea associated with it. He was selling a fantasy he had painstakingly created, and then cashing in on the trinkets he could pawn off on people as they walked out—like a gift shop at the exit of an amusement park.

The Evil Empire

Created in 1887, the Third Imperial Egg was named for its dull distinction as the third in Fabergé's series. For almost a century it was one of the infamous "lost Fabergé eggs;" the ones that disappeared during the revolution, and never resurfaced. It's a simple golden egg. It sits in a lion-footed tripod of the same color gold, festooned with minimal golden garlands and set with one small sapphire and a large diamond. When pressed, the top pops open to reveal a pocket watch–sized clock.

It might have been the least interesting of all of the Imperial eggs— had it not suddenly turned up last year in the unlikeliest of places: in the hands of a scrap dealer in the American Midwest. The man bought

it at a flea market, near a Dunkin' Donuts. He had intended to melt it down for its heavy gold weight. It was only by chance that it was recognized, not only as Fabergé but also as one of the priceless handful of missing imperial eggs.

In the end, Hammer kept very little of the money from the sales of all of the treasures, both real and counterfeit. It later turned out that Russian agents would frequently oversee the inventory to make sure nothing had gone missing and that the Hammers weren't pocketing any extra money. The fact of the matter was that Armand Hammer was little more than an international fence. But the stolen goods he was fencing had been stolen from an entire civilization of people, and he was fencing them for a hostile foreign government—one that was intent on the downfall of the United States.

The members of the American middle class who gobbled up the Fabergé pieces weren't buying eggs. They weren't buying too much of anything. Nothing real, anyway. But by spinning a story of a lost opulent empire and deposed royalty, of the beauty and glamour and doomed romance of tsarist Russia, Hammer managed to leverage the desires of the average middle-class American and transform the buyers themselves into an unwitting sales force. Who wouldn't fall in love with the idea of owning a piece of real treasure?

With every double-headed eagle crest or Fabergé stamp (real or forged), Hammer transformed those objects into symbols of something that we Americans have always had a love-hate relationship with: royalty. He made the Fabergé eggs psychological shorthand for wealth and power. While most consumers were buying the avalanche of more modest silver or enamel items, ultimately the frenzy around the items made them so valuable that the very wealthy people, like Malcolm Forbes and Treasury Secretary Andrew Mellon, began buying up the larger and more outrageously expensive items for small fortunes. Then, when the American public had bought in, Hammer parlayed those bottled-

up feelings into untold hundreds of millions of dollars, which he subsequently funneled directly into Stalin's accounts. And thus we Americans—the consumer middle class—funded those first, rocky years of the Soviet state.

And what became of all that money? Well, the Soviet Union. Spy versus spy, the space race, Sputnik, and the Cold War. The Western world's greatest enemy of the twentieth century, the "Evil Empire," as Ronald Reagan called it, was bought and paid for—first by Germany—and then by *us*.

PART III

HAVE

INDUSTRY, INNOVATION, AND THE LIGHT AT THE END OF THE TUNNEL

Desire doesn't necessarily end with consummation. Sometimes getting a thing is the beginning of getting over that thing. Sometimes getting what you want just makes you want more of it. So how does actually having a thing shape and change its owner? In turn, how can having a thing change the world?

We've discussed the illusion of value and its deeply subjective definition. We've looked at the ways desire shapes our sense of worth. In the story of the beads that bought Manhattan, we've seen how desire shapes our sense of value, and how our notions of value then feed back into the structure of our desire. In the tale of poor Marie Antoinette's lost head, we've seen how it informs our sense of moral value as well.

In examining the way desire informs our sense of ethics, we've tracked the transition from stone to symbol, examining

what a piece of jewelry can come to mean, and looked at the consequences, good and bad, of emotion made physically manifest. We've seen how desire, when denied, can lead to aggression, corruption, and even war.

Having explored the questions of what a stone is worth, and what a jewel can mean, we can now ask: What can a jewel do? Can it save a civilization? Can it alter the framework of time? What about values that aren't imaginary? What about industries and organizations and even armies all launched on the back of a few glittering jewels?

This final section examines the upside of down: how mankind's obsession with beauty and our endless pursuit of precious jewels and whatever we deem scarce or valuable has led, not only to violence and chaos but to surprising developments in science and in economic and social infrastructure. "Have" is about desires fulfilled and consequences far more interesting than mere satisfaction.

A noodle maker who dreamed of farming vast fields of pearls, and inadvertently saved Japanese culture from mandated destruction; a watchmaker, catering to the seemingly unnecessary whims of his female clientele, not the least of whom was a Hungarian countess, who ultimately revolutionized modern warfare with a single fashion statement. Each of these people satisfied an individual desire, but it was only after they'd achieved their original objectives that their real journeys began. Who they were, who they became, and why they matter—easily transcended their short-term goals.

"Have" is the story of how things change—and how things *change the world.*

THE BOSS'S STRING

Pearl Culture, Cultured Pearls,
and Japan's Race to Modernity

(1930)

There are two things which couldn't be made at my laboratory—
diamonds and pearls. It is one of the wonders of the world that you
were able to culture pearls. —THOMAS EDISON

All things are artificial, for nature is the art of God.
 —SIR THOMAS BROWNE

In 1603, Japan determined that the rest of the uncivilized world
had nothing to offer except religious strife, contention, and trou-
ble. So the powers that be closed Japan's doors to foreigners for-
ever. At least that was the intention. Nearly 250 years later, those
doors were forced back open at gunpoint by a fleet of smoke-
billowing American ships, all of them so radically modern that
many Japanese mistook them for dragons.

On July 8, 1853, an American admiral named Matthew Perry
sailed with a fleet of ships up to a culturally, technologically, and
militarily unprepared Japan with four heavily armed warships.
In theory, his mission was a diplomatic one. He carried letters of
introduction from the U.S. president, as well as treaties of peace
and mutual trade agreements.

But in reality, each action was a clear and deliberate show of force. They wanted Japan open for business. The Tokugawa shogunate, the ruling government of Japan, had so aggressively restricted contact between Japan and the rest of the world, that just the presence of the American ships made their message clear: *Play ball or else*.

Before their uninvited guests sailed away, the Japanese were forced to sign humiliating and lopsided free trade and passage agreements and various peace treaties. They were simply outgunned. As the stunned Tokugawa shogunate watched the ships disappear, they vowed that they would catch up and overtake the West at all costs. They would be no one's colonial slaves.

Thus, at the dawn of the twentieth century, the Japanese were thrust forcefully back onto the global stage. They made the wrenching decision to abandon, if not systematically dismantle, their own centuries-old, heavily traditional and feudal culture in an all-out sprint to catch up with 250 years of social and technological progress. Floods of students were sent to Europe and the United States to study. Emissaries were sent abroad to learn as much as they could about modern industry, science, and commerce. And westerners of all sorts were imported to consult on everything from the building of railroads to the running of banks. Foreign "experts" even retrained the samurai to function as a modern Western army.

Japan developed a number of industries during this rapid modernization, including powerful steamship manufacturers and modern textile factories, but no advancement or success held a candle to Mikimoto Kôkichi's* *invention* of cultured natural pearls, an invention that was the beginning of the biotech industry, shot the starting pistol on the Japanese technological revolution, and helped make Japan a global superpower.

* In English, it's Kokichi Mikimoto, so that's how we'll refer to him hereafter.

The First Five

Kokichi Mikimoto, the man who would bring pearls to the masses, was born in 1858, the very same year that Japan finally opened its doors to the rest of the world.* The eldest son of an impoverished noodle maker, he lived in the backwater fishing village of Toba. Though the Meiji reforms (more about them later), which rocked the country in the decades following Perry's intrusion, made economic mobility possible in theory, for many *poverty* unsurprisingly prevented that mobility in practice. When the young Mikimoto was eleven years old, his father fell ill, leaving him the primary breadwinner for his large family. He worked all day selling vegetables and making noodles, and most of the night pushing a noodle cart.

One of the few advantages to his life of drudgery in a small fishing village was the access it gave him to the coastline. As a young man, he became transfixed with pearls. And probably also with the topless Ama, the traditional pearl-diving girls who had been sourcing oysters from the coastline for centuries. He saw that even the tiniest seed pearls were valuable, as they could be taken to city markets where they were ground and sold as medicines and cosmetics. But it was the perfect ones that fascinated him: how they formed, why they failed, and the possibilities surrounding human induction. In essence he became obsessed with growing the perfect pearl. His dream was to farm pearls in vast quantities and make them accessible to everyone. Later on, he claimed it was his dream to adorn the neck of every woman in the world with a strand of pearls. Even when his company was up and

* Perry may have arrived in 1853, but the Treaty of Amity and Commerce (known as the Harris Treaty) wasn't signed until five years later, in 1858. That was the one that really allowed any and everyone in and out of the country to pursue all forms of business.

running, he said he hoped one day to produce enough pearls to sell a strand for two dollars to every woman who could afford it, and give one away to every woman who could not.

At the age of twenty-three, Mikimoto still worked from dusk till dawn selling noodles, but he married the daughter of a samurai. Her name was Ume, and she was as much to credit for the success of cultured pearls as her husband. She was not only the head of the household while he was away in other villages—scouting bays, checking crops, and attempting to grow pearls—she also ran the family noodle shop, a position that would've been as unthinkable in the previous generation as marrying a peasant—all the while assuring her husband that his, perhaps their, dream was within reach.

He dreamed of pearls and beauty, but he had other, secret ambitions that only a decade earlier would have been considered even more fantastical: He wanted to be a scientist.

One of the high points of his later life was in 1927, when he was invited to meet his idol Thomas Edison. Edison hosted Mikimoto in his home, showed him his laboratory, and lauded Mikimoto's great contributions. Edison told him, "This isn't a cultured pearl, it's a real pearl. There are two things that couldn't be made at my laboratory—diamonds and pearls. It is one of the wonders of the world that you were able to culture pearls. It is something which is supposed to be biologically impossible."[*]

Early on, he worked his way up through local politics and in the mid-1880s became the chairman of the Shima Marine Product Improvement Association. There he met Narayoshi Yanagi, the secretary general of the Japan Fisheries Association. In 1890, Yanagi invited Mikimoto to the third National Industrial Exposition.[†] There he met Japan's foremost marine scientist, Kakichi

[*] Letter from Thomas Edison to Mikimoto Kokichi, 1927, museum at Mikimoto
 Pearl Island.
[†] Nick Foulks, *Mikimoto* (New York: Assouline, 2008).

Mitsukuri.* One of the few who didn't think his plans sounded crazy, Mitsukuri shared a huge amount of background information and education with him.

Years went by without success, but still his projects, and associated gambles, got bigger and bigger. Finally disaster struck in 1892, when he looked out across the bay to see the water turning blood red. It was a red tide, a toxic algae bloom, and it wiped out everything they had, killing five thousand oysters. It should have been the end of cultured pearls; Mikimoto was ready to give up. But his wife reminded him of a few tiny secluded oyster beds that might still be alive, and she eventually dragged him out to look. In fact, it was Ume who pulled the first successful cultured pearl from an oyster, after her husband had abandoned hope. She found five, in total, that day in the secluded oyster bed. It was her last contribution to their project. She died not long after.

It was in July 1893, and they were only half-round pearls. But they were enough to prove that his system worked, and to receive a patent in 1896.† He set about marketing his half-round cultured pearls and used the proceeds to continue his research. Mikimoto wasn't the first person to attempt to culture pearls. But the scientist in him realized that the secret to success would be repetitive, well-documented, systematic experimentation, conducted over a period of years. And it would take many more years to create perfectly spherical pearls.

He was certain that he could place an object, or a nucleus, in the oyster to be coated in nacre, the same way he had already created mabe, or half-round, pearls. But he couldn't make an object *inside* the oyster tissue, away from the shell, irritate the bivalve enough to induce nacre production without killing the oyster or being rejected by it. He tried everything he could think of to seed the pearls: soap, metal, wood. One

* Foulks, *Mikimoto*.
† Ibid.

day, it occurred to him to try a bead made out of shell. That attempt was successful but unreliable; the oysters only sometimes coated the shell beads.

After years of attempting to create freestanding spherical pearls and failing time and again, he considered a new method. He wrapped the entire nucleus in living tissue from another oyster. It was time-consuming and expensive, and Mikimoto had no idea why the "all-lapped" technique worked, but that did the trick. In 1896, he patented this technique of wrapping his pearls entirely in donor tissue.

It turns out that the transfer of epithelial cells from the ruffled edges of the mantle tissue to the inner area of the oyster causes the pearl sack to form.* That's why merely introducing foreign objects to the inside of the oyster was ineffective, and why placing them in between the shell and the oyster so that they made contact with the mantle tissue and the shell created half-round pearls.

That little piece of living tissue from another oyster, Mikimoto would discover, was the vital ingredient—and he almost never discovered it at all. Nearly out of money, and betting everything on his "all-lapped" pearls, he waited patiently for the crop to reach maturity. But disaster struck *again* in 1905, when another red tide wiped out his entire stock, more than *850,000* oysters this time, before they were ever harvested. Unwilling to give up—or maybe just on the verge of a nervous breakdown after a few really hard years—he sat on the beach for days amid stinking heaps of rotting oysters, opening them one by one. Though most of them

* In more recent years it's become clear that the nucleus isn't strictly necessary for pearl production, and a lot of freshwater pearls are cultured using only tiny sections of mantle tissue. It's been theorized that when a parasite makes its way into a pearl naturally, it drags some of those epithelial cells with it, forming the pearl sack around itself as they activate. As the nucleus of a cultured pearl is surgically inserted into the oyster, a small section of tissue has to be inserted with it.

had been destroyed, in the end, out of the thousands of shells, he once again found five pearls. But this time, they were perfect spheres.

The Birth of Biotech

Once Mikimoto had settled on the system for creating pearls, he started growing them in huge amounts. He didn't just pioneer culturing single pearls; he also invented and refined the process of *pearl farming*, which was a completely new concept. He had Ama divers search for wild akoya oysters, and over time, in a process not unlike the selection of racehorses or roses, narrowed down the oysters he would use in his farm, evaluating them for everything from their color and hardiness to their potential to be prolific producers for both nucleation and reproduction. Once the pearls were seeded, he placed them in baskets that hung from giant floating rafts along the coast of his own island.

In 1916, he received a second patent for spherical cultured pearls. Mikimoto's cultured pearls were of high quality, and could be mass-produced, so he set about marketing and selling them to the entire world. By the 1920s, massive crops of pearls were available for commercial export, and Mikimoto Kokichi was named one of Japan's top ten scientists.

The cultured pearl was the beginning of the twentieth century's fusion of technology and nature. Akoya pearls were the very first industrial products incubated in a live host. In another inversion of the De Beers model, they were *all* sold at varying prices. Even the subpar pearls, the ones not suitable for jewelry, were eventually crushed up and used to create calcium supplements and cosmetic products by Mikimoto Pharmaceuticals.

In certain respects, the Meiji period, during which Japan rushed to catch up to the rest of the modern world after centuries

of deliberate resistance to it, served Mikimoto as well as he served it. Having been born a noodle maker, he would not have had the freedom to pursue scientific or industrial pursuits in the era before Japan's rapid modernization. In many ways, Japan's industrialization was the equivalent of the South African diamond rush, but its success is credited to scientific endeavor and hard work instead of dumb luck and exploitation. Rather than scheming to amass a fortune of his own—Mikimoto was a frugal and spartan man until the day he died—he intended that the farmed pearls of Japan be *for* Japan. They were, in his mind, the solution to a problem. Japan's small size and relative lack of raw materials resulted in a primarily mercantile economy, in which raw materials were imported and finished products exported. To show that his life's work had been for his country and not for himself, Mikimoto offered up the first successful crop, saying, "I dedicate and present this crop to the Emperor of Japan."*

By the time the Meiji period was over, Japan was the sole exporter of millions of perfect pearls.

Cultural Quarantine

And that's the story of Mikimoto's triumph, or at least the beginning of it. But let's go back to the beginning of the beginning. That's where the tiny seed is always planted.

A lot of countries have claimed isolationism as their foreign policy of choice, but most of them don't actually cut ties with the rest of the planet. Usually isolationism is just a dodge against doing things they don't want to do, *with* or *for* other countries. But when medieval Japan said *get out and stay out* to the Western

* Robert Eunson, *The Pearl King: The Story of the Fabulous Mikimoto* (Rutland, VT: Charles E. Tuttle, 1955).

world, it actually meant just that. More impressively, it managed to enforce the policy for a few hundred years.

Way back before Mikimoto cultured pearls in the twentieth century, medieval Japan was ruled by feudal lords, called daimyo, who controlled vast individual armies of highly trained samurai knights. As the impotent imperial court looked on, these daimyo fought for territory, power, and influence. They also constantly battled with unwelcome European traders and missionaries. The decentralization of power, constant fighting among the lords, and the intrusive, subversive, and destabilizing forces of aggressive Christian missionaries made for a country in chaos. As a result, Japan spent most of the fifteenth and sixteenth centuries at continuous war with itself.

Japan's troubles finally boiled over in 1600 with the Battle of Sekigahara, after which one victorious samurai named Tokugawa Ieyasu seized control and consolidated power throughout Japan. He ruled from his home base in his heavily fortified castle in Edo—or as we know it today, Tokyo. By 1603, the imperial court was completely powerless, but they were not completely blind. They saw which way the wind was blowing, and formally named Tokugawa Ieyasu as Japan's supreme military commander, or *shogun*. In doing so, they almost unintentionally created the Tokugawa shogunate, the dynasty that would rule Japan for the next two-and-a-half centuries and would preside over Japan's classical period.

As shogun and unofficial ruler, Tokugawa's first concern was stitching his country back together after a century of civil war, foreign intrusion, and religious discord. He set about returning Nippon, as they called their country, to traditional Bushido* values and Shinto and Buddhist beliefs. Tokugawa believed that if this could be accomplished, economic prosperity and peace would

* *Bushido,* a modern term rather than a historical one, was a philosophy and code of conduct not unlike chivalry but with a greater emphasis on discipline, self-sacrifice, and perfectibility.

come. One of the first things his government did in that pursuit was to throw out all the foreigners.

The Japanese had observed the Christian church embroiled in various global religious wars for centuries, and the conservative authority in Japan didn't like that it was springing up in their backyard. More important, missionaries posed a fundamental threat to a feudal society. In Japan, much like feudal Europe, a vast majority of the population were peasants who owed their undying loyalty not just to the ruler but more immediately to their individual, local daimyo. The notion that there might be a higher authority to whom a person could owe allegiance, be that the pope or the actual Christian God, was a dangerous and disruptive influence in Japan's carefully ordered social structure.

In addition to the question of religious authority, European trade practices that many Japanese felt were unfair, and finally the possible military threat posed by foreign, increasingly aggressive colonial powers on their doorstep formed a persuasive trifecta. By 1636, those combined concerns motivated the Tokugawa shogunate to enforce the most passive-aggressive foreign policy on record: the Act of Seclusion, which effectively cut ties with the Western world. By 1639, the government had imposed a dictatorial policy called Sakoku, meaning "closed country."

Under this extreme policy, Christian worship was both outlawed and fiercely punished. Contact with any foreigners was strictly forbidden, and all westerners were expelled. Sakoku forbade any foreign visitors from entering Japan, however briefly, and the Japanese people themselves were not allowed to leave their own country. There were even a few accounts of shipwrecked Western sailors, washed up on Japanese shores, being sent back onto the open seas, killed, or detained and treated like prisoners. The single exception to this hard-line policy was one tiny outpost near Nagasaki, a small, fan-shaped island in Nagasaki harbor called Dejima. It was populated by a handful of closely guarded Dutch commercial traders, who apparently, the shogunate found

slightly less offensive or subversive than their European fellows.[*]
Even so, these foreigners were strictly isolated.

Japan maintained regular commercial and diplomatic rela-
tions with China and Korea during this period, but the small con-
tingent of Dutch traders on Dejima constituted its only window
on the Western world—a window that was more like a keyhole.[†]

The Rising and the Setting Sun

Japan's classical Edo Period lasted from 1603 to 1867. During that
time, the entire country was peaceful and prosperous. Although
the Edo Japanese had no political, scientific, or industrial revolu-
tions of their own during their centuries of sleepy seclusion, other
areas of national pride flourished. The Japanese economy grew
dramatically, as did its agricultural production. The increased
wealth of this peaceful period allowed for the expansion of craft
and local commerce, which in turn gave rise to a wealthy and
educated merchant class, many of whom settled in complex grow-
ing city centers like Osaka and Kyoto.

Japan had entered a golden age, which peaked around 1700.
During this time, the arts blossomed. The new Kabuki theater and
Bunraku puppet theater entertained theatergoers, while haiku and
other innovative forms of poetry enlightened readers. During this
era, the art of geisha emerged, and the delicate woodblock print-
ing we associate with classical Japan was perfected. Sakoku Japan
was orderly, safe, and prosperous, and, after the expulsion of Chris-
tians, united in a single, aberrantly mellow religion.

[*] Remember the unofficial motto of the VOC: Christ is good, but trade is better.
[†] John W. Dower, project director, *Black Ships and Samurai: Commodore Perry
 and the Opening of Japan (1853–1854)* (Cambridge, MA: MIT Visualizing Cul-
 tures Project, 2010).

Unfortunately, like most social systems, it also had its flaws. At its heart, Edo Period Japan was an inflexible society with a major prohibition against class mobility. At the top of the Edo pyramid was the imperial family, who were powerless figureheads but revered nonetheless, and the shogun, who was actually in control. The most privileged class was the samurai, a class of warrior nobility. Below them were the artists, performers, and craftspeople, as well as merchants, who were the lifeblood of the increasingly vital urban centers. All the way at the bottom of the pyramid, there were peasants, who made up about 80 percent of the population.

People were born into their class, and they could no more leave their station than they could Japan. Severe rules prohibited any casual recreational activities not designated to one's class, which made life and commerce even more restrictive. The authoritarian prohibitions on class existed to ensure economic and social stability. But in the final decades of the Edo period, just before Perry's intrusion, the system had begun to crumble.

It wasn't only peasants who were prohibited from acting outside their designated roles. Samurai warriors and nobility were no more allowed to engage in commerce than the peasants were allowed to do anything but farm. The result was increasingly resentful merchant and peasant classes, supporting a militaristic aristocracy that, with no wars to fight, was living on borrowed money that it had no way of repaying.

The virtues and flaws of the system were so inextricably bound together that they produced the genesis, fluorescence, and decay of classical Japanese culture—all within a single era.

Guess Who's Coming to Dinner?

When Japan deliberately isolated itself from the rest of the world for more than two and a half centuries, it missed a few things—

like the collapse of Spain, the Enlightenment, the French Revolution, the globalization of the British commercial empire, the formation of the United States, and the Industrial Revolution. Through their tiny Dutch keyhole, a handful of Japanese academics stayed informed of world developments, which they referred to as "Dutch studies." Nothing they learned could have prepared them for the shocking reality of Commodore Perry and his fleet's aggressive arrival on their shores.

The first thing that villagers and sailors in Uraga saw on July 8, 1853, was as terrifying as it was inexplicable: a giant black cloud of smoke on the horizon, like some massive thing burning—out over the *open water*. The sight was so terrifying that all the scattered fishing boats along the coast frantically rowed for shore, while the people on land ran for cover, convinced that the smoke must be coming from dragons.

It was the stuff of nightmares. The village was thrown into a panic. Bells rang, alarms sounded. Some hysterical villagers shouted, "Giant dragons puffing smoke!" while others, with either a clearer head or just a clearer view, cried, "Alien ships of fire!"* It was only moments before the villagers on land could also see the unfathomably enormous monsters that had terrified the fishermen out of the water: four towering, black, iron ships approaching, burning coal, billowing smoke, glowing from their portholes, and bristling with guns and cannons. Actual dragons might have been less frightening.

As the black ships approached, people scattered. Some hid in their homes, others headed for the hills. A few scrambled for the capital, Edo, not far away, to tell the shogun what was happening. The most levelheaded among them realized that this could only be a return of the "southern barbarians" they had so long ago expelled, now wielding great power and terrible machines.

* Rhoda Blumberg, *Commodore Perry in the Land of the Shogun* (New York: HarperCollins, 1985).

The ships were as strange and intimidating as Columbus's giant wooden galleons had been to the New World natives. During their period of isolation, the Japanese had sailed only short distances along their own coasts, using the same small wooden one-sailed 'junks' they'd always used. But the West had continued to circle the globe, for both war and commerce, in increasingly large, fast, powerful ships. In 1600, traversing the Pacific was dangerous and difficult and few attempted the trip. In 1853, though, a voyage from San Francisco to Japan took only a breezy eighteen days.

Perry's "fleet" consisted of two massive steam-driven frigates, the *Mississippi* and the *Susquehanna* and two slightly smaller sloops. Together, they carried almost one thousand men and countless guns, and each burned thousands of pounds of coal every hour. When the older and lesser of the two steamships, the *Mississippi*, was launched in 1841, its huge engines were described as "iron earthquakes."* The Japanese took to calling American ships "Black Ships," not only because they looked black or because they emitted strange, dirty smoke, but also because, to the Japanese, these ships were shrouded in an aura of impending doom. The Black Ships would come to represent both Western technology and the looming threat of Western colonialism. To some, they were the embodiment of evil itself.

Big Guns

The terror that Perry's fleet inspired was intentional. The display of the military and technological upper hand was a deliberate technique, a scare tactic that would come to be known as "gunship diplomacy." In another act of psychological warfare, Perry

* Dower, *Black Ships and Samurai*.

waited another week before actually disembarking and showing himself to the breathless Japanese people. He let the Japanese get good and scared first, as the Americans flew flags, fired off gun salutes, and rearranged cannons. When he finally went ashore, he brought more than three hundred heavily armed soldiers with him. And a band.

He came bearing a letter from the U.S. president and demanded to meet with the emperor of Japan. He was depending on the fact that Japan's centuries of isolation would have left them somewhat ignorant of Western hierarchies, enabling him to exaggerate the importance of his own rank.* But that ignorance cut both ways. He had no idea that the emperor of Japan was at that point largely a symbolic position, nor that the shogun and the shogunate held the power. Ultimately, it was representatives of the shogunate who came to meet him.

The negotiations—a generous word for the demands that Perry made under the thinly veiled threat of violence—dragged on for days. The Americans demanded one or two ports for use by U.S. vessels; access to coal, fresh water, and provisions for resupplying the ships; and better treatment of American castaways on Japanese soil. The terms seem quite reasonable on paper, but the American style of gunship diplomacy made every request and gesture overwhelmingly hostile. After days of arguing, haranguing, and bullying, the Americans left for Hong Kong, effectively declaring the negotiations *over*. They promised to return, sooner rather than later, for an answer.

As soon as the Black Ships were gone, the shogunate did something unprecedented: They asked for suggestions. It was such an extraordinary situation, and so much was at stake, that the shogunate simply had no idea what to do. The president's letter was translated and circulated among the daimyo for opin-

* Emily Roxworthy, *The Spectacle of Japanese American Trauma: Racial Performativity and World War II* (Honolulu: University of Hawaii Press, 2008).

ions. Some demanded war, others suggested acquiescing to inevitability, but all feared that what "trade" really meant was colonialism.

Six months later Perry returned with his Black Ships—ten of them this time—and a promise that he could have one hundred more warships off the shore of Japan within twenty days. The Japanese understood as well as the Americans did that they were in no position to argue. So, at gunship point, the Japanese signed various treaties mandating mutual trade.

It's Always About Oil

At that point, the rest of the East was already actively engaged with the West, either as trading partners or colonial subjects. Given both the booming trade—by which I mean lopsided, opium-pushing trade—in China and the still extensive trade in precious stones, spices, and other exotic materials in Indonesia and the rest of Southeast Asia, why did the United States care about Japan at all?

The answer is, for a long time it hadn't. Nobody had. At that point in history, Japan was an isolated, unfriendly, and still arguably medieval society—just a string of four islands in the vast Pacific. Japan wasn't hostile. It wasn't threatening or bothering anyone who left it alone. As far as anyone knew, it didn't have anything particularly unique or desirable to trade or sell. That's how the country managed to remain in its self-imposed isolation for so long.

But the landscape had changed while Japan was sleeping. The United States broke free from British colonialism, declared its Manifest Destiny, and proceeded to spread across the North American continent like a bloodstain. By the late nineteenth cen-

tury, factories ran all day and night, railroads crisscrossed the nation, steamships patrolled the Atlantic and Pacific oceans. Coal was powering the expansion, and so was oil—just not the kind of oil you think.

This was the era of the great whaling vessels. As Melville wrote in *Moby-Dick*, "If that double-bolted land, Japan, is ever to become hospitable, it is the whale ship alone to whom the credit will be due." For years, Western whaling ships had lurked just outside Japanese waters, trying to fish the rich areas around the northern island. Though the ships were unwelcome, the Japanese were in no mood or position to engage them. Instead, they simply forbade the whalers from coming near their shores—even for supplies—and they made sure that any shipwrecked sailors who washed up on their land would be sorry they'd come.

The whalers continued to go anyway—because they could just make so much money around the islands. In the mid-nineteenth century, electricity was still in its infancy, and yet cities across the United States were lit up, the engines of progress were turning, and they were all dependent on whale oil. Whale oil helped to light everything from streetlights to the lamps in factories, businesses, and people's houses. It lubricated engines and industrial machinery. And one thing Japan did have, other than a very convenient location for refueling, resupplying, and gathering more coal for those black ships headed for East Asia, was an absolutely lush whaling industry. That asset played as much of a role in the forcible opening of Japan to trade as did diplomacy, defense, or Manifest Destiny.

There was, of course, an enormous market for whalebone as well, since it was the material of choice for those corsets that crushed the ribs of millions of American and European women. Ironically, not long after Japan was forced to trade with the United States, those corsets would fall out of favor, just as electricity would come to the fore, making the whale less valuable.

But by then, Japan would have a monopoly on something far more valuable than proximity to oil, something everybody had always wanted, and always would.

Pearls.

It's the End of the World
as We Know It—and I Feel Fine

Those millions of perfect, glistening pearls would be fished out of the same cold Pacific water as the whales, but they wouldn't be conceived there. They were conceived instead in the mind of Kokichi Mikimoto. In Edo, Japan, he would have remained a peasant. But after the intrusion of the West, everything changed.

The Tokugawa shogunate, the government that signed the United States' "peaceful" documents under duress, was overthrown shortly thereafter. The coup that dismantled the two-and-a-half-century-old shogunate restored real power to the emperor. Or so they said. In reality, the emperor, Meiji, was only fourteen years old, and the restored imperial government was run by the cabal of daimyo behind the regime change.

Though their country had been forced to sign humiliating agreements, the new government vowed to be prepared when the West returned, so it set about making massive reforms. The period that ensued, known as the Meiji Restoration in honor of Emperor Meiji, spanned the years from 1868 to 1912 and was responsible for the emergence of Japan in the early twentieth century as a culturally and technologically modern nation.

The Meiji Restoration wasn't so much a restoration as a complete teardown followed by a national makeover on the most epic scale. It was perhaps the most rapid, most stunning, and most heartbreaking modernization in history. Men and women of all classes adopted Western dress and customs and began rebuilding

cities to mirror Western ones. In a very short time, the Japanese people ruthlessly abandoned centuries of deeply rooted cultural tradition in order to catch up with and overtake the rest of the world.

Incredible things came of the Meiji Restoration on an individual scale too. The feudal system was immediately dismantled. Peasants were no longer forever ensnared in the class to which they had been born. People of noble birth were no longer considered fundamentally superior. Samurai were forcibly disbanded and had their hair cut off. Geisha learned to type. The samurai Iwasaki Yatarô sent agents abroad to see what alternative uses there might be for his sword steel. He eventually called his company Mitsubishi. (Spoiler: He became a steel magnate and amassed a fortune in the transportation business.)

But no one was a more luminous example of the period than Mikimoto himself, who married the daughter of a samurai, invented, perfected, and commercialized pearl culturing, and became celebrated both as a scientist and a businessman. Born an impoverished peasant, he died the so-called Pearl King of the World.

Unlike most countries that have tried it—Russia, I'm looking at you—Japan succeeded in its sprint to modernity. Within a few short decades, it succeeded to such an extent that it not only participated in World War I (which arguably had very little to do with Japan—or possibly anyone else) but also founded a nasty colonial empire of its own. It even, for a while, gave us a run for our money in World War II. And all in only fifty years. Well played, Japan.

But there were some things about the Meiji Restoration that were not so wonderful. Edo, Japan, was in a unique position. When Japan closed its doors, essentially freezing itself like a ship in a bottle, it did so in a safe, small, geographically isolated place, which allowed it to cultivate not just peace and prosperity but also a remarkable civilization. In addition to Bushido, the Japanese

developed some very unique priorities. Beauty was paramount, and art sacrosanct. Above all, they placed an enormous emphasis on the perfection of tasks, however large or small. It was a quality that would influence both Mikimoto's quest for perfect pearls and the approach he ultimately took to creating them.

With the Meiji period came not just changes but destruction. The day that Perry's Black Ships arrived left a deep psychic wound in the country. All the Japanese from the shogunate to the rice farmers and the fishermen realized for the first time, and more important, really *felt*, how vulnerable they were. Shaken to their core, they sought to arm themselves as quickly as possible with the trappings of modernity. They were a society in the throes of transition, and the desperate game of catch-up turned into the planned destruction of an entire culture. Japan was at war with itself once again, but this time the civil war was the battle between the ancient and the modern.

The official motto of the Meiji period was *Fukoku kyôhei*, "enrich the country and strengthen the economy," but the unspoken dictate was to catch up and overtake the West. Within only two years, Japan had built railroads that crisscrossed all the islands, powerful steamships, industries to rival those of the United States, colonial holdings like the British, and commercial enterprises on a par with anything in the Middle East or Asia.

They caught up, all right—and then, thanks to the cultured pearl industry, they did indeed overtake. Mikimoto's company shifted the pearl center of the world from the traditional Middle East and the later Gulf of Mexico to East Asia. The upstart was so successful that we've all forgotten that pearls didn't always come from Asia. By the 1930s, Japan dominated the world pearl industry just as South Africa dominated diamonds. Japan had developed its first domestically produced major export product.

And what a product it was. With the advent of culturing and farming pearls, one of the most valuable gemstones in human history was now patented and exclusively *grown* in Japan.

Skin Deep

So what is a cultured pearl? According to Mikimoto himself in a 1904 interview, "the cultured pearl . . . is obtained by compelling the pearl oyster to produce pearls that is—after the seed pearls, small round pieces of nacre (mother-of-pearl) are inserted into the living oyster by a certain secret method. And the oysters are put back in the sea and there for at least four years, during which time they cover the inserted particle with their secretion and thus form pearls."*

In other words, a cultured pearl is just a pearl that has been planted in an oyster, like a seed in the ground. Much in the same way hunter-gatherers searched the forest for edible plants, snatched them up, and took them home, for thousands of years pearl divers risked their lives scouting the ocean floor for oysters. When they were lucky—about one out of every forty times—that oyster would yield a pearl. A very, very slim fraction of those pearls were valuable.

Cultured pearls form in just the same way as their wild counterparts, but instead of being the result of a sneaky parasite or nasty infection, they're actually seeded, just like corn in the field. Row upon row of oysters, bred for decades for their matching and perfect colors and peak luminescence and shine, are each implanted with a "seed" or irritant that, in two to three years, will yield a pearl.

That seed might be any number of things. More often than not, it's a spherical polished piece of oyster or mussel shell. Modern, cheaper versions, which Mikimoto would never have tolerated, consist of a large plastic bead covered by a very thin layer of nacre.

* "Pearl Culture in Japan, the Process by Which Oysters Are Made to Produce Pearls, and Mr. K. Mikimoto, Its Discoverer," *New York Herald*, October 9, 1904.

These fake cultured pearls are mostly made at mass-production facilities in China. Genuine cultured pearls are grown over a solid oyster-shell bead, and are coated in years' worth of accumulated nacre. Authentic cultured pearls *are* pearls, through and through.

How it's done, frankly, is a little bit grosser than even what Mother Nature has devised. Victoria Finlay described the process as "surgical rape," musing that few outside the trade are aware that "almost every pearl on sale today was born of the planned sexual violation of a small creature, and that considerable suffering hangs on those necklace strings."* Beautifully polished, carefully implanted, shell spheres may sound less disgusting than an oozing parasitic infection—but I assure you, the procedure is no less distasteful.

The process is called nucleation. First, a donor oyster, chosen for its exquisite pearl offspring, is sacrificed. The thin, ragged tissue along the oyster's edge, called mantle tissue, contains the cells that actually secrete nacre. A strip of that mantle tissue is sliced off the donor body and cut into tiny 2-millimeter squares. It's standard practice to then relax the many, still-living, host oysters (the ones that will receive an implant) in a warm bath, sometimes with an anesthetic. When the oysters open, manufacturers jam a wedge into them to prevent them from closing again even when removed from the water. While forced open, surgical tools not unlike those commonly employed by dentists are used to cut into the oyster's gonads and form a pocket. One little square of the mantle tissue from the sacrificed oyster is placed against a polished shell bead, and that bead is placed inside the incision in the open oyster's sex organ, along with that magical 2 millimeters of live tissue from the donor oyster. The wedge is removed, and the oyster closes up.

Many oysters die from the trauma. Others reject the nucleus. After a few months in the oyster ICU, those that live are placed

* Victoria Finlay, *Jewels: A Secret History* (New York: Random House, 2007).

out to sea on movable racks in the shallow beds of pearl-growing farms. The immune response within the oyster itself creates what's called the "pearl sack" around the bead, like a cyst. Over time, that cyst secretes nacre, which evenly coats the bead. After a few years, the oysters are opened and their pearls removed. The 5 to 10 percent of those pearls deemed worthy are then sorted, matched, and subsequently put on the market.

Making Money

Money may not grow on trees, but it does grow in oysters, and it grows very quickly—especially compared with how slowly other gems develop, many of which require millions or even billions of years and highly specific environmental pressures. Mikimoto was hardly the first person to notice that fact, or to see its financial potential, and attempt to grow genuine pearls. He wasn't even the first person to succeed. Like alchemists trying to turn lead into gold, inducing an oyster to grow a pearl has, through the millennia, been the singular fixation of many scientists, sorcerers, and fortune hunters. By the time Mikimoto succeeded, learned men had been trying to culture pearls for thousands of years.

The first account of artificially induced pearls was recorded by Apollonius of Tyana in the first century CE. He described how the Arabs along the Red Sea "made" pearls. According to the historian, the process involved pricking the flesh of the open oysters with a sharp tool until liquid dripped from the wounds. The fluid was then poured into special lead molds where it would harden into beads.* There are numerous different accounts of this, though none of the actual pearls survive as evidence. These

* George Frederick Kunz, *The Book of the Pearl* (New York: Century, 1908).

accounts do, however, attest to both the ancient human desire to possess pearls and the human desire to innovate. Whether these experiments were successful or not, those third-century Arabs had uncovered an important piece of the puzzle: It was injury to the soft oyster tissue, and the ensuing immune response, that created nacre.

The Chinese also tried their hand at pearl production, focusing on the pearly inner shell and its potential for growth. Their centuries of successful attempts have survived, though they only ever managed to grow mabe, or blister, pearls, like Mikimoto's first five. A mabe pearl is a hemispherical pearl, rounded on one side like a dome and flat on the other. It grows not in the oyster tissue, but attached to the inner surface of the shell. The ancient Chinese accomplished this feat by gluing buttons to the inside of the oyster shell—or, more often by placing flat lead medallions in the image of Buddha inside the oyster, between the shell and the live tissue. The resultant irritation caused the mantle tissue to secrete nacre. When the Buddha medallion was adequately coated in pearly residue, the Buddha pearl was cut from the shell and polished. Those Buddha pearls have been prized and sold in China for both religious purposes and the tourist trade for thousands of years. Though they were not the first people to cultivate pearls, the Chinese were the most consistent.

Carl von Linné, better known to biology students as Linnaeus, the father of modern scientific nomenclature, caught the pearl culturing bug in the 1750s. He loved his evolutionary trees but was an even bigger fan of pearls. He even claimed he would rather be the man famous for pearl science than for nomenclature. He spent a great deal of his professional career attempting to figure out how exactly pearls formed, and how to culture them.

His most successful method involved drilling a small hole in the shell, inserting a limestone sphere into the oyster, and suspending it away from the shell using a T-shaped silver pin to avoid creating a blister pearl. He created some spherical freshwater

pearls of moderate quality and sold his invention to another man, Peter Bagge, in 1762. Significantly, although Bagge received a monopoly permit from the king of Sweden, he never did anything with it*—a fact that speaks not only to the difficulty and expense of creating those pearls but also to the general disregard for their value, as cultured pearls were not really considered genuine. So Linné may have succeeded in culturing a round pearl, and he may even have been the first to do so, but he failed to leave the recipe for his success behind. His secret was lost for 144 years. His "lost papers" were rediscovered in 1901, in the building that now houses the Linnaean Society.

By then, Mikimoto had advanced and patented pearl culturing technology, and no one had any use for limestone pearls. While Mikimoto may have been the ultimate winner, he wasn't even the first of his contemporaries in the late nineteenth century to successfully cultivate pearls. At least two other men managed it, to varying degrees—but they created only half-round mabe pearls. When Mikimoto discovered that the men had competing patents, he bought them and incorporated the patents into his own. Only Mikimoto managed to cultivate perfect spherical pearls in large quantities, and only *after* he had perfected the pearls did he accomplish his most impressive feat: He made the world accept cultured pearls as real.

Pearl Culture and Cultured Pearls

While emeralds look like money, and diamonds glitter for attention, pearls whisper of exclusivity. Part of the appeal of pearls has always been their association with royalty and their perceived

* Neil H. Landman et al., *Pearls: A Natural History* (New York: Harry N. Abrams, 2001).

scarcity and uniqueness. More important still, the appeal of pearls has to do with the pursuit of perfection. The fantasy of that one perfect pearl—elusive, rare, nearly impossible to obtain—has long driven the value of the entire industry.

Natural pearls, created by accident and found by divers, are never perfect: They're never exactly round and they never quite match. Unlike gemstones, pearls don't come from a mine, or a vein—they come one at a time from living creatures, and are rarely even similar to each other. The genetics of each oyster determines the color of a pearl's nacre, so for two pearls to match exactly, they would have to come from two identical oysters. A professional pearl diver could work his or her whole life, quite successfully, without ever accumulating enough matching round pearls for an entire necklace. And in spite of stories and legends of huge pearls like La Peregrina, it's incredibly rare to find a pearl over 8 millimeters in the wild. Natural pearls are actually quite small—usually less than 3 millimeters across. That's smaller, by half, than a *pencil eraser*.

Unlike diamonds and gemstones, waiting forever in the earth to be discovered, pearls are born, they grow. And they die. And funny enough, they're frequently eaten—mostly by octopuses. (Can't say that about rubies.) Even if you are lucky enough to find them, unlike mineral gems, they aren't all there on any given day, nor are their host oysters. Because they form organically in a living organism, most don't exist yet, or they've already gone. So unlike diamonds and gemstones, which were historically for sale to the highest bidder, especially large or fine pearls were most often reserved for royalty, simply because they were genuinely scarce.

In the first place, oysters have only a limited lifespan during which they can grow pearls. In the case of the akoya oyster, that lifespan is six to eight years. A pearl can only get so big before its host dies of old age. Also, they're apparently delicious. Not

to mention that they're touchy little suckers, completely susceptible to red tides, parasites, stress, barnacles, temperature fluctuations—you name it, they can die from it. They're worse than orchids. But over time, Mikimoto devised a way to coat the shells of the oysters, making them stronger and more resistant to the rabble, and enabled them to live up to ten or eleven years.

Cultured pearls also start with a size advantage. The same bead nucleus that signals to the oyster to produce nacre also gives the oyster a head start on size. A cultured pearl sack doesn't start around a tiny speck of intruder but around a bead several millimeters across. Over decades, the farmed oysters were selectively bred, just like farm animals or grains, to produce the biggest, whitest, brightest, and most iridescent pearls they possibly could. Cultured pearls aren't only real pearls, they're *better* than real pearls—that is, as long as you're not valuing them in lives lost obtaining them. I don't mean *better* in the sense that cubic zirconium sometimes sparkles more than a diamond. They *are* real, natural pearls, grown in real natural oysters, in the real natural sea. They just happen to be round, glossy, and matched.

It sounds great: perfect pearls, on demand. But scarcity determines value, and money makes the world go round. And the whole world stopped when Mikimoto debuted his round, perfect, identical pearls to the West in 1920.

The Tsunami from the East

K. Mikimoto & Co. was the first jewelry store *ever* to focus solely on pearls. No one else had ever *had* enough pearls to fill a whole store. There was another reason, beyond supply, to venture into jewelry retail. Mikimoto was looking for more than an outlet in which to sell his pearls—he was looking for an image with

which to sell them. To convince the world that cultured pearls were real gems, not artificial ones, he knew it would be best to present them *as jewelry*.

In 1919, Mikimoto, now possessed of an adequate supply, had an eye for world conquest. He opened branches of his Tokyo store in capitals all over the world, from London and Paris to New York, Chicago, and Los Angeles. In addition to strands of pearls, he employed designers to create contemporary Western jewelry and stunning works of art, like the *yaguruma*, "wheel of arrows," sash clip. It was created using diamonds, sapphires, emeralds, and forty-one identical, akoya pearls. While it had a modern European Art Deco look, there was something uniquely Japanese about it. It could also be disassembled and reassembled into twelve different pieces of jewelry.

When the pearl dealers of the world saw Mikimoto's flawless spherical pearls, all approximately 6 to 8 millimeters in diameter, they went absolutely insane. Just not in the way Mikimoto had hoped.

For thousands of years, the pearl industry had been built upon the perception that perfection was unobtainable yet something to strive for. But Mikimoto's pearls *were* perfect. More perfect, in fact, than "real pearls." Not only were Mikimoto's pearls less expensive and totally dazzling, they were also abundant. Cultured pearls came like a tidal wave from Japan and drowned out the competition. Even if Mikimoto's pearls had been similar in quality to the natural scavenged pearls, the sheer *quantity* of them was devastating to the existing pearl industry. At their peak in 1938, there were approximately 350 pearl farms in Japan that produced ten million cultured pearls a year. By contrast, the number of natural pearls found every year ranged from the dozens to a few hundreds.

Not only was Mikimoto mucking up the supply chain, he was also competing in the jewelry market. He was a pioneer of vertical integration: He made his own jewelry, exhibited it, and sent

samples around the world.* It was, for the entrenched pearl industry, a complete and utter disaster.

The Blowback from the West

There was an overwhelming panic in Europe and America among both pearl sellers *and* buyers. The pearl market crash of 1930 absolutely gutted the jewelry business. Prices dropped by 85 percent in one day. Given that pearls were among the most valuable gems in the world, the crash rippled through the economy.

In fact, cultured pearls played a very small, if not negligible, role in the crash itself, which was mainly a result of the Great Depression. But that didn't stop the people with a stake in natural pearls from blaming Mikimoto and the cultured pearl industry. The onslaught of better-quality pearls pouring in from the East over the previous decade had taxed dealers to the breaking point. When the market crashed, they were left with almost nothing. Their only option was to eliminate the competition, and the only way to do that was by exploiting the gray area between what's real and what isn't.

Whether it's due to scarcity or positionality, humans have a very fluctuating sense of both value and reality. It is a fundamental structural weakness in our worldview that has always been exploited by purveyors of beauty (among others). In this case, the only way for the entrenched natural pearl dealers to reclaim their place was to prove that cultured pearls weren't *real*.

That year, the European pearl syndicate sued Kokichi Mikimoto. They claimed that his pearls were fraudulent and should be removed from the market. At first Mikimoto fought back

* Landman et al., *Pearls*.

with science. Professor Henry Lyster Jameson of Oxford University testified. The former president of Stanford University, Professor David Starr Jordan, submitted the official conclusion that as a "cultured pearl is of exactly the same substance and color as the natural or uncultured pearl there is no reason why cultured pearls should not have the same value as natural pearls."* There was also, of course, the endorsement of the most famous scientist of the century, Thomas Edison, who had already proclaimed them "real pearls."

Mikimoto won the lawsuit and his cultured pearls did not have to be removed from the market—nor, for that matter, did he have to cite their origin so as to differentiate them from "natural pearls." But the industry wasn't finished fighting. They tried to impose such high import taxes on Mikimoto's cultured specimens that they outweighed their value. They even attempted to find scientific ways of distinguishing one kind of pearl from the other, if only to create an imaginary stigma. In a desperate last bid, a consortium of European jewelers got together and demanded that his pearls be labeled in a variety of ways—cultured, from Japan—they hoped consumers would find unappealing. None of it worked.

Most people's wallets were thinner in the 1930s, and they were happy with both the price cut and the newly created *price range*. After all, with millions of pearls a year to sort through, rather than hundreds or thousands, cultured pearls could not only be perfectly matched, they could be graded for varying degrees of excellence, just the way diamonds were. The flappers of the Jazz Age and their passion for ornamentation had already laid the groundwork for mass pearl demand, and those with new money, which would within a few generations become old money, were demanding aristocratic pearls of their own. There were buyers in every market.

* Landman et al., *Pearls.*

If cultured pearls couldn't actually be *proved* fake, then for the syndicate it was a matter of *implying* that they were. Reality, like value, is determined by mob mentality, and just being *deemed* genuine—or fake—was enough to make it so. Planting a tiny seed of doubt in the customer's mind was really no different than planting a nucleus in a pearl. For some customers, that tiny seed of doubt grew, and they became convinced that cultivated pearls were not real pearls.

So Mikimoto decided to fight propaganda with propaganda.

He volunteered to label his pearls as cultured—*despite* the court ruling that stated he did not have to do so—as if it were a mark of distinction, not a blemish. He made extensive efforts to educate the public as to what exactly cultured pearls were and how they were farmed. He published both academic and popular articles explaining the process and product: where his pearls came from, how and why they were exactly the same as natural pearls—and how and why they just might be *better*.

Truth in Advertising?

Truth and lies have an imaginary economy all their own.

Cultured pearls are funny things. When you hear *cultured,* you think *fake*. But they're no more inauthentic than an apple picked from a tree in an orchard. The seed may not have landed there by accident and grown into a tree unnoticed, but that doesn't make the fruit any different.

Real, it turns out, is just as flexible a concept as *value*.

Mikimoto's favorite story, one he retold throughout his life, was the story of a beloved horticulturist who, after many years in business, wished to make a bigger name for himself. He did so by taking a pretty but common variety of ornamental red-berry plant and painting the berries white. His pure white berries became a

phenomenon. He was celebrated, successful, and wealthy—until it rained. The white paint ran off, he lost his business, and worst of all, no one ever trusted the man again.

Unlike the man selling the beautiful white berries, Mikimoto made a point of telling everyone exactly what his pearls were. He labeled them and he actively publicized the facts of their origin. He published article after article. He gave interviews. In certain publications he even *included diagrams* explaining how exactly pearls were cultivated. By putting the lie right out there, he stripped it of its power. There were no painted berries here. No one could accuse him of trying to slip artificial pearls into the natural pearl market.

Mikimoto has been described as "a revered figure in Japan, sort of a Henry Ford and Thomas Edison wrapped up in one."[*] But he was also a natural showman—and at least one of those parts was more like P. T. Barnum. He knew that if people saw his pearls, *their very standards would be redefined*, and he would cut his detractors off at the knees. Mikimoto staged spectacles, sending his pearls far and wide, to ensure that everyone got a chance to see what a perfect pearl could look like. First he created a model of Mount Vernon, George Washington's family home, from 24,328 pearls, to be exhibited at the 1933 Chicago World's Fair. It was, without question, the greatest number of pearls anyone had ever seen in one place—and every last one of them was flawless. It caused a sensation among the American public, incited an enormous curiosity about cultured pearls—and etched the name Mikimoto in everyone's mind. He built other models, including a five-story pagoda made of 12,760 pearls, and a scale model of the Liberty Bell for the New York's World's Fair in 1939. This last model was fashioned out of 12,250 perfect white pearls and 366 diamonds, its famous crack

[*] Stephen G. Bloom, *Tears of Mermaids: The Secret Story of Pearls* (New York: St. Martin's, 2009).

re-created in ultrarare (previously nearly unobtainable) blue pearls.*

Mikimoto's greatest and most effective public spectacle wasn't an act of creation, but actually an act of destruction. In 1932, foreign journalists witnessed a scene in front of the Kobe Chamber of Commerce that was recorded in photographs and articles published all over the world. Concerned, Mikimoto claimed, about imperfect pearls tarnishing the market, he lit a bonfire outside the Chamber of Commerce building. As soon as a large enough crowd had gathered, he began burning pearls. He had brought them in buckets and shoveled them into the flames as the stunned crowd looked on. He claimed that these pearls, superior in many ways to the best natural pearls, were simply not good enough—not for him. Perfection was obtainable, he preached, but not if the market was prepared to compromise. He declared these less-than-flawless pearls worthless, "only good for burning." He roasted *720,000* of them. He shoveled them into the fire, scoop after scoop, burning millions of dollars' worth of jewels—like so many fall leaves.

The Taisho-Ren

It's neat when the magician saws the lady in half, but it's not really a successful magic trick until he puts her back together. Creating pearls was only half a magic trick. Convincing the world that they *wanted* cultured pearls was the other half.

In the battle for people's confidence in the reality of cultured pearls, there were jewelers tricked into publicly admitting they couldn't tell cultured pearls from naturally formed pearls, and there

* Mikimoto Archives, Pearl Island Museum, Japan, http://www.mikimoto-pearl-museum.co.jp/eng/collect/index.html.

were scientists who went on record saying that cultured pearls were physically identical to their less stunning (but natural) cousins. Cultured pearls even had the weight of legal ruling on their side.

But none of it mattered in a climate where pearls were valued for their uniqueness—not in the sense that one valued a pearl's flaws, but in the sense that one valued the triumph of having obtained *as* flawless a pearl as possible. Famous treasure hunter Mel Fisher insisted that it wasn't just the treasure, but the *hunt*, that gave a jewel value. An unending supply of identically perfect pearls gutted the economy of that hunt. Pearls were no longer associated with the unobtainable ideal. And what are we to do, as humans, when there's nothing left to want?

Mikimoto found a solution to that particular problem: the Taisho-ren, as his employees called it, or the Boss's String of Pearls. Quite simply, Mikimoto created a strand of pearls unparalleled in beauty and quality, even among cultured pearls, one that *reestablished* the presence and thus the value of the unattainable pearl.

Choosing only the largest, most perfect, and most beautiful matching pearls, he amassed a long, slightly graduated strand of forty-nine pearls, the largest of which was 14.5 millimeters*— which is aberrantly large for a cultured pearl and almost impossible to find in naturally occurring ones. It took him over a decade to assemble it, even with millions of pearls a year to choose from. It was the most spectacular pearl necklace anyone had ever seen. In a world where natural pearls were an average of 2 millimeters, almost never over 8, and only a handful had ever been deemed "perfect," the Taisho-ren was a wonder of the modern world.

* The Taisho-ren is on permanent display at the Mikimoto Memorial Hall, on Pearl Island in Toba, Japan. It's one of the few pieces deemed far too valuable to ever leave the island—which, I was told in confidence by a representative from Mikimoto, is why it was not at the celebrated Pearls exhibit the Victoria and Albert Museum hosted in London in 2013–14.

There was something to want again. And everyone *did* want it.

Had it been for sale, it might have led to wars, feuds, and political tensions like those discussed in previous chapters. But it *wasn't* for sale, despite the plethora of offers Mikimoto continued to receive—and decline—until his death. Mikimoto humbly said that the necklace was his. He claimed he simply liked to carry it around in his pocket. And, of course, show it to people.

In fact, the pearl fire could be seen as a publicity companion piece to the Taisho-ren. With the pearl fire, Mikimoto showed that he would not tolerate imperfection. With the Taisho-ren he displayed perfection that was achievable but not *obtainable*. Once in possession of the most desirable pearls in the world, he simply refused to sell them.

As a result Mikimoto became synonymous with perfection. Not just that one-in-a-million kind of perfection: the actually unobtainable, and thus immeasurably valuable, kind.

The Perfection Precedent

Perfection is, of course, almost by definition an impossible standard. Many gemstones are defined by their imperfections. Others, like rubies and emeralds, are so rare in a gem-quality form that their imperfections are taken for granted, an accepted part of the stone's unique and individual character.

The idea of a flawless gem has really only ever existed in the diamond industry. There the idea is facilitated by the fact that carbon is so ubiquitous and diamonds are so very common, especially the white ones. But a pearl, an organic by-product, in perfect form? That's an impossibility. A whole string of them—a fantasy.

At least it was for the thousands of years during which humans collected, worshipped, and fought over those luminous

spheres. Before Mikimoto, the "round" pearl was really just a "mostly round" pearl. You can see them in museums and in private collections. Usually they're egg shaped, or a sphere with a few lumps. At best, they look spherical, or white—at least until you look very closely. Shakespeare called these defects the "blots of Nature's hand." The rest of us call it genetic diversity.

But after Mikimoto introduced the process of culturing pearls and the selective breeding of individual oyster lines for their specific color and luster, it actually became easier to produce a true spherical pearl than it was to find a blemished natural pearl. In a sense, Mikimoto was the Henry Ford of precious gems. He standardized the gemstone without diminishing its value.

Well, OK—the value of natural pearls took a little bit of a hit. But remarkably, not for the reason those panicked dealers thought it would. The pearl dealers of the Western world were petrified that Mikimoto would flood the market with too many standard pearls, thereby reducing their value. Instead, he flooded the market with too many *exceptional* pearls, and for a very long time the market for the more expensive, more dangerous and difficult to obtain "natural pearl"—and its inferior quality—was diminished. The London panic, the lawsuits, the smear campaigns—they were all about the fear. Fear of competition, fear of change, mostly, fear of *perfection* and what it would do as precedent.

Not all of it can be put down to psychology. Perfection isn't as simple as an extension of positional good, where a pearl is only as good or as bad as its comparison with another pearl. Human beings are hardwired to *overwhelmingly* appreciate symmetry. For that reason alone, a spherical pearl would be preferable to any other one, a flawless one preferable to one with a single blemish on the surface.

Semir Zeki, professor of neuroaesthetics at University College London, studies the neurology of beauty. Apparently, accord-

ing to Zeki, the only constant among brains beholding beauty is activity in the brain's reward and pleasure center, the medial orbital frontal cortex. See something beautiful, you get a buzz. But beauty is in the brain of the beholder. You can deem an object beautiful at first, but *as its flaws become apparent,* the pleasure effect will be weakened. As Zeki put it, "Perception of beauty may weaken when we do start to recognize those defects."[*] In other words, the fact that people had only seen a few pearls made them all seem magical. With millions of perfect pearls hurled at us every year, those flaws become fatal.

There's still a small market, mostly among collectors, for natural pearls. To this day it exists, and for the right price you can have a pearl that someone may very well have died for—though one wonders why you would want to, when the cultivated variety is just as real and more appealing. The fact of the matter is that there are only a handful of natural pearls on the market every year, and most of them are antique. Even the finest, most exquisite, and most expensive pearls from the most reputable companies and dealers are, in fact, cultivated.

There are a lot of reasons for this predominance of cultured pearls. People now need difficult-to-obtain permits in most countries to dive for oyster pearls at all, and in many places, like Scotland, which used to produce river pearls in abundance, fishing for pearls is illegal altogether. By the turn of the twentieth century, overfishing had resulted in a dwindling supply of oysters almost everywhere. Had Mikimoto not mastered the science of pearl culturing and convinced the entire world not only to accept cultured pearls but also to change their standards for perfection, there might be no oysters left at all. Think about that next time you eat one.

[*] Elizabeth Landau, "Beholding Beauty: How It's Been Studied," CNN, March 3, 2012.

The People's Pearls

When the pearl dealers of the world were so afraid that cultured pearls would flood the market and obliterate the value of their own stock. At the turn of the century, that value was at an all-time high. Pearls were in such demand that the period was considered the second great age of the pearl—not because of their sudden availability, but because their popularity had skyrocketed. The new American aristocracy—captains of industry, oil barons, gold millionaires—all knew that pearls were the gem of royalty, and they demanded their own.

There weren't enough pearls to keep up with the demand. Natural supplies dwindled to dangerously low levels, and prices soared to unprecedented heights. In 1916, Cartier traded a single pearl necklace to Morton and Mae Plant for one of their townhouses, near the Vanderbilts', to use as Cartier's Fifth Avenue headquarters in New York.

Cultured pearls were good enough to confuse consumers, not to mention jewelers, scientists, and everyone else. Because the market for pearls has always hinged on the scarcity effect and the pursuit of perfection, everyone feared that the preponderance of such convincing gems on the market would completely destroy the value of *all* pearls, through overabundance.

In the end, the value did plummet, but not for the reason that pearl dealers around the world had feared. Cultured pearls didn't flood the market and tank natural pearl prices along with their own—they just tanked the *demand* for natural pearls. The market for the natural pearls diminished because cultured pearls were better. They were real, superior in quality, and less expensive. And as we looked at both offerings, our brains began to see flaws in the natural pearls that didn't seem to have been there before. Gradually, the natural pearls became genuinely less attractive as cultured perfection became the standard.

No one got to have the Taisho-Ren. But anyone could have Mikimoto pearls. *Anyone.* Long before Mikimoto ever produced his first pearl, he wrote in a letter that it was his dream to adorn the neck of every woman in the world with a string of pearls. So he produced pearls in every size, every quantity, and at every price point. And even though as a result, pearls ceased to be the exclusive purview of the wealthy, they retained their value and their standing as precious stones, thanks in large part to Mikimoto's natural showmanship—and to the Boss's String, the world's most perfect and unobtainable strand of pearls.

As a result, cultured pearls became a vital aspect of the Meiji sprint toward economic and industrial modernity, and Mikimoto knew it. He may have been obsessed with perfection and enchanted by the idea of a strand of pearls adorning every woman in the world, but he was no stranger to commerce. He had a samurai sense of perfection and the soul of a poet. He had benefited from the Meiji Restoration and he intended to return the favor. As much as he loved America, Mikimoto was a nationalist. He dedicated his first successful crop of spherical pearls to the Emperor of Japan—and in a sense, since 75 percent of the world's pearl trade runs through Kobe, he dedicated the pearl industry itself to his country as well.

Mikimoto was described as the "most glowing example of the era which had made it possible for the common man to shake off his bonds and be free."* It was that freedom that allowed him to aspire to something greater. Businessman, scientist, Pearl King of the World. With pearls, Japan found its first (and last) major homegrown export good. Like Mikimoto himself, the country found a new identity in the twentieth century as the vanguard of emerging technology, driven by innovators and scientists—and this identity didn't require the complete erasure of their past.

In a perfect circle, just like the ones he created, Mikimoto's

* Eunson, *The Pearl King.*

pearls allowed Japan to retain some integral part of itself, to preserve economic and cultural distinctness, and to resist the intrusion of foreign colonization. The money didn't hurt either. The revenue from cultured pearls was so vast that the ever dramatic Mikimoto once romantically claimed that he would "pay compensation for the lost war with [his] pearls."[*]

By 1935, there were 350 pearl farms in Japan producing ten million cultured pearls annually. Japan is, to this day, the largest exporter of pearls in the world. For the first time in history, Mikimoto Pearls had effectively democratized a gemstone.

The cost of pearls may have diminished with abundance, but they are still perceived as a precious gem. That emotional value, along with the revenue and the commercial power it generated, was more than enough to pay for a seat at the international table.

[*] Eunson, *The Pearl King.*

TIMING IS EVERYTHING

World War I and the First Wristwatch

(1876)

> It is the framework which changes with each new technology and
> not just the picture within the frame. —MARSHALL MCLUHAN

> Time is on my side. —THE ROLLING STONES

Timepieces are the most paradoxical kind of jewelry. They're
mass-produced objects that are also valued for the wealth and sta-
tus they imply. They're decorative, sure, but they're also one of
the few pieces of jewelry that actually performs a function. They
tend to be made of precious metals and gems, but their real value
is in the crafted mechanism. For a device meant to keep, record,
and measure time, watches have surprising associations with the
leisure class—and yet, watches have also been an integral tool in
both industry and war. Indeed, wristwatches were initially asso-
ciated with feminine adornment, but their use in wartime skewed
more masculine.

Clocks have a long and storied history but, as timepieces go,
wristwatches are a remarkably recent innovation. Amazingly,
no one thought to strap a small working clock onto a wrist until
about a hundred years ago—and even then it was only because a
rich Hungarian woman wanted a little extra attention.

The first real wristwatch was made by Patek Philippe in 1868 for a lady named Countess Koscowicz.* It was a silly bauble—which had some very serious and lasting effects.

In order to make a point about her wealth and influence—to make sure her peacock feathers, as it were, did not go unnoticed—Countess Koscowicz of Hungary commissioned the most expensive and extravagant piece of jewelry imaginable: She had Patek Philippe, the Apple-like innovators of the nineteenth century, create a fully functioning, microminiature clock that was small enough to replace the large central stone in an expensive diamond bracelet.

It was a thick, golden bangle bracelet, prominently displaying a triptychlike golden box. The center of the three triptych squares holds a large diamond, which is set in a flowering of golden petals. On either side, the central square is flanked by two smaller boxes, with more elaborately diamond-inlaid flowers backed by black enamel. The entire bracelet is covered in and surrounded by ornate swirling golden swags and is held in place by similarly Belle Epoch golden curls. The central square in the triptych, which holds the largest diamond, is actually a lid. It clicks open to reveal a fingernail-sized working clock. The face is white and black enamel, with numbers designed to match the swirling motifs of the bracelet. The watch was wound with a golden key.

Koscowicz's bracelet didn't just include a timepiece for good measure. It specifically existed to secure and display the component itself, like the ring watches of the Renaissance. It also incor-

* Fastidiousness is something one expects in a watchmaker, but Patek Philippe really takes it to an extreme. The 179-year-old company has kept records on every watch it has ever made. It's in part due to those records that we know it was the Countess Koscowicz of Hungary who wore the first wristwatch.

 According to Bonham's auction house, "It has been claimed that pocket watches were adapted to be worn on wrist bracelets prior to 1868, perhaps as early as the 1570's. However, there is no concrete evidence to support this, and Patek Philippe's design for Countess Koscowicz [in 1868] was the first true wristwatch in the modern sense of the word."

porated the exacting engineering and the protective gold cover of a modern functional pocket watch. It was the first real hybrid of time-fetish jewelry and functional clocks.

The entire piece was called a "wristlet." While it was a functioning miniaturized timepiece, it was, for the countess at least, primarily a status symbol, and it was, by contemporary standards, far more like a bracelet than a watch. The original wristlet was intended to be little more than a glittery piece of eye candy. And while it was as much a piece of jewelry as it was a timekeeper, it was a hit—among women anyway. The countess's wristlet had the desired effect. It was coveted across Europe. Among the royal and aristocratic women who could afford them, jeweled wristlets were the order of the day. It didn't take propaganda for the trend to spread, just good old-fashioned expenditure cascading.

But progress, like time, marches on. By the twentieth century, warfare had become a modern affair, and precise and coordinated timing also became a necessity. As society, technology, and more important, warfare modernized, soldiers found it critical to keep time while still having the use of both hands.

By the turn of the century, a wristwatch—while still associated overwhelmingly with female ornamentation—had become a military must. During "the war to end all wars," the "strap watch," inspired by Countess Koscowicz's wristlet, became a key piece of technology and a soldier's best friend. As World War I raged on, watches were produced in great numbers to issue to soldiers on the frontlines. When the Allied troops encountered the kaiser's forces—men who were still winding their pocket watches—it was clear who had the upper hand.

By the time World War I had ended, wristwatches had evolved into precise machinery, with a permanent place in jewelry, technology, and fashion. As the technology behind watches advanced, watches kept time more accurately, and as they got more accurate, the demand for them not only increased but also changed—and so did the people who wore them.

This is the story of a vain countess who, with a single fashion statement, would subsequently reinvent warfare and forever alter the modern human experience of time.

A Brief History of Timekeeping

From the dawn of civilization to the invention of the atomic clock, our lives have been governed by time. We've parsed our days and our activities with the seasons, with society, and with each other. Consciousness of time is so fundamental that it's hard to imagine how units of time, and the very process by which temporal progress is tracked, have greatly evolved over the centuries. The technology of timekeeping has changed the world and in turn, has been changed *by* that new world, over and over again throughout history.

In the beginning, the only time that mattered was Father Time: the journey from birth to death, symbolized for millennia by the old man with the scythe. Of course, there was also Mother Earth, who dictated when to sleep, when to rise, when to reap, and when to sow. Minutes and hours were inconsequential. Our only clocks were the sun and the moon, and time was determined by need. The closest we came to modern clock-oriented time— and it wasn't very close—was in the broader sectioning of the day into rough ideas of morning, noon, and night, each demarcated by the sun's position in the sky.

The earliest devices for keeping time were, unsurprisingly, sundials. The oldest existing sundial dates back to 15,000 BCE and the Egyptian Old Kingdom. Sundials come in all shapes and sizes, and work in a variety of different configurations. No matter how a sundial is designed, however, it must adhere to one basic principle: the rotation of the heavenly bodies in a predictable, but

nonfixed, path. Drawn from a developing human understanding of the movements of the planets, solar-based timekeeping devices employ shadows to mirror or suggest this path. A single shadow-casting object, usually a rod or spike called a "gnomon," is fixed either vertically or horizontally to a surface marked at equal intervals. As the sun moves from east to west across the sky, the gnomon casts a shadowed line on the marked surface. As time passes and the sun moves, so does the shadow, rotating around the central point over the course of the day.

Sundials are great on a bright and sunny day. Unsurprisingly, without the sun they don't do much. Because of this obvious flaw, they only ever served to track time during daylight hours. Since people in 15,000 BCE mostly slept at night, that was mostly all right. Of course, sundials had other limitations: They were also useless inside and on overcast days.

Eventually, sundials were followed by short-span timers—the ancient ancestors of the stopwatch, hourglasses, and water clocks. Both items were similar in design and used a predetermined quantity of water or sand that moved from one place to another at a fixed rate. By waiting for the clock to run out, a person could track smaller units of time, many of them task oriented: how long to leave something in a vat of dye, for example, or how long to let mortar cure.

Time technology, you see, has always both *kept pace with* and *set the pace of* human endeavor, and as we moved from fields to cities, clocks became increasingly complicated. Many thousands of years after the first standing stone circles were used to track the sun and the seasons, real mechanical clocks came into being. These massive, if not particularly accurate, clocks employed complex puzzles of gears, springs, weights, and levers. They still only indicated the hour, like a sundial—but no sun was required, reflecting both our increasingly indoor lifestyle and our newly emerging tendency to stay up after sunset.

They were too new, too costly, and too rare to be owned by the average person. By the Middle Ages, time belonged primarily to the Church, which rang bells to tell people when to rise, when to work, and when to assemble. (Those were the only appointments that mattered to most people.) Eventually, as secular government took the place of theocracy, public clocks took the place of church bells. Still, time and its management was the job of the powers that be.

During the Renaissance, with the invention of more accurate pendulum clocks and spring clocks, there were small signs of evolution, both in the technology of time and time *authority*. It wasn't really until the Industrial Revolution in the nineteenth century that small increments of time mattered. With the growth of cities and the rise of factory jobs, people had tighter schedules to adhere to—schedules that weren't, of course, exigencies of the field but of the production line. Suddenly there were trains, train schedules, punch-out cards, and official timetables of every sort for citizens to track. Fortunately for them, that same revolution in industry that had engendered the need for accurate timekeeping also provided the answer: mass production of interchangeable parts that would for the first time democratize the availability of the clock. The same technology that would make time and timekeeping available to individuals would also make it relatively affordable.

No matter how far clocks evolved, though, their function was unchanged from the Paleolithic days of standing stone circles. They existed to chart the earth's rotation around an axis and its movement in and out of the sun's warmth. That's why, to this day, the hands of a clock still spin around a central axis in the same way a shadow moves in a circle around the sundial, and why noon, or "high noon," when the sun is at its apex in the sky, is always at the top of the clockface.

Temporal Mechanics

The first mechanical clock, one involving what we consider *clockworks* as opposed to shadows, was created in China in 725 CE. Initially, even mechanical clocks still relied on water or sand to tell time. These systems were far more complicated than, say, an hourglass, since they used falling water to power the gears of the clock, rather like a waterwheel. Eventually, these systems were replaced by the more sustainable (and less soggy) system of falling weights and pulleys. But a true mechanical clock, as opposed to a sundial or an hourglass, requires a power source, and throughout most of human history, an electronic power source was not an option.

So what to do?

Figure out some physics: Kinetic energy is the energy of motion. Potential energy is the energy an object possesses due to its position (i.e., it's all stored up and ready to go). A bowstring, pulled taut, possesses *potential* energy that will be transferred into kinetic energy when the arrow is released—enough energy to power the arrow's flight. At the top of a waterfall, water possesses *potential* energy that can be released as the water plummets, which can subsequently be used to turn a waterwheel.

There are two different types of potential energy: gravitational and elastic. The falling water that powers the waterwheel is an example of *gravitational* potential energy: It exploits the effect of gravity to move the object from one place to another. The bow and the drawstring are an example of *elastic* potential energy. New force has to be put into the system, by stretching or compressing it, in order to generate potential energy. In the case of the bow and arrow, pulling the bowstring backward puts energy into the system, which creates elastic potential energy, which is then, when the bow is released, converted into kinetic energy.

Regardless of whether a watchmaker uses gravitational or

elastic potential energy—uses, in other words, either a pendulum or a spring—a mechanism is required to convert that captured power and transform it back into motion. In a mechanical clock, that device is called an *escapement*. As a pendulum swings back and forth, the lever attached to it turns a gear at a steady rate.

Every pendulum swing is regular, meaning that each sweep of the pendulum moves the primary gear one click at a time, which subsequently allows all the interconnected gears to move at a steady, measured rate, and thus move the hands of the clock at identical intervals. An unwinding mainspring serves the same purpose as a weight or pendulum, but allows for the miniaturization and portability that a pendulum does not.

Smaller, portable, spring-powered clocks—the predecessor of the watch—started to appear in fifteenth-century Europe. They had solved the problem of size and portability but were subject to a new difficulty. As a spring winds down, it loses energy. That loss of energy is, on the one hand, how the spring powers the device—by transferring it, essentially, to a gear— but it's also the major flaw in its design. The spring starts out very tight, at a high-energy state, and ends up very loose, at a low-energy state. As it unwinds, the clock slows down. In other words, these early models were small and portable, but couldn't keep steady time.

The solution arrived in 1657 with the invention of the balance spring: a very, very thin, coiled strip of metal attached to a balance wheel. As the balance spring unwinds, it causes the balance wheel to oscillate with a resonant frequency, essentially turning the spring and wheel mechanism into a harmonic oscillator, which pulses like a heartbeat at a precise rhythm of identical intervals. That heartbeat—the oscillation—controls the rate at which the wheels and gears run, distributing the spring-powered force evenly over an extended period, resulting in steady time-keeping. That single innovation, however, took almost five hundred years to arrive.

All told, clocks are among the very oldest forms of technology. In any given millennium or century, including our own, timekeeping and the technology engineered to render it more precise represents the pinnacle of craft, mechanical engineering, and cosmological understanding.

Watch Me

Now let's press PAUSE. For a moment, I want to take a leap from the seventeenth-century innovation that forever altered portable clocks to a technological field of twenty-first-century interest: eye tracking. *Eye tracking* and its study are a modern innovation, an emergent field in our understanding of the psychology of attention. Sound like a major leap from the history of the first watch? Not really, when you consider the role vanity, emulation, and most important, attention seeking, have played in the development of timekeeping technology.*

The way eye tracking works is complicated. First, a small device is fitted to the face over the eyes. This device quite literally "tracks" in which direction a subject's eyes move, where they rest, and for how long. It's an indisputable record of what appeals to the eye and to what degree. It's far more accurate than simply asking a subject what interests him or her—people lie, of course, and more important, people *don't actually seem to know what they're looking at or why*.

Eye tracking technology has been used in humans to inform advertising strategy and to understand how we interpret visual data on a page or screen. The results are often comically obvious. For example: When a mixed group of men and women were shown the same advertisement of a woman in a bikini, the women

* The same goes for jewelry in general—more on that in a bit.

predictably looked the longest and most frequently at her face, whereas the men divided their time fairly evenly between her face, her breasts, and her other . . . assets. (Don't misunderstand—the women ogled the bikini-clad woman too, but their attention was more predominantly focused on her face.) Interestingly, when men and women were shown a photo of an attractive *man*, the results were exactly the same, rather than reversed. The women still mostly looked at his face and marginally at his body, the men still primarily checked out their imaginary rival's physique and particularly his equipment.

What are we really looking for? It's not as simple as sex. Heterosexual men and women aren't primarily, let alone exclusively, focused on the bodies of the opposite sex. We can't reduce our looking patterns to envy either, or women would look longer and harder at the figures of their competition than they do at their faces.

What we're unconsciously looking for is the human equivalent of a peacock tail. What do they have that we don't? A more symmetrical (i.e., genetically "fit") face? A body that implies children? Perhaps the affluence to eat well, or maybe the genetics to outsize the competition? We're looking to place ourselves in some subjective rank, by making objective assessments of our peers. Remember positional good? Eye tracking allows us to chart exactly what sort of assets we're comparing.

We can observe a less obvious but more concrete display of this tendency when we take sex—and bodies themselves—out of the experiment. When both groups, male and female, are shown a picture of a man and woman from the shoulders up, the eye tracking results for both groups are nearly identical. Both genders spend an equal, and extraordinarily long, amount of time looking at *each and every piece of jewelry* the subject is wearing—in most cases, far longer than they spend looking at the faces. They are unconsciously searching for assets, for signs of position and rank, for ways to compare.

People's need to assess the value of who and what is around them, and to place themselves in some positional context, is universal. It's in our animal nature to compete and to measure, compare, and rank. It's also a pretty standard instinct to want to be the most valued or the most desired. It's the basis of sexual selection and Darwinian evolution.

But to be desired, one must first be seen.

Like glittery blue butterflies or peacocks with giant fanning tails, the fastest way to grab attention is to have something special. When it comes down to it, that's really the primary function of jewelry—to stand out, to sparkle, to catch and hold people's attention. Sometimes jewelry enhances beauty, while other times it telegraphs wealth and power. Either way, it's always an expression of advantages, either natural or procured.

Look at it this way. Genetic fitness, youth, and fertility are pretty hard to fake—though in the twenty-first century, we do our best. But other material assets can convey other, more material advantages, ones that either aren't physical, or don't fade with time—or possibly both. Things like money, power, influence, or access. Maybe that's why, while women look more at the faces and men look more at the bodies, *everybody* looks most at the jewelry. The fastest way to get attention and communicate privilege is to possess a status symbol.

Preferably a very sparkly one.

Buying Time

Humans, as we've established, have few biological means at our disposal to communicate wealth or convey an advantage. Unlike our glittering and feathered friends, we have no tails or wings or scales. So we look to our one unique competitive advantage over the rest of the animal kingdom: mechanical ingenuity.

Let's go back another few hundred years, to the emergent technology of the day: pocket watches.

Sometime in the fifteenth century, well before the development of the balance wheel and spring in 1657, the earliest proto–pocket watches emerged, barely different from earlier portable spring-loaded clocks. They were remarkably large and barrel shaped in order to accommodate the spring inside. They had to be wound repeatedly throughout the day, only had an hour hand, and kept terrible time—they often lost *several hours* of time a day.

Despite their cumbersome nature and questionable utility, they were designed to be worn. They were so desperately expensive and so hard to find that their scarcity made them an immediate and ostentatious display of wealth and privilege. By the sixteenth century they had become a favorite form of ornamentation among the elite.

Eventually, having just a single pocket watch wasn't enough, and in a classic expenditure cascade, the wealthy of Europe demanded increasingly complicated, and therefore increasingly expensive designs. Within a century, the fad was for small clocks in whimsical shapes that could be worn fastened to one's clothing or on a chain around the neck. They ranged from iconic items, like stars and crosses, to more elaborate decorative themes, like flowers and animals. They were even crafted in the form of skulls. The so-called Death's Head watches were a poetic, if morose, reminder that Father Time is coming for all of us.

By the seventeenth century, the artistic demand for smaller portable clocks in interesting shapes gave rise to more advanced timekeeping technology, like the balance spring. Charles II of England had just popularized waistcoats, a fashionable garment with side pockets, and so it became trendy to keep a relatively accurate, small, flat clock in one's pocket. The "pocket watch" was born.

Until the early twentieth century, functioning clocks were the epitome and apex of modern technology. Then, just like now,

the smaller the technology was, the newer and more expensive it became. Watches were, traditionally, the specific purview of the extremely wealthy. Even when they didn't work well, which was pretty much from the time of their inception until about one hundred years ago, they were still priced like rare jewels and were just as difficult to come by.

Henry VIII, never shy about showing off, was the first to demand a "pocket clock": a salad plate–sized clock that he could wear on a chain around his neck. Predictably classy. His daughter, Elizabeth I, wore one around her upper arm. A round pocket watch encircled by diamonds and attached to an "armlet," the watch was a gift from her favorite admirer and alleged lover, the earl of Leicester, Robert Dudley.* Even Marie Antoinette got in on the action, having supposedly commissioned a diamond bracelet involving some sort of a timekeeping mechanism.†

Ring watches, which were also quite popular, date back to at least the Renaissance. These watches, which substituted a timekeeper‡ for a gemstone, were primarily ornamental and had only an hour hand to indicate the general time, one that often got stuck or skipped ahead. They were utterly useless, but still a favored form of showing off for centuries. A diamond tiara doesn't keep your head dry either.

By the eighteenth and nineteenth century, pocket watches, though still fragile and susceptible to every kind of damage, were finally accurate enough to be valued for their utility alone. Even so, they were still regarded, to a great degree, as jewelry. The watches themselves were dressed up in cases of gold, enamel, diamonds, and other gems, meant to catch the eye like jewelry.

* Dominique Fléchon, *The Mastery of Time: A History of Timekeeping, from the Sundial to the Wristwatch: Discoveries, Inventions, and Advances in Master Watchmaking* (Paris: Flammarion, 2012).

† "The State of the Art in Women's Watches," *Chicago Tribune*, November 25, 2014.

‡ Ironically, functional or not.

But like the jeweled reliquaries that hold the bones of saints or the shroud of Turin, those precious glittering cases were really just a tribute to what was inside, something beyond common value: *time*.

Time and science. While it takes extraordinary skill for a diamond cutter to cut a diamond, or a goldsmith to fashion a ring or a chain, piecing together a clock takes even more skill. Watchmakers needed to match the extraordinary precision necessary to create such tiny, intricate moving parts with an understanding of the mechanics of time and space. People needed a solid understanding of day and night cycles and of the movements of the planets and stars in order to build a functioning sundial. Add to that a substantial grasp of metallurgy and mechanical engineering, and you could make yourself a clock. With the greatest and rarest skill, along with a decent grasp of harmonics, a watchmaker could miniaturize that technology and create a pocket watch.

What better way to convey your wealth and privilege to those around you than by wearing the very workings of the cosmos on the end of a gold chain?

First Watch

With the occasional exception of powerful female monarchs, money and authority traditionally belonged to men, and so too, with a rare few exceptions, did watches. By the nineteenth century, the pocket watch industry was on fire, and there were models and styles to suit every need and price range. There were women's pocket watches for wealthy ladies to flaunt, although they were less highly regarded within the watch industry itself, where they were generally considered expensive trifles.

Patek, Czapek & Co. were numbered among the many watchmakers that sprang up to fill the demand for portable timepieces.

Founded in 1839 by Polish designer Antoni Norbert Patek and his partner, Franciszek Czapek, Patek, Czapek & Co. specialized in ornate, decorative pocket watches that referenced traditional Polish themes.

In 1845, about a decade after they first opened shop, Patek met the technically brilliant watchmaker Jean Adrien Philippe, who was in Paris debuting his brand-new "stem-winding" system. Philippe's brilliant new design would eliminate the key that had until then been necessary to wind watches and clocks. He replaced it with the stem-winder, an *internal* key of sorts, which terminated in a small, windable finial at the top of the watch. Patek asked Philippe to join him as his new partner and technical director. By 1851, Patek Philippe & Co. was up and running, and Czapek had been kicked to the curb.

Soon afterward, and despite the prevailing notion that watches were predominantly for men, Queen Victoria became a customer. At the Crystal Palace Exhibition in London, she was taken with one of Patek Philippe's mechanical wonders. She bought a lady's pocket watch: a pale blue enamel piece encrusted with floral sprays made of diamonds, one of the first keyless models.

At the time of the London exhibition, the first *real* wristwatch was still seventeen years away. While Elizabeth I and even her iconographic antithesis, Marie Antoinette, both liked to wear their watches on various parts of their arms, they couldn't really have been called wristwatches for a simple reason: They didn't work. The technology for miniaturization just wasn't there until the nineteenth century. More to the point, they were hardly *meant* to work. Whether obscured by gems, like Marie Antoinette's, or strapped to a part of the arm visible only to others, like Elizabeth's, these early timekeepers were considered just a new style in jewelry, in which priceless technology was substituted for a gem.

The runner-up for the position of first wristwatch, in the modern sense, was one designed by Abraham-Louis Breguet for

Caroline Murat, the queen of Naples, in 1810. It was a very thin, oblong repeater watch, and it almost certainly wasn't intended to keep accurate time. Since it was affixed to a delicate band of "hair interlaced with gold thread" on the wrist and not to an actual metal bracelet or leather strap, it's a safe and generally accepted assumption that the watch was strictly ornamental. Breguet's weird hair watch even included a thermometer, perhaps presaging the eventual inclusion of "complications"* in more elaborate nineteenth-century watches.†

Not on My Watch

Paradoxically for jewelry, when it came to wristlets, *smaller* meant *more expensive* and was therefore more desired. The clock was the computer of its day, and then just like now, miniaturization meant money. But while the countess's pinky-nail–sized, fully functioning clock excited people's imaginations and certainly inspired envy, very few people were convinced by the idea that the clock could actually keep time.

Men, for their part, found the idea of wearing a pocket watch on their wrist patently absurd. Influenced in part by the history of nonfunctioning display watches worn as jewelry and in part by their notions of technical limitations, the male buyers of Europe were having none of it. Because wristlets were so small, neither rival watchmakers nor consumers had any real confidence that

* "Complications" are elements added to increase the intricacy of watches. They are capable of tracking and displaying cycles beyond just hours, minutes, and seconds. Early complications were often repeating calendars. Grand Complication watches often include ornate sun and moon phases, chronographs, and sky charts.

† Fléchon, *The Mastery of Time*.

the micromini mechanism could ever keep accurate time. They also didn't buy the idea that people could wear a small, fragile, precise machine on their wrist without breaking it, either through impact, movement, moisture, or even variation in temperature.

But with the debut of the wristlet, microminiaturized, mechanized jewels worked perfectly for the first time in history. To say that the watch industry in general was hostile to the idea of wristlets would be an understatement. Wristlets were seen as no more than a brief passing fancy, a function of the whims of ladies and their ever-changing fashions, and the watch industry of Europe was only too happy to assume that wristlets would soon be gone. One Professor Bolk, of Hamburg, said as late as 1917 (even as World War I raged, and the demand for men's wristwatches was at an all-time high), "the latest idiocy in fashion is to wear one's watch on a bracelet, which exposes it to the most violent movements and to dangerous variations in temperature. It is to be hoped that this that will soon pass."[*]

Not that the prevailing mood among men did anything to dampen the enthusiasm of wealthy women for the trend. The relative wealth of the average female wristlet buyer did, however, reinforce the notion that a woman who could afford a wristlet had nothing to do and therefore no need to be anywhere on time—whereas *all* men were very busy and important. Timekeeping was a vital aspect of a man's day, as his time was, in fact, valuable.

The wristwatch was born in the same decade in which the pocket watch reached the height of its popularity and its perfection. From a commercial perspective, pocket watch makers had a lot to lose if wristwatches caught on. Even so, their objections seemed to be more emotional than financial. Objections to the

[*] Fléchon, *The Mastery of Time*.

wristwatch took on a very misogynistic tone. The prevailing opinion that "women have no need to measure time"[*] was shared by both working- and leisure-class men, who associated the miniature timepieces with women and often complained that they'd "sooner wear a skirt" than sport a wristlet.[†]

As luck would have it, the wristlet's most dubious and least desired attribute—its perfect precision in miniature form— would soon lead to a revolution in watchmaking. In an attempt to miniaturize a fully functioning clock, numerous advances were made not just in watchmaking but in related industries—and technology in general.

For the time being, people could not believe that Patek Philippe had created an accurate watch small enough or tough enough to wear. The wristwatch was fine for the rich and idle women of Western Europe like the Countess Koscowicz, while manly men the world over continued to carry their watches where they belonged: in their pockets.

Bros Before Hoes

In fact, the men of Europe carried those pocket watches all the way to war—and they were rapidly becoming more of a hindrance than a help. It turns out that a delicate watch that has to be held, opened, wound, and kept in a vest pocket is not the most convenient way to tell time on a battlefield. It didn't help that warfare had quickly modernized after the Boer War. Goodbye, horses and bayonets. Hello, mustard gas and machine guns. Not only did modern soldiers need both hands free and available,

[*] Fléchon, *The Mastery of Time*.
[†] Ibid.

there was a new and constant need for the military to precisely synchronize movements, firing, and cover operations—to say nothing of the new requirements of aviation and bombing. As it turned out, the ultramanly armed forces became the one exception to the bro-ban on girly wristlets.

The first timepieces for men that intended to emulate the wristlet design were military issue and were mass-produced by Swiss watchmaker Girard-Perregaux in the 1880s. They were intended for use by the Imperial German Navy to help facilitate the synchronization of naval attacks. Supposedly, the idea was the midbattle brainchild of a German artillery officer who couldn't manage his pocket watch while timing a bombardment. Finally, he strapped the watch to his wrist like a wristlet. His superiors liked the idea "so much that watchmakers in La Chaux-de-Fonds were asked to travel to Berlin to discuss series production of small gold watches attached to wrist bracelets."[*]

The Girard-Perregaux models were still relatively primitive and still very much modeled after pocket watches; they were just attached by a gold chain to a wrist rather than a waistcoat. Still, they would have been a huge leap forward—had they made it into service. For the guys on the ground, the simple utility of the "strap watches" outweighed any embarrassment about sporting a woman's accessory. To the powers that be, however, the new strap watch wasn't yet a necessary piece of military technology, and so they were never actually distributed.

That changed during the Second Anglo-Boer War, when the newfangled strap-on watches were largely credited with helping the outnumbered British troops achieve victory.

[*] Michael Friedberg, *Wristlets: Early Wristwatches and Coming of an Age in World War I* (n.p., 2000), http://people.timezone.com/mfriedberg/articles/Wristlets.html.

Strap-Ons

The Anglo-Boer Wars were a pair of clashes fought in South Africa between imperialist British forces and the not-so-indigenous Voortrekkers. The Voortrekkers were local South Africans of Dutch extraction. Between 1835 and 1845, the Voortrekkers were feeling politically marginalized by the pushy British Empire, and they were none too happy with various British social policies—particularly the ones that banned the holding of slaves and made less land available to them at Cape Colony.

So in a supremely passive-aggressive gesture, approximately fifteen thousand disgruntled Voortrekkers picked up and moved out of the British-held Cape Colony. They trekked (hence the name) across the Orange River and into the interior of South Africa, where they set up their own country in the form of two independent republics: the Transvaal and the Orange Free State.

The Boers—which, incidentally, means "farmers"—spent about a decade loosely self-governing their two republics. At the time, these two republics mostly comprised subsistence-level farmsteads. The Transvaal and the Orange Free State were even (casually) recognized by Great Britain. But, unfortunately for them, the Boers were farming at the convergence of the Orange and Vaal Rivers, so they were at ground zero for the impending South African diamond rush. In 1867, one year before Countess Koscowicz would debut her wristlet, a little boy pulled a giant diamond from the Orange River, and the rest is colonial, and cartel, history.

Needless to say, the Boers had to move it or lose it.

The Boer Wars began in 1880 and ended in 1902, with only a short stretch of peace between them. They were pretty much a politically self-justified land grab by the British. Ultimately, the Boer Wars would change the landscape, literally and figuratively, of all South Africa.

The British troops had superior training and far better equipment, but were outnumbered by the Boers, who were fighting on their home turf. It was obvious from the start that traditional battlefield tactics—the kind that had been employed in significant wars until that point—weren't going to get it done. Thanks to the Industrial Revolution, technology was developing very quickly, and breakthroughs like the magazine rifle, the automatic or machine gun, and even smokeless gunpowder had started changing the very framework of warfare. New military techniques were far less dependent than older ones on the valor of individual soldiers on the battlefield. In this new military climate, every individual soldier had to behave like an interdependent piece of a precise working whole. The Boer Wars were the world's first little taste of modern warfare—and were, in a broader historical context, a warm-up act for the World Wars.

The advent of new materials and equipment introduced precision-timed warfare on an unprecedented scale. Precision timing required precision timekeeping, and the new equipment required that both hands be free to use it. The watch ordered but forgotten by the Germans in the 1880s was rediscovered by the British soldiers in turn-of-the-century South Africa. Necessity is the mother of reappropriation, after all.

Between 1900 and 1902, the British soldiers fighting the Boers—remembering their wives' wristlets—took their own pocket watches and strapped them to their wrists with primitive cupped leather bands. British officers used these makeshift war wristwatches to orchestrate simultaneous troop movements, coordinate flanking attacks, and synchronize massive strike firing against the enemy formations.*

* A military-issue wristwatch wasn't the only mandated costume change that resulted from the Boer Wars. Before the Second Boer war, the British uniforms maintained their distinctive scarlet color. After embarrassingly failed attempts to fight the guerrilla forces in South Africa while wearing that particular shade, khaki was finally adopted in 1897 as the official service color for overseas Brit-

In fact, the service or strap watch was an idea so successful, and suddenly so celebrated, that for the first time, the idea of a man's wristwatch became interesting to watch manufacturers. Companies began manufacturing the new strap watch and developed advertising campaigns for them—most of which capitalized on the British victory in South Africa.

Watchmen

When the 1901 *Goldsmiths Company Watch and Clock Catalogue* advertised a military pocket watch, listed as the company's "Service Watch," it made a point of including what was titled an "Unsolicited Testimonial" dated June 7, 1900. The soldier cited in the testimonial claimed to own the very same pocket watch advertised, and stated that "I wore it continually in South Africa on my wrist for 3½ months. It kept most excellent time, and never failed me. Faithfully yours, Capt. North Staffs. Regt."[*]

Even though watch companies had started manufacturing strap watches, most of the advertising by watch companies around the turn of the century was still for pocket watches. In the 1906 Omega watch catalog, forty-eight pages of pocket watches crowd out only three wristwatches. Even so, the watch industry was beginning not only to tap into the military market but use the military *to market*. The Service Watch that Goldsmiths Company advertised as endorsed by a Boer War veteran was described as "the most reliable timekeeper in the World for Gentlemen going on Active Service or for rough wear."

Once men began to accept the idea that a wristwatch could be

ish soldiers. Fashion, insofar as it was seen as equipment, was shifting to keep pace with a rapidly changing and expanding world.

[*] Friedberg, *Wristlets*.

reliable, functional, and moreover *manly,* women's wristwatches underwent another cosmetic shift: They were referred to as ladies' bracelet watches. *Wristwatch* came to imply a man's watch exclusively, but the wristwatch still had a long way to go before its use would be widely accepted and embraced by the average public consumer, and especially by men.

The masculinization of watches in the minds of men was a battle more of symbolism than commercialism. Though the wristwatch was a functional piece of equipment, it was also still jewelry. And jewelry, as we have seen, is laden with imaginary values and symbolic meanings and worth. To make a man wear a watch—outside the context of trench war—*the watch needed to make the man.*

All little boys love airplanes—and they especially loved them at the turn of the twentieth century. In 1904, Louis Cartier did a solid for his friend the famous Brazilian aviator Alberto Santos-Dumont, and in turn Santos-Dumont did a lot for the watch. Prior to the twentieth century, aviators were forced to navigate gliders, balloons, and eventually—by the turn of the century—even early engine-powered airplanes completely by sight. This line-of-sight navigation really only worked at very low altitudes when coastlines or landmarks were visible. Santos-Dumont, one of the early pioneers of aviation, asked Cartier for a better time-piece for use on his long solo flights, one that would help him navigate by *instruments* rather than sight.[*]

Trench innovations notwithstanding, the aviation watch designed by Cartier for Santos-Dumont was the first wristwatch that was *expressly* designed for men. The watch was as pioneer-ing as Cartier's aviator friend. It was designed to be worn on the left wrist so it would be easily accessible to the pilot. Rect-angular and sleek, it looked nothing like a pocket watch, and it wasn't meant to stand in for one either. The timepiece was

[*] Fléchon, *The Mastery of Time.*

attached with metal horns to a band, rather than a strap, and it was secured with a clasp to keep it firmly in place. (You don't want to drop your watch while flying across the channel.) The Santos-Dumont watch was the first watch worn by a man that didn't try to hide or conceal the central fact that it was, indeed, a bracelet. Gone were the days of improvised strap-ons and converted pocket watches.

As soon as the problems of accurately tracking and calculating time, speed, and position were dealt with, aviation became much easier and more widespread. Santos-Dumont was an exciting and romantic figure, and Cartier was popular with everyone. Strap-on service watches may have initially inspired the idea of a wristwatch that was specifically masculine, but the collaboration between Cartier and Santos-Dumont inspired men to *want* one. In an inversion of the way that jewelry, in some historical contexts, has come to signify feminine virtue— as in the case of Elizabeth I and her pearls, for instance— wristwatches became symbolically associated with the manliest of men and with their supposed virtues: the brave fortitude of soldiers, the daring and sex appeal of early aviators, and, as wristwatches became more expensive, the wealth and privilege of bankers and industrialists.

And the wristlet was all but forgotten.

The new, macho wristwatch was a sensation among military men, who bought their own, both for practical reasons and because wristwatches became something of a badge of distinction. While the British didn't make them standard issue until a year or two into the conflict, by the middle of World War I the entire British military was outfitted with a rough-and-tumble version of Countess Koscowicz's fashionable wristlet. American troops were also wearing versions of the newfangled design, most made by the newly founded companies Rolex and Zenith.

Time Bomb

World War I, which was considered the war to end all wars, was the most devastating and far-reaching conflict the world had ever experienced. The Boer Wars may have been dry runs for World War I, but they were nothing compared to the years of trench warfare, peppered by machine-gun fire and strafing, of poisonous gases so horrifying they were ultimately outlawed, that characterized the Great War. It wasn't just the *scope* of the war that was dramatic, engulfing as it did all of Europe and embroiling allies and enemies as far-flung as Japan and America. It was the *newness* of it.

The terrified soldiers and civilians who lived through the Great War were people whose parents and grandparents had fought in wars involving cavalry charges and swords. Until fairly recently, *cannons* had been the pinnacle of military technology. Suddenly soldiers were wearing gas masks and dropping bombs from planes. The modern era had begun, and it was born on the battlefield.

Like Clockwork

The wristwatch was one of the most critical and overlooked pieces of technology to inaugurate the conflict and the modern world that succeeded it. It wasn't the biggest, the loudest, or the scariest weapon in the newly emerging world order's arsenal, but it was the most powerful. Coordinating accurate timing among thousands of individuals proved vital in modern war. Without it, the rest of the technological advantages didn't really work. Airplanes capable of dropping bombs on entire regiments, for example, are impossible to fly without proper instruments, and at the

turn of the century, those instruments were a lot more low-tech than they are now. There was no GPS, and no missile guidance. The most powerful instrument that a pilot (like sailors of centuries past) possessed was the ability to keep accurate time, and therefore make calculations about distance, speed, position, and attitude. You can't drop a bomb unless you know exactly where you are. (Well, you can—but you shouldn't.)

An infantry outfitted with machine guns was far more powerful than one armed with single-shot rifles and bayonets.* But in any century, attacks had to be timed and coordinated. A few decades earlier, organizing these attacks had involved the commander in charge shooting off blasts in sequences to signify to the waiting combatants when it was time to fall into formation, to advance, and to fire. That technique didn't really work once the other side could hear those blasts too and could promptly throw a grenade into your trench. The new era of more destructive mechanized warfare required *silence* as well as synchronization. And speaking of grenades (or missiles or mines or bombs), a chronometer, particularly an accurate one, is pretty indispensable when you're working with explosives—at least if you care about, you know, not blowing yourself up. The same goes for the deployment of tear gas grenades, mustard and chlorine gas, and other poisonous fogs.

* A *barrage* is a long line that is bombed or fired at continuously to break a defensive position or provide cover. By 1915, World War I's most iconic artillery tactic, the creeping barrage, was being used to great effect against the Germans. In a creeping barrage, armed infantry foot soldiers advance just behind the barrage line being created by artillery gunners. As the enemy defenses fall back foot by foot, the infantry advances. The gunners continue the barrage, and the soldiers keep inching their way forward, covered by the gunners' barrage line, which remains intact between the infantry and the adversary. The perfect synchronization required between the artillery creating the barrage and the infantry advancing behind it are just one example of the quiet, subtle, and completely indispensable role wristwatches played in the technological battles of World War I.

Humans hadn't conceived of so many creative and horrific ways of killing each other since the Inquisition. In addition to British and German bombers, there were massive British warships like the HMS *Dreadnought* and smaller but equally lethal German submarines, zeppelins, surface-to-air missiles, tanks, and flamethrowers.

By the end of the Great War, all the major powers had started to get a handle on the chilling and unwieldy technology of the twentieth century and had adjusted their understanding and expectations of warfare accordingly. The wristwatch and the universality of identical time and time synchronization that it brought to individuals in any place or condition was absolutely integral to that process. Time, as they say, was of the essence. *Watches* ultimately showed themselves to be the lynchpin in facilitating the use and evolution of machines— machines that were incorrectly assumed to be game changers on their own. Though Countess Koscowicz's desire to be noticed was motivated primarily by her concerns about fashion, she unwittingly instigated the creation of a perfectly timed and modern military.

Dressed to Kill

At their annual general meeting in 1916, a British watchmaking company, H. Williamson Ltd., made the statement, "The public is buying the practical things of life. Nobody can truthfully contend that the watch is a luxury. In these days the watch is as necessary as a hat—more so, in fact. One can catch trains and keep appointments without a hat, but not without a watch. It is said that one soldier in every four wears a wristlet watch, and the other three mean to get one as soon as they can. Wristlet watches are not luxuries; wedding-rings are not luxuries.

These are the two items jewelers have been selling in the greatest quantities for many months past."[*]

Wristwatches were not standard issue in the military for the first several years of World War I, even though they were in high demand by soldiers. Some bought their wristwatches with their own money, while others improvised on the battlefield in much the same way they had done during the Boer Wars, refashioning pocket watches into improvised strap watches. British officers wore wristwatches, despite the military's reluctance to issue them early on, quite simply because British officers were expected to supply their own kit.

The only army to march into World War I with standard-issue wristwatches from the start was the U.S. Army. American officers rolled in wearing standard-issue American military watches produced by a new company called Zenith. Almost every other watchmaker jumped in as well. (Rolex pioneered waterproof watches; Omega made wristwatches for the British Royal Flying Corps and spy watches for the U.S. Army.) While German troops were up to snuff on all other war technology, they dropped the ball when it came to keeping time. Allied troops, on the other hand, "had a wide range of new [watch] models to choose from."[†]

In all fairness, the Americans had the advantage of entering the war later than everyone else. By the time the United States put boots on the ground, many soldiers were already wearing wristwatches of their own, including low-level British soldiers, who were so determined to have wristwatches that they had been buying or making their own. The British procurement officials, who had mostly issued pocket watches at the beginning of the war in 1914, were already reconsidering their previous denounce-

[*] Stephen Evans, "10 Inventions That Owe Their Success to World War One," BBC News, Berlin, April 13, 2014.

[†] John E. Brozek, "The History and Evolution of the Wristwatch," *International Watch Magazine*, January 2004.

ment of the wristwatches' utility on the battlefield. By 1917, the British War Department began issuing wristwatches to their own officers en masse.[*]

That wide range of options during the last years of World War I reflected both the advancements in watchmaking and the diversity of soldier's needs. All standard service watches had certain elements in common: They were strong, relatively waterproof and shockproof, easy to read, and secure. And, of course, they kept perfect time. These military-issue wristwatches featured an all-metal case. They featured black or white enamel dials with large clear Arabic numerals. These numerals, along with the hands, were treated with a radium finish that made them luminescent so that soldiers would be able to read them in the dark of trenches, tanks, planes, or subs. Many models included tempered steel grilles to protect the glass from shrapnel; others included extra navigational aids, especially those for aviators and sailors.[†]

Almost all of them were the same in one other very important regard: They were "hacks," meaning they had a staccato second hand, which ticks forward one second at a time, rather than one with the smooth, continuous rotation that had previously been desirable. This newest partitioning of the very smallest units of time enhanced timing and allowed for exact synchronization between watches and actions.[‡]

While the years between 1914 and 1917 saw service wristwatches flood the military market on the Allied side, German procurement officers were more conservative. They never really came around to the usefulness of wristwatches, despite having been the first to commission service wristwatches back in 1880. The German forces continued to issue antiquated and unwieldy

[*] Z. M. Wesolowski, *A Concise Guide to Military Timepieces: 1880–1990* (Ramsbury, GB: Crowood Press, 1996).

[†] "Vintage Military Wristwatches," *Collectors Weekly* (Market Street Media LLC, 2007–2015).

[‡] Ibid.

pocket watches[*] to their soldiers throughout the war. There was still, at that point, a doubt in more traditional circles about the viability and propriety of men's wristlets.

By the last year of the war, pocket watches (and Germany) had lost the battle. Wristwatches had made the transition from jewelry, to novelty, to required military tool. According to *International Watch Magazine*, "WWI marked the emergence of the wristwatch as a piece of the military kit."[†] It was a completely indispensable one, it would seem—at least according to *Knowledge for War: Every Officer's Handbook for the Front*, the definitive guidebook for soldiers on their way to the trenches, published during the war. *Knowledge for War* included a list of forty items necessary for the standard officer's kit. The first item on the list, well ahead of essentials like a knife, a first-aid kit, or even boots, was a "luminous wristwatch with unbreakable glass." It was so vital, in fact, that it was placed just ahead of a "revolver."[‡]

Semper Fabulous

When an entire generation of men came home from the Great War, post-traumatic stress disorder[§] wasn't the only parting gift

[*]　Brozek, "The History and Evolution of the Wristwatch."

[†]　Judith Price, *Lest We Forget: Masterpieces of Patriotic Jewelry and Military Decorations* (Lanham, MD: Taylor, 2011).

[‡]　B. C. Lake, *Knowledge for War: Every Officer's Handbook for the Front* (repr., London: Forgotten Books, 2013).

[§]　In fact, an unprecedented number of soldiers came home with PTSD. While postwar conditions like so-called soldier's heart were well established, the sheer magnitude of WWI soldiers who came home suffering from an extreme variety gave rise to the belief that it was a new condition, the result of a thoroughly new kind of war. Experts deduced that the sufferers were "shell-shocked," that is, mentally and emotionally damaged by the endless, deafening barrage of gunfire and explosions that they had been subjected to.

they took with them. Those military-issue watches, so vital to their actions in Europe, were theirs to keep. The popularity of the wristwatch among fighting men, war heroes, and an entire population of grateful civilians would make it not just an indispensable tool but a newly endowed emblem of masculinity, modernity, and First World status.

Both American and European soldiers continued to wear their service watches even after returning to civilian life, and the new fad was not restricted to the superwealthy. The ongoing possession and display of their watches led to a rapid acceptance of—and, in fact, craze for—wristwatches among men. What was once a look-at-me wristlet had been refined over half a decade of warfare and was now a badge of bravery, fittingly called a "trench watch."

In 1917, the British *Horological Journal* published an article that claimed, "the wristlet watch was little used by the sterner sex before the war but now is seen on the wrist of nearly every man in uniform and of many men in civilian attire."* Within ten years, the ratio of wristwatches to pocket watches would be *fifty to one*. There was no longer a debate: The wristwatch was here to stay. Professor Bolk must have been so disappointed.

The rise of the wristwatch was also illustrative of a huge emotional shift. Two decades earlier, men would rather have worn a skirt than a wristlet; after World War I, men wouldn't be caught dead without one. What had been a fashion had shifted its gender appeal, turned into a weapon, and grown into both a psychological and a socioeconomic necessity. Watches had become sexual status symbols for men everywhere.

As was the case for most jewelry, there were unofficial sumptuary rules in effect around the possession and use of wristwatches. For a short time after the wristwatch became an acceptable acces-

* Emily Mobbs, "Watches Are a Man's Best Friend," *Jeweller: Jewellery and Watch News, Trends and Forecasts,* January 8, 2014.

sory for men, but before it became universally embraced, wearing one was a social privilege, not a right. In a stunning inversion of previous attitudes, men not only needed watches to appear to be men but, in some circumstances, were actually *forbidden* to wear them, since they had not earned the right to boast of such masculine virtue as the watch now conveyed. In his history of the Illinois Watch Company, Fredric J. Friedberg relates the story of one such unfortunate man, writing that "after the end of World War I, a lawyer was arguing a point of law in court when Judge Kenesaw Mountain Landis noticed that the lawyer was wearing a wristwatch. The judge halted the lawyer in mid-sentence and asked him if he served in the war. When the lawyer responded he had not, Judge Landis ordered him to remove the watch, admonishing him that it was inappropriate for non-veterans to wear a wristwatch."*

Ouch.

As when a woman is ridiculed for wearing fake diamonds, society both lives by and loathes false advertising—particularly the false declaration of status or assets one doesn't really possess. Poseurs are almost always socially punished. But eventually, the watch-shaming purists lightened up. By the end of the war era, the wristwatch had become to men what pearls have always been to women: a badge of gender, and a symbol of all the presumed and imagined traits associated with it.

Modern Times

Suddenly, every man had to have a wristwatch—whether it was a rugged service watch that conveyed the fact (or lie) that he had

* Fredric J. Friedberg, *The Illinois Watch: The Life and Times of a Great American Watch Company* (Atglen, PA: Schiffer, 2005).

been in the military, or an expensive golden wristwatch, communicating wealth and success to everyone who saw it. After all, as the science of eye tracking has taught us, to the unconscious human eye, baubles are more captivating than bodies.

Because the demand for wristwatches rose so quickly, all the watchmaking companies of the world went into hyperdrive. Between all the millions of watches distributed to soldiers during World War I, early redesigns and military commissions for what would eventually become World War II, and the high demand among civilian consumers, the men's wristwatch market had become an industrial juggernaut. As watch production surged, so did technological innovations, both in the watch industry and in some surprisingly interrelated fields.

Watch case makers invented new ways of making better-sealed cases for the complex mechanisms inside them by making them resistant to water and dust. In 1926, Rolex introduced the Oyster, the world's first completely waterproof watch, followed rapidly by its Auto Rotor, a self-winding model. Dozens of other companies offered various improvements in shock and scratch resistance, durability, and design. These superwatches were developed in an effort to create a watch that could be worn with ease—worn without thought, as though it were part of one's arm.

The problem of fragile glass was solved by the first synthetic gemstone: synthetic sapphire crystal, which eliminated the need for a trench watch's metal grid, or its predecessor, the more antiquated pocket watch cover. The synthetic crystal was created in 1902 by French chemist Auguste Verneuil, and was superior to glass in every way. It was capable of sustaining a far greater impact without shattering, it was almost completely scratch resistant, and—perhaps most important—it could be produced cheaply in large quantities.*

* Incidentally, while synthetic sapphire crystal revolutionized the watch industry, it has continued to be technologically important to this day. Synthetic sap-

The ensuing decades saw more advances in time technology. Shortly after the debut of the Oyster, Antoine LeCoultre debuted the world's smallest mechanical watch movement. One year later, in 1930, the Breitling Watch Company won a patent for the first stopwatch. Next, the Hamilton Watch Company released the first successful electric watch, followed a few years later by Seiko's quartz crystal, battery-powered models. By 1970, the Hamilton Watch Company introduced the Pulsar, the world's first solid-state digital wristwatch prototype. The LED technology employed in the Pulsar's bright red digital screen was a design revelation, and the quartz circuitry used in place of metal springs and gears was as great a leap forward as the balance spring and wheel harmonic oscillator were in their day.

The extensive innovation in the development of weapons and the expansion of telecommunications fields are generally considered two of the primary legacies of World War I. They set the stage for decades of rapid, world-changing advances in science and technology and, inevitably, in society and social interaction. But in just the same way that the wristwatch was the quietest yet most vital weapon developed during World War I—the one that facilitated the use of all the others—so too would the wristwatch subtly but indispensably facilitate those decades of groundbreaking technological and social changes.

In 1983, thirteen years after the Pulsar, Swatch introduced its first line of *plastic* Swiss quartz watches. Swatch marketed the new plastic timepieces not as disposable per se, but as "affordable" fashion accessories. Replacing the traditional metal watch case and band with plastic started a revolution in fashion, but the most game-changing effect of the introduction of plastic into

phire crystals are used in a wide variety of modern machines, from the glass on grocery store scanners, to high-power, high-frequency CMOS integrated circuits, used in cell phones and satellites. As of 2014, Apple had invested upward of $700 million in the production of new synthetic sapphire crystal screens for its smartphones and new smartwatches.

watchmaking was the drastic reduction of production costs down to almost nothing.

As the watch industry innovated, what was new one moment was obsolete the next, and groundbreaking technology was tossed aside or handed off to other industries in the constant pursuit of the newest new. Meanwhile, the watch industry upped its mass production of watches, and as it did, the processes and the components on which production depended became cheaper and cheaper until, for *the first time in human history*, everyone could afford to have a watch.

And that's when something really magical happened.

Since the beginning, timekeeping has been a rare and exclusive commodity, understood and managed by the elite few. Consequently, what we *did* with our time was similarly managed—for the many—by the few. Our lives have always been circumscribed by time, and the question of who dictates and allots those hours and minutes, has forever been linked to the worth and identity of the recipients.

The person, institution, or even vocation that told you the time, *owned* your time. They told you what to do, where and what to be, and to some extent, who you were—farmer, soldier, parishioner, subject, worker—from one moment to the next. Ringing church bells that called people to prayer, even telling them when to stand and when to kneel, defined them as Christians and as churchgoers. Factory whistles chopping up the days and nights, shifts and breaks, of postindustrial men and women, that told them to stand and sit as surely as the bells in church had and claimed them for the workforce rather than for one religion or another.

Whether our time was read on a sundial and owned by the seasons, or was the property of the church and announced to us by the ringing of bells, our ability to *tell* time has always dictated our ability to control it. When watches became truly available to everyone, time itself became privatized. For the first time ever,

individual human beings, everywhere in the world, *owned their own time*.

As time got smaller, cut into minutes and seconds rather than days and seasons, it also got bigger. We partitioned our lives into minute increments, all of those units of time, like identical and interchangeable parts, read and understood simultaneously throughout the entire world. Because others did the same, we became part of a larger time. We became part of global collective time.

The whole of humanity works on exactly the same timetable now, down to the second. After the innovation of time zones and Greenwich Mean Time, all that was required to put the whole world in lockstep, physically and psychologically, was the ability of each individual to know exactly what time it was in any given place. There were no more church bells to wait for, no more pocket watches to consult, and no more public clocks to adhere to. Time had finally become 100 percent accurate, actually privatized, and completely universal.

And the result? Nothing short of the modern world.

Epilogue: Necessary Objects

By the second half of the twentieth century, owning a wristwatch had become essential. Wristwatches had evolved. On the one hand, they were key luxury items used to signify class and enforce the social order, but on the other, they were just as essential to the common workingman; in a world in which everyone knew the time and being late was no longer a subjective affair. Wristwatches certainly had become indispensable in a world of rapid transportation and global communication.

By that point, people had as many watches as they could afford to own. Watches were just as essential and effective when

used as social tools as they were when used as *actual* tools. There were rugged outdoor models for deep sea diving, high-altitude climbing, and sports of every kind. There were precision models for work. There were nearly disposable watches for fashion, expensive dress watches, and, of course, glittering jewelry watches that also happen to tell the time. Watches had blossomed technologically but managed to remain, like most jewelry, a means of telegraphing social status, employment status, personal interests, and style.

To this day, the men's watch market has its equivalent only in the diamond engagement ring market. Luxury watches are the ultimate male status symbol. Just like wedding rings, even when a watch isn't that good, just having one (or not having one) is a statement. For most men, watches are mandatory, and no cartel manipulated us into believing in the rarity or specialness of the watch. We convinced ourselves, by attaching emotional, sexual, and psychological connotations to an object that just tells the time.

When the first wristwatch made its debut on the countess's wrist in 1868, there was no way to anticipate what else was coming, from airplanes and submarines to long-range communication. All that unexpected new technology, when combined with the surprising and unexpectedly necessary abilities the wristwatch gave people, including the complex construct of global time synchronization, formed the scaffolding around which the modern world has taken shape.

So where are watches today? The fate of the new Apple watch and its many competitors is in limbo as they emerge on the market. While some diehard consumers are excited, the vast majority of people have waved off the smartwatch as nothing more innovative than a shrunken down iPhone you can strap on your wrist. People are concerned that a computer is too fragile to wear on the wrist and that, because this miniaturized iPhone is smaller, it will do less (and be worth less) than that old hand-

sized pocket model. Most critics swear that it's just a passing fad, a novelty item.

Sounds familiar, doesn't it?

In this case, who knows whether the critics, detractors, or proponents of the new technology are correct. But if the story of the first wristwatch tells us anything, it tells us about flux. The story of the first wristwatch is really a story of expectations and reversals. The very thing that made the countess's watch so appealing to her and her set was the newness of it, the strangeness and the exclusivity—and yet, only a few decades later, part of what made the watch so successful was its sheer proliferation. Our lives are circumscribed by watches in unprecedented ways, all because we give meaning and value to them.

As the world changed, the watch changed, and changed the world again with it.

There's still no way to know what surprises are coming, or what simultaneous technological advancements lie ahead, which may be enabled or enhanced by a change as seemingly minute as wearing a smaller version of a smartphone on your wrist. Past is only ever the prologue. But the future, as always, is wide open.

VALUABLES

In 1977, an African dictator named Jean-Bédel Bokassa successfully overthrew the government of the Central African Republic and immediately declared himself emperor of the Central African Empire. Needless to say, the Central African Empire lasted only a few years and was never internationally recognized. During that short time, however, Bokassa enjoyed the kind of absolute power only dictators and would-be emperors enjoy.

What Bokassa didn't have were any crown jewels to symbolically back his claim. Having no treasure, and more guns than credibility, he did the only reasonable thing a dictator in his position could do: He tried to buy legitimacy. He expressed his desire to legitimize his reign with some instant crown jewels to Albert Jolis, the president of Diamond Distributors, Inc. He demanded a state ring, like kings and popes wear. He demanded a diamond "no smaller than a golf ball."

Jolis wanted to retain the contract, and probably his life, but he didn't have the money to come up with the diamond for the emperor's ring. After a little sweating, Jolis did something really quite brilliant. He bought a giant piece of black industrial rough diamond (not to be mistaken for a gem-quality black diamond, which is really a thing of beauty). This is the crappy stuff that gets ground up to make abrasives for machinery. It looks more like a chunk of asphalt than anything else. He used a piece about

the size of a plum and carved it into the shape of the continent of Africa. He then took one *very* small, perfect, faceted white diamond and had it set in the black Africa rock at approximately the location of the emperor's new country. Then he made the whole mess into a ring.

The entire thing was worth about five thousand dollars, but the trembling Jolis presented it to the emperor as worth in the neighborhood of $25 million. And something remarkable happened. When the dictator heard how very rare, unique, and valuable this hideous craggy black diamond was, and above all, *hearing its estimated price*, he put the ring on his hand and proudly walked around the room, presenting it to each of his attendants in turn.

A few years later, the dictator was overthrown. The only thing he took with him into exile was his beloved ring. When Jolis was told of Bokassa's exile, and about the ring, Jolis was quoted as saying: "It's a priceless diamond . . . as long as he doesn't try to sell it."

In the end, there is no reality to what's real.

That's an alarming idea, particularly because it strikes at the very heart of our sense of truth, disabling the compass that allows us to navigate the world: what we value.

We've asked what a stone is worth, and what a gem can mean. What can jewels be? What can they do? They're all good questions. And in the end, they're all a version of the *same* question.

What makes a jewel?

There are a lot of ways to make a gem. They can be tortured into existence in the churning, boiling center of the earth and then explode to the surface, like scattered diamonds. They can merge and grow in the ground, a strange hybrid by-product, like emeralds, formed by the shock of worlds colliding with each other. They can be biological waste, like pearls. They can even be formed by human mechanical ingenuity, like timepieces. But perhaps the most exceptional thing about jewels is not the way

they physically come into being, but the ways in which they come to be important.

Real *jewels* are formed less in the earth or a lab then they are in the human mind. They seem powerful. Certainly they've had the ability to change the world over and over again. And yet, really they're just . . . objects. They're not objects that can kill, or objects that can cure, or build or even think. The very purpose and nature of jewels is one and the same: to transfix and reflect. Just like their glittering surfaces, jewels have one, and only one, real power: They reflect our desires back to us and show us who we are.

Acknowledgments

———

This book endeavors, at least in part, to tell the strange and circuitous story of how things come to happen. The story of how this book came to happen is just as full of coincidences and accidents as any I've ever told.

The first person I should thank is my friend Alex MacDonald, for welcoming me to London and inviting me to Paris, where the first tangible events that resulted in this book were set in motion. Alex, you are fun.

While in Paris, I spent several days with my old friend and college roommate Laura Schechter. While at the first night of her characteristically multiday birthday celebration, I was seated at a dinner table next to a girl wearing an engagement ring that I happened to have designed while at Tacori. When she told me that she'd heard I was a jewelry designer and asked what sort of jewelry I designed, I told her. In her excitement to meet the designer of her ring, she introduced me to her husband, Stephen Barbara, the man seated across from me.

A conversation about engagement rings, diamonds, peculiar histories, and relative value ensued over the course of the night and took a shape that might now sound familiar.

Stephen Barbara was Laura's book agent and is now mine as well. They were not only there at the inception of this idea, but their encouragement, assistance, and faith in my ability to write this book has made all of the difference.

Thank you, Laura, who insisted I come for waffles the first week of school, when I wasn't particularly hungry. And who insisted I come to her birthday party in Paris last year, even

though I was supposed to be somewhere else. It was Laura who insisted I should *definitely* write a book when the idea was suggested, even though I said I didn't really want to; it sounded like a lot of work. She also insisted, all year long, that I could definitely see this through.

Laura, you are a force of nature. Whether it's waffles or novels, there's no point in arguing with you. And besides, when you say, *Come with me,* what you're doing is usually fun. Thanks for always inviting me.

And thank you to my phenomenal agent, Stephen Barbara. He's done a remarkable job on this project, my first. He tolerates my peculiar sense of humor and my high-concept mood swings. And he gets yelled at, probably more than he deserves, mostly about things he has no control over and have nothing to do with him. Federal drug cartels, intermittent ice ages, provocatively dressed robots, and so on . . . Stephen, you are a giant. And you've done an extraordinary job of making me believe this project would be successful—while undoubtedly *making* it successful in reality as well as in my mind.

I also want to thank everyone who worked on this project at Harper-Collins: Emma Janaskie, who tolerates my spelling, among other things; Katherine Beitner; Sonya Cheuse; Craig Young; Ben Tomek; and Dan Halpern. All success is a team effort—and what an exceptional team.

I'm especially grateful to my editor, Hilary Redmon. Her editorial advice is only the beginning of her contribution. Hilary not only selected the manuscript for publication, she has actively collaborated on every element of this book, from its structure to its cover, and has been a tireless and enthusiastic champion for the project. I couldn't possibly have scored a better partner. Thanks, Hilary.

Everyone who has helped behind the scenes, I thank you as well. Shane Hunt, for your amazing tenacity and skill in wran-

gling image rights—thank you. My close friend and associate Tavish Ryan, like a smartphone, has become over the years not just my friend but subtly and frighteningly indispensable. Without Tavish nothing would get done—by anyone, anywhere.

Most of all I'd like to thank my family: My mom, who has always insisted that I can do anything I want to do (no matter how strange). And, in fact, has often enforced that dictate. My dad, who then proudly tells everyone what I've done (no matter how strange). My brothers and sisters, who sometimes nervously cheerlead—sometimes raucously. Sometimes they jump right in.

My family are my favorite people.

Thanks for the critical mass that makes us a party, or a mob, depending on our mood. Thanks for listening to decades of endless facts and stories, for tolerating my temper, enjoying my eccentricities, and indulging my particular obsessions.

And obviously—Mom—thanks for all the jewelry.